THE PARA-ACADEMIC HANDBOOK

THE PARA-ACADEMIC HANDBOOK

A TOOLKIT FOR MAKING-LEARNING-CREATING-ACTING

edited by Alex Wardrop & Deborah Withers

HammerOn Press

THE PARA-ACADEMIC HANDBOOK:
A TOOLKIT FOR MAKING-LEARNING-CREATING-ACTING
© Individual authors, 2014

http://creativecommons.org/licenses/by-nc-nd/3.0

First published in 2014 by HammerOn Press
Bristol, England
http://www.hammeronpress.net

ISBN-13: 978-0-9564507-5-3
ISBN-10: 0956450753

Cover photo *Arise* by Rachael House 2013
www.rachaelhouse.com
Cover design by Graeme Maguire/ Eva Megias
www.graememaguire.com
Typeset by Eva Megias www.evamegias.com

Acknowledgements

We would like to thank all the contributors, Gary Rolfe, Isabelle Stengers, Ruth Barcan, Sam Thomas, Ika Willis, Rob Crowe, Eva Megias, Rachael House, Sue Tate, Hannah Austin, Graeme Maguire, Maud Perrier, Natalie Brown, Genevieve Lively and all those who support para-academic movements of knowledge making, learning, creating, thinking and acting.

Contents

WE ARE ALL PARA-ACADEMICS NOW

Gary Rolfe

I have recently been struggling to find a word to describe the growing movement of resistance towards the ever more corporate mission of the university. I toyed at first with calling this emerging body of people, ideas and practices the *Subversity* in recognition of its largely subterranean nature. But it is no longer an underground movement; the resistance may not be immediately apparent, it may not advertise itself overtly, but it is there, unseen in plain sight, functioning side-by-side with the corporate mission. I finally settled on the *Paraversity*, which I described as a subversive, virtual community of dissensus that exists alongside and in parallel to the corporate university.[1] Had I thought of it at the time, I might well have also coined the term 'para-academics' for those individuals who work across and against the corporate agenda of what Bill Readings called the ruined university,[2] whose mission is, as far as I can see, the generation and sale of information (the so-called research agenda) and the exchange of student fees for degree certificates (the teaching agenda). However, it seems that I have been beaten to it by *The Para-Academic Handbook*.

The corporate university is not going away, but neither is the paraversity; in fact, I would go so far as to say that we are all para-academics now. Of course, when I use the word 'we', I do so with certain qualifications. Firstly, the 'we' I refer to is those who are likely to read this book and others like it: *we* dissenters; *we* who feel disenfranchised by what our

universities have become; *we* who simply cannot passively go along with the doxa, the general consensus of what a university is nowadays for. And, in any case, to ask what a university is for is completely to miss the point. As Michael Oakeshott put it, 'A university is not a machine for achieving a particular purpose or producing a particular result; it is a manner of human activity'.[3] This at least should give us hope. *We* must resist at all costs the idea of the university as a machine: a university should not be defined by what it produces (information, graduates) but by what *we* (para-) academics do and by how *we* relate and respond to one another. *We* (that is, *we* para-academics) must resist becoming cogs in a corporate machine; to borrow from Deleuze and Guattari, *we* are each of us separate and independent 'little machines' whose operations are defined by our connections to one another.[4] I repeat: not cogs but individual machines, and machines that are defined not by what we produce but by how we produce it; by process rather than product; quality rather than quantity. As I said, this should give us hope. If the university is, as Oakeshott suggests, 'a manner of human activity', then we can change the university by changing how we think and behave as its constituent parts.

Which brings me to the second qualification on my use of the word 'we'. Bill Readings warns that the university is in danger of becoming 'an autonomous collective subject who is authorised to say "we" and to terrorise those who do not, or cannot, speak in that "we"'.[5]

I suspect that some academics and others who are reading these words will, like me, have already felt the terror of the collective 'we'. The *we* to which I refer, then, is not the 'we' of consensus, of compromise in the name of getting on (in both senses of the term), but describes what Jean-Luc Nancy calls a plurality of singularities, or what Readings refers to as a community of dissensus.[6]

Dissensus is not dissent, it is not the opposite of consent, but a special case of it. The practice of dissensus is a commitment to thinking alongside and in parallel to one another with no pressure to reach agreement; indeed, the purpose of thinking in parallel is to keep discussion and debate open and alive precisely by avoiding coming to agreement.

A community of dissensus is a community of thinkers committed to formulating questions rather than providing answers and to keeping those questions alive, active and productive for as long as possible. A community of dissensus is a community of researchers, scholars and students (that is, of para-academics) committed to asking questions of one another, to listening and respecting each other's views and ideas, and to describing, explaining and advocating their own ideas with no expectations or obligations to agree. A community of dissensus is a community that consents not to be bound by consensus.

The para-doxical (that is, parallel to the doxa, to received opinion) space in which we para-academics operate should not be thought of as either inside or outside of the orthodoxical university. In fact, it would be misleading to think of the paraversity as existing in space at all. As academics, we all of course occupy a physical space within the university; we are each, to some extent, tethered to a discipline, a department, a curriculum, a course. However, to the extent that we are also para-academics, we are also individual little machines, free to roam physically, intellectually and emotionally. Universities organise and understand themselves as linear, unidirectional tree-like hierarchies in which we are leaves attached to twigs, attached to branches, attached to a central trunk. In contrast, the paraversity takes the form of a rhizome, an underground, tangled root structure in which, as Deleuze and Guattari tell us, any point can be connected to anything other, *and must be*.[7] It is the duty of the little para-academic machine, then, *to connect with anything other*, to plug in, to become entangled with as many people and projects as possible.

This multiplicity of singularities which makes up the paraversity is reflected in the content of this *Para-Academic Handbook*. These are mostly singular visions and singular projects. That is not to say that they are undertaken in isolation from what is going on around them; indeed, many of them are delightfully tangled and woven into the tissue of the orthodoxical university. However, they make no concessions to the doxa and no compromises in the face of the terror of the collective 'we'. You do not need to have read this handbook to know this to be true; you need

only look at the contents page which will also, I am sure, suggest to you that what you are holding is not only a *hand*book, but also a *head*book and a *heart*book.

We, the plurality of singularities reading this book, the *we* who reject the doxa in favour of the para-doxa, who think, create and scheme together in parallel without the need or desire to converge, who resist the terror of the collective and the pressure to be productive; *we are all para-academics.*

Notes

1 Rolfe, Gary (2013) *The University in Dissent*. London: Routledge.
2 Readings, Bill (1996) *The University in Ruins*. Cambridge MA: Harvard University Press.
3 Oakeshott, Michael (2001) *The Voice of Liberal Learning*. Indianapolis: Liberty Fund, 106.
4 Deleuze, Gilles and Guatarri, Felix (1989) *A Thousand Plateaus*. Minneapolis: University of Minnesota Press, 4.
5 Readings, *The University in Ruins*, 188.
6 Nancy, Jean-Luc (1996) *Being Singular Plural*. California: Stanford University Press.
7 Deleuze and Guatarri, *A Thousand Plateaus*, 7.

Gary Rolfe is Professor of Nursing at Swansea University and Visiting Professor at Trinity College Dublin and Canterbury Christ Church University. He is also Associate Professor in Innovation and Practice Development with Abertawe Bro Morgannwg University Health Board. He is Assistant Editor of *Nurse Education Today*, where he also edits the 'Big Ideas' section, and sits on the editorial boards of *Educational Action Research* and the *International Journal of Practice Development.*

Gary has published ten books in the field of practice innovation in healthcare, reflective practice, practitioner research, philosophy of healthcare and education, along with well over one hundred book chapters, journal papers and editorials. He regularly receives invitations to speak at conferences and give seminars across the world. His most recent book is *The University in Dissent: Scholarship in the Corporate University*, published by Routledge.

RECLAIMING WHAT HAS BEEN DEVASTATED

Deborah Withers & Alex Wardrop

Reclaiming is an adventure, both empirical and pragmatic, because it does not primarily mean taking back what was confiscated, but rather learning what it takes to inhabit again what was devastated. Reclaiming indeed associates irreducibly 'to heal', 'to reappropriate', 'to learn/teach again', 'to struggle', to 'become able to restore life where it was poisoned', and it demands that we learn how to do it for each zone of devastation, each zone of the earth, of our collective practices and of our experience.[1]

Scoundrels have infiltrated the academy—bureaucrats, managers and marketing 'experts'—some of whom know very little, or even care about, education. Armed with training manuals that outline 'best practices' and productivity mantras, permanent academic, administrative, and facilities staff members buckle under the increasing strain of paper work and mandates, emotionally drained by petty fights over room allocation and resource management. Students file in to classes, burdened by extortionate debt, as they scramble to use their learning to achieve meaningful ends within their life-to-come in the unforgiving capitalist marketplace. Or they drift into lectures listlessly, baffled by the broken promise of a dream, snuffed out by the atrocious sell-out the university has become. It is a *devastated* place.

The utterly dispensable para-academic watches this scene from the margins—subjected to the callous mediocrity of temporary contracts that offer absolutely nothing in terms of 'career development', or any kind of rung on the ruthless academic ladder. Detached somewhat from the chaotic horror of the neoliberal academy, and certainly without the voluminous administrative burdens placed on permanent staff members (but not without their fair share of it), they, nonetheless, participate tentatively in its demise—all in exchange for the perks of library access and the meager portion of teaching that keeps them 'in the game'. Within the institution the para-academic can, as Margaret Mayhew suggests in her contribution to this volume, 'feel like a mosquito, constantly buzzing in the ears of my colleagues, asking for basic information, listening in on corridor chat, smiling and hoping I can be included [...] yet I am not quite and not ever one of them.'

Yet, as the para-academic witnesses the hierarchical zones of devastation tearing through the contemporary university, a flicker of something else 'flashes up at a moment of danger'.[2] Armed with the skills that years of university training and experience have afforded them, they absolve precisely to '"to heal", "to reappropriate", "to learn/teach again", "to struggle", to "become able to restore life where it was poisoned"' because they understand deeply that knowledge, learning and thinking emerge from *collective* practices, despite all seeming evidence to the contrary.

Within the multiple sites of devastation they hover between, the para-academic conducts a continuous series of improvised responses. Always kept on their toes, hand to mouth, idea to idea—there is no glory in this struggle—the anxiety and depression can be debilitating for those thrust within its course. Nevertheless, they carve out opportunities to inhabit spaces that appear off limits under the terms of the contemporary academy, which has been so thoroughly 'occupied' by marketisation. They work for and with others who have been similarly discarded to sustain the very simple (but somehow, now, very rebellious!) idea that thinking and learning are worthy activities with multiple values beyond the scope of any capital-driven market, and which exceed quantification

in economic terms. As default, thrown out, thrown in rebels born of an impossible situation, their refusal 'does not imply a renunciation' even if it announces 'the existence of a borderline' once the para-academic has begin to 'think', more so, to *act*.[3] A streak of militancy, therefore, carries their action forth, grounded in the 'care of the possible,' emerging from the committed yearning of applied imagination.[4]

As a term we first encountered 'para-academic' among the drift of information that flows through social media. It captured our attention because it seemed to describe the knowledge making and learning practices we were involved in as trained scholars who were unable to, or felt uneasy about, securing a permanent role within the contemporary neoliberal university. The notion of the para-academic gestured toward a person but, also, potential *collectivities* of people and practices existing simultaneously inside, outside, and *alongside* the conventional academy. They often occupy their positions through force of circumstance, choice or an ambivalent mixture of both. The figuration of para-academics also suggested an image of an *alter*-university where knowledge, learning, and thinking could be continually re-articulated and reclaimed in what may be seen as idealist or even naïve terms—naïve, that is, when compared with what is currently offered by the marketised university.

Articulating the experiences of para-academia was also attractive because it helped us to name some of the particular employment frustrations of a significant number of higher education workers who find themselves thrust into the job-seeking wilderness post-PhD, sometimes armed with nothing but a very hefty, specialised qualification, promised nothing other than precarious, short-term contracts. We realise however that not all para-academics are in this position, even if this more or less describes our experiences. Some may never have been to university, but are committed to creating learning situations or are otherwise involved in knowledge production. We hope this collection manages to speak to different aspects of the para-academic, and the varied configurations of para-academic practice conjured here. We include, for example, the speculative theoretical work of *DUST*, the work of Paul Hurley which operates at the intersection of academic, community and artistic

concerns and the activist research conducted to empower marginalised communities explored by Charlotte Cooper. These different approaches, alongside others in the book, describe, theorise and interpret varied applications of emergent para-academic practice and knowledge-making.

SITUATING THE PARA-ACADEMIC

The first articulation of the contemporary term 'para-academic' is often attributed to the US-based academic Nicola Masciandaro,[5] however higher education scholar Bruce MacFarlane published an article in 2011 that used 'para-academic' to describe the 'unbundling' of the 'all-round' academic. Within this context, MacFarlane argues, the increased emphasis on specialisation into teaching, research, administration, management or pastoral care roles 'runs the risk of undermining the holistic nature of professional identity with reward systems encouraging a strategic disengagement from broader elements of occupational responsibility.'[6]

Para-academic practice is particularly visible 'outside' the academy in the Open Access publishing of punctum books and in journals such as *continent*, for example.[7] Theorists such as Michael O'Rourke and Eileen Joy have contributed a great deal to understandings of what para-academia can mean for (un)learning and thinking out or alongside the boundaries of conventional universities.[8] And we are delighted that Michael, alongside Éamonn Dunne, and Eileen, have contributed to this collection. Yet, while the term may itself be relatively 'new', arising from a very specific set of economic and social circumstances befalling academics in the early 21st century, people working in a para-academic capacity have existed for sometime, as Tony Keen's contribution in this collection demonstrates. Moreover, critical theorists, radical knowledge producers and transformative teaching practices have not, historically, been the exclusive purview of the university, as Joyce Canaan's interview reminds us. It is, therefore, imperative to be wary of what Laura Sterry describes as the 'myopia' of the academy that prevents critical engagement with its exclusionary mechanisms operating at pedagogic and economic levels.

The technological conditions in the early 21st century have, to a degree, enabled the flourishing of the contemporary para-academic—the infinite archive of digital culture provides a rich resource for the unmoored critical thinker seeking stimulation and inspiration. The digital pirate libraries of websites such as AAAAARG[9] were imagined as an 'infinite resource, mobilised (and nurtured) by reading groups, social movements, fringe scholars, temporary projects, students' that 'actively explored and exploited the affordances of asynchronous, networked communication.'[10] The contemporary tendency to obsessively document and publicly distribute *everything* means that lectures and conferences are recorded and even streamed live under the ruse of 'engagement' and 'impact'. In an everyday manner the normative internet culture of 'sharing' also facilitates the distribution of resources, even if time and attention to digest such information has become scarce.[11] As figures circulating within and also producing 'public' information, para-academics are well placed to take the knowledges universities offer, and make the rest up ourselves. As Paul Boshears argues in the collection, para-academia is a practice of 'public-making' albeit in a context where the public has become a funding crowd, Oliver Leistert & Theo Röhle suggest.

Para-academia emerges amid a crisis of *value*. When the financial costs of higher education are continually changing and opaque to students and staff alike, the cultural or personal value of higher education becomes peripheral. Debates about the value of HE are dominated by talk of debt, cost, high salaries, low salaries, no salaries, and forecasted graduate income. This leaves little room for the potential value of higher education in terms of empowerment, personal development, wellbeing, and as a catalyst for social transformation and critique. The twin forces of austerity and marketisation have also enveloped other cultural learning institutions, from schools to museums, who are forced to become entrepreneurial or enter into commercial partnerships so they can be productive contributors to the creative and cultural industries.[12] In response to these multiple crises, many independent educational networks have emerged, as Joyce Canaan outlines.

The struggle over value is accentuated by an increasing emphasis

on *standardisation*, emerging from protocols established as part of the Europe-wide 1999 Bologna Accord on education. Although it is claimed that 'the Bologna Process does not aim to harmonise national educational systems but rather to provide tools to connect them,' [13] artists have offered critique of how the policy encourages the control, regulation and management of institutional educational practices. Artists have 'turned' toward education in order to 'search for other languages and other modalities of knowledge production, a pursuit of other modes of entering the problematics of "education" that defy, in voice and in practice, the limitations being set up by the forces of bureaucratic pragmatism.'[14]

Despite operating in a landscape where ideals and values are devastated, the para-academic does, however, remain somehow *attached* (physically, intellectually, emotionally) to the university, or at least *an idea of* the university. We understand, like the name of the Dublin-based collective featured in the book, that the university is always *provisional* and therefore susceptible to transformation. And there are, of course, many academics working on the 'inside' that use their position to access funds, conduct research, and run workshops that directly benefit communities or the activities of social movements. These actions can work *against* the closing-in dogma of neoliberal academia. There are always loopholes to exploit and tiny incisions that can be made, as Tom Henfrey and B.J. Epstein suggest in their contributions. Conversely, difficult professional situations can arise for people who cross borders, as Louise Livesey articulates.

Para-academia—as a space that is not one—signals the limits and the many different escape routes from the business as usual of the neoliberal academy.[15] We hope this collection will inspire people to keep thinking, making, learning, creating and acting in whatever ways make sense to them. In a historical moment when learning, reading and thinking 'just for the sake of it' appear like marginal practices, remember that this book is here. Remember that people are doing things and you have the power to do things too. Remember that nothing is inevitable, and everything is possible.

Notes

1 Stengers, Isabelle (2008) 'Experimenting with Refrains: Subjectivity and the Challenge of Escaping Modern Dualism', *Subjectivity*, 28, 38-59: 58. Available online: http://www.palgrave-journals.com/sub/journal/v22/n1/pdf/sub20086a.pdf. Last accessed 9 January 2014.

2 Benjamin, Walter (1977) 'Theses on the Philosophy of History', *Illuminations*. Glasgow: Fortuna: 255-267, 257.

3 Camus, Albert (2000) *The Rebel*, London: Penguin, 19.

4 Stengers, Isabelle (2011) interviewed by Erik Bordeleu 'Care of the Possible', 12. Available online: http://www.scapegoatjournal.org/docs/01/01_Stengers_Bordeleau_CareOfThePossible.pdf. Last accessed 9 January 2014.

5 See Nicola's work associated with the Public School, New York http://thepublicschool.org/node/3753. Last accessed 19 June 2014.

6 MacFarlane, Bruce (2011) 'The Morphing of Academic Practice: Unbundling and the Rise of the Para-academic', *Higher Education Quarterly*, 65: 1: 59–73, 60.

7 http://punctumbooks.com/; http://continentcontinent.cc/index.php/continent. Last accessed 19 June 2014.

8 Joy, Eileen (2012) 'Two Roads Diverged in a Yellow Wood, and I, I Took the One Less Travelled By: Why I Resigned My Professorship' *In the Middle*. Available online: http://www.inthemedievalmiddle.com/2012/10/two-roads-diverged-in-yellow-wood-and-i.html. Last accessed 12 February 2014.

9 http://grr.aaaaarg.org/txt/. Last accessed 12 February 2014.

10 Dean, Jodi *et al* (2013) 'Materialities of Independent Publishing: with AAAAARG, *Chto Delat?*, I Cite, *Mute*, and *Neural*,' *New Formations*. 78: 157-207, 166-167.

11 Stiegler, Bernard (2010) *Taking Care of Youth and the Generations*, trans. Stephen Barker, Stanford: Stanford University Press; http://www.culturemachine.net/index.php/cm/issue/view/24; Crary, Jonathan (2013) *24/7*, London: Verso.

12 See, for example, *Museums Change Lives,* published by the Musuems Association (2013). http://www.museumsassociation.org/download?id=1001738. Last accessed 19 June 2014.

13 See http://www.eua.be/eua-work-and-policy-area/building-the-european-higher-education-area/bologna-basics.aspx. Last accessed 19 June 2014.

14 Rogoff, Irit (2010) 'Education Actualized' in *e-flux*, 03/10. Available online: http://www.e-flux.com/journal/"education-actualized"---editorial/. Last accessed 15 February 2014. See also other articles in the same journal http://www.e-flux.com/issues/14-march-2010/; Neill, Paul and Wilson, Mick (eds) (2010) *Curating the Educational Turn.* London: Open Editions.

15 Papadopoulos, Dimitris *et al* (2008) *Escape Routes: Power and Subversion in the 21st Century.* London: Pluto.

Deborah Withers is a thinker, researcher, writer and mover between worlds. She has written articles, books, songs and blog posts; curated exhibitions, published books and created learning spaces for herself and others to be in. She continues to do all these things. More here: debi-rah.net

Alex Wardrop is a temp, a teacher, and a community arts practitioner. She is interested in the histories of thought, how fraught spaces can challenge thinking, and how higher education can challenge itself to be better than it is. She completed her PhD in 2012 and has successfully gotten over it.

A PROCRASTINATION[1]

Alex Wardrop

ποῖ δὴ καὶ πόθεν
Where are you going, and where've you been?
[Plato, *Phaedrus*, 227a]

Carry on my wayward son
There'll be peace when you are done
Lay your weary head to rest
Don't you cry no more
[Kansas, *Carry on Wayward Son*, 1976]

We are dust and desert souls
[Tatiana de la Tierra][2]

I keep getting caught on the *movement*. On an image of a road departing from some ruins into a desert oscillating between some false dream of Americana and the false reality of the suburbia of my childhood. The movement, however fast, leaves nothing behind. The ruins follow the road; dead birds, dead animals, scraps of rubber, and metal, and bones. The ruins still remain however fast I accelerate.

Thinking about what to write, I get caught on this movement. And I want to flee. I have done the washing—twice—cleaned the bathroom,

and now the pile of dishes is looking longingly at me. I want to go down any road, just so long as it's not this one. *I am procrastinating.* I do it very well.

In response to my anxieties, my oldest friend sent me this message:

> Stop telling yourself you're procrastinating – you're living your life. You don't owe anyone anything. xxxxxxx

Along with soothing my procrastinatory panics and reminding me of things too easily forgotten, this message sums up a condition of the precarious words/worlds which form this book; that fraught trying to pass as something solid, feeling all the while like dust that won't stop blowing.

What I want to write is this: *everyone stop trying so goddamn hard, start procrastinating a little; you don't owe anyone anything, don't cry no more!* And I want that heard by anyone who has ever cared about higher education, even just for a moment. But I won't. Because I know no one wants to hear it, everybody *is* working too goddamn hard to stop and listen. There's no time.

I still get caught on the movement.

Something about the name, *para*-academic demands thinking about higher education as a moving, ongoing process rather than any fixed topography. Like Alexandra Kokoli writes in the (re)opening of this handbook, *para* is a prefix which *moves*—the word, the reader, the idea. Hasn't the so-called Ivory Tower been in ruins long enough for people to be comfortable with the constant transformations of its fragile remnants?[3] Or, if not comfortable, at least *aware* that their topography is a pile of shrapnel and debris, more open, at times more painful, definitely more curious than some false architecture which refuses any erosion or transformation?

Although in many real and imagined ways, universities saved my life, one of the reasons for *choosing* to operate alongside them, with them, but not always *for* them, was because, more often than not, I felt the walls

close in and my chest tighten with lack of oxygen. As much as I loved my teaching and my research, I could no longer feel the wind in my hair. I know now that my spirit left long before my body bumbled its way out of the doors. And I knew that I could carry what I loved on my back.

Working with/in the ruins of higher education gives space to imagine, in the words of Alison Phipps, 'what happens when the air is our teacher'.[4] Taking the transient, transformative, rebellious topography of air as her ground allows Phipps to think through and de-script the 'exhausted situation' of university, where the 'creative, generative' gasp rush of air, of inspiration, challenges the cynicism of creativity as exhausted commodity.[5]

Plato, a little less recently, wrote of Socrates and Phaedrus leaving the walls of Athens behind to take time to walk along the banks of a river, barefoot, and sit under the shade of a plane tree, where there's a breeze and the sounds of cicadas ring in the air. In the fresh air, they talk of girls walking on walls and of logic and rhetoric and *eros* and writing as remedy and poison. And Socrates gets inspired and feels a manic, poetic, musical *enthusiasmos*; an inspiration.

Leaving the walls of Athens, the proper place of *logos*, learning and the 'Academy'—the *polis*—they take time to waste time with each other, with enchantment and the light-play of air and shadow, the ring of cicadas. In *this* walk along the walls of the academy, Mason and Purcell look back to similar ancient *other* spaces of learning and thinking – Aristotle's concept of *scholē* – to offer new (but very old) maps for reclaiming higher education. This book, so often, *moves* across 'spaces of possibility', as Milatovic and Wargrenn assert, in an effort to reclaim what some of us never had, or knew we needed.

For both Phipps and Plato, then, it is the air that is the space of the possible, a responsive and response-able re-enchantment of existing systems of knowledge. For Plato, stepping out, beside the walls of *logos*, in the fresh air, gives the space, just for a moment, to waste time, and think differently. For Phipps, thinking with the air gives an understanding of the decreative potential of higher education: 'the known place of desire, where one is left when once-known creative elements depart.'[6]

Wasting time breathing, or playing in the open air, then, becomes the way to respond to the 'carelessness' which Kathleen Lynch sees as shaping the contemporary university, where the 'ideal academic is now officially defined ... as being capable of working without time limits and without primary care responsibilities'; taking time to breathe, then, is a luxury.[7] *A waste of time.*

In *This Bridge We Call Home* Tatiana de la Tierra writes of the need for those who are marginalised, excluded and silenced in the modern university, and privileged societies at large, to write on academic walls, **'we have a right to be here.'**[8] de la Tierra reminds readers that dust souls can't be swept under carpets for too long. Responding to different conditions of exclusion and silence, different patterns of breathlessness, this book serves as a call to sometimes challenge what, and where, 'Here' could be in the first place. Acknowledging throughout that 'Here' means something very different to different people, that 'Here' can hurt as much as hug.

Thinking through, and working with, the topography of movement— whether the open road, the walk beside the wall, or that air coursing through your body as you read—demands that the limits of higher education be opened up, challenged, (re)made a little more creative, and a lot more inspired.

We all need inspiration. In the process of editing this book, I felt compelled to read the work of one of the best cartographers of *hauntopographies* I know: Gloria Anzaldúa, that activist shaman scholar queer sister poet reader writer activist para-academic lover woman philosopher.[9] Reading Anzaldúa is always fraught, always inspirational and always *needed*. Through writing books, thinking, remembering, breathing, bridging to the world in order to encounter a multitude of contested and refused knowledges and fraught and painful places, this became the way for Anzaldúa to open, 'the locked places in me and taught me first how to survive and then how to soar.'[10]

The very real risks of erosion and exhaustion within higher education —of carelessness and decreation—the woundings at the hands of ourselves and each other, become re-mapped as the 'endless cycle of making it worse, making it better,' which is 'always making meaning

out of the experience, whatever it may be'.[11] For both Anzaldúa and Plato in the *Phaedrus*, then, however different their histories and legacies are, it is writing which becomes marked as this contradictory *pharmakon* experience of making meaning in different, creative, painful and pleasurable ways. This making meaning differently—in embodied, complex, fraught, ways—is elaborated in Durden, Govender and Reddy's remapping of Paulo Friere's groundbreaking reclamation of pedagogy as a practice of survival and liberation. The authors remind us how higher education is a participatory resource of survival, embodied challenge, and political critique.

The idea that higher education can be a space of *personal* survival—as well as the survival of precarious or subjugated knowledges—is not something academics talk about very often. It is not appropriate to say that higher education gave me the many languages necessary to keep breathing when my hands are bleeding ink or blood or tears, when survival feels a road too far.

When the air is right, then, higher education bequeaths a similar practice of necessity, challenge, and healing in the cracks that paper over the holes in an architecture never finished. Sometimes against my better judgement but always deep in my gut, higher education remains the 'vital necessity of our existence',[12] the poetry, the air, the sound of cicadas, the shadows of the *Platonos*, the plane tree, which gives space and time to play, think, and survive.

But this higher education now is radically altered, open, beyond the walls of any one institution, and certainly any discipline—*a wayward son, or daughter*. This is because 'within structures defined by profit, by linear power, by institutional dehumanization,' as Lorde breathed, 'our feelings were not meant to survive.'[13] But feelings *do* survive. In the rush of panic breath which has replaced inspiration. In the chest infection you get on the first day off in months. In the sound of your heart beating at 4am or the sound of the washing machine. In the sound of you breathing right now.

It is time to rest my weary head in this book. It is your time now.

Notes

1 Some of this text has been re-used, re-cycled, and re-imagined from the 2011 *BIRTHA* annual debate, 'What is a University?' held at the University of Bristol. The changes in text reflect the changes in topography, but the sentiment remains the same.

2 de La Tierra, Tatiana (2002) 'Aliens and Others in Search of a Tribe in Academe' in Anzaldúa, Gloria and Keating, Analouise [eds] *This Bridge We Call Home: Radical Visions For Transformation*. New York: Routledge. 358-369, 358.

3 Readings, Bill (1996) *The University in Ruins*. Cambridge, MA: Harvard University Press and Rolfe, Gary (2011) *The University in Dissent*. London: Routledge.

4 Phipps, Alison (2010: 13), 'Drawing breath: creative elements and their exile from higher education'. *Arts and Humanities in Higher Education*. 9: 42-53, 51.

5 Phipps, 'Drawing Breath', 51.

6 *Ibid*, 47.

7 Lynch, Kathleen (2010) 'Carelessness: A hidden *doxa* in higher education'. *Arts and Humanities in Higher Education*, 9. 54-67, 58.

8 de la Tierra, 'Aliens and Others in Search of a Tribe in Academe', 368. Emphasis mine.

9 Anzaldúa, Gloria (1987; 2007) *Borderlands/La Frontera: the new mestiza*. San Francisco: Aunt Lute Books.

10 Anzaldúa, *Borderlands/La Frontera*, 19.

11 *Ibid*, 95.

12 Lorde, Audre (1984: 36) 'Poetry is Not a Luxury' in *Sister Outsider: essays and speeches*. New York: The Crossing Press, 36.

13 *Ibid*, 39.

NOTES ON THE PREFIX

Alexandra M. Kokoli

STARTING SMALL

A handbook, let alone a 'toolkit', promises at least the potential for practical application: an arsenal of ideas and practices to help the para-academic cope with the vicissitudes of her/his precarious status, if not arm her/him with the means of challenging the boundaries and established modus operandi of mainstream academia. This contribution falls short of such ambitions and starts on a suitably unstable footing. Does a chapter on the prefix 'para-' smack of the intellectual indulgences and navel-gazing of the kinds of postmodernism that have been blamed for the present failures of academia to collectively resist the neoliberal onslaught on the public university?[1] Although ascribing some culpability on the theoretical legacies of postmodernism for the present state of higher education has become something of a truism in certain circles, Claire Donovan argues that the concept of the 'postmodern university' is no more than a chimera, albeit a widely disseminated, influential and damaging one. To move beyond the disempowering fatalism of this fiction, Donovan proposes a careful distinction between postmodernity and postmodernism, in which the very existence of the former is challenged with the help of a hybrid 'toolkit', including elements of critical theory that would be most likely classified as postmodern.[2] Although there is little doubt that the

university as an institution, the experience of working or studying in Higher Education and, notably, the labour practices of the sector – from which the para-academic emerges – have undergone some monumental changes over the past few years, distinctions between (so-called) theory and (so-called) practice are blurred even in the process of working out, managing and attempting to preserve or reassert their boundaries.

The practice of resistance in any academic or para-academic setting cannot but be intertwined with the practice of intellectual labour, thinking work on and with ideas – and, yes, theory. The value of the 'minor', of starting small and strategically remaining off-centre, has been both philosophically explored and practiced in the deployment of DIY strategies and the establishment of physical, digital and blended alternative platforms for exchange and debate, including independent publishing. In *Kafka: Towards a Minor Literature*, Gilles Deleuze and Félix Guattari address the resistance of Kafka's writing to interpretation: such resistance does not present itself as semantic impenetrability but rather as an irreducible multiplicity of possible points of entry into the text, in which no one way is privileged over another. Kafka's writing thus makes experimentation necessary for the reader, through strategies that are simultaneously political and literary or, rather, that inexorably politicise literature.[3]

Without the support of its philosophical and literary underpinnings, it would be easy to slip from this preoccupation with the minor to a mere alliance with or support of minorities, desirable in itself but also open to co-option by liberalism and neoliberalism. This has been the fate of many other fundamentally progressive practices and ideas, as, for example, open access in contemporary UK Higher Education policy. 'Minor' and 'minoritarian' are of course interconnected but shouldn't be collapsed into one another. Firstly, minorities aren't necessarily smaller in number but ideologically and socio-politically subjugated: Deleuze and Guattari cite the example of women, who make up over 50% of the population but have been historically oppressed by patriarchy. Secondly, the minor mode can be adopted by those who do not obviously belong to any visible or otherwise identifiable minority: one of the most challenging implications

of this schema is that it can tease out minoritarian identifications through subtle subversions of dominant modes and, in this sense, explode the semiotic model of external classification into a constantly shifting performative configuration, whereby identifications freely circulate. After all, we all 'suffer from interpretation'.[4] Finally, 'a minor literature is not the literature of a minor language but the literature a minority makes in a major language': in other words, it is an expression of a minority against the grain, which reclaims, sabotages and transforms the means of cultural production of the majority. Thus, the practice of/in the minor mode may begin to blur the very distinction between the minor and its range of opposites ('major', mainstream, dominant) and make the boundaries between the centre and the margins permeable. Deterritorialisation[5] infects language with plurilingualism and sends it flying into a permanent state of 'becoming-minor'. For this reason, 'there is nothing that is major or revolutionary except the minor'.[6] Deleuze and Guattari are not alone in mining the revolutionary potential of the denigrated margins. Notable examples of more recent theoretical practice include Judith/Jack Halberstam's formulation of a 'low theory' derived from 'eccentric archives' (para-archives?) and her/his[7] suggestion that failure can emerge as a productive mode of being and thinking that offers collaborative, unexpected and often counterintuitive solutions to shared problems.[8]

Following this lengthy introduction on the minor mode and an attempt to not only blur but also question the distinction between theory and practice is a reflection on two hopefully instructive uses of the prefix 'para-': one from contemporary art practice that invites a reconsideration of the boundaries of a historical artistic movement; and another in reference to a political and cultural movement that has always negotiated the tensions between theory and practice and whose influence has recently been reasserted, even in the face of uncertainty as to what its futures might look like. In both cases, feminist and gender-critical theory and practice play an instrumental role: feminism has long been attuned to the subversive possibilities of minor modes and spaces, has shown a commitment to unearthing the politically marginalised and

the culturally repressed, and has experimented with the refashioning of sites of oppression into sites of resistance and alternative practices.

MOVING SIDEWAYS[9]

Looking back on the history of conceptualism and her own changing positioning within it, artist Susan Hiller spots a gender-specific pattern of marginalisation and alternative practice, in which neither visual pleasure nor a concern with the unconscious were sacrificed to a semblance of objectivity:[10]

> [We] moved sideways. [...] We wanted to say other things [...] other than what's already in language [...] not necessarily feminist political things, but other kinds of things, and you couldn't do that without inventing other ways of going about the whole procedure of making art.[11]

'Moving sideways' in order to act and be otherwise, sidestepping instead of turning away, was a prodigious response to exclusion. It calls to mind counter-cultural strategies that were enabled by the Women's Liberation Movement, if not always developed within it, as well as earlier radical projects of the 1960s, such the peace movement and the Black Liberation movement (Hiller has been based in London since the early 1960s but previously lived and studied in the US, where she was born). 'Moving sideways' evokes critiques of progress and linearity and the rejection of vertical hierarchies in favour of the parity that lateral connections permit. 'Moving sideways' also reveals a style of intervention that is typical of Hiller's thought and practice and reverberates with multiple significations. Whilst it places her oeuvre in a historical canon from which it had originally been excluded, without erasing its previous exclusion nor its specificity, it also signposts Hiller's affinity with second-wave feminist thought at its nascent, avant-garde moment. Furthermore, it alerts the reader/viewer to the importance of metaphors in Hiller's art and texts,

the weight they hold in her perception of the world and their analytical and transformative function in her practice. In 'Women, Language, Truth', a contribution to a panel discussion organised by the Women's Free Art Alliance in London in 1977, Hiller deployed the same metaphor, albeit in disguise:

> Each of us is simultaneously the beneficiary of our cultural heritage and the victim of it. I wish to speak of a 'paraconceptual' notion of culture derived from my experience of ambiguous placement within this culture. This placement has been painful to recognise and difficult to express.[12]

In retrospect, the neologism 'paraconceptual' does more than signify the ambiguous, ambivalence-inspiring mixture of belonging and not belonging, victimisation and complicity. Elsewhere, it is the possibilities opened up by this precarious self-positioning that are emphasised: 'like being a foreigner, being a woman is a great advantage'.[13] Just sideways of conceptualism and neighbouring the paranormal, a devalued site of culture where women and the feminine have been conversely privileged, the 'paraconceptual' opens up a hybrid field of radical ambiguity where neither conceptualism nor the paranormal are left intact: the prefix 'para-' allows in a force of contamination through a proximity so great that it threatens the soundness of all boundaries. Forty years on, paraconceptualism has become enfranchised within conceptualism both in art historical terms and, organically, through practice, having first shifted and expanded the demarcations of the conceptualist movement.

Just like feminist 'paraconceptual' art practice, the para-academic relates to a field of power, (relative) privilege and attachment to a canon of knowledge and discourse, which it contaminates, appropriates and disrupts by positively intervening and contributing to its operation and evolution. Compared to permanent, full-time affiliated academics, the para-academic does not merely enjoy greater freedom (admittedly at the cost of insecurity and the risk of marginalisation) but her/his presence

changes the workings of academia and, inevitably, also its character. A resourceful counterpart and critical ally to their tenured equivalent, the para-academic does not simply question but revises, broadens and even restores the remit of the university as a safe haven for the free circulation of ideas, rather than an issuer of qualifications promising transferable skills for the workplace. It is difficult to predict the future of para-academics let alone the shape of academia forty years from now, but few would doubt that their fates are intertwined.

(DIS)CONTINUITIES

Unlike movements without explicit emancipatory ambitions, feminism presents a problem for its junior ranks: how does newness come into a movement that is by definition culturally progressive, politically revolutionary, committed to the pursuit of equality alongside and often through an ever-elaborate interrogation of difference? And it is not just the movement itself whose aims are debilitatingly righteous but, yet more vexingly, the foremothers of those new to the sisterhood do not make acceptable Oedipal rivals for one to defeat and triumph over. If women indeed think back through their biological and intellectual mothers, as Virginia Woolf (among others) influentially claimed, then established understandings of intellectual and cultural genealogies based on struggle to supersede and replace precursors who are simultaneously envied and admired no longer apply. Feminist thinkers have offered alternatives based on kinship, affinity and shared interests, sometimes drawing on matrilineal models from mythological or non-Western traditions,[14] or rejecting genealogy as a paradigm altogether, limited as it is by the biological and psychoanalytic implications of filiation and a chronological/causal linearity that is too easily cast in hierarchical terms. Instead, Deleuze and Guattari's rhizome, a metaphorical rootstock, offers a fundamentally anti-geneological alternative, 'multiple, diverse, heterogeneous, generative, resistant to hierarchies, and productive in its channelling of desire.'[15]

Although the rhizome may respond to the gender bias of genealogical thinking, it does not quite resolve the need for a model of change and self-critique within movements of resistance. In an effort to imagine, articulate and justify the development of such models, art historian Amelia Jones proposes 'parafeminism' to suggest a simultaneous affirmation of commitment to the same basic causes, if not always a sisterly affinity, combined with a sharp assessment of paradigms in both critical and creative practice that are deemed too restrictive or no longer helpful.

> If postfeminism implies an end to feminism, through the term parafeminism—with the prefix 'para-' meaning both 'side by side' and 'beyond'—I want to indicate a conceptual model of critique and exploration that is simultaneously parallel to and building on (in the sense of rethinking and pushing the boundaries of, but not superseding) earlier feminisms.[16]

Crucially, parafeminism relies and builds on its feminist heritage even as it critiques and revises it, recognising that without it it couldn't have come into existence. Parafeminism has the potential to lead to a new feminist politics that is non-binary in at least two ways: not only does it not aim to overthrow the past, using it instead as an essential building block for the future, but it also shrinks from any steadfast demarcation of boundaries between feminism and potential allies. Thanks to its prefix, parafeminism can evolve into a bridge, or rather a hybrid platform for more than feminist critique, let alone women's rights. In my interpretation of Jones's argument, the feminist 'para-' specifically paves the way for mutually reinvigorating allegiances between feminist and queer politics and practices, in which identity is at once eradicated and affirmed.[17]

Both a symptom and an agent of change, the para-academic transformatively intervenes in academia not only through a different set of practices but by forging links, sometimes through their mere presence, with the outside world. At a time when universities come under pressure to seek financial support beyond public funding and when

research is watered down and instrumentalised as paid consultancy, it is more important than ever to demonstrate that the multiple networks in which both academia and academics are *already* embedded exceed, as a rule, financial transactions. Para-academics bring their own multiple allegiances and affiliations into the mix, boosting its diversity and wilfully folding together the high and the low, the minor and its soon-to-be-minoritised others.

TAKING LIBERTIES

Over the past few years there has been a shift in discourse around the labour practices in academic contexts from the 'casualisation of academic labour' to the 'para-academic', emergent as a term but already current as a concept. If the discourse of casualisation remained cathected on a normative paradigm of full-time permanent posts for life, which are fast becoming scarce in all sectors, the para-academic operates in a profoundly transformed landscape where labour is inherently precarious and everyone's employment situation (let alone career progression) is tenuous and changeable. Such developments should not be unquestioningly accepted and need not be assumed to be irreversible, even as they currently appear to dominate higher education, at least in the UK. Yet the para-academic, in her/his existence, as a self-reflective subject and as the focus of self-reflective discussions in academia, is much more than the fallout of a worrying and largely harmful overhaul of labour relations in late capitalism and the neoliberal assault on the (still) public university. If casualisation was a plight to be protested, resisted and hopefully reversed, embracing the status of the para-academic should not be interpreted as making a virtue out of feared defeat but as a valid alternative that challenges false dichotomies and explodes the binary logic of either/or. Until the para-academic becomes enfranchised in a revolutionised university, she/he will be a welcome thief and constructive squatter:

[I]t cannot be denied that the university is a place of refuge, and it cannot be accepted that the university is a place of enlightenment. In the face of these conditions one can only sneak into the university and steal what one can. To abuse its hospitality, to spite its mission, to join its refugee colony, its gypsy encampment, to be in but not of—this is the path of the subversive intellectual in the modern university.[18]

Notes

1 For an early example of this point of view, see Taylor-Gooby, Peter (1994) 'Postmodernism and Social-Policy: A Great Leap Backwards', *Journal of Social Policy*, 23: 385-404. See also Gopal, Priya 'The Neoliberal University', Convention for Higher Education, University of Brighton, 24 May 2013, http://www.youtube.com/watch?v=UWeFPGySLmY. Last accessed 6 June 2013.

2 Donovan, Claire (2013) 'Beyond the "Postmodern University"', *The European Legacy: Toward New Paradigms,* 18(1): 24-41.

3 Deleuze, Gilles and Guattari, Félix (1986 [1975]) *Kafka: Towards a Minor Literature.* Trans. Dana Polan. Minneapolis: University of Minnesota Press.

4 Brinkley, Robert (1983) 'What is a Minor Literature? [Editor's Note]', *Mississipi Review* 11(3): 13, http://www.jstor.org/stable/20133921. Last accessed 13 June 2013.

5 '[T]erritorialization, deterritorialization, and reterritorilisation [...] may be defined as the creation and perpetuation of cultural space, the dissolution of that space, its recreation. Codification, decodification and recodification can serve roughly as synonyms. By emphasising cultural space, however, Deleuze and Guattari can formulate as alternatives of coded behaviour, a dissolution of cultural boundaries and the movement of a nomad through territory. These formulations seems particularly appropriate to the mobile and metamorphic geographies which Kafka presents in his narratives.' *Ibid.,* 28, n. 1.

6 Deleuze and Guattari, *Kafka*, 26.

7 Cf. Halberstam, Jack (2012). 'On Pronouns'. http://www.jackhalberstam. com/on-pronouns/. Last accessed 26 June 2013.

8 Halberstam, Judith (2011) *The Queer Art of Failure*. Durham, NC: Duke University Press.

9 This section (up to 'Forty years on, paraconceptualism has become enfranchised within conceptualism both in art historical terms and, organically, through practice, having first shifted and expanded the delineation of the movement.') draws heavily on a previous publication: Kokoli, Alexandra (2011), 'Moving Sideways and Other Sleeping Metaphors', in Ann Gallagher [ed], *Susan Hiller*, Tate Publishing: London, esp. 143-144.

10 Works by Susan Hiller can be found in numerous public collections, including the Tate. Some examples can be viewed at her home page http://www.susanhiller.org/. Last accessed 19 June 2013.

11 '3,512 words: Susan Hiller with Jörg Heiser and Jan Verwoert', in Susan Hiller (2008) *The Provisional Texture of Reality: Selected Talks and Texts, 1977-2007*, ed. Alexandra Kokoli, JRP|Ringier: Zurich & Les Presses du réel: Dijon, 129-130.

12 Hiller, 'Women, Language and Truth', *The Provisional Texture of Reality*, 115.

13 Hiller, Susan (1993) 'Susan Hiller in Conversation with Andrew Renton', in Adrian Searle (ed.) *Talking Art I*. London: ICA, 99.

14 Jacobus, Mary (1995) *First Things: The Maternal Imaginary in Literature, Art, and Psychoanalysis*. London: Routledge, 16-18.

15 Deleuze, Gilles, and Guattari, Felix (1988). *A Thousand Plateaus: Capitalism and Schizophrenia*, trans. Brian Massumi. London: Athlone Press, 10-11. For a feminist exploration of this model see Tickner, Lisa (2006) 'Mediating Generation: The Mother-Daugher Plot', in Armstrong, Carol, and de Zegher, Catherine [eds] *Women Artists at the Millennium*, Cambridge, MA: MIT Press, 91.

16 Jones, Amelia (2006) *Self/Image: Technology, Representation and the Contemporary Subject*. London: Routledge, 213. See also Jones, Amelia (2012) *Seeing Differently*. London: Routledge, 183.

17 Sedgwick Kosofsky, Eve (1993) *Tendencies*. Durham, NC: Duke University Press, 8.

18 Moten, Fred & Harney, Stephano (2004) 'The University and the Undercommons: Seven Theses'. *Social Text* 22(2),101-115.

Dr. Alexandra Kokoli is Senior Lecturer in Visual Culture - Fine Art, Middlesex University. Her research, which has appeared in *n.paradoxa*, the *Art Journal*, and *Performance Research*, focuses on feminist art history, theory and practice, contemporary artists including Susan Hiller, Monica Ross and Tracey Emin, and the history of the woman artist as a distinct classification. She is the curator of *Burnt Breakfast and other works by Su Richardson* (Goldsmiths, 2012) and the editor of *Feminism Reframed: Reflections on Art and Difference* and *Susan Hiller, The Provisional Texture of Reality: Selected Talks and Texts, 1977-2007*. Her monograph on feminism, art and the uncanny will be published by Bloomsbury Academic in 2015.

SPACES OF POSSIBILITY: PEDAGOGY AND POLITICS IN A CHANGING INSTITUTION

Lena Wånggren and Maja Milatovic

Organising an inclusive academic event in a location of privilege is a particular challenge, especially when considering the existing intersecting oppressions which work to include specific groups and alienate others. Teaching and learning in an increasingly marketised institution negotiates our roles as teachers and learners, while higher education in the UK remains a privileged and predominantly white male space. How do we challenge excluding practices and how can we strategise against racism, sexism, ableism, classism and various other intersecting oppressions in academia? The interdisciplinary symposium *Critical Pedagogies: Equality and Diversity in a Changing Institution*, held at the University of Edinburgh on the 6th of September 2013, emerged from many frustrated conversations about teaching and learning, and about race and gender equality, within the confines of higher education today. Inspired by the scholarship on equality, diversity and institutional whiteness by Heidi Safia Mirza and Sara Ahmed[1], we wanted to gather researchers, teachers, students and activists to discuss the issues surrounding gender, race, sexuality, ability, class and numerous other intersections in our changing institutions. The symposium aimed to bring people together in a dialogic and productive space in order to strategise around the marketisation of universities, and question the ways in which the increasingly neoliberal

structures in higher education impact individuals' learning, teaching and researching in higher education. Within this context, critical pedagogies challenge the notion that knowledge and teaching methods can be value-neutral. Our relationships within academia reproduce or negotiate those of society as a whole, and the classroom itself works as a microcosm of wider social structures. How do we, as academics, students, activists, teach and learn in an institution that no longer encourages learning for learning's sake, and which does not prioritise learning that is accessible to all? And finally, what power relations are involved in constructing that 'we' highlighted in our call for discussion, action and engagement? What are the risks involved in reproducing certain oppressive power structures by speaking about privilege from a location of privilege, organising an event in the context of an already exclusionary space?

With the increased marketisation and commodification of higher education in the United Kingdom, now more than ever we need to consider the ways in which we learn and teach, both as university educators and as members of communities. Neoliberalism, as an ideology that holds market exchange and economic rationalism as ethics in themselves, capable of acting as a guide for all human action, has seeped into higher education during the last three decades, reflecting its spread throughout the rest of UK society and internationally. As David Harvey notes, '[n]eoliberalism has become hegemonic as a mode of discourse. It has pervasive effects on ways of thought to the point where it has become incorporated into the common-sense way many of us interpret, live in, and understand the world'.[2] We observe this, as Rosalind Gill outlines, in the 'importing of corporate models of management into University life; the reformulation of the very nature of education in instrumental terms connected to business and the economy'; the transformation of students into 'consumers' rather than as learners or knowledge-producers, seen especially in the staggering increase in tuition fees; and the 'degradation of pay and working conditions for academics, seen in the increasing casualisation of employment'.[3] With all these changes, universities are turning into machines for making profit, rather than institutions for education;

that is to say places for learning and growing. Neoliberal policies and philosophies thus reduce education to a commodity, something to be purchased as part of one's individual capital in the job market. However, as scholars and educators such as Paulo Freire, bell hooks and Jacques Rancière[4] have demonstrated, the 'banking concept' of education works to put down rather than to empower students and learners.

In our classrooms and lecture halls we negotiate the same interactions, oppressions, intersections and transformations as in the world beyond academia. So where do questions of race, equality and diversity end up in a system which privileges quick and easy answers above a dedication to social justice? In the context of changing institutions as well as public life, issues of equality, diversity and inclusiveness in the classroom become more and more imperative. Critical pedagogy is conceptualised as an inherently crossdisciplinary praxis, encouraging and fostering discussion and development around issues of equality and diversity. Our discussions were framed by a feminist, intersectional perspective which acknowledges, as Les Back puts it, the damage that racism has done to education as well as academic and civic freedoms.[5] Our use of such terms as 'equality' and 'diversity' was motivated by Sara Ahmed's arguments on institutional diversity, as she argues: 'the very talk of diversity allows individuals to feel good, creating the impression that we have "solved" it. Diversity thus participates in the creation of an illusion of equality'.[6]

Challenging racism, sexism, ableism, bias and prejudice begins from complicity and acknowledging institutionalised whiteness. Racism and other forms of discrimination alienate and exclude those who do not fit in the predominantly white institutions of higher education. In a great deal of UK institutions, students and staff do not have the opportunity to interact with underrepresented groups or engage with different perspectives and scholarship.[7] More specifically, in the UK, the percentage of women and minority academics in higher education remains extremely low: only one in five professors is a woman and only one in thirteen professors is an individual from a minority ethnic background. As Heidi Safia Mirza states: 'Universities in the UK are still very much white, male institutions of privilege and self-reproduction'.[8] Those who do not

fit the norm are presumed outsiders or incompetent, questionable and suspicious.[9] Bringing the perspectives of critical pedagogy and equality and diversity issues together through the notion of critical pedagogy, the symposium aimed to tackle issues of racism, sexism, ableism, classism and numerous other intersecting oppressions in academia. Focusing on teaching and learning, higher education can be envisioned as a site of negotiation, challenge and transformation, or, in bell hooks' words, the classroom as 'the most radical space of possibility'.[10]

Organising an accessible academic event represents numerous challenges, and self-reflexivity is required on behalf of the organisers as well as careful planning and consideration. One of the key elements in making the symposium possible and accessible was the reduced registration cost. Creating connections and discourses at conferences is vital for strategising and sharing personal experiences, but it is frequently made impossible through very high conference registration fees and few initiatives to ensure support for students, unwaged or hourly-paid participants (even at events that paradoxically deal with equality, diversity, neoliberalism and precarity). While funding for events is always difficult to secure, there are various ways in which accessibility can be improved and worked on with consideration. Accessibility must also be considered in its physical form: in Edinburgh, famous for its non-accessible buildings and cobbled streets, we struggled (but managed!) to find a space which was fully accessible.

We were overwhelmed by the positive response the event received and the support from a wide variety of academics, researchers and teachers, students and activists who attended the event – with over 100 participants, the great interest shows that there is a great need for these kinds of discussions. Many of the conversations during and after the symposium insisted that there should be more time dedicated to these discussions, and more similar events, to organise around these issues. In addition to presentations and workshops, there was also great deal of dialogue, connections and conversations taking place, not only within the panels, in the warm-up workshop the day before, or at the final roundtable, but equally during breaks and over dinner.

Our first keynote speaker was Heidi Safia Mirza, Professor of Race, Faith and Culture at Golsmiths College and one of the first black women professors in Britain. She gave an inspiring lecture entitled 'Decolonising Pedagogies: Black Feminist Reflections on Teaching Race, Faith and Culture in Higher Education', which motivated those much needed discussions on privileges, language and decolonising methodologies and served as a thought-provoking introduction to the rest of the symposium. The second keynote speaker was Joyce Canaan, previously Professor of Sociology at Birmingham City University, whose lecture 'Expanding Critical Pedagogy's Radical Potential In and Outside the University' highlighted the precarious situation in which numerous students and staff find themselves in higher education, and urged for action, networking and organising in order to strategise against increasing casualisation and managerialism.

Panels such as 'Resisting Marketisation' and 'Educate, Agitate, Organise' highlighted ways in which we might resist the neoliberal structures of contemporary higher education in the UK and beyond. They included Stephanie Spoto's discussion of teaching and activism, about being an anarchist in a marketised state institution, Camila Camacho's report on the Chilean student movement and the privatisation of the Chilean education system, and papers examining new learning technologies and their use in and against the neoliberal university. Ana Lopes and Indra Dewan presented their research on the experiences of hourly paid workers in higher education, while also questioning the participants about their own experiences of casualisation. In the panel 'Decolonising the University', Aretha Phiri highlighted exclusions in debates around austerity in academic feminisms, a theme which was further explored in the panel 'Inclusions and Exclusions: Breaking Silences', which included papers on student participation, disability and accessibility, and processes of silencing and marginalisation within higher education. The panel 'Theory / Praxis' brought together discussions of critical theory and critical practice, including a workshop on feminist praxis and informal hierarchies, led by Eva Giraud. The final panel, 'The Classroom and Beyond,' focused on widening participation and the use of queer theory

as pedagogy. The engaging presentations and workshops provided a variety of perspectives, emphasising the urgency for an intersectional, feminist and antiracist approach across panels and discussions.

Finally, the day ended with a roundtable on the subject of education, intersectionality and social change with Heidi Safia Mirza, Michelle Keown, Janine Bradbury, Aretha Phiri and Mike Shaw. All participants shared their own experiences and struggles, breaking silences surrounding racism, institutional whiteness and processes of Othering in higher education. One of the most interesting aspects of the roundtable which provoked a great deal of discussion was the (im)possibility of creating a safer space. How can the classroom function as a safer space? Who gets to create that space? Can a symposium such as this one function as a safer space? It is imperative to highlight the need for more dialogic and productive spaces like those generated by the symposium: feminist and antiracist spaces in which to meet, discuss and organise, in order to strategise around and against the marketisation of higher education in an inclusive manner. However, we also need to ask the question 'who did not attend?', and consider the reasons why, as the absences reflect limitations such as access and funding, as well as the persistence of problematic power relations and exclusions implicated in the already privileged location of higher education.

Notes

1 See Ahmed, Sara (2012) *On Being Included: Racism and Diversity in Institutional Life*. Durham, NC: Duke University Press; and Heidi Safia Mirza (2008) *Race, Gender and Educational Desire: Why Black Women Succeed and Fail*. London: Routledge.

2 Harvey, David (2005) *A Brief History of Neoliberalism*. Oxford: Oxford University Press, 2-3.

3 Gill, Rosalind (2009) 'Breaking the silence: The hidden injuries of neoliberal academia', in Róisín Ryan-Flood and Rosalind Gill [eds] *Secrecy and Silence in the Research Process: Feminist Reflections*. London: Routledge:

4 See Freire, Paolo (1996) *Pedagogy of the Oppressed*, trans. Myra Bergman Ramos. London: Penguin Books; bell hooks (1994) *Teaching to Transgress: Education as the Practice of Freedom*. New York: Routledge; and Jacques Rancière (1989) *The Ignorant Schoolmaster: Five Lessons in Intellectual Emancipation*, trans. Kristin Ross. Stanford, CA: Stanford University Press.

5 Back, Les (2004) 'Ivory Towers? The Academy and Racism', in Law, Ian *et al* [eds] *Institutional Racism in Higher Education*. Stoke on Trent: Trentham Books, 4-5.

6 Ahmed, Sara (2012) *On Being Included: Racism and Diversity in Institutional Life*. Durham, NC: Duke University Press, 71.

7 Douglas, Delia D. (2012), 'Black / Out: The White Face of Multiculturalism and the Violence of the Canadian Academic Imperial Project' in Gutiérrez y Muhs *et al*, eds. *Presumed Incompetent: The Intersections of Race and Class for Women in Academia*. Utah State University Press: Logan, 50-64, 59.

8 Williams, Rachel (2013) 'The university professor is always white', *The Guardian*, 28 January 2013 <http://www.theguardian.com/education/2013/jan/28/women-bme-professors-academia>. Last accessed 20 June 2014.

9 See Gutiérrez y Muhs, Gabriella et al eds. (2012) *Presumed Incompetent: The Intersections of Race and Class for Women in Academia.* Logan: Utah State University Press.

10 hooks, bell (1994) *Teaching to Transgress: Education as the Practice of Freedom.* London: Routledge, 12.

Lena Wånggren is a Research Fellow in English Literature at the University of Edinburgh, where she also teaches. Her research interests include late nineteenth-century literature and culture, feminist theory and practice, intersectionality and pedagogy. She is the Education Coordinator for the feminist activist group Hollaback! Edinburgh.

Maja Milatovic is a final-year PhD candidate at the University of Edinburgh, researching the ancestor figure in African American women writers' neo-slave narratives. In addition to African American literature and the Black Atlantic, Maja's research interests include Indigenous studies, digital humanities and education, and more broadly, critical race and whiteness studies, postcolonial, feminist and trauma theory.

INTERVIEW WITH JOYCE CANAAN

DW: Joyce, can you introduce yourself.

JC: I am Joyce Canaan, and I was a full-time professor of Sociology at Birmingham City University, until July 2012. I left then because the university was making me ill. Over the past five or six years, I have studied and still study the impact of neoliberal and neoconservative processes on universities from the 1970s, and of regimes of accountability or audit introduced from the late 1980s to ensure academic compliance with these processes.[1] Like Bronwyn Davies who also studied the academy and then left because she 'could no longer bear what neoliberalism was doing to academic work',[2] I had been thinking that if an opportunity for leaving voluntarily was on offer, I would take it. More recently, another academic has reported[3] that she was leaving academia because she saw herself as 'part of an oppressive and hierarchical structure that demands the compromise of individuality and creativity in order to fit the mould'. I don't believe that we are alone.

I am aware that I was one of the lucky ones; I could leave full-time work when I did because I got a redundancy package and now receive university and state pensions. Yet my younger colleagues in the academy (like others elsewhere) face a longer working life and growing work intensification and precarity. Indeed, on the day when the *Times Higher Education* reported on the rise of zero hour contracts, with the Russell Group University, Edinburgh, having the highest number of such contracts,[4] I was at a conference at Edinburgh University where two presentations resonated with this story; one explored the conditions

of Hourly Paid Lecturers (HPLs)[5], whilst the other examined those of Postgraduates Who Teach (PGWT).[6] What kind of madness is it that some of us leave the university due to overwork and time consuming, soul-destroying tasks (are we canaries in the coal mines?), whilst others inside face worsening and lengthening conditions and still others, seeking academic jobs, face poor pay and conditions with no guarantee that they will ever get on 'the ladder', even if the conditions on offer inside are hardly welcoming or easy?

DW: Joyce, you described the time we are living in as one of 'deep neoliberalisation'—what for you are the characteristics of those depths, and why do you think that the current crisis in HE is different to previous ones?

Let me answer the first part of your question first. I did describe the present times as those of 'deep neoliberalisation'. This concept isn't mine, but that of Brenner, Peck and Theodore.[7] They argue that from the 1970s to the present, there has been a gradual reconfiguration of national and increasingly supranational structures and processes globally. They speak of the initial 'disarticulated' 'regulatory experiments' that started with the US-backed coup in Chile on 'the other September 11th (1973)', introducing the neoliberal project that was then spread to other nations first in Latin America and then more widely; at its core this project brought 'financialization, liberalization, workfare and urban entrepreneurialism'.[8] From the 1990s neoliberalism and neoconservativism have widened and deepened, bolstered by the re-organisation of supra-national organisations like the IMF and the World Bank and the creation of other supra-national organisations like the WTO (1995), with the European Central Bank following shortly thereafter. Brenner, Peck and Theodore then argue that the economic crisis of 2007-2009 initiated what could be the first steps in a 'disarticulated counter-neoliberalization' in which experiments of disparate, local redistributive regulatory alternatives in response to the crisis could move in either a progressive or reactionary direction towards a more 'orchestrated counter-neoliberalisation'[9] that

could link, extend and rework these counter-experiments and their underpinning logic.

This analysis seems convincing and I argued for it in a recent paper.[10] But my reading about the economy over the past few years, and my thinking about the present crisis in HE, persuade me otherwise. I take on board Rikowski's argument that policymakers since the 1970s have failed to allow economic crises to do the kind of 'vital cleansing work for the health of the capitalist system as a whole' required if capitalism is to be returned to health'.[11] Fearing the massive disruption [and possibly deep questioning of the capitalist system that occurred in the 1930s] policymakers . . . have favoured inflation (at times, particularly from the mid-1970s to the mid-1980s) and especially the huge expansion of credit and debt to avoid the denouement'[12] since then. The evasion of crisis, initially in the 1970s with the amassing of debt, to the post 2007-2009 'bailouts and fiscal stimuli' (like quantitative easing) that continue to intensify, entail, as Rikowski puts it, 'a determined effort amongst ruling classes and their ideological representatives not just to get back to "business as usual", but in some cases . . . to go ever further with neoliberal economics and politics'.[13] Rikowski here makes a similar point to that of Harvey:[14] capital is reorganising the economy and social life generally to the benefit of the elite and to the cost of all others. If Rikowski and the economists he has read are correct, then whilst a crisis is not imminent, its deferral may very well indicate that capitalism faces a much wider and deeper crisis in future. Further, neoliberal policies are adding to national debt in many countries north and south as unemployment and underemployment for the many grows . . . and as resistance to these policies flares up. . . We need only think of recent resistance in Gezi Park in Istanbul, the central square in Mexico City, Ecuador, unrest in Bulgaria, Romania and most recently Sudan, the latter which may indicate the spreading of the Arab spring further south into Africa.[15]

In the UK, we have had and continue to have to endure this widening and deepening of neoliberalism and neoconservativism. Policymakers have used taxpayers' money to pay for bank bailouts and further tax breaks for already wealthy individuals and for the corporate/financial

sector—socialism for the rich—whilst cutting back funds for the public sector, including universities. They do so by using the economic crisis, Labour's supposedly profligate spending during its prior period in government (1997-2010), and the cost that benefit 'cheats' (whose supposed cheating actually amounts to less than 1% of all that tax evasion, avoidance and non-payment)[16] have added to the economy as their rationale.

At the same time, punitive measures against protesters are growing; students protesting against raised tuition fees were threatened, with long prison sentences rather than being cautioned, as was previously the case. Fifty-eight people were arrested for violent disorder, the second most serious public order offense that can lead to a prison sentence of up to five years. Most of those charged had their charges dropped. Two who did not claimed that their action was one of defending themselves and other protestors from police violence. Indeed after three trials over two years, both were acquitted and their legal defender pointed out that during the prior decade, several months after, and in response to, protests against George Bush's second visit to the UK in 2003, the police made more aggressive use of 'Section 2 of the Public Order, violent disorder', upping the charge from that previously applied of 'cautions, or tickets, [and] fixed penalty notices,'[17] indicating that 'a clear attack on protest' was now occurring.

145 protesters in the UKUncut flashmob of central London's Fortnum and Mason, who had a peaceful sit down protest alongside the 26th March 2011 national demonstration against government cuts, were initially arrested for reported aggravated trespass, although charges were later dropped against 115 protestors.[18] Clearly the government sought to send a message to protestors that acts of resistance can result in arrest, potentially impacting individuals' future work prospects. Yet the legal quashing of approximately 75% of these arrests points to their symbolic power, sending a message to potential protestors and representing protestors as seemingly lawless.

Riots or uprisings occurred in summer 2011 across English cities, as an immediate response to the police murder of Mark Duggan in

Tottenham, north London, whose death was the fourth in police custody or surely a police incident in Tottenham since 1985 and the 320th in custody nationwide since 1990.[19] Uprisings erupted and swept across a number of cities in England during the following week. Contributing factors to these uprisings were: government cuts to Further and Higher Education student support, cuts of up to 75% to youth services[20] and increasingly high levels of poverty and unemployment. Guided by David Cameron's urging for 'tough love', average sentences were 16.8 months compared with sentences for similar offenses the prior year of an average one-quarter of this length. This example, and the others I've discussed, indicate that the government's response to resistance increasingly is the threat of long prison sentences to warn people against further resistance.

Consequently, we, the public, and our public sector, are bearing the brunt of these government policies. Thus far this government has introduced: higher VAT, an ostensibly 'equal' tax on goods that impacts most deeply on those with the lowest income; a later retirement age; a freezing of wages and salaries; and smaller pensions for which workers pay more. And the next few years are likely to be even worse. According to the Institute for Fiscal Studies (2013), public sector spending is likely to 'fall by 18.6% in real terms between 2010–11 and 2017–18'.[21] We are told (but should we believe?) that the NHS, schools and aid spending are being protected from cuts through to 2017–18, whilst 'unprotected' departments could face budget cuts of one-third over these seven years. If so, and given that we are approximately half way through this period, then at least 50% of these cuts will occur over the next 3.5 years. This is not a very promising scenario.

This brings me to your second question. We can already see the effects of these cuts on HE and undoubtedly these effects will continue. The radical restructuring of the university in the wake of the Browne Report and the Higher Education Act of 2011 have resulted, starting with the university cohort of 2012-2013, in a near trebling of tuition fees to £9,000 from an already more than trebled rate of £3,375 in 2011-2012, which followed the initial fees of £1,000 introduced in 1998-1999. The terms and conditions of student loans obtained for these much higher tuition

fees have changed. Whilst government still directly grants them, it obtains loans from private providers who can change the terms and conditions of these loans at any point in the estimated 30-year loan repayment period (which students will only repay if they earn more than £21,000 per year). Further, private universities are, under the ConDem government, being encouraged to enter and compete in the increasingly market-like organisation of HE. As McGettigan notes, 'global higher education providers' are now being invited to run universities as businesses, and consequently do so for profit, not students' individual good or for social good.[22] The first such private provider (BPP) in recent years granted university status in 2010, immediately set out to cut its running costs by 25%. It spent an estimated 25% of its budget on marketing.[23] At least some of this provider's running cost cuts came from learning and teaching.

Thus the situation is now worsening in HE from the initial disarticulated experiments in neoliberalisation from the 1970s. What can be done to resist this situation? I firmly believed, when working full-time in the university that it was of utmost importance to use any and every space available in the university to introduce alternatives. I was able to initiate some progressive interventions. I created, with student support, what students call 'the beanbag room', where there are no lectures but largely discussions enhanced in part by students and teachers sitting 'at the same level' (as students noted in module evaluations), guided by critical pedagogy insights that facilitate reflection through dialogues amongst students and with lecturers. A colleague and I co-created a second and third-year routeway in Public Sociology that took place in the beanbag room, where classroom activities again rested on critical pedagogy insights and also encouraged students to develop 'radical' insights about the world—radical in the sense of getting to the root of issues/theories/methods, critically examining their underpinnings and assumptions.[24] These efforts had some success. Students produced projects or worked at placements in their second and third years. Some students worked with progressive grassroots groups I had known and worked with as an activist over the years, such as asylum support groups, anti-academies campaigns and working with the NUS during

the 2010-2011 academic year to encourage student activism. Others worked on projects they set up independently (with a church group or a women's group they established). Students didn't write (many) essays but mostly were asked to examine the degree to which the projects they were involved in realised Public Sociology's tenets of working with groups to bring about change through activism.

And yet . . . these efforts were more limited than I, and my colleagues, would have liked. With regard to the beanbag room: yes, it encouraged greater dialogue that did make a difference to students' engagement as they said in module evaluations; but there were often over twenty students in the room at any time, which inhibited dialogue, and some students voted with their feet with regard to group work and deep engagement with ideas being encouraged—hardly surprising given that this was just one module in a relatively traditional degree programme. And the Public Sociology routeway was hard to recruit students to, and again students voted with their feet with regard to engagement. There were also serious limits to how much I/we could invest in these potentially transformative programmes given that regimes of accountability took up more and more of our time year on year and that staff who left were not replaced, adding to the workloads of those who remained.

How could things have been otherwise given that these effects were a small part of one programme in one university, and given students' workloads as part or full-time workers paying for their university education? Further, our students had, in their prior educational experiences, been taught by teachers who had to ensure high pass rates on national exams and the national curriculum offered little space for them to subvert dominant ideas and encourage students' critical thinking.

And so, I am uncertain as to how much can be accomplished inside the university. Do I say this because I now occupy a position of some comfort (other than financial) outside? Perhaps, but from this position it feels as if I can do more outside. I now have a clarity of purpose, a renewal of energy, and space/time to think and to do, and to live the other parts of my life that are also important to me as a human being, parts that I think others should also have the space/time, energy and clarity to enjoy.

DW: What historical examples of resistance to elitism in HE inspire you most and propel you to keep creating spaces for teaching, learning and education, generally?

I think it's hard for many of us, even on the left, to believe that we live in what could be seen as potentially revolutionary times. We have the media, and the at least temporary dominance of corporate and finance power globally, to thank for that. Like many others, I am mindful of Jameson's statement that 'it's easier to imagine the end of the world than it is the end of capitalism'. But the present is much more contradictory than this and we can see this in HE, as I've already suggested.

May '68 was of course an important moment in the struggle, in part against what HE had become and in part due to the ways that HE tensions spoke to wider tensions. But what a different university system there was then! It was highly-resourced and expanding—serving its largely white, middle class students and staff very well—in English-speaking and European-romance-language-speaking countries. Nonetheless, by 1968, student resistance in eastern and western Europe, the US and UK occurred, in part expressing their unease with what Marcuse called 'the numbing of the mind and soul by the affluent society',[25] and in part against ongoing imperialist wars such as those of Algeria and Vietnam.[26] In France, student rebellion expanded beyond the university and led to the largest general strike ever, which the government could only quash by deploying the military. Badiou has spoken of this as 'an event', a moment when the impossible suddenly seemed possible, as students and factory workers of all ages united against the state, meeting and talking together in spaces outside the comfort zone of each group.[27]

In the past few years, student resistance has again been growing, and not just in Europe and North America, but globally. In England, there were occupations at more than 30 universities against their administrations' silence over, and commercial and media complicity with, Israeli occupations of Gaza in 2009.[28] This was followed by occupations at universities in England against cuts to academic and administrative staff and to entire departments (including Leeds, Middlesex and Sussex) in

2009 and early 2010. At this time, a generation of students were assaulted by government and media messages telling them that they had little choice but to succumb to the supposedly 'overpowering leviathan' of globalisation,[29] and reportedly sought refuge in the 'communicative sensation-stimulus matrix of texting, YouTube and fast food'.[30] The four national demonstrations and occupations of nearly 50 universities that occurred in the aftermath of the Browne Report leading up to a parliamentary vote to implement most of Browne's findings did not come from nowhere; it was preceded by political activism in 2009 and early 2010.[31]

This activism was also impelled in part by prior and ongoing student activism elsewhere. In the US, when the state of California threatened to treble tuition fees and cut faculty and other staff pay at state universities and colleges, demonstrations and occupations took place. Similarly at universities across Europe, demonstrations and occupations took place in response to the Bologna Agreement that supposedly would 'harmonise' the European university system, cutting down four-year, eight-semester undergraduate degree programmes to-three year, six-semester programmes. Many students and lecturers recognised that these changes were part of a re-visioning of the university as a market-like place that would ostensibly prepare students to enter the market as graduates. And then in 2011, in Chile and Canada, schools and universities were occupied in response to government efforts to privatise these systems and these actions, like those of May '68 in France, received much support: locally, nationally and internationally.

I suspect that such resistance will continue, especially as the neoliberal and neoconservative assaults bite ever more deeply.

DW: What types of activities are there in the UK, and further afield, that offer frameworks and practices for resisting the enclosure of HE by market forces?

JC: Some very interesting projects that have been developing in the UK during the past five or six years that offer some hope for present troubling

and harsh times. One notable initiative within the university is that which Mike Neary, since becoming Dean of Teaching and Learning at Lincoln University in 2007, built with colleagues: 'Student as Producer'. Neary and Amsler, one of his colleagues, write about this project as part of a paper. That paper starts with an acknowledgement that 'the spatial and temporal organisation of learning and teaching in the university is what makes the production of capitalist knowledge possible.'[32] Thus they recognise that there are limits to what can be done within such a system. Nonetheless, they use insights from the Occupy movement to 'imagine how the revolutionary energy of the movement might be extended beyond the most visible occupied spaces and into the institutions and everyday practices of capitalism.'[33] Note their words—they want to bring the revolutionary energy from an anti-institutional movement to guide their efforts within the university, creating what they call an 'anti-curriculum' guided by 'an explicit critical pedagogy set against the consumerist ideology that the idea of student as consumer, increasingly at the centre of university life, presumes.'[34] They and their colleagues have taken up the mantle of re-organising how teachers might approach learning and teaching so as to counter the consumerist ideology that shapes so many aspects of university life. They have created the 'Student as Producer' project, influenced by Walter Benjamin's 'Author as Producer', written in response to the question 'how do radical authors act at a time of crisis?'[35] Similarly, at the present moment of crisis in the university, Neary and Amsler suggest how learning and teaching might be organised differently. Lecturers are 'asked to explore pedagogical research that points to the effectiveness of learning by discovery and doing' and to use insights from such research to redesign student work so that it entails not answering questions lecturers pose, but engaging in 'research and research-like activities' that start from students' own questions.

And yet . . . Neary and Amsler recognise that to succeed, the Student as Producer project 'must exceed its own institutional and idealised form . . . [It requires that] the neoliberal university must be dissolved, and reconstituted as another form of "social knowing."'[36] This clearly is not possible in the university at present, and so the project acknowledges

its limits—and seeks to take it as far as possible. I still wonder, despite my admiration for this project, how deeply (in answer to your question) it can resist the enclosure of higher education by market forces, given that the University of Lincoln is being marketised at present, that staff face the same regimes of accountability as elsewhere, and that students also have high workloads to pay for their living costs, loan provision for tuition fees.

Given these limits, Neary, Amsler and their colleagues have created a second leg to their project, which is one of those that have emerged in the aftermath of the Browne Report and the Higher Education Act of 2011. The Social Science Centre, Lincoln (SSC) explicitly does not seek to defend 'the public university' but to create 'an entirely new kind of university out of the ruins of what the university has become'.[37] The SSC is a centre in the sense of being influenced by national and international movements to create social centres as spaces of 'autonomous politics and resistance to the corporate take-over, enclosure and alienation of everyday life'[38] and their aim is to create alternative 'social spaces, times and relations of learning'[39] around the city of Lincoln.

The SSC provides 'free higher education [that is] managed cooperatively and collaboratively by its members'. Organised as a cooperative, all members pay one hour of their monthly income if they can and nothing if they cannot to support the SSC. Funds don't pay staff but for resources and publicity. Thus they seek to avoid the kind of marketising and commodifying now occurring in the university. All teachers and students are 'scholars', a name indicative of efforts to dissolve 'the distinction between academics and students'. Further, although at the end of part time undergraduate, MA or PhD training student-scholars receive the equivalent of a degree, validated by external academic review by scholars based around the world, the educational programme in which they engage has 'radical political aspirations'.[40] This is in part because of the originators' left political leanings/orientations and that pedagogically, a dialogical way of learning. Further, student- and teacher-scholars engage collaboratively in research as part of their educational project that is guided by what Gigi Rogero calls 'militant enquiry or co-research

[that] challenges the border between research and politics, knowledge and conflicts, the university and its social context, as well as the barriers between work and militancy'.[41] Research thus aims at praxis, the fusion of theory and practice for political purposes, as the concept of militant enquiry suggests. What an amazingly thoughtful, creative and hopeful project this is! I would like to find out more about how it is negotiating contradictions and tensions that undoubtedly must be arising as its organisers are realising this project; having attended a few early meetings, I remember feeling energised by the recognition that decisions being made had consequences were not previously considered and these were seen as interesting challenges. There have been other alternatives, most of which have not survived, but which are of great significance and readers of this collection might want to find out more about them if they are thinking of creating their own alternatives. If so, look at two websites to get a flavour of what they offered: the University for Strategic Optimism and the Really Open University.[42]

Other projects are being created that are alternative educational projects with communities. I don't have time to mention them in any detail but let me just name them and again interested readers can follow them up if they wish. One of these is Birmingham Radical Education (BRE(A)D),[43] in which I am involved. We start with a few assumptions. First, mindful of Freire's point that revolutionary praxis, needs to have an 'educational dialogical quality' to keep it 'from becoming institutionalized and stratified',[44] we seek to work with local activists in Birmingham to develop a fuller understanding of the campaigns and actions we and others are involved in so that we can more effectively and fully mobilise more people to fight against government cuts in future. We want to develop dialogical ways of thinking and doing that enable us to prefigure in the present the kinds of democratic ways of thinking and doing of and for the future. We're at an early stage, planning our first few meetings, in which participation of as many people as possible will be at its core, and I am hoping that we can move forward.

Another group is the Education for Action network, which has had two meetings to date and seeks to resist 'the privatisation and dismantling of

higher, further, trade union and community education', by creating spaces and developing resources to support efforts to resist this privatisation and dismantling of educational spaces. They are linked to two other really interesting groups, one of which is the Independent Working Class Education network that began three or four years ago and aims to retrieve the history of working class education initiatives/materials from the industrial revolution that have helped working class people acquire really useful political, theoretical and practical knowledge in order to understand and work to overturn ruling class power. By reintroducing past documents and materials, and producing more from recent and present struggles, their aim is to offer 'a diverse range of education materials for trade union and trade union and other working class and progressive movement groups' today.[45]

Finally, the Peoples' Political Economy (PPE) seeks to enable ordinary people to 'better understand the political and economic conditions that structure the crisis affecting their lives'. Their pilot educational programme began in Oxford in autumn 2012 and ran in autumn and winter 2012/2013 with the aim of helping working-class young people engage in a 'collective critical dialogue' about 'the political and economic structures and institutions that regulate, shape and all too often constrain their lives'.[46] Whilst their pilot project sought to facilitate personal transformation, their aim in 2013-2014 is to work collectively and critically toward understanding and working to change the world. The PPE has a three-tiered structure of an organising committee looking outwards towards publicising events and inwardly towards ensuring the smooth running of the project's classes. They have external advisors, who guide programme and curriculum development and support training for facilitators in using critical pedagogy so as to create dialogical conversations that start from participants' experiences.

And so I believe that even in these darkest of times, creative, alternative spaces of and for pedagogies and practices of resistance and possibility are being built.

DW: How do you feel about the term 'para-academic' and do you see any historical precedents?

JC: I like the term para-academic, despite not having heard of it before I found out about this book through fortuitously meeting you at a stream of papers on 'higher education in crisis' I organised at the London conference on Critical Thought in June 2013.[47] Maybe this meeting wasn't so fortuitious, given that the concept of para-academic in particular and the Handbook in general speak to those working in, against and beyond the university in its current state, and that was the intention of my stream. As I understand it, the concept of para-academic legitimises the thoughts, actions and interventions of those occupying liminal positions in and/ or outside the university. I would add, given the present crisis which the creation of my stream and this concept and Handbook indicate, that para-academics should pursue knowledge for the purpose of liberation: praxis (collectively created, progressive political change). In saying this, I am mindful that some very renowned scholars from the past could be considerd para-academics. I am thinking here, of course, of Marx, and his Critique of Feuerbach immediately comes to mind: not only his final thesis that 'Philosophers have only interpreted the world, the point, however, is to change it', but the theses more generally. These emphasise the ways that people come to theorise the world and test their theories in the world through action, aware of the material and social conditions that shape their circumstances and the responses they create to these circumstances. I guess that you could say that Marx in all of his work was a para-academic who took sides, struggling with others, reflecting on that struggle, in order to build more effective ways of understanding how the world worked in order to overturn capitalism and the ways that it degraded so many people, practices and ideas. The aim of the struggle was to help build a more just and equal world in which people's humanity and dignity could be affirmed. And since Marx, many left theorists could be considered para-academics, including Gramsci, Fanon, Freire (influenced by the other three and many others), and more recently, Guy de Bord, Hardt and Negri, Holloway and sub-Comandante Marcos of

the Zapatistas. So there is a grand past to the neologism para-academic that can potentially be carried further in the future!

DW: As this is a toolkit for learning-making etc., what tools, drawn from your own practise as a radical educator and protector of spaces for free, creative learning, can you offer the person wanting to create alternatives?

JC: My practice, as a radical or critical educator, builds in part on insights from Paulo Freire. Freire recognised that education is an inherently political process and that formal education serves ruling class purposes. Like the other authors I've just mentioned, whose work influenced his and whose ideas guide mine, Freire recognised that education, whilst always politically charged, can never completely serve ruling class purposes as it is dialectical, always in motion against the tendency currently dominant. That which is imposed can be resisted, overcome, or at least some spaces of alterity can be created within and outside. If education is always a political process, then critical pedagogy works dialectically, with and then against students' and teachers' prior understandings, assumptions, actions. Freire suggested that educators should listen carefully to students' words, as these words embodied both prior reflections and actions (here we see shades of Marx's critique of Feuerbach).[48] The teacher's role is not just to reflect back on students' current understandings, but to pose problems to students and offer additional ideas.

Perhaps an example from my own practice, a couple of years prior to my departure from the university, illustrates this point. I had to teach a module on 'Work, Organisation and Society' that I inherited from a colleague who had recently retired. I decided that on the first day of class I would start the module with questions. Here is my memory of the conversation, with 'JC' for my input and 'S' for that of different students:

JC: What is your biggest fear as students?
S: Not getting a job after graduation.
JC: Why do you think you might not get a job?
S: Because there's fewer jobs for graduates than there used to be.

JC: Why are there fewer jobs now?

S: Because the economy's in crisis.

JC: Why is the economy in crisis?

S: Because the banks had to be bailed out.

JC: Why did the banks have to be bailed out? Why couldn't they be left to collapse?

At this point, there was silence, and students seemed really engaged, with many leaning forward, eyes gleaming with curiosity. I then asked, 'Can the bailout be because the banks are owned by very wealthy individuals and corporations who use their power to influence government?' And, 'Why can't the government get the money by collecting taxes from those individuals and corporations who evade, avoid or fail to pay their income tax?' I then suggested that these were the kinds of questions we would be examining in this module. I tried to maintain this level of problem-posing throughout the module. What I hope this example shows is that I started with what students thought and then asked them questions that dug deeper and deeper beneath the surface of their assumptions and raised questions that they might want to consider.

This kind of pedagogy presumes that people are 'beings in the process of becoming'[49] who can move 'out of and beyond' themselves with others, towards others, in and through thinking and acting together. As I've already said, Freire didn't just view this methodology and philosophy as crucial to learning, but for maintaining the vitality and energy of revolutionary practice. As I've already talked about the modules, learning spaces and routeways I organised and co-organised using these insights, I won't mention them again but rest assured that they were very clearly informed by Freirean insights.

DW: Why do you think there is so little collective resistance to the changes in FE/HE among academics, and so much individual compliance? (I loved Gurnam Singh's point at the LCCT conference that ultimately the REF 'didn't matter' in the face of the erosion of education, learning and so forth...)

JC: It is certainly the case that academics have little alternative but to be at least partly compliant with the new order now structuring HE. But I think I've already suggested that there is collective resistance against this order. And my own response to the growing work intensification and insecurity, and to the regimes of accountability that are so powerfully usurping academics' minds and souls' is indicative of the levels of exhaustion and depletion that academics are experiencing—if they're lucky enough to be in full-time employment or unlucky enough to be working as hourly-paid lecturers or postgraduates who teach.

In this context, and in the context of a mainstream media that bombards us all with the idea that there is no alternative to the current order, I think it is crucial for people to read and see progressive alternative sources of information. Read 'ROAR' magazine, the *Huffington Post, the Guardian, New Statesman*, globalresearch.ca; watch 'The Real News Network', 'Reel News' and 'Democracy Now' and find other sources of alternative information. And get involved in alterative projects and actions. It is crucial at present that as many people as possible work to help build alternatives in, outside and against state education and much more widely.

Notes

1 Canaan, Joyce (2008) 'A Funny Thing Happened on the Way to the (European Social) Forum: Or How New Forms of Accountability are Transforming Academics' Identities', in Joyce Canaan and Wesley Shumar (eds) *Structure and Agency in the Neoliberal University*, London: Routledge, 256–277; Canaan, Joyce E (2013) 'Resisting the Neoliberalising University: What critical pedagogy can offer', *Journal for Critical Education Policy Studies*, 11: 2 http://www.jceps. com/?pageID=article&articleID=286; Canaan, Joyce E. (2010) 'Analysing a "Neoliberal Moment" in English Higher Education Today', in Morrish, L. and Sauntson, H (eds) *Gender and the Neoliberal University. LATISS— International Journal of Higher Education in the Social Sciences*, 3(2), 18:55-72; Shore, Cris and Wright, Susan (2000) 'Coercive Accountability: the Rise of Audit Culture in Higher Education' in Strathern, Marily ed. *Audit culture. Anthropological studies in accountability, ethics and the academy*. London: Routledge, 57-89.

2 Davies, Bronwyn (2011) 'Leaving the academy' http://bronwyndavies. com.au/blog/47-leaving-the-academy. Last accessed 28 February 2014.

3 Lopez y Royo, Allesandro (2013) 'Why I'm Leaving the Academy', *Times Higher Education*, 22 August 2013. http://www.timeshighereducation. co.uk/comment/opinion/why-im-quitting-the-academy/2006622. article Last accessed 28 Feb 2014. See also http://bundlr.com/b/ academia-and-mental-health.

4 Morgan, John (2013) 'UCU Homes in on Widespread Use of Zero-Hour Deals', 5 September 2013, http://www.timeshighereducation.co.uk/news/ ucu-homes-in-on-widespread-use-of-zero-hours-deals/2007035.article Last accessed 28 Feb 2014.

5 Lopez, Ana and Dewan, Indra (2013) 'Workshop: Precarious Lecturers = Precarious Pedagogies: the Impact of Short-Term Contracts on Higher Education Teaching', paper given at *Critical Pedagogies: Equality and Diversity in a Changing Institution*, University of Edinburgh, 5-6 September 2013.

6 Thwaites, Rachel (2013) 'Power and Empowerment in the Classroom of

a Feminist Postgraduate Who Teaches', paper given at *Critical Pedagogies: Equality and Diversity in a Changing Institution*, University of Edinburgh, 5-6 September 2013. See also Lena Wånggren and Maja Milatovic's contribution to this collection.

7 Peck, Jamie, Nik Theodore and Neil Brenner (2009) 'Postneoliberalism and its malcontents', *Antipode*, 41: 6, 380-404; Brenner, Neil, Jamie Peck, J. & Nik Theodore (2010) 'After Neoliberalization?', *Globalizations* 7(3), 327-345.

8 Brenner, Peck & Theodore, 'After Neoliberalisation?', 337.

9 *Ibid*, 340.

10 Canaan, 'Resisting the Neoliberalising University.'

11 Rikowski, Glenn (2012) 'Life in the Higher Sausage Factory', Guest Lecture to the Teacher Education Research Group, The Cass School of Education and Communities, University of East London, 22nd March, part 1, 5. Available online: http://www.flowideas. co.uk/?page=articles&sub=Life%20in%20the%20Higher%20 Sausage%20Factory. Last accessed 28 Feb 2014.

12 *Ibid.*

13 *Ibid*, 12.

14 Harvey, David (2005) *A Brief History of Neoliberalism*, Oxford: Oxford University Press.

15 ROAR (2013) Spirit of Revolt Moves South as Austerity Protests Rock Sudan, http://feedproxy.google.com/~r/roarmag/~3/ V6Yi1Dl4okI/?utm_source=feedburner&utm_medium=email. Last accessed 28 Feb 2014.

16 Murphy, Richard (2012) 'Why are they increasing the tax gap?', *Public and Commercial Services Union*, http://www.pcs.org.uk/en/campaigns/ national-campaigns/tax-justice/why-are-they-increasing-the-tax-gap. cfm#Executive_Summary. Last accessed 28 Feb 2014.

17 Davis, Petra (2013) 'Alfie Meadows and Zak King are Not Guilty: Now its Time for Police Behaviour to be Scrutinised, *New Statesman*, 9 March 2013, http://www.newstatesman.com/austerity-and-its-discontents/2013/03/ alfie-meadows-and-zak-king-are-not-guilty-now-its-time-police- Last accessed 10 March 2013.

18 Penny, Laurie (2013) 'Where are the Activists When Austerity Bites? They Have Been Beaten Back', *The Guardian*, 4 April 2013, http://www.guardian.co.uk/commentisfree/2013/apr/04/where-are-the-activists-austerity; Malik, Shiv (2011) 'Fortnum & Mason Protestors Convicted of Aggravated Trespass', http://www.theguardian.com/uk/2011/nov/17/fortnum-mason-protesters-convicted-trespass Last accessed 28 Feb 2014.

19 The Reel News (2011) 'Rebellion in Tottenham' http://reelnews.co.uk/rebellion-in-tottenham-2011/. Last accessed 28 Feb 2014.

20 Iossifidis, Miranda and Thomas, Philippa (2012) 'Reading the Riots: One Year On', *Open Democracy*, 30August 2012, http://www.opendemocracy.net/ourkingdom/miranda-iossifidis-philippa-thomas/reading-riots-one-year-on. Last accessed 28 Feb 2014.

21 Institute for Fiscal Studies (2013), http://www.ifs.org.uk/budgets/gb2013/GB2013_Ch6.pdf. Last accessed 28 Feb 2014.

22 McGettigan, Andrew (2013) *The Great University Gamble: Money, Markets and the Future of Higher Education*, London: Pluto.

23 Shepherd, Jessica (2011) 'Privately run BPP launches bid to run 10 publicly funded counterparts', *The Guardian*, 21 June 2011, http://www.guardian.co.uk/education/2011/jun/21/bpp-private-bid-run-public-universities; Hotson, Howard (2011) 'Don't Look to the Ivy League'. *London Review of Books*, 33:10, 20-22. Available from http://www.lrb.co.uk/v33/n10/howard-hotson/dont-look-to-the-ivy-league. Last accessed 28 Feb 2014.

24 Feagin, Joe and Hernan Vera (2009) *Liberation Sociology*. Boulder and London: Paradigm Publishers.

25 Marcuse, Herbert (1967) 'Liberation from the affluent society', 1967 lecture, London, http://www.marcuse.org/herbert/pubs/60spubs/67dialecticlib/67LibFromAfflSociety.htm. Last accessed 28 Feb 2014.

26 Doyle, Clare (1988) *France 1968: Month of Revolution*, London: Fortress books.

27 Badiou, Alain (2009) *The Communist Hypothesis*, London: Verso: London.

28 Amsler, Sarah (2012) 'Revalorising the critical attitude in critical education', in *Journal of Critical Education Policy Studies,* 60-76, 63.

29 Hassan, Gerry (2010) 'The new sound of the streets', *OpenDemocracy,* 12 December. www.opendemocracy.net/ourkingdom/gerry-hassan/ new-sound-of-streets Last accessed 10 January 2011.

30 Fisher, Mark (2010) *Capitalist Realism,* Winchester: Zero books, p. 24.

31 Amsler, 'Revalorising the critical attitude in critical education'; Canaan, Joyce E (2011) 'Is this "just the beginning"?: exploring the possibilities of the autumn 2010 student movement', in Hatcher, R and Jones, K *No Country For the Young,* Tufnell Press: London.

32 Lefebvre in Neary, Mike and Amsler, Sarah (2012) 'Occupy: a new pedagogy of space and time?' *Journal for Critical Education Policy Studies,* 10:2. http://www.jceps.com/?pageID=article&articleID=277, 117

33 *Ibid,* 113.

34 *Ibid,* 121.

35 *Ibid,*120.

36 *Ibid,* 124.

37 Neary, Mike (2011) The Social Science Centre: a radical new model for higher education, http://www.opendemocracy.net/ourkingdom/mike-neary/social-science-centre-radical-new-model-for-higher-education Last accessed 7 October 2011.

38 *Ibid.*

39 Neary and Amsler, 'Occupy: a new pedagogy of space and time?', 125.

40 *Ibid,* 126.

41 Neary, Mike (2013) Occupying the city with the Social Science Centre— an interview with Mike Neary, http://classwaru.org/2013/09/02/ occupying-the-city-with-the-social-science-centre/#more-375. Last accessed 28 Feb 2014.

42 The Really Open University (2011), What is the Really Open University? http://reallyopenuniversity.wordpress.com/what-is-the-rou/; University for Strategic Optimism, About, (http://universityforstrategicoptimism. wordpress.com/about/) Last accessed 28 Feb 2014.

43 Birmingham Radical Education (BRE(A)D, http://bread4brum. wordpress.com/.

44 Freire, Paulo (1996) *Pedagogy of the Oppressed*, London: Penguin, 118.

45 Education for Action network, http://www.redpepper.org.uk/education-for-action-a-new-network-to-resist-the-commodification-of-education/; Independent Working Class Education network, http://iwceducation.co.uk/index.php/about. Last accessed 28 Feb 2014.

46 PPE--Peoples' Political Economy (2013) 'Inaugural report: from foundation to future', 6. http://www.ppeuk.org/PPE%20Report%20 2013.pdf Last accessed 28 Feb 2014.

47 http://londonconferenceincriticalthought.files.wordpress.com/2013/04/lcct-2013-programme-final.pdf Last accessed 28 Feb 2014.

48 Friere, *Pedagogy*, 68.

49 *Ibid*, 65. Emphasis in original.

Joyce Canaan is Professor of Sociology in the Faculty of Education, Law & Social Sciences, Birmingham City University. She has published extensively on critical pedagogy and learning and teaching in, against and beyond the neoliberal university. Most recently, with Sarah Amsler, Stephen Cowden, Sara Motta and Gurnam Singh, she co-authored *Acts of Knowing: Critical Pedagogy in, against and beyond the University* (Bloomsbury 2013). She also published two articles in special issues of the *Journal of Critical Education Policy Studies* in 2013 as well as articles in other journals including *Learning and Teaching in the Social Sciences, Enhancing Learning in the Social Sciences, Cultural Studies<>Critical Methodologies*. Other recent books include *Structure and Agency in the Neoliberal University* (co-edited with Wes Shumar, Routledge, US and UK, 2008) and *Why Critical Pedagogy and Popular Education Matter Today* (with Sarah Amsler, Stephen Cowden, Sara Motta and Gurnam Singh, C-SAP, Birmingham University 2010).

A PEDAGOGICS OF UNLEARNING

Éamonn Dunne & Michael O'Rourke

I am interested in the humbling that occurs when one says, 'I am stupid before the other' which is absolutely a taboo. You cannot imagine someone in a university saying, 'I am stupid', or 'I am stupid before my students'. This humbling and destabilising of the *sujet supposé savoir*—of the subject who is supposed to know or who is posed as a functionary of knowing—creates minor insurrections for me—Avital Ronell[1]

You must forget well, you have to forget. Strange double or divided saying, injunction out of joint … it must be shared, and not only in language; one never forgets entirely on one's own; forgetting well entails an openness to infinite hospitality—Nicholas Royle[2]

In a very practical sense, this will be to strike at oneself—to relinquish one's comfortable disciplinary identity, to stop 'being disciplined.' Rather than disciplined repetition, alterdisciplinary intervention requires yielding to the other discourse, the other protocols, the other language, the other scene, through a renewed emphasis on listening *to*, engaging *with*, connecting *with* the other, on other terms—Paul Bowman[3]

Everyone is of equal intelligence—Jacques Rancière[4]

Indeed, nothing outside the text, no origin, no indivisible mooring, no inviolable resting-place, no falling back into the house of being or into the sense of a pathway. Nothing, and for that reason it amounts to an incessant journeying. It is a voyage that has its marks and points of reference, that doesn't fail to orient its hesitation in the face of divergent sense and direction—Catherine Malabou[5]

If the system is too tight, too ordered, nothing new can happen. I admit this is risky business. But the point is that playing it safe all the time is also risky business—it risks the prevention of the future, of the event. Nothing is safe. Everything is risky. Now having said this, we can ask, is this structural exposure to the event not a perfect way to describe the institution in general and in particular educational institutions—the administration, the curriculum, teaching 'methods,' testing and evaluation, everything that goes on in education. A teacher gives a class, or maybe just makes a comment in class, and a student's life is changed. The teacher does not know she did this, and at the same time neither does the student. That is the event—John Caputo[6]

There are many different kinds of intelligence, and there will always be a few writers who don't need to read Shakespeare in college, or game designers who don't need economics courses to get rich. But a terrible narrowing of the mind and of mental experience is ongoing in our country, sometimes waved on by the very scientists who ought most of all to respect the mind's powers. As the philosopher Guillaume LeBlanc has argued throughout his oeuvre, philosophy is work performed in and on behalf of particular cultures and ecologies. This requires a new ethos of the philosopher, for whom the question of belonging to an ordinary world has become, not something to bracket or transcend, but vital. Understanding how ordinariness is produced, and critiquing self-evidence, remain crucial activities of cultural analysis. But we are also bound to deciphering the relationship of our work to

the arts of thriving and surviving, and it is time to fight not just for this or that way of thinking, but for the experience of mind itself—L.O. Aranye Fradenburg[7]

Derrida's university 'without condition' is, in some important respects, a guarantor of the *freedom of thought*. For Derrida, it was always a futural project, one that Derrida claimed *could take place tomorrow*, but that tomorrow, as far as I am concerned, is now. The future, of necessity, needs to remain always open to the unforeseen—this is the matter, and the determinative *time*, of justice—but there is no reason to defer everything. Certain decisions can be made—every day, in fact—that can be designed to keep the future productively open, which is also a way to keep the Now creatively messy and unsettled. This will also mean understanding that the other critical term here, in addition to freedom, is *responsibility*. Someone, or some distributive collectives of someones, needs to take responsibility for securing this freedom for the greatest number of persons possible who want to participate in intellectual-cultural life, and for enabling the greatest possible number of forms of such life, thereby also ensuring the creative robustness of the larger social systems within which we are all enfolded together, whether university, whiskey bar, apartment building, city park, subway car, kitchen, church, cruise ship, bedroom, or *polis*—Eileen Joy[8]

The university is in ruins and higher education is in the teeth of a crisis. So, what good can it possibly do to think about the pedagogical stakes and promises of unlearning, of stupidity, ignorance, cluelessness, forgetting, loss and failure? Perversely, we want to suggest that it is *only* in *not knowing* what we are doing that a genuine teaching event can emerge. Lacan admitted this in his seminars a long time ago: 'The only genuine teaching is one which succeeds in awakening an insistence in those who are listening, this desire to know which can only emerge when they

themselves have taken the measure of ignorance as such—in so far as it is, as such, fruitful—and no less so on the part of the one who teaches.'[9] Ignorance, for Lacan, is something we must take the full measure and weight of if teaching and learning are to be in any way productive: 'For something new to come into existence, ignorance must exist. That is the position we are in, and that is why we must conceive, in the full sense. When we know something, we are already not conceiving anything any longer.'[10] He goes even further by asserting that any coming to sense must be predicated on ignorance: 'If you are not coming to put into question everything you do, I don't see why you're here.'[11] Lacan is encouraging us, those subjects supposed to know, to inhabit the critico-pedagogical position of the one who is castrated, or in other terms, the loser. Psychoanalytically and educationally the teacher is the one who is expected to occupy the position of knowing-it-all, of mastery, of having the phallus. However, what we are calling the pedagogics of unlearning occupies the paradoxical posture of failure-to-know-it-all or failure to have and to hold the phallus. The one who loses the phallus exposes just how stupid it is to think that one grasps it all in the first place. The teacher as loser, the one who fails again and fails better each time, knows better than that.

There can be no teaching and no learning without stupidity. Avital Ronell's book *Stupidity* even goes so far as to admit that we are ignorant of stupidity itself: 'all we know at this juncture is that stupidity does not allow itself to be opposed to knowledge in any simple way, nor is it the other of thought. It does not stand in the way of wisdom, for the disguise of the wise to avow unknowing.'[12] In *The Ignorant Schoolmaster* Jacques Rancière describes the distribution of capabilities and knowledges as being partitioned into 'knowing minds and ignorant ones, ripe minds and immature ones, the capable and the incapable, the intelligent and the stupid.'[13] His book narrates the remarkable story of Joseph Jacotot, a nineteenth-century teacher exiled to Louvain to teach French to students in Flemish, a language he neither speaks nor understands. To his surprise, the students learn French through a Flemish translation of *Telemachus* and obtain a remarkable fluency. Rancière derives several

alterdisciplinary (in Paul Bowman's terms)[14] lessons from this pedagogical event: firstly, that explication is stultifying insofar as knowledge is seemingly transmitted from the one who has mastered it to those whom he or she does not (yet) expect to understand or grasp it; secondly, he notes that this 'myth of pedagogy' is dependent upon the false premise that the intelligences of the master and student are unequally distributed.[15] The third lesson Rancière derives from this pedagogy as stultification is that, on the contrary, all intelligence is equal: 'the same intelligence is at work in all the productions of the human mind.'[16] In his emancipatory pedagogical method one must become an 'ignorant master' and 'to teach what one doesn't know is simply to ask questions about what one doesn't know.'[17] Rancière's pedagogics of unlearning insists that everyone is capable of teaching what they do not know and, moreover, that *everyone* can teach *anyone anything*.

Barbara Johnson in *A World of Difference* writes: 'the teaching of ignorance is probably not what the majority of pedagogues have in mind. It may indeed, be a structurally impossible task. For how can a teacher teach a student not to know, without at the same time informing her of what it is she is supposed to be ignorant of?'[18] Why on earth, Johnson is asking, would you want to teach a student *not to know* something? But Johnson's point is that 'the question of education is the question not of how to transmit knowledge but of how to *suspend* knowledge.'[19] What she gives the name 'positive ignorance' is not negative and it is only, perversely, in the interstices between ignorance and knowing that successful learning or teaching can take place. For Lacan, as we already heard, you must not know what you are doing or else you wouldn't be doing it. In referring to non-knowledge Lacan means something other than stupidity, incompetence, disorientation. He doesn't mean that you should be befuddled about *why* you teach or learn, but rather that, if you are now engaged in that pursuit, you must not know *what* you're doing, or else you wouldn't be doing it. You must not know where you are headed. The journeying is, as Malabou says, 'incessant'. In saying that, Lacan means something like the fruitful ignorance Johnson is arguing for. Lacan is suggesting that you must not know what you are doing

or else you wouldn't be doing it *so well*. That moment of productive ignorance is not one which is temporary. Rather it must be permanently, riskily, stupidly held open. It must hesitate as Malabou tells us. In this hesitation, a 'forgetting well' as Royle puts it, lies the very opening to infinite hospitality or 'responsibility', a collective responsibility, a being with(in) stupidity or epistemological humility, which, as Joy reminds us, will not wait.

Avital Ronell has in various places tracked the intractable question of stupidity through philosophy, psychoanalysis and politics, and when she is asked in an interview by Diane Davis about the political implications of what she, Ronell, calls 'foolosophy', she answers: 'I am interested in the humbling that occurs when one says, "I am stupid before the other" which is absolutely a taboo. You cannot imagine someone in a university saying, "I am stupid", or "I am stupid before my students". This humbling and destabilizing of the *sujet supposé savoir*—of the subject who is supposed to know or who is posed as a functionary of knowing—creates minor insurrections for me.'[20] Ronell's subtle argument here is that you have to know what stupidity is in order to say 'I am stupid before the other'. But stupidity is, paradoxically, unknowable, unrecognizable, un-understandable, non-ontologisable. She admits that 'as long as I don't know what stupidity is, what I know about knowing, remains uncertain, even forbidding.'[21] This is the crux, a wavering undecidability, between knowing and not knowing, between Rancièrean intellectual emancipation and the limitations of learning. To maintain a fidelity to learning is to be faithful to the call of stupidity, to adopt a position of epistemological and pedagogical humility, to be humble before the other, *just* because one simply doesn't know.

In *What is Called Thinking?* Martin Heidegger comes very close to answering the call of stupidity for an ethico-politico-pedagogical praxis. He says there: 'Teaching is more difficult than learning because what teaching calls for is this: to let learn. The real teacher, in fact, lets nothing else be learned than learning. His conduct, therefore, often produces the impression that we properly learn nothing from him, if by "learning" we now suddenly understand the procurement of useful information.

The teacher is ahead of his apprentices in this alone, that he still has far more to learn than they—he has to learn to let them learn. The teacher must be capable of being more teachable than the apprentices…if the relation between the teacher and the taught is genuine, therefore, there is never a place in it for the authority of the know-it-all or the authoritative sway of the official.'[22] To let learn, this pedagogical *gelassenheit*, is a massive responsibility, a calling.

In *Cinders,* Jacques Derrida takes that call. He confesses that the secret that impassions is 'the passion of non-knowing.'[23] As John Caputo explains, 'by un-knowing or non-knowledge Derrida does not mean some sort of despair which gives up on trying to know or an obscurantism which takes delight and prefers non-knowledge. "I am all for knowledge!" he protests.' Instead, what he has in mind is 'a structural non-knowing, something irreducibly foreign and heterogeneous to knowledge, which constitutes a 'more ancient, more originary experience, if you will, of the secret.[24] Where we are going is moved by the impossible of non-knowing.

Derrida is not proposing a 'learned unknowing', a 'knower's unknowing'. Rather he has in mind a 'lover's unknowing, an *ignorantia amans*, not a learned but a loving, expectant unknowing, which keeps the future open by the passion of its love.'[25] Derrida delimits knowledge in order to make room for faith in what is to-come, *à venir*. Knowledge, for Derrida, always means a prescient programming of the future, predelineating the foreseeable range and foreclosing the possible scope of the future. That closure within the possible is what Derrida means to cut open, the castrating cut of the loser pedagogue, by speaking of the impossible surprise and the absolute secret. The passion of non-knowledge protects the future and keeps it open by keeping it secret—indeterminate, unforeseeable, unprogrammable—as opposed to confining it within the parameters of the possible. Teaching, in Derrida's eyes (and in the eyes of his pupils), is a profession of faith, a mad leap, an unfathomable risk. We don't, we can't, know in advance how students will react to our teaching. That is the humbling call of stupidity. A loving pedagogy, one which responsibly answers that call is one which takes up the stance of stupidity before the other. This is the only hospitable, future dawning, loving, giving philopedagogics imaginable.

Notes

1 Ronell, Avital (interviewed with D. Diane Davis) (2004) 'Confessions of an Anacoluthon: On Writing, Technology, Pedagogy, and Politics' in Julian Wolfreys (ed) *Thinking Difference: Critics in Conversation.* New York: Fordham University Press, 55.

2 Royle, Nicholas (2009) *In Memory of Jacques Derrida.* Edinburgh: Edinburgh University Press, 137.

3 Bowman, Paul (2008) *Deconstructing Popular Culture.* Basingstoke: Palgrave, 182.

4 Rancière, Jacques (1991) *The Ignorant Schoolmaster: Five Lessons in Intellectual Emancipation*, trans Kristin Ross. Stanford: Stanford University Press, 101.

5 Malabou, Catherine and Derrida, Jacques (2004) *Counterpath: Traveling with Jacques Derrida.* Stanford: Stanford University Press, 162.

6 Caputo, John D. (2012) (interview with T. Wilson Dickinson) 'Education as Event: A Conversation with John D. Caputo'. *Journal for Cultural and Religious Theory* 12.2, 26.

7 Fradenburg, L.O. Aranye (2013) *Staying Alive: A Survival Manual for the Liberal Arts.* New York: punctum books, 122.

8 Joy, Eileen A. (2013) 'A Time for Radical Hope: Freedom, Responsibility, Publishing, and Building New Publics', *In the Middle* weblog (November 19, 2013).

9 Lacan, Jacques (1988) *The Seminar of Jacques Lacan, Book II: The Ego in Freud's Theory and in the Technique of Psychoanalysis, 1954-55*, (ed) Jacques-Alain Miller, trans. Sylvia Tomaselli. New York: Norton.

10 *Ibid.*

11 *Ibid.*

12 Ronell, Avital (2002) *Stupidity.* Urbana and Chicago: University of Illinois Press, 5.

13 Rancière, *The Ignorant Schoolmaster*, 6.

14 Bowman, Paul 'Alterdisciplinarity: Deconstructing Popular Cultural Studies' in *Deconstructing Popular Culture*, 169-186.

15 Rancière, *The Ignorant Schoolmaster*, 6.

16 Rancière, *The Ignorant Schoolmaster*, 18.

17 Rancière, *The Ignorant Schoolmaster*, 30.

18 Johnson, Barbara (1988) *A World of Difference*. Baltimore: John Hopkins University Press, 68.

19 Johnson, *A World of Difference*, 85.

20 Ronell, 'Confessions of an Anacoluton', 55.

21 Ronell, *Stupidity*, 4-5.

22 Heidegger, Martin (1968) *What is Called Thinking*, trans. J. Glenn Wray. London: Harper & Row, 15.

23 Derrida, Jacques (1991) *Cinders*, trans. Ned Lukacher. Lincoln: University of Nebraska Press, 75.

24 Caputo, John D. (1997) *The Prayers and Tears of Jacques Derrida: Religion without Religion*. Bloomington & Indianapolis: Indiana University Press, 102.

25 *Ibid.*, 103.

Éamonn Dunne is researcher in education at Trinity College Dublin. He is the author of *J. Hillis Miller and the Possibilities of Reading* (2010) and *Reading Theory Now* (2013). His primary research interests are in literary theory, contemporary continental philosophy and radical pedagogies. He has also published a number of journal articles on, among others, Heinrich von Kleist, Jacques Rancière, J. Hillis Miller and Paul Auster. He is currently working on a monograph on unlearning in education and a co-written book with Michael O'Rourke on reading and perversity.

Michael O'Rourke lectures in the school of Arts and Psychotherapy at Independent Colleges, Dublin and works mostly at the intersections between queer theory and continental philosophy. He is the co-editor of *Love, Sex, Intimacy and Friendship Between Men, 1550-1800* (Palgrave Macmillan 2003, paperback 2007); *Queer Masculinities, 1550-1800: Siting Same-Sex Desire in the Early Modern World* (Palgrave Macmillan, 2006), *The Ashgate Research Companion to Queer Theory*

(Ashgate, 2009) and *Speculative Medievalisms: Discography* (punctum books, 2013) and the editor of *Derrida and Queer Theory* (forthcoming), *Reading Eve Kosofsky Sedgwick: Gender, Sexuality, Embodiment* (Ashgate, forthcoming) and *P.E.S.T.* (forthcoming).

He is the author of *Queering Speculative Realism* (forthcoming), *Rogue Theory* (forthcoming) and co-author (with Éamonn Dunne) of *The Pervert's Guide to Reading* (forthcoming). He is also the editor or co-editor of several journal special issues and many articles and book chapters (some of his publications can be found here: http://independentcolleges.academia.edu/MichaelORourke). He has co-convened The(e)ories: Advanced Seminars for Queer Research since 2002 and is the series editor of the *Queer Interventions* book series at Ashgate and of the *Queer Aisthesis* book series at punctum books. He is also co-editor of *O-Zone: A Journal of Object Oriented Studies*, associate editor of *Rhizomes: Cultural Studies in Emerging Knowledge* and contributing editor to *Studies in Gender and Sexuality*. He recently co-founded the sound/art philosophy collective REVERB and is a visiting lecturer at the Institute of Social Sciences and Humanities, University of Skopje, Macedonia and a faculty member of the Global Center for Advanced Studies.

EMBOLDENED AND UNTERRIFIED

Christian Garland

In the UK, the indeterminate and precarious world that is the subject of this volume finds its own peculiarly in the non-specific hinterland of casually employed and underemployed *para-academia*. Postgraduate study in the UK has never had much funding available to it, and what little there ever was is diminishing all the time. At the same time the management of universities are paid salaries in the hundreds of thousands even when they are being tasked with 'having to make unpopular decisions'. That generic and frequently preferred euphemism for culling whole departments, and thus subject provision, has the additional effect of producing wide-scale redundancies for staff members on permanent contracts. The position of the para-academic is brought home by the *de facto* requirement of a PhD that entitles you to apply for the ever-fewer actual lectureships that come up. These highly-skilled academics add to the plentiful supply of 'part-time, hourly-paid, sessional staff'—what are called 'adjuncts' or 'instructors' in the US—and are expected to tread water indefinitely in the pool of casualised academic labour; a deep and vast pool that gets vaster all the time.

To better define the precarious and casualised position of the UK *para-academic* it is helpful to sketch some of the features of British Higher Education as it stands currently. The previous decade was still, after all, the time of New Labour, that post-ideological confection of

neoliberalism *par excellence*. Whilst still in the early part of last decade, the then education minister, Charles Clarke,[1] made much of the necessity for British universities to 'harness wealth creation.'[2] This example of crude instrumental reason neatly distils the essence of what 'education', and specifically Higher Education, should be about according to politicians of all shades—from undergraduate degrees up to Doctorates, and of course all 'research' conducted in the academy: the preservation and advancement of capitalism. New Labour—of which Clarke was a leading ministerial light—made much of its determination to 'get 50% of young people into Higher Education', aware of the socially progressive connotations that seemingly opening up universities to a wider section of society carried, but well aware that this actually had no such aim. The aim to 'widen participation' was in fact to create a relative upward re-skilling and a much faster production line for the social factory, in which the graduate end-product's 'transferable skills' gained from a degree would mean that many more interchangeable and standardised products could be chosen from by employers, all the while intensifying competition and exerting pressure on the same graduate workforce to refine itself to better 'meet the needs of business'.

Following the General Election of May 2010, the outlook for Higher Education in the UK became even bleaker and even more crushed by the dead weight of market imperatives courtesy of the Conservative-led coalition government, which has also made much use of disingenuous claims that this is about 'widening participation'. The incumbent coalition's Higher Education policy is indeed every bit as crudely instrumental and market-focused as what preceded it, but in spite of also trying to claim this aims at 'widening participation', it is aware of the fact that the policies being enacted will in fact *restrict* and *limit* the student intake at undergraduate level, and is indeed, well aware of the additional knock-on effects that this will have on postgraduate education, any new intake of faculty, and the research that can be undertaken. To be sure, and put crudely (but it is after all a crude policy), besides the *tripling* of undergraduate tuition fees,[3] universities are expected to run themselves as enterprises looking to 'generate revenue', working

at cost-cutting and cost-efficiency, and so courses and institutions are becoming disciplined and limited according to whether they can 'prove their worth' in market terms. For the undergraduate on a three or four year degree course, what becomes important is what their degree can 'offer' them as an 'investment' that they hope to get a 'return' on in advancing their future into a well-paid graduate job. The bad faith of such an ideological explanation and justification for importing that original homily of the Dismal Science itself, 'rational economic (wo) man,' into the academy and making a university education into a saleable commodity is of course the ever-diminishing number of actual well-paid 'graduate' roles on offer.

The Browne Review, *Securing a Sustainable Future for Higher Education*,[4] which reported back its findings in the autumn of 2010, could be seen as the apotheosis of New Labour's Higher Education policy—by whom it was commissioned in 2009—whilst also containing much of interest for the new Conservative-led coalition government and its plans for British universities, particularly the *de facto* recommendation for removing teaching funding for the Arts, Humanities and Social Sciences. Among the many policy recommendations were the signature items of 'uncapping' undergraduate fees from their previous limit of £3,000 and withdrawing or at least vastly curtailing government funding for all but 'priority' subjects such as medicine. The government followed the findings of the report, with the issuing of its own White Paper in June 2011, *Higher Education: Students at the Heart of the System*,[5] which stated plainly: 'universities will be under competitive pressure to provide better quality and lower cost'[6]—effectively summing up the entire document in one sentence. Indeed, as has been convincingly argued:

> Education is seen as an investment in human capital and a primary responsibility of individuals. In the report, there is not a single mention of the wider purposes of education, other than the purposes of the contribution to economic growth and for the contribution to the employability and future income of the student. That is unique in a report on higher education. Of course,

the Browne report couldn't refer to other public values of higher education—were it to do so it would pose immediately the question it didn't want to ask: if there are public values to higher education and public benefits, then should the public not pay for them?[7]

The decision to indeed *cut altogether* the teaching grant for Arts, Humanities and Social Sciences is very transparent in its implications: such subjects, besides being of less market worth and less about 'meeting the need of business' than others, teach students to *think*, and think *critically*. This is not something to be encouraged on a mass scale, particularly when the student body is to be drilled in cost-benefit analysis. To be sure, the nakedly instrumental purpose of universities in the wisdom of politicians and political parties (whether governing or in 'opposition') is simply to produce skilled drones, prepared to compete for diminishing 'professional' roles using means-ends calculation when choosing what subject their degree should be in and how 'value added' it is likely to make them on graduation. Indeed, as Terry Eagleton notes, 'there is no university without humane inquiry, which means that universities and advanced capitalism are fundamentally incompatible. And the political implications of that run far deeper than the question of student fees.'[8]

(IN AND OUT OF) THE FORTRESS ACADEMY, ESCAPING BUREAUCRATIC AND METRIC TYRANNY

Currently, the academic *precariat* is a growing and increasingly visible group, and one that in spite of its always-present material insecurity is also sometimes prepared to use its mobility and fluidity to subvert the bureaucratised and quantified tyranny of the 'fortress academy'. To clarify this could be said to be complete indifference and frequently outright rejection of all the demands of academic careerism: standardisation, 'REF-able' writing (i.e. only writing and publishing of a certain nature in certain publications near the top of the spurious hierarchy of prestige)

'professional development' and bureaucratic and procedural hoop-jumping of all kinds. Insomuch as rejection and invalidation is constitutive of 'what a university is supposed to be about', there is also the existential and intellectual validation—the subjectivity—and assurance of those engaged in it. To be sure, this validation, assurance and recognition—both of the quality of one's work and antagonism toward the bureaucratised institution—can be and often is shared by those in less insecure and precarious situations. The fact that *para-academics* are themselves the equal (in intellectual and peer-review terms) of any of the 'real', tenured academy can also be a sore point with the latter group, some (but by no means all) of whom see the *para-academic* community as insubordinate to the proper hierarchies of 'earned' prestige and lacking due respect for 'career progression' and the traditional subaltern 'apprentice' role of learning their thoroughly instrumentalised and bureaucratised craft. The now all-but-mandatory requirement of a PhD for even the most temporary salaried post is the best example of this dynamic in play.

For in spite of the fact that many, many para-academics are also undertaking doctorates (or already have one) this remains absolutely no guarantee of a full-time or permanent university post, and so there is also the so-called 'glut' of completed PhDs competing for very few academic jobs: a situation at a more highly specialised level not unlike the one faced by graduates the para-academic will likely have taught as undergraduate students. Indeed, PhDs (and not with the slightest disrespect meant to anyone who has one, is doing one currently, or intends to get one) much of the time have very little to do with intellect or knowledge, and very much more to do with a 'sifting' process of elimination so as to get the widest possible pool of people to choose from, who merely just by having one are deemed to have reached a certain minimum standard of jumping through the requisite procedural and bureaucratic hoops. No doubt whoever gets a post from those shortlisted, will also be seen as likely to be good at 'securing external funding'—something frequently listed under 'desirable' criteria in further particulars for academic posts. This outcome can be seen as one consistent with neoliberal logic: quantification of literally anything and everything at any and every cost, the better to

intensify competition and thus supposedly provide the 'best' available—the market serves all.

Para-academics will frequently be employed as 'part-time, hourly-paid' staff at different institutions, and as precarious as this material existence is—arguably *because* of it—they have little choice *not* to be. In this sense, a whole new category of 'Fellow' and 'Associate' job descriptions are invented to describe *non-salaried* posts by universities for the few precarious and temporary jobs that are advertised for competition between PhDs, to Post-Docs, and everyone in between and after. In the last two years, the University of Birmingham, University College London, and most recently the University of Essex have all had to hastily withdraw ads for *unpaid* posts, in effect internships, following negative publicity storms they had clearly believed to be likely only in the imaginations of critics, or which could at least be averted with the help of PR. Neither was of course the case. As has been convincingly argued already,[9] unpaid internships (in addition to the many problems they bring with them) bring out in glaring contrast the nonsense of 'level playing fields' and 'meritocracy'- both very loaded terms in their own right and both beloved by politicians and the business world, even though neither even adheres to their own 'post-political' ideological explanations for the persistence of class division and social inequality. Needless to say, the *actual* reasons for the very existence of classes and class division can never be touched on.

Indeed, the graduates sometime taught as undergraduate students by para-academics face the added adversity of a handicap start in the race-to-the-bottom that is graduate employment prospects, since only those with substantial parental funds are able to take up the 'opportunity' of an unpaid internship. In the very precarious conditions of British para-academia, the fact that at least three universities have been prepared to advertise 'non-stipendiary' 'posts'—borrowing the term from Oxbridge—involving 'research' and/or teaching and admin duties (again, at a much more specialised level) brings home the choice on offer to para-academics, not unlike their former students: between Scylla and Charybdis.

There is also the problem of the 'Fortress Academy', a term I use to describe the very few number of actual 'openings' in universities for a younger generation of scholars who are all but obliged to 'have or be close to completing' a PhD, as well as 'research potential' if not a 'research record': that is, publications. There is of course very little funding for PhDs, and what little remains seems to disappear in almost perfect synchronicity with doctorates getting ever closer to becoming formally mandatory to be able to apply for the tiny number of 'permanent' faculty roles that come up. Without wanting to present the unfortunate UK Higher Education landscape as a generational problem, it is worth noting that 25-30 years ago (and certainly before then) PhDs were far from even being a 'preferred', let alone 'essential' requirement for faculty roles, hence the not insignificant number of full professors who are not doctors, though those most senior members of faculty are in many cases retiring or near to it. The societal changes wrought in the course of the second half of the twentieth century—particularly toward its end— and into the second decade of the twenty first cannot be overlooked and the fact that universities are no longer simply for a very small section of the population is something many—if not all—academics and para-academics would welcome. But no sooner has the incoming student body been broadened, and university made at least in part more available to anyone who wants it, than graduates have their education *devalued* by their own achievement, meaning education as an end in itself is also devalued, as are the academic and para-academic communities.

So why do para-academics persist with such a precarious existence in/outside the academy? It might also appear strange to some that such a community should even exist, and an answer to that observation would be the contention that the para-academic community is not an 'accepted' one by the bureaucratic and neoliberal university, even as it extracts the maximum possible from those comprising this 'secret community' in erratic hours, sometimes vast workloads and far from vast remuneration.[10] In one sense, the materially very insecure para-academic community is comprised of those who place the greatest importance on thought as an end in itself, intellectual inquiry, knowledge for its own sake and this is

reflected in their writing and research. This work has the recognition of peer-review, but is not under the pressures of the Research Excellence Framework, nor does it privilege getting 'into four-star journals'[11] in order to remain visible in the mainstream of academia and therefore risk publishing work of a very specific, mainstream nature, of interest only to the author and the other few specialists within their field. In bold contradistinction, para-academics are unlikely to be good at hoop-jumping any more than they will be likely to conscientiously follow a standardised and set path into academia in order to climb the hierarchical career ladder. Herein lies the very reason for being a para-academic. Emboldened and unterrified, para-academics escape bureaucratic and metric tyranny in/outside and—*in spite of*—the academy; the knowledge they contribute to is not confined to the university, any more than they themselves are, or could be, confined to or by it.

Notes

1 The former Minister Charles Clarke, after losing the Parliamentary seat of Norwich South at the General Election in May 2010, was appointed to two part-time academic posts in the autumn of that year: as Visiting Professor in the School of Political, Social and International Studies at the University of East Anglia in September, and as Visiting Professor of Politics and Faith in the Department of Politics, Philosophy and Religion at Lancaster University in November.

2 Quoted in Garland, Christian (2008) 'The McDonaldization of HE? Notes on the UK Experience', *Fast Capitalism* 4.1. Available online: http://www.uta.edu/huma/agger/fastcapitalism/4_1/garland.html. Last accessed 23 June 2014.

3 Savage, Michael (2010) 'Universities Face Cuts of £4bn, Leaked Memo Says.' *The Independent*, 16 October; Morris, Richard and Nigel (2010) 'Rebellion Fears as Tuition Fees Rise to £9,000.' *The Independent*. Articles retrived from Nov. http://www.independent.

co.uk/news/education/education-news/rebellion-fears-as-tuition-fees-rise-to-1639000-2124588.html. Last accessed 25 June 2014.

4 Browne, John (2010) 'Securing a Sustainable Future for Higher Education: an independent review of higher education funding & student finance'. Available online: https://www.gov.uk/government/uploads/system/uploads/attachment_data/file/31999/10-1208-securing-sustainable-higher-education-browne-report.pdf. Last accessed 25 June 2014.

5 Department for Business, Innovation & Skills (2011) 'Higher Education: Students at the Heart of the System'. Available online: http://www.bis.gov.uk//assets/biscore/higher-education/docs/h/11-944-higher-education-students-at-heart-of-system.pdf. Last accessed 25 June 2014.

6 *Ibid*, 2

7 Holmwood, John (2013) quoted at the BSA annual conference, 2013. See also, 'In defence of the Public Higher Education' http://www.ucu.org.uk/media/pdf/m/a/In_Defence_of_Public_Higher_Education.pdf. Last accessed 25 June 2014.

8 Eagleton, Terry (2010) 'The death of universities.' *The Guardian*, 17 December. Available online: http://www.theguardian.com/commentisfree/2010/dec/17/death-universities-malaise-tuition-fees. Last accessed 25 June 2014. For much on the historical background that is mentioned in this article, see Salusbury, Matthew (1989) *Thatcherism goes to College: The Conservative Assault on Higher Education.* London: Canary Press.

9 Eve, Martin Paul (2012) 'Unpaid research internships reveal a dangerous hypocrisy in academia'. *The Guardian,* 2 August. Available online: http://www.theguardian.com/higher-education-network/blog/2012/aug/02/unpaid-research-internships-academic-hypocrisy. Last accessed 25 June 2014.

10 Grove, Jack (2013) 'Academics' bin diving "caused by zero-hours contracts"'. *Times Higher Education*, 6 June. Available online: http://www.timeshighereducation.co.uk/news/academics-bin-diving-caused-by-zero-hours-contracts-ucu-says/2004381.article. Last accessed 25 June 2014.

11 'Four-star journals' are supposedly the 'best' journals, defined arbitrarily by a spurious attempt at quantifying the abstract and measuring the immeasurable: the number of citations accorded to published articles. From this unedifying task comes the childish awarding of 'stars' on a scale of one to four: something traditionally more the preserve of primary school teachers than academics. Some of the 'best' work is published in journals that are certainly 'rated' in terms of quality and peer review, but less concerned with how many 'stars' they may or may not have been awarded—the same goes of course, for the work published, as for the author's own intellectual integrity.

Christian Garland writes and publishes—broadly speaking—in the tradition of Critical Theory, the Frankfurt School kind, but has interests beyond that. Having the degrees BA Philosophy and Politics (UEA) and MA Social and Political Thought (Sussex), he will return to a PhD in September, subject to funding. He has taught—casually and on precarious terms—at the Universities of Edinburgh (formerly ECA), Warwick, Bedfordshire, and most recently at Middlesex.

A LESSON FROM WARWICK

The Provisional University

'Alas,' said the mouse. 'The world is growing closer every day. In the beginning it was so wide, that I was afraid. So I went on further and was happy when, in the distance, I saw walls to the left and to the right. But these walls race towards each other so quickly that I am already in the last room and there in the corner is the trap, into which I run.'—'You only need to change directions,' said the cat and ate her.

('Little Fable' by Franz Kafka)

Warwick University was founded in 1965. It is a satellite university, some miles outside the towns of Coventry and Warwick. The roads on campus are shiny, as are the buildings arranged in regular blocks of a similar height. The buildings are clearly marked as different research units, such as the 'International Automobile Research Centre', sponsored by the Indian automobile manufacturer, Tata. There are restaurants, hotels, supermarkets and cafes on campus. Barclays, Costa, Costcutters. But perhaps the biggest brand name is 'Warwick University'. It is written above the giant TV screen which looms over one of the main thoroughfares on the campus—beside the glass-fronted Students' Union—booming out news and sport from morning to night. It is also emblazoned on the uniforms of all the staff that work there, like workers on a Martian space station.

Like a space station all the doors are automatic. Passing into the reception I am stopped by two security guards who ask me my business. I am here for a summer school. I am directed to the special Conference Marquee set up for the summer. Here, the girl at the long counter tells me that there are twenty three conferences taking place that day. She claims it is a quiet day. Two thousand teachers will be arriving in a couple of days for a primary teachers' conference. They have conferences for everyone: Nike; Trade Unions; even Coventry Football Club, who take advantage of the state-of-the-art football pitches. Later on, I meet a man wearing a Warwick University uniform jangling a set of keys. He tells me that the conferences are all about money. He claims the organisers get paid £500 a day. Money, money, money, he says.

I was in Warwick for a Summer School at which Nigel Thrift, the Vice Chancellor, gave a keynote talk on the future of the public university. Only four weeks before, part of the Senate House, where I was checked by the security guards, was occupied by undergraduate and postgraduate students of the University. The occupiers called themselves 'Protect the Public University'. Their protest was against the growing inequality that has become so evident in the UK university system. A microcosm of society at large, this inequality is a consequence of privatisation and marketisation, the insertion of the university into a global competition for resources and investment and the withdrawal of the state as the guardian of public goods, such as education.

Nigel Thrift began his talk: 'In order to understand what the future holds we must first understand and recognise where we are beginning from. We are beginning from a situation in which there is no money. I cannot emphasise this fact enough: there is no money, no money, no money'. Three times for clarity. From this fact he proceeded to put forward certain prognoses. First, that competition for scarce resources is a reality that the university must adapt itself too. This involves developing in order to become more attractive to top students, funding and investment. Second, that privatisation in some form or another is a reality which cannot be ignored. Universities cannot rely on public funding, which means that they must generate other forms of investment in order to maintain high

research and teaching standards. Finally, the globalisation of the university is a reality that will require opening up to markets abroad, attracting an ever-expanding population of potential students and researchers who wish to gain a high-quality education and entry into the job market.

To begin with the 'fact' of scarce resources is to allow arguments such as Nigel Thrift's to occupy the ground of 'the no alternative'. His arguments are presented as pragmatic and realistic. Nearly all of the questions and comments which came afterwards consented to this pragmatism. The one question which raised the possibility of opposition, alluding to the occupation, was dismissed with the same calculating voice of reason: the protestors were only 'a small minority'. They did not represent the larger student body. As if to convince himself, and us, Thrift kept repeating the phrase: 'The fact of the matter is....'. It is a mantra; it obscures the political nature of decisions and policies that entrench inequalities and exclusion. It closes down the possibility for disagreement or debate by turning everything into an economic question: how to efficiently manage scarce resources. This justifies further privatisation. It justifies an increase in fees for students. It justifies pay rises for Vice Chancellors. These are the decisions that have thus far enabled Warwick University to climb the League Tables and become one of the most competitive and successful universities in the UK. They are also the decisions that have made it a dystopian vision of the future.

The future of the university heads off down this narrow path, like the mouse in the fable, because we begin with an apparent shortage of money. But there is money everywhere. We can begin with the money spent on my two-day participation at a Summer School. My flight and accommodation were paid for. As a participant in the conference I was brought out to dinner both nights. The first evening was to a French restaurant, where all the delegates enjoyed a three-course meal. The second was to one of the two hotels on Warwick University Campus, a development designed to cater for visiting academics and, presumably, the large amount of conference attendees. The restaurant was empty except for us. The table was enormous, something like a comical banquet. The desserts arrived on a trolley.

But I wasn't paid a wage and my expenses were small. The occupation of the Senate House in Warwick University was triggered by a salary rise of £42,000 for Nigel Thrift, the Vice Chancellor. This raise brought his salary to £316,000. This is not so different to the salaries of the Provosts and Presidents and Vice Chancellors of major universities around the world. In the case of Warwick, Thrift's salary is twenty-two times the wage of the lowest-paid employee in the University—such as the janitor who I met opening the doors for the conferences, and who saw clearer than Nigel Thrift that money was everywhere, just not for him. In this way the janitor has something in common with the students who pay £9,000 a year in tuition fees, leaving them with crushing debts in a job market that doesn't exist.

Nigel Thrift is not the only person in a position of power who assumes that we live in a time of austerity. Yet as cuts and tax rises increase we see plenty of evidence to suggest there is more monetary wealth today than ever. It is evident in the astronomic amounts of public money transferred to private banks and bondholders and the record quarterly profits reported by multinational corporations that skirt around national tax regimes like they don't even exist. Perhaps even more tangible are the vacant plots and buildings that populate cities even as the level of homelessness rises. The problem, as always, is not scarcity but the distribution of wealth, a question of access. If we begin from this abundance, and the recognition that it belongs to everyone, then we open up a very different horizon of possibilities.

While Nigel Thrift's vision was determined in one sense by an acceptance of scarce resources, it was also determined by an assumption that you need lots of money to have a university. Money to build facilities for conferences and hotels for conference attendees. Money to build world-class sports facilities to attract foreign students. Money to invest in cutting-edge bio-technological research. In that familiar and revealing rhetoric, the university was described as both an essential part of economic growth and as the preserve of independent research. But the university is neither of these things. First and foremost, the university is defined by the activity of the student. And this activity is driven by a desire to discover things,

to question and understand. In this sense it is not the preserve of the university. We learn from others and by reading books, but we don't just acquire knowledge as though it were a commodity to consume. The student always performs his or her own capacity for reasoning. They connect one text or experience with others, thereby using their own intelligence. This is the basis of intellectual life, of critical thinking, and it can occur anywhere at anytime. You don't need money to think. You need money to get a certificate to get a job. All that the university institution has (and it is a lot) is a monopoly on what counts as knowledge and education and what doesn't.

The current organisation of the university is excluding the very subjectivity, the very desire, on which it relies. It is becoming, in the words of Patrick Pearse, a murder-machine. If we consider the university today, enveloped by institutional torpor and hierarchy, competition and assessment, then it is hard to see where this figure of the student might be found. Despite the shiny appearance of a university like Warwick, the experience of being in the university today is not one of desire and optimism. Not for the student working under the pressure of a large debt and the need to ensure a job, or the postgraduate researcher competing for limited positions, forced to publish and apply for rounds and rounds of funding streams, or the lecturer who is faced with students 'paying' for a 'service' and the pressures to publish in departments with limited budgets for genuinely critical research.

A different place to start thinking about the future of the university might then be to get beyond 'defending or adapting' the institution to current 'realities', and instead focus on those places and people where critical thinking and learning is taking place, where questions are being asked by people who want to get beyond the narratives and explanations given by so-called 'experts' and 'analysts'. There are important struggles to be fought within and against the university institution, but it is important that we recognize that these struggles, as well as those beyond the university, are processes of learning and transformation in themselves. If things are to change, new categories and visions must be created. These can only emerge through a process of thought in motion—people

asking questions and trying to figure them out collectively. Through this process new knowledge is produced, but more importantly new agents of knowledge are produced—people who can think for themselves. This is the university we should be defending.

The Provisional University is a collective that has been together, in different forms, for about four years. We have been doing research for the past year on contemporary forms of enclosure in the city (high costs of rent, policing of public space, commercialisation of social and cultural life) in Dublin and new forms of the commons which have emerged in response (collectively-run DIY spaces). We present this research in different forms—blog, public talks and discussions, and texts which we try and circulate. It is all a bit of an experiment and something we have been working out along the way.

> You can find out more about us at the blog:
> http://provisionaluniversity.wordpress.com/about-2/

As a collective the things we publish or present are not individual— we think that is important. This is very different, for example, to the ways in which we are forced to compete with one another for places in the university, channeling all our energies into improving our CVs. All knowledge is social and collective and we have experienced this very clearly in the way our ideas and work emerge not just in specific times and places but often through everyday conversation, shared experience etc.

BEYOND THE DEFENCE OF THE PUBLIC UNIVERSITY

Kelvin Mason & Mark Purcell

INTRODUCTION

In 2012 the Participatory Geography Research Group (PyGyRG) of the Royal Geographical Society (RGS) agreed on the 'communifesto for fuller geographies'.[1] This was at once a statement of the group's militant particularism[2] and an expression of solidarity with others opposing the neoliberalisation of academia. PyGyRG then shared the communifesto with a wider community of geographers, inviting critique and contributions to a project intended to always be a work in progress. In this chapter we summarise the communifesto and one particularly pertinent critical response, 'Schools of our Own' by Mark Purcell,[3] which argued for building educational associations of our own, beyond the public university. In this, Purcell developed Aristotle's notion of *schole*, a lifelong project to develop our human potential. We then analyse the interaction of these texts before offering some examples of related practice. Finally, with para-academics at the forefront of our thought, we reassess the ideas developed in the communifesto and 'Schools of our Own' in the light of our examples, drawing out lessons for creating autonomous educational spaces of mutual-aid, creativity and transition.

THE COMMUNIFESTO FOR FULLER GEOGRAPHIES: SOLIDARITY AND DEFENCE OF THE SELF

> *What we believe is that each of us can act to bring about at least a little of what we hope for: warm-blooded, positive, generous and imaginative acts which both support each other and our other others.*[4]

A 'participatory communiqué', the communifesto for fuller geographies, was initiated by a call for participation which focused on the impact of global neoliberalisation and its 'increasingly uneven geographies: economic and environmental "crises", poverty, social inequality, and disconnection between dominant political (and geopolitical) discourses and everyday lived lives'. Specifically on academia, the call ran:

> Through both our research and teaching, participatory geographers remain committed to working with communities and students in the co-construction of agencies and knowledges that can respond to these issues. Yet, this is also a time when we see academic jobs disappearing, an increase in precarious forms of academic employment, and artificially separated career tracts based on research or teaching-only positions. Collegiate and socially engaged modes of working remain undervalued.[5]

In response to the call, a group of academics and activists, by no means all geographers, met in an RGS conference session in Edinburgh and formulated a set of strategies and tactics which was later elaborated and ratified by PyGyRG. The aim of the communifesto is to serve as guidelines that academics can use in creative resistance and constructive (re)engagement to contest personal and disciplinary insecurities. At the heart of the strategy is resisting divisive individualisation, developing mutual-aid, and so building the 'communiversity' as a two way flow between the university and community,[6] a space too in which an ethics of care and respect can be fostered.[7] Also key to the communifesto is

resisting the dominant culture of exchange value and monetisation and reconsidering how education and research ought to be valued.[8] It proposes that the onslaught of neoliberalisation can be 'an opportunity to build solidarity, finding common ground with colleagues and others within and beyond the university who share our struggle, frustration and insecurities'.

Paraphrasing somewhat, the communifesto's tactics include:

- Sharing an open-source list of strategies and tactics for subverting neoliberalisation;
- Developing alternative, non-market metrics for valuing research and teaching;
- Sending colleagues, particularly those in management, examples of good participatory academic work to legitimate such approaches as an alternative to current neoliberal trajectories;
- Examining university charters to reclaim foundational values, which are often altruistic and inclusive, and using them to hold management accountable;
- Creating or supporting forums for colleagues who experience trauma in their dealings with universities,[9] as well as challenging false forums that govern the conduct of conducts rather than empower;
- Sharing the lived experiences of working in the neoliberal university with each other, and making this experience public knowledge;
- Developing links with organisations and initiatives which have similar visions, including unions, community organisations and social movements.

PyGyRG's militant particularism is space-relational: the politics of a community united by its commitment to an ethics of participation and entangled in academia, a dominant (global) industry. For PyGyRG, 'militant' denotes challenging a system that reproduces myriad inequalities, being vigorously active in pursuit of mutual-aid, and building

the communiversity. Moreover, the group's militant particularism is consciously and critically constructed with the idea that it will encounter and interact with those of others in the formation of a global movement.[10] PyGyRG's militant particularism is always already engaged and outward-looking, widely and intimately linked to activist and public geographies and so geared to meaningful social change.

The communifesto intends to actively counter any perception of PyGyRG as naive, Eurocentric or isolated from existing struggles.[11] Working with (often marginalised) communities and groups underlies PyGyRG's appreciation of the relatively privileged position of most academics. Co-production, which attracts increasing interest in academia, is central to the ethos of participatory geographies. It involves research and teaching *with* communities beyond academia and implies thinking creatively about the spaces, places and practices of collective knowledge-making and sharing. That said, critical scholars must remain wary of the incorporation of the co-production ethic into the norms of neoliberalism. For example, the term is also used to signify the co-production of exchange value with commercial partners. PyGyRG take seriously concerns about individuals becoming part of what we resist and, indeed, benefitting from the process.[12]

PyGyRG's militant particularism is not only passionate but emotionally engaged on the level of everyday academic practice. Neoliberalism, as with prior dominant regimes to a large extent, views emotions as anathema to academic processes and practices.[13] PyGyRG argue that making space and time for emotions and subjectivity in all aspects of academic work is vital for creativity and critical to the remaking of academia as the communiversity. In this, the group is exploring productive tensions between commitments to social justice and an ethics of care which begins with the self, extends to the wider political community, and reaches to the global scale.[14] Most notably, an ethics of care is wary of the universal 'rules' that underpin most conceptions of justice. Instead, it prefers to make space for the 'compelling moral claim of the particular other'.[15]

SCHOOLS OF OUR OWN: A REVOLUTIONARY PROJECT

In the publication of the symposium on the communifesto for fuller geographies in the journal *Antipode*, Mark Purcell suggested that as we confront the challenge that neoliberalism poses to higher education, we might want to ask whether we should be *defending* the public university against neoliberal privatisation: what is it exactly about the public university that we want to preserve? Certainly it is true that in our present society a university degree is an important key to good employment and material wealth, and we want that key to be as widely accessible as possible. It is also true that in our present society the public university (understood to mean a university funded and managed by the state) helps socialise the cost of higher education and therefore helps keep education affordable for all. This affordability is clearly important: we have seen over the past decade that what happens when the state retreats from funding is that tuition rises sharply, and students must bear the increasingly high cost of education themselves. Those without significant financial resources (which is most students) will be forced to go into significant debt to get their degrees. This emerging state of affairs is corrosive to both higher education and society more broadly.

But, at the same time, we want to propose that there are very real limits to thinking about the university and education only in these terms. When we conceive of the struggle over the university only as a struggle to defend the public university as it used to be before neoliberalisation, as a state-funded and state-managed institution, we assume some givens about society that we shouldn't assume. We implicitly *accept* a system in which state-controlled universities stamp individuals with an imprimatur so that they can be successful in the capitalist economy. Certainly it is better when that imprimatur is available to all rather than only a few, but we should not accept this reduction of education to an activity that merely prepares people to (possibly) succeed in a capitalist economy, an economy that relentlessly intensifies inequality, competition and exploitation, one that alienates people from their labour and from each other. This vision of education is setting the bar far too low. We should

imagine much more for the university. We should conceive of university education, at least in the long run, as something through which we *abandon* capitalism, not re-inscribe it.

So what would that mean? How could we imagine education in this way? We think a good place to begin is Aristotle's concept of *schole* as found in *The Politics*. For Aristotle, *schole* is the lifelong struggle to develop our human potential, to hone our particular excellence as a species. He thought this species-excellence has many aspects, including philosophical knowledge, practical wisdom, physical skills, and social intelligence. He says that people cannot realise this potential on their own; rather they must develop their potential in fellowship with others. The good city, for Aristotle, is a place that helps citizens[16] realise their human excellence.[17] They do so by participating fully and effectively in the affairs of the *polis,* by coming together to make decisions that concern the community. In order to participate effectively, Aristotle argues, citizens need *time to practice* public affairs, to develop their ability to interact with their fellows and to make good collective decisions. *Schole* is precisely this *time to practice*. Though it is typically translated as 'leisure' in English versions of *The Politics*, Aristotle is clear that *schole* is nothing of the sort: it should be used by citizens to engage in the serious effort of political action, which for Aristotle is how citizens can best develop their human excellence.[18]

However, even though Aristotle's vision is explicitly political, it is nevertheless limited as a political model we can follow today. That is because he thought *schole* was a project that only a few could engage in. For Aristotle, the 'citizens' who do *schole* were only those men of wealth who could devote themselves to *schole* because they had others (women, slaves, children) to do the many non-*schole* tasks necessary for survival. So for us today, in order to make *schole* come alive politically, we argue that it is necessary to saturate Aristotle's concept with Marx. That is because Marx insists on a community to come in which everyone participates fully in the life of the community. Aristotle's notion of *schole* resonates greatly with Marx's arguments in the *Grundrisse* about what he calls 'really free working'.[19] Also sometimes rendered as 'free spontaneous activity',[20] really

free working is an intense effort that people undertake both to *understand* the conditions of their own existence and to *reappropriate* control over those conditions. This act of understanding-and-reappropriating requires that people become active, that they take up the formidable project of managing their labour, and their lives, for themselves. Free activity is *schole* in the sense that people take up the responsibility of engaging actively in political affairs, but in Marx's vision those political affairs are understood explicitly to be shaped by class struggle in a capitalist political economy. Jacques Rancière, in *The Nights of Labor*, provides an excellent example of what Marx is talking about. He tells the story of workers in mid-nineteenth century Paris who in their off hours gathered together to read, discuss, learn, play, commune and develop their human potential.[21] Through their activity they began to construct an analysis and shared understanding of their political and economic situation as workers under capitalism. And, importantly, they developed this understanding on their own terms, in their off hours, *outside* the context of wage labour in the factory.

So, we argue it is possible to begin with Aristotle's concept of *schole* but then to, in a sense, stain *schole* with Marx's free activity and Rancière's Parisian workers. When we stain it in this way, *schole* becomes not just a general project of developing our human potential, but a *revolutionary* project of developing our full humanity, beyond a capitalist political-economy that reduces value to exchange value, human relations to competition, and human beings to workers and consumers.[22] Such a project would understand education, very broadly, as the general effort to make room for and engage in *schole* as free activity.

If we were to understand education in this way, what role would the university play? *Schole* is necessarily a lifelong project, and so we cannot expect students to complete it in their brief time at university. The most we can expect of the university as an institution, we think, is to offer its students a sort of kick-start. It can be an opportunity for students to practice *schole* intensely, to devote their time to *schole*, rather than fit it in during the scant 'free time' the capitalist economy affords. Understood this way, the university becomes a place where we are surrounded by

others also devoted to *schole*, where we train each other to become better scholars.[23] It is a chance to practice techniques (poetry, critical thinking, logic, rhetoric, philology etc.) and develop habits that are essential for *schole*.

In this vision, universities are important to preserve only if they effectively provide this kick-start for *schole*. The point is never the university itself, not the structure of the institution, nor the degrees it offers, nor whether or not it is managed by the state. The point is always the active, difficult and joyous project of *schole*. We only need the university if it is useful for *schole*. We should always remind ourselves that preserving the university as a state-funded institution is not the goal. Even the 'good old' public university, if it ever existed, the one where state support drawn from fair taxation ensured the academy was accessible to everyone – even that university was only worth preserving if it effectively encouraged students to practice *schole*. Did it stoke students' lifelong revolutionary project? If we are honest, we would probably admit that it did not, at least not very well. Such a university, no matter how preferable it is to the emerging neoliberal one, has always been far more likely to train students to be good workers, or loyal citizens, or State officials, than to nurture a revolutionary *schole*.

In the long term, then, we probably shouldn't place too much importance on defending the public university. Ultimately, we need to figure out a way to do *schole* on our own, without State institutions, without corporations, without large foundations.[24] Schole is a struggle to increasingly manage our own affairs for ourselves. It is best done, as the workers in *The Nights of Labor* did it, by creating on our own encounters in which we work together to nurture, celebrate and augment each other's *schole*. We might find it useful to create autonomous associations of mutual aid and solidarity to support those encounters. We could call these associations 'schools'. They would be associations we manage ourselves, in which we strive together to develop our *schole*. It is such schools of our own—*not* the public university—that should be our long-term vision.

SCHOLE AND FULLER GEOGRAPHIES

PyGyRG embraced Purcell's reconceptualisation of *schole* as 'a way forward that is both grounded and inspiring'.[25] *Schole* meshed with PyGyRG's evocation of joy and hope as everyday, embodied activist virtues.[26] PyGyRG understand hope as 'an act of defiance, or rather as a the foundation for an ongoing series of acts of defiance, those acts necessary to bring about some of what we hope for while we live by principle in the meantime'.[27] Ultimately, the task is not to better public universities, but to end them, as Engel-Di Mauro underscores:

> In a capitalist context, universities simply cannot be expected to become socially just. They are institutions of (negative forms of) power, where intellectual hierarchies and worldviews are forged and diffused (sometimes even by force) to maintain or intensify, as well as legitimise, the rule and control by the few. If one finds this to be a correct interpretation of the university, the struggle should then not be focused on the university, but on much wider social relations. Education, as a way of producing knowledge and as part of social reproduction, is a social, not a particular institutional process.[28]

Though they may be intensely difficult to differentiate between and disentangle in practice, keeping *schole* in mind allows us to defend against neoliberalisation only those aspects of the public university that contribute to the transformation of knowledge making and sharing. PyGyRG suggested 'degrowth'[29] as a source of further intellectual and tactical engagement, focusing particularly on the social movement's emphasis on environmental sustainability, diverse local economies and new forms of democratic institution. Through seemingly small and playful actions, meanwhile, such as introducing the ethos and technologies of consensus decision-making,[30] we can sow the seeds of *schole* in the cracks of existing institutions. We suggest that what PyGyRG's militant particularism brings to the revolutionary project of *schole* is a normative

and strategic imperative to develop emotional faculties as well as rational ones, i.e. the ability to feel as well as to think, because that 'is key to going beyond a capitalist political economy, humanely and equitably'.[31] In other words, *schole* must enfold its revolutionary project, its politics of education and pursuit of justice, within a feminist ethics of care that begins with caring for the self and extends relationally in space, time and materiality[32]. *Schole* thus becomes both a time and space in which to practice the politics of collective self-determination.

DOING *SCHOLE*

We turn now to some examples of praxis which both illustrate and further interrogate our conception of *schole*. We first consider the 'Transitions Reading Group' set up in Aberystwyth in Wales in 2008.[33] The group brings students and academics from the university together with citizens and activists from the town and district. It began as one element—a working group—of a Transition Town project, a community venture which sought to build local resilience in the face of the perceived threats of climate change and peak oil.[34] Dependent on the extramural enthusiasm and efforts of a handful of members, the Transitions Reading Group remains active after the wider project has run out of energy [sic].[35] Early in its existence the group pluralised 'transition' to indicate an intention to read beyond the Transition Towns literature. Indeed, one of the early readings chosen by the group was 'The Rocky Road to a Real Transition', a critique arguing the political naivety of the Transition Town movement.[36] Since then, the group has read and discussed both academic and activist work which spans the eclectic range of topics that the term 'transitions' opens up. However, it retains a core interest in transitions to a more environmentally sustainable and just society.

Central to the group's discussions too has always been exchanging relevant personal experiences and relating readings to local socio-economic and political conditions. The group does not confine itself to written material and listens to podcasts, watches films, views art

exhibitions and attends theatre performances. It meets in cafes, barrooms, and public spaces in the university complex. In 2010 and 2011 members of the group actively supported occupations and teach-ins by students opposing hikes in tuition fees and cuts in higher education budgets. Future activities may involve reading fiction, listening to and discussing music, art and poetry, as well as inviting authors and artists to discuss their work. In many ways, the group resembles the kind of autonomous, mutual-aid school that Purcell imagines.

Recently, some members raised the question of citing participation in the group on CVs and job applications. The potential tension is between trading on the reading group for personal benefit and, on the other hand, bringing an example of doing *schole* to the attention of others. As the neoliberal metrics of higher education in the UK are unable to measure the value of such participation, thereby negating the possibility of personal benefit, group members judge that the scales tip in favour of disseminating *schole*:

'I don't see any negatives to it. Neither from the reaction of others, nor in the sense of 'using' the reading group tactically for personal career advancement... It is another way of promoting the group and the issues it raises, and bridging academic/activist divides and so on. But I haven't had anyone comment on it particularly in job applications' (group member).

Our second example concerns a form of direct action called 'the academic seminar blockade'. To date, there have been at least four instances of academic seminars doubling as direct actions in public space. In 2007, as part of Faslane 365, a year-long, campaign against the UK's Trident nuclear missile system and its replacement, a network of academics concerned with nuclear weapons proliferation from a range of perspectives twice staged seminars as blockades of the main gate of Faslane Naval Base in Scotland, home of the submarine fleet which carries Trident missiles.[37] Again in 2012, in response to a call for participation made via various academic and activist mailing lists, a seminar action was staged at the main gate of the base in support of the adjacent peace camp, which has existed for 30 years.[38] Thematically, temporally and geographically the seminar action was 'informally' linked to the RGS

Annual International Conference which took place in Edinburgh in the days preceding the action. The theme of the RGS Conference was the 'Security of Geography/Geography of Security,' which presented the perfect opportunity for the organisers of the seminar action to present it in a conference session entitled 'Civic Geographies: Securing Geography in Everyday Life.'[39]

In the seminar action, academics presented their papers alongside empirical and normative presentations by peace camp activists and supporters. For tactical and ontological reasons that emerged during its course, the seminar action was not staged as a blockade but rather subverted the expected protest performance by incorporating the police guarding the base into the seminar, inviting them to listen and participate. No longer were protesters surrounded, instead the police 'were welcomed into *our* circle.'[40]

'This has reminded me of how struck I was by the difference in feeling between giving my paper in a university room in Edinburgh the day before, and giving it in such proximity to those whose livelihoods depend on working to continually reproduce Trident and all of its supporting assemblages/infrastructure/power dynamics' (participant).

At the COP15 in 2009, taking all aspects of climate change as its theme, a multidisciplinary and international seminar blockaded a coal-fired power station in Copenhagen as part of a series of simultaneous actions coordinated through the Climate Justice Action network.[41] As well as being an effective action in its initial space-time, the papers given in and around the seminar blockade resulted in a special issue of the critical geographic journal *ACME*. Such actions, we suggest, embody the revolutionary project of *schole*, putting critique into practice with others, which, in turn, contributes to critique.

Though based on a specific case, our third example is presented in general terms for reasons of confidentiality. We believe it is indicative of similar actions taking place throughout academia. When staff are employed on short-term contracts, it is all too easy for academics in a department not to really register their arrival, terms and conditions, contribution, and then departure. Most of us have done it—hardly had

the time to look up from our own workload to record that a colleague has already come and gone. Instead we might commit ourselves to care as hospitality, which can then lead to solidarity. We ought to welcome newcomers, understand their workloads and any injustices they face, and help mobilise appropriate personal and professional support. We can collectively challenge unfeasible workloads, foster open discussion, and advocate for temporary staff to have as much say as possible in departmental decision-making. There may be more opportunities for such actions than we imagine: an over-worked head of department might be quite open to more shared responsibility and so 'allow' almost imperceptible subversions of the university's closed and hierarchical structure of decision-making.

Permanent staff can help those employed on successive temporary contracts by lobbying for the creation of a permanent position. In some cases, staff who take the time to become informed discover that the reasons given by Human Resources departments to defend exploitive practices can be successfully challenged. Staff can also work with the relevant union. Also vital to solidarity is to keep exploited and precariously positioned staff 'in the loop.' It is important to recognise that a major source of anxiety and stress for such staff is a lack of knowledge due to poor communication, and permanent staff must make a particular effort to ensure that temporary staff have all the information they are entitled to. Rejecting the valorisation of abstract reasoning in moral theory, Held writes: 'The ethics of care respects rather than removes itself from the claims of particular others with whom we share actual relationships'.[42]

CONCLUSION: DEVELOPING *SCHOLE* AND BUILDING OUR SCHOOLS

For us, what the Transitions Reading Group example illustrates most is what it might be like to go beyond defending the public university and instead begin to build schools of our own. Often we can be absorbed by the act of resistance, and it can take all our time and energy. But we argue

that it is vital to also explore what positive alternatives we might create, what spaces and opportunities there might be to build schools of our own. We must remember to physically experience 'some of what we hope for', to participate in schools, to tinker with concrete utopias, to catch sight, scent, taste, sound, and feel of alternative futures. It is inspiring, energising and empowering. The Transitions Reading Group is also an illustration of the distinction between the generative and creative 'work', of shared enquiry and knowledge-making, and the draining 'labour' that increasingly defines waged employment in universities. While there is no material or status benefit for academics who participate in building such schools, nevertheless such activities do pass beneath the radar of neoliberal academia, helping revolutionary thought and action to grow and spread. Inventing and developing our schools depends on establishing relational solidarities among similar projects.

Academic seminar blockades and similar actions in public space are an embodiment of the communifesto's strategic aim of finding common ground with others beyond the university who share our struggles and insecurities. However, it is often difficult to pursue such projects inside the current university structure. Many, perhaps most, universities consider participation in public spaces of protest on issues like peace, justice, and environmental sustainability to be 'political' and so inappropriate. Nevertheless, we suggest that opportunities do exist to be paid for our labour even while we do our work. The 2012 seminar action at Faslane was constructed to make a mildly subversive strategic link between activists and a mainstream academic institution which, like most, appears frightened by the prospect of being tainted by 'radical politics', i.e. any vision of society that is different from the status quo. Tactically, it was important to closely link the seminar action with the timing and location of the RGS conference so that academic geographers were more able to participate. Meanwhile, developing the 2009 seminar blockade in Copenhagen into a special issue of an academic journal helps widen a crack in mainstream academia wherein *schole* can grow and come to be practiced in plain view. As Kenrick and Vinthagen observe:

If you want to defend community and celebration, you have a feast on the road, eat, dance and celebrate life – while blockading. If you want to defend academic enquiry and critical reflection, you have an academic seminar in the road...*Our hope is that this new form of academic exercise will become part of the academic repertoire and help create a University movement of creatively and politically engaged academics.*[43]

Our third case study is perhaps not as clear an example of *schole* as the others. It does, however, demand that we interrogate our conception of *schole*. Even if we want ultimately to move beyond the public university, temporary staff are currently involved in real struggles for dignity, respect, and employment security in the university. An ethics of care helps guide how we might support that struggle in the short term. We must work together to ensure that para-academics have a chance to earn a decent living doing the work they love. We must ask ourselves what warm-blooded, positive, generous and imaginative acts we can undertake today to support para-academics. But *schole* also asks for more, to think in terms of a longer horizon. It urges us *not* to accept stable employment in a public university as the end goal. That is not yet a revolutionary educational project. We must be careful not to merely expand the floor of our cage within capitalist political economy. And so we must pay attention to and learn from the micro-tactics of everyday struggles: we must develop militant particularisms in place as well as spatially. We think it is the caring relationship developed between the relatively securely employed academics and the precariously employed para-academics that is key here. It is a way we can build spaces of mutual aid, creativity and, ultimately, transition to a collective educational project beyond the public university. When we become emotionally engaged with others, we begin to collectively understand the conditions of our mutual existence and so can begin to re-appropriate control over those conditions.

From the perspective of the project to move beyond the contemporary public university, para-academics are not just vulnerable victims of oppression and exclusion from the ideal of stable employment in

the public university. They are much more importantly a reserve of potential power, a source of hope. They are not fully incorporated into the public university, and so they are in a position to know most fully what schools of our own might mean. In the long term, then, we might see para-academics not so much as a problem population that needs to be integrated into the ideal world of the public university, but as a kind of vanguard, a population of people in-between that are in the best position to do *schole* on their own, in association with academics, with other para-academics, and with non-academics. They are the people, it seems to us, who are most likely to be already building schools of our own.

Acknowledgements

As well as PyGyRG and those critical geographers who responded to the communifesto for fuller geographies, we would like to thank Jenny Pickerill, Carl Death, Sam Saville, Katherine Philips and Kye Askins for their contributions to this chapter.

Notes

1 PyGyRG (2012a) 'communifesto for fuller geographies', *Participatory Geographies Research Group*. Available at http://www.pygyrg.co.uk/ the-communifesto-for-fuller-geographies-towards-mutual-security/ http://pygyrg.org/pygyrg/communifesto-for-fuller-geographies/ Last accessed 12 August 2013.

2 See for example Williams, Raymond (1989) *Resources of Hope*. London: Verso and Harvey, David (1996) *Justice, Nature and the Geography of Difference*. London: Wiley.

3 Purcell, Mark (2013) 'Schools of Our Own', *Antipode*. Available at http://radicalantipode.files.wordpress.com/2012/10/purcell-response. pdf. Last accessed 12 August 2013.

4 PyGyRG (2012b) 'Connectivity, Creativity, Hope, and Fuller Subjectivities: Appreciating the Responses to the Communifesto for Fuller Geographies'. Participatory Geographies Research Group, *Antipode*. Available at http://radicalantipode.files.wordpress.com/2012/12/pygyrg-reply.pdf (Last accessed 12 August 2013.

5 PyGyRG (2012a) 'communifesto for fuller geographies'.

6 mrs kinpaisby (2008) 'Taking stock of participatory geographies: Envisioning the communiversity', *Transactions of the Institute of British Geographers* 33(3), 292-299.

7 Held, Virginia (2006) *The Ethics of Care: Personal, Political, and Global*. Oxford: OUP.

8 Sandel, Michael (2013) *What Money Can't Buy: The Moral Limits to Markets*. London: Allen Lane.

9 Moss, Pamela (2013) 'Taking Stock in the Interim: The Stuck, the Tired, and the Exhausted', *Antipode*. Available at http://radicalantipode.files.wordpress. com/2012/10/moss-response.pdf. Last accessed 21 October 2013.

10 Routledge, Paul (2003) 'Convergence space: Process geographies and grassroots globalization networks', *Transactions of the Institute of British Geographers* 28(1): 333-349; Harvey, David (1996) *Justice, Nature and*

the Geography of Difference; Featherstone, Dave (1998) 'Some Versions of Militant Particularism: A Review Article of David Harvey's Justice, Nature and the Geography of Difference', *Antipode* 30(1), 19–25 and Mason, Kelvin (2013) 'Academics and social movements: Knowing our place, making our space', *ACME* 12(1), 23-43.

11 Engel-Di Mauro, Salvatore (2013) 'Towards Much Fuller, More Politically Engaged Geographies'. *Antipode*. Available at http://radicalantipode.files. wordpress.com/2012/10/engel-di-mauro-response1.pdf. Last accessed 12 August 2013.

12 Kindon, Sara (2013) 'Responses to a Communifesto', *Antipode*. Available at http://radicalantipode.files.wordpress.com/2012/10/kindon-response. pdf. Last accessed 12 August 2013.

13 Askins, Kye (2009) "That's just what I do': Placing emotion in academic activism', *Emotion, Space and Society,* 2: 4-13.

14 MacGregor, Sherilyn (2006) *Beyond Mothering Earth: Ecological Citizenship and the Politics of Care*. Vancouver: University of British Columbia Press; Held, *The Ethics of Care*.

15 Held, *The Ethics of Care*, 11.

16 Who are only a small subset of the population, as we discuss below.

17 For Aristotle the good city is very much *not* measured in terms of economic growth.

18 Aristotle (1998) *Politics*. Translated by C. Reeve. Indianapolis: Hackett, Bk II, Ch. 11; Bk. III, Ch. 9; Bk. IV, Ch. 4; Bk. VII, Ch 9.

19 Marx, Karl (1993 [1939]) *Grundrisse: Foundations of the Critique of Political Economy*. New York: Penguin Classics. In Notebook VI, in the Section on 'Adam Smith: work as sacrifice.' See also Merrifield, Andy (2011) *Magical Marxism: Subversive Politics and the Imagination*. London: Pluto Press, esp. 155-157.

20 In the *Economic and Philosophic Manuscripts*, see Marx, Karl (1994 [1932]) *Selected Writings*. Edited by L. Simon. Indianapolis: Hackett, 64.

21 Rancière, Jacques (1991) *The Nights Of Labor: The Workers' Dream in Nineteenth Century France*. Philadelphia: Temple University Press.

22 Engels, Friedrich (1996 [1845]) 'The Great Towns' in LeGates, R. and Stout, F. (eds) *The City Reader*. New York: Routledge, 46-55, 47-48.

23 Of course, 'scholar' just means someone devoted to *schole*.

24 More generally, we need desperately to decouple the idea of 'public' from that of the 'state', and we need to figure out together what it means to be a public without a state.

25 PyGyRG, 'Connectivity, Creativity, Hope, and Fuller Subjectivities: Appreciating the Responses to the Communifesto for Fuller Geographies'.

26 Zournazi, Mary and Hage, Ghassan (2002) "On the side of life': Joy and the capacity of being—a conversation with Ghassan Hage' in Zournazi, Mary (ed) *Hope: New Philosophies for Change*, London: Routledge, 150-171.

27 Solnit, Rebecca (2005) *Hope in the Dark: The Untold History of People Power*. Edinburgh: Canongate,123.

28 Engel-Di Mauro, 'Towards Much Fuller, More Politically Engaged Geographies'.

29 Demaria, Federico et al (2013) 'What is degrowth? From an activist slogan to a social movement', *Environmental Values*, 2, 191-215.

30 See for example Trapese Collective (2007) *Do it yourself; A handbook for changing our world*. London: Pluto Press.

31 PyGyRG (2012a) 'communifesto for fuller geographies'.

32 Held, *The Ethics of Care*.

33 http://abertransitionreadinggroup.wordpress.com/.

34 Hopkins, Rob (2008) *The Transition Handbook: From Oil Dependency to Local Resilience*. Totnes: Green Books.

35 Mason, Kelvin and Whitehead, Mark (2012) 'Transition Urbanism and the Contested Politics of Ethical Place Making', *Antipode* 44(2): 493-516.

36 Trapese Collective (2008) 'The Rocky Road to a Real Transition'. Available at http://trapese.clearerchannel.org/resources/rocky-road-a5-web.pdf Last accessed 12 August 2013.

37 Vinthagen, Stellan et al (2012) *Tackling Trident: Academics in action through academic conference blockades*. Sweden: Irene Publishing.

38 Mason, Kelvin and Askins, Kye (2012) "'Us and Us": Faslane 30 and academic direct action', *Medicine, Conflict and Survival* 28(4): 282-288.

39 Mason and Whitehead, 'Transition Urbanism and the Contested Politics of Ethical Place Making'.

40 Mason, Kelvin and Askins, Kye "Us and Us': Faslane 30 and academic direct action', 286.

41 Mason, 'Academics and social movements: Knowing our place, making our space'.

42 Held, *The Ethics of Care*, 11.

43 Kenrick, Justin and Vinthagen, Stellan (2012) 'Critique in action – Academic Conference Blockades' in S. Vinthagen, J. Kenrick and K. Mason (eds.) *Tackling Trident: Academics in action through academic conference blockades*. Sweden: Irene Publishing

Mark Purcell is a Professor in the Department of Urban Design and Planning at the University of Washington where he studies urban politics, political theory, social movements, and democracy. He is the author of *Recapturing Democracy* (2008), *The Down-Deep Delight of Democracy* (2013), and numerous articles in journals including *International Journal of Urban and Regional Research, Urban Geography, Environment and Planning A, Antipode, Urban Studies, Political Geography, Review of International Political Economy* and *Planning Theory*.

His blog is: http://pathtothepossible.wordpress.com/

Kelvin Mason is a human geographer and activist. His research interests include activism, Wales, the environment and justice, particularly in the context of climate change. He is engaged in transformative social movements, edits the Wales page of *Peace News*, contributes to *Red Pepper, Planet* and other radical magazines, and is active in the Participatory Geographies Research Group (of the Institute of British Geographers), particularly via the 'fuller geographies' project. He lives in and is committed to Aberystwyth in West Wales but (in early 2014) is unable to find paid employment locally.

DECENTRING KNOWLEDGE PRODUCTION

Laura Sterry

I start this paper with a description of an encounter that seems emblematic of the difficulties of space in higher education at present. In 2010 I was studying part-time for a Master's in Brighton and attended an informal seminar series on anti-capitalist responses to the economic crisis. Each week we met in different rooms in the University and mostly in secret, not because the content of the discussions was threatening to the institution, but because the classes were informally run. Although seminars were attended by University staff and students they had no right to inhabit a room because the activity taking place was not a formal course for which fees had been paid, thus making it invisible within the University's administration. All this took place as the coalition government proposed higher tuition fees in higher education, and at the time this experience struck me as a rather intriguing irony. As a practice, learning across disciplines and sharing ideas appeared in that moment to be operating in opposition to the mechanisms of the University, namely the role of the market (fee-paying students) in choices about resource allocation. If the opportunity to take part, to be included in the learning that takes place in higher education, is determined by how students as consumers spend their money, equality of participation is limited by the institution's treatment of education as a tradable commodity because not everyone has equal access to funds. The disjuncture between theory and practice in the learning environment of Universities will be the central concern

of this paper. At the heart of this is the notion that there is a relationship between the practice of education and the kinds of knowledges that are produced. I will discuss the idea of a meeting of practice and theory as I see it in the writings of Gloria Anzaldúa and bell hooks and in the contemporary free education movement as a place in which to think through these themes.

Inequality in the UK Higher Education system persists, despite attention to social inclusion.[1] Marginalisation and discrimination are evident from the underrepresentation of women and BME academics,[2] through to the reduction in courses like Black Studies or Women's Studies and the difficulties now faced by students from less economically wealthy backgrounds to cover the ever increasing costs of higher education.[3] If limitations are placed on the diversity of student cohorts, the workforce and subject choices, the extent to which academic institutions can really engage with concepts like equality is severely compromised. Sociology modules on inequality may interrogate the causes of poverty and Widening Participation[4] agendas may inscribe values about raising aspirations within policies. However if institutional practices marginalise in the ways suggested above, and as described by Sara Ahmed, a brick wall emerges between the commitment to diversity and the practices that are meant to enable it.[5] These debates about inclusion and accessibility within higher education have been brought into sharp focus by the changing economic landscape because the relationship between education and students is no longer one of right as implied by the Human Rights Act,[6] but instead the student is a consumer in the educational marketplace. The choices that we are led to believe consumers have however are severely limited because nine out of ten universities are charging the maximum fees.[7] Fees also present financial barriers both in terms of who feels they can afford to go to University and in relation to which degrees are seen as valuable commodities in the job market.

LEARNING THEORY

> I came to theory because I was hurting—the pain within me was
> so intense that I could not go on living. I came to theory desperate,
> wanting to comprehend—to grasp what was happening around
> and within me. Most importantly, I wanted to make the hurt go
> away. I saw in theory then a location for healing.[8]

The sense in which the practice of social and critical theories can be
liberating, here exposed by bell hooks as a deeply personal experience,
resonates with my own relationship with social theory, and specifically
from poststructuralist and post-colonial disciplines. hooks describes a
desire to understand the world in a new way, to make sense of inequality,
and to find a framework in which to explain her lived experience.
That this paper is about the politics of knowledge formation touches
on *my* desire to understand my own environment. The way in which
I feel confident approaching questions about representation and the
significance of knowledge politics is thanks to my introduction to
poststructuralist and post-colonial theories when I was studying as
an undergraduate in 2004. Poststructuralist theory has developed a
very cogent way of talking about the way that knowledges about things,
social entities, people, places, have been produced. Michel Foucault for
example argues that the history of subjects is not linear or evolutionary,
but in fact discourses or framings of knowledge emerge out of particular
social and political conditions.[9] For me, reading Foucault and coming
to understand that knowledge about the social world does not just exist
because of objective scientific reasoning, but is a product of complex
relations of power has been instrumental to my own academic work on
transnational feminism.

That there is a relationship between knowledge and power asks
questions about what can be said and who can say it. It strikes me that
listening to Foucault, again, can offer very significant questions for
learning spaces like universities. When I think about that idea, that
relations of power structure which narratives are legitimised and which

are rendered hidden (subjugated knowledge, in Foucault's language), I immediately think of Edward Said's contribution to poststructuralism.[10] In *Culture and Imperialism* Said deconstructs the Western canon, considering how the language, imagery and symbolism of major works such as Jane Austen's *Mansfield Park* or Joseph Conrad's *Heart of Darkness* have contributed to the formation of the subjectivities of the oppressed and the oppressor. He exposes the relationship between the cultural imagination and the justification and perpetuation of Empire and the power relationship in which those subject to colonial rule are represented as 'other'.[11]

To use Said in the context of learning spaces has profound implications for teaching disciplines because it is an acknowledgement that cultural texts are not neutral. In short, there are narratives that are taught and there are narratives that are not. The narratives that we don't learn about, such as the voices of black women activists or women from the third world, become further marginalised from spaces of knowledge production and learning. These histories are delegitimised by this practice because it is only what gets taught that comes to be framed as *proper* knowledge. To use an example from the organisation of my undergraduate Sociology syllabus, the core subjects were classical sociological theory on Marx, Weber, Durkheim, and later contemporary theorists such as Foucault and Said. Standard textbooks on my Sociology course included Anthony Giddens' *Capitalism and Modern Social Theory: An Analysis of the Writings of Marx, Durkheim and Weber*, and Ian Craib's *Classical Sociological Theory: An Introduction*, whose first section 'What is Society and How Do We Study It?', comprises four chapters introducing the works of Marx, Durkheim, Weber and Simmel.[12] The Giddens text is described as 'the classic text for any student seeking to understand the three thinkers who established the basic framework of contemporary Sociology,'[13] a clear example of the way in which the framework of classical sociological theory has come to dominate a student's entry into the field of learning about this subject. This perspective then frames how students approach an understanding of the social world as their primary reference for thinking about relations between social entities. I learnt about feminism at university through a

non-compulsory module on violence against women. Learning about race and ethnicity were positioned as critical perspectives to the main subjects, rather than embedded into the syllabus or featuring at the forefront of teaching about social theory. The framing of subjects such as feminism or perspectives on race as non-normative—'add-ons' to the important learning about canonical figures—not only limits the extent to which they are learned, but denies the relationship this scholarship has with the development of Sociology, as if gender and race exist outside of discourse on social theory.

The deconstruction of Eurocentric knowledge structures like classical sociological theory is an ethical project because it calls into question how justice and equality operate in learning spaces if teaching fails to include contributions that address racism and patriarchy in a meaningful way. bell hooks suggests that marginalisation of discourses that are critical of racism and imperialism happens because of a lack of reflection and attention to these issues by the professional class of experts that teach in universities and organise course materials.[14] As I stated in my introduction, gender and race discrimination are endemic within UK Higher Education institutions. There are fewer opportunities to validate the knowledge brought to universities by black and women scholars, partly because courses that are attentive to Black or Women's Studies are dwindling, and partly because of a lack of representation of black and women academics at the professorial level. In both cases what is at stake is which voices frame the experience of learning about an academic subject.

If discourse is a product of power relations that legitimise certain narratives, so too is the expert—the person afforded the authority to speak on that subject, the person in the position to teach. In other words, what is taught and who does the teaching are interrelated issues. In the spaces where poststructuralist critiques are taught there is an opportunity to deconstruct the role of the expert and rethink how subjects are taught, in practice as well as theory. Yet, analysis like hooks' is strikingly relevant to the situation for UK Higher Education institutions given that courses continue to be structured according to static concepts like classical sociological theory which, lacking attention to how racism and patriarchy operate in

those discourses *in practice,* present Eurocentric social theory as neutral and objective.

RE-THINKING MARGINALISATION

It is frustrating that this practice is prevalent within subjects like Sociology, where teaching about subjects like feminism and poststructuralism, whose aims are to deconstruct the proliferation of knowledge frameworks associated with domination and oppression, is itself framed by marginalising practices. The relationship between teaching practice and marginalisation is very much the focus for thinkers like Gloria Anzaldúa[15] and bell hooks. Although emerging from the USA in the 1980s and 1990s, these works are highly relevant to the UK context from which I write, and provide a helpful framework for both deconstructing how marginalisation happens in pedagogical spaces and reconstructing a teaching practice that is attentive to marginalisation and othering. In *Teaching to Transgress,* bell hooks argues that academic institutions delegitimise certain narratives through the selection of teaching materials solely from the canon of expert knowledge at the expense of 'other' knowledge such as that produced by activist communities. Teaching on a subject in this way creates 'hierarchies of thought which reinscribe the politics of domination by designating work as either inferior, superior, or more or less worthy of attention.'[16] As I've described, this happens when subjects like feminism, and particularly from the perspective of women of colour or queer women, are taught as marginal subject positions. Teaching about European white male social theorists as fixed canons of sociology without locating relations of racism and patriarchy within that teaching means that racism and patriarchy are rendered invisible in those contexts.

If marginalisation is the product of unchecked power relations at the point at which knowledges are produced, taught, and learned, those narratives and experiences that have been silenced by mainstream teaching hold some potential to make marginalising power relations transparent. Anzaldúa argues that to understand the process of marginalisation, we need to include contributions from the margins

in pedagogy.[17] This would mean recognising that all subject positions are in some way marginal and are produced by power relations such as patriarchy and racism. In teaching, this might be reflected in black or women's studies perspectives contributing more widely to the study of art, history, philosophy and literature, rather than being confined to marginal or critical positions within academic subjects. Both Anzaldúa and hooks argue that this requires a degree of self-reflection both in the organisation of teaching spaces and in the practice of teaching itself. In teaching social theory this might involve considering how racism and patriarchy manifest themselves in classical theory and how this may have framed our own practice, as teachers and students. This is potentially transformative as it considers that teaching on subjects, including historical ones, is a process; social entities are not static concepts that we learn about in isolation from our current experience.

EDUCATION AND NEW SYSTEMS OF VALUE

Twenty years after the emergence of this perspective on pedagogy and in the context of a changing Higher Education sector in the UK, the idea that academic institutions themselves are responsible for legitimising and delegitimising certain narratives has taken on a renewed significance, as new fee structures and funding streams inscribe courses with a new sense of value. Women's Studies and Black Studies courses have been dwindling for some years, with the latter barely existing in UK Higher Education systems. These have traditionally been places in which to engage in a critique of systems of domination and oppression that draw on both academic and activist knowledges.[18] In an education culture driven by the twin influences of consumer capital (the power students have as fee payers to make choices) and career anxiety, educational value means offering courses with high levels of progression into high-earning careers. This relationship reinforces the belief that humanities and arts subjects are 'soft' and lacking in the vocational skills needed to succeed in a high-earning job. It undermines the value of critical thinking skills

gained by students taking these kinds of courses and is responsible for delegitimizing subjects like Women's Studies and the knowledges produced in them in new ways.

I would argue that the disjuncture between the theory and practice of principles such as deconstruction points to a lack of self-reflection for some Higher Education practitioners. For me the contribution of hooks and Anzaldúa has been to frame the idea of reflexivity and deconstruction as pedagogical practice and not something distinct from that. In other words, it is not sufficient to teach the deconstruction of capitalism, imperialism, or patriarchy, we have to practice it. Ultimately, what this does is to recognise that teaching is itself a social process, and like the social phenomena deconstructed by social theory such as poststructuralism, it is not free of the relations of power that produce exclusion and inequality or that perpetuate capitalism, racism and patriarchy. Earlier I stated that it is frustrating that oppressive and marginalising practices continue to prevail in teaching about subjects like feminism. I think the phrase 'teaching about' is probably the giveaway here; using Anzaldúa and hooks it is possible to think of teaching practice not as the consumption of knowledge about something (pre-existing) but instead a collaborative learning process through which there is an acknowledgement of the way that knowledges are produced in these environments and an attentiveness to thinking through marginalisation in that context. It is a personal project as well because it necessitates thinking about ourselves in relation to the learning space; who we are as participants is framed by the relations of privilege and marginalisation. We face challenging times in Higher Education and we should revisit these writers and activists when conceptualising an alternative which not only criticises the current economic problems of Higher Education, but reconstructs an education practice that is attentive to how marginalisation and myopia happen within the institution.

PRACTICING THEORY – THE FREE UNIVERSITY MOVEMENT

I will now talk briefly about a space that I think offers a place of praxis, the Free University Movement[19] and specifically the Free University in Brighton.[20] I believe that the Free University Movement invites us to consider the relationship between what is taught and the practice of teaching because the principle of open access to education makes a strong statement about the way that knowledge is constructed through social relations between people. The coexistence of deconstruction and reconstruction in pedagogical practice is a key aspect of Anzaldúa's conception of learning spaces.[21] The very practice of education using the Free Education model is both a critique of market-driven pedagogical practices and a viable alternative. There are no league tables or hierarchies of legitimate subjects and no experts, which disrupts the notion that the purpose of education is to learn something that is pre-formed. By privileging the way that discussion between participants produces valuable knowledge about subjects, these spaces are interesting places to discuss the way that knowledge is legitimated in certain institutions in the current context of cuts to Higher Education and austerity measures more broadly. At its core a deconstruction of the privileging of certain knowledge frameworks or subjects over others, the Free University Movement could be considered a poststructuralist project and certainly practices the key themes that I have identified in the works of hooks and Anzaldúa.

Free University Brighton (FUB) was set up in October 2012 by Ali Ghanimi as a response to the privatisation of Higher and Further Education and cuts to the adult education sector.[22] Intended to provide free education that is accessible to everyone regardless of their ability to pay, FUB is a kind of one-stop-shop for free education, bringing together the range of free classes already running in Brighton, with new events determined by what participants want to learn. The learning takes place in various locations throughout the city, including libraries, community centres and cafes. FUB is driven by a principle of knowledge and skills sharing, just like the Free University movements

of the 1960s. Although Ali coordinates FUB, its driving force is the contributions of the participants who learn and share concurrently through suggesting classes for the future and providing experiences to inspire other participants. Classes themselves are also enormously varied, including at any one time, family history workshops, how to use free software, and events discussing austerity and the alternatives in a public way. This range of different learning opportunities reflects the Free University Movement's commitment to bring experience into the practice of teaching, dismantling the idea that some experiences are more valid as teaching tools than others. As Howard Slater of the Copenhagen Free University, which ran from 2001 to 2007, powerfully states, 'it's a material, everything's a creative material really'.[23] This looks very much like one possible application of Anzaldúa's reflections on teaching, calling on pedagogical practice to reflect the varied ways in which we experience the social world, through family and friendships for example, as a way of understanding the multiple subject positions that we can inhabit.

For Ali, 'the most important thing is that it's publicising what's happening with education, the marketisation of it'.[24] The existence of free education is itself making a statement about public dissatisfaction with higher tuition fees and the erosion of further and adult education. It is in this space that a discussion is taking place between teaching and activism, between the practice of how we offer education and the content of classes themselves. A very simple but radical principle of the free education movement is that the existence of education spaces in non-traditional places creates new ways of learning and identifying with one another because the relationship between 'expert' and 'student' is subsumed, and everyone is a participant in a process. Indeed for hooks, we are all participants in a learning process when we open ourselves up to the idea of education as a liberatory project.[25] Thinking about education's relationship with the goals of inclusion and equality, the difference then between this model and that of Higher Education institutions is that focusing on the process of teaching as it is aligned to the power relations that enable liberation speaks very transparently about the social

relations that inhibit liberation. It is an acknowledgement that being engaged in education does not in itself create equal relations between people. Gathering teaching material from multiple sources, and paying particular attention to those on the margins not only challenges narratives perpetuated by the mainstream discourses, but goes deeper than that to make a profound statement about the way that certain types of knowledge are privileged, and what the impact of that is. That this goes further than the specific context to ignite discussion about conditions of knowledge production globally is incredibly powerful. The belief at the heart of both of these statements is that challenging power structures must start from the very practice of how and where we learn about subjects. This practice is necessarily very reflexive. For teachers like hooks, education is a right not a privilege, but certain spaces in which education happens are becoming a privilege for the few. If we are to believe in the principle of free education, challenging the marketisation of the education system must begin from the point of reflection on our own practices.

This also asks pertinent questions about what education means and how we value it in the current context not only of privatisation of education but more broadly of the dogma of austerity in the UK and Europe which encourages us all to make decisions based on the apparent economic reality of deficit and recession. Ali Ghanimi says that providing a free education asks that we 'remember what education is and should be about. It's about freeing your mind, getting you to think for yourself, think independently and exploring and challenging and questioning.'[26] This certainly sounds like something hooks would welcome. As well as equipping individuals for the world of work, education has a significant role to play in encouraging creative, critical thinking. Thinking about and discussing concepts like poststructuralism has had an impact not only on the academic work that I have chosen to engage in as a graduate, but it also frames the way that I think about the work that I have done in the social care sector for example. The point is that this happens through the practice of providing education, as well as in the subjects that are taught.

As well as knowledge, this is as much about the space made available for learning and the impact of space on how that learning happens.

This brings me back to my observations at the start of this paper. The significance of space for groups like FUB is changing in the context of the changes to higher education because of the price attached to accessing education and the value this assigns to courses that do not generate revenue. Speaking to Ali about FUB and this paper, she told me that although finding free spaces was not always problematic, what is difficult is making time for the project. Space is not just about where but when and how we make room for this kind of venture. That increasingly projects like this are relying on free labour raises concerns about their sustainability. The preponderance of free education movements and the networks that support them contribute to a sense in which the conversation that is happening about education is actually a transformative act in itself. In the long term, collaborations between the academic university and the free university may go some way towards sustaining a future for free education and for the continuation of that conversation. This movement does not threaten the institution, but creates a platform for debate and the necessary conditions for a more meaningful relationship between the practice of teaching and the production of knowledge.

Notes

1 For example the Aimhigher scheme implemented under the Labour government in 2003, which aimed to widen participation in Higher Education among learners from underrepresented groups.

2 The UCU Report 'The Position of Women and BME Staff in Professorial Roles in UK HEIs' (2012) states that it will take 38.8 years for women and 15.8 years for BME staff to be represented among the professoriate in the same proportion as they are currently represented at non-professorial academic grades. http://www.ucu.org.uk/media/pdf/9/6/The_position_ of_women_and_BME_staff_in_professorial_roles_in_UK_HEIs.pdf. Last accessed 7 December 2013.

3 The NUS estimated that in 2012 students would face an estimated average

funding shortfall of £7,654 for those living inside London and £7,693 for those outside London. http://www.nus.org.uk/en/news/press-releases/nus-figures-show-new-students-face-cost-of-living-crisis/. Last accessed 30th December 2013.

4 'Widening Participation' is a term used by the Higher Education Funding Council for England describing its commitment to encourage participation in Higher Education from students from disadvantaged backgrounds and includes a scholarship programme. http://www.hefce.ac.uk/whatwedo/wp/policy/. Last accessed 30 December 2013.

5 Ahmed, Sara (2012) *On Being Included: Racism and Diversity in Institutional Life*. Durham: Duke University Press.

6 Article 26 of the Universal Declaration on Human Rights states that everyone has a right to education and that higher education should be accessible on the basis of merit. http://www.un.org/en/documents/udhr/. Last accessed 30 December 2013.

7 Grove, Jack (2013) 'Nine out of 10 Universities opt to charge the higher fee' *Times Higher Education*, 11th July 2013 http://www.timeshighereducation.co.uk/news/nine-out-of-10-universities-opt-to-charge-maximum-fee/2005624.article. Last accessed 13 December 2013.

8 hooks, bell (1994) *Teaching to Transgress: Education as the Practice of Freedom*. New York: Routledge, 59.

9 Foucault, Michel (1972) *The Archaeology of Knowledge*. London: Tavistock.

10 Said, Edward (1994) *Culture and Imperialism*. London: Vintage.

11 *Ibid.*

12 Craib, Ian (1997) *Classical Sociological Theory: An Introduction to the Thought of Marx, Weber, Durkheim & Simmel*. Oxford: Oxford University Press.

13 Giddens, Anthony (1971) *Capitalism & Modern Social Theory: An Analysis of the Writings of Marx, Durkheim & Weber*. Cambridge: Cambridge University Press.

14 hooks, *Teaching to Transgress*, 63.

15 Anzaldúa, Gloria (1987) *Borderlands/La Frontera: The New Mestiza*. San Francisco: Aunt Lute Books.

16 hooks, *Teaching to Transgress*, 64.

17 Anzaldúa, Gloria (1990) 'Bridge, Drawbridge, Sandbar or Island: Lesbians of Color *Hacienda Alianzas*' in Albrecht, Lisa & Brewer, Rose, M. (eds.) (1990) *Bridges of Power: Women's Multicultural Alliances*. Philadelphia: New Society Publishers.

18 hooks, *Teaching to Transgress*, 15.

19 For example the Free University Network (UK) http://sustainingalternatives.wordpress.com/, the Social Science Centre, Lincoln http://socialsciencecentre.org.uk/, Ragged University, Edinburgh http://www.ragged-online.com/.

20 *Free University Brighton*, http://freeuniversitybrighton.org/about/. Last accessed 7th September 2013

21 Anzaldúa, *Borderlands/La Frontera*, 38-39.

22 *Free University Brighton*, http://freeuniversitybrighton.org/about/.

23 Transcript '*Copenhagen Free University*, 18th March 2002' Copenhagen Free University, 18th March 2002, http://copenhagenfreeuniversity.dk/exchange.html. Last accessed 7 September 2013.

24 Fuentes, Virginia (2013) 'FUB: A School Without Walls' *Vimeo* video, 3:46. August 2013. http://vimeo.com/70184256. Last accessed 7 September 2013.

25 hooks, *Teaching to Transgress*, 13.

26 'FUB: A School Without Walls'.

Laura Sterry is a researcher, writer and organiser who currently lives and works in Bristol. She is the co-organiser of *Translation/ Transmission: Women's Activism Across Time & Space* Film Season (http://translationtransmission.wordpress.com) and her research focuses on the intersection between Transnational Feminism, Film and Pedagogy.

EDGE, EMPOWERMENT AND SUSTAINABILITY

Tom Henfrey

This chapter draws on my experiences of working at the interface between academia and grassroots movements for environmental and social justice. Its central argument is that this interaction reveals basic incompatibilities between the ethical and practical imperatives of these movements and conventional academic practice. This cultural clash results from academia being embedded in institutional forms that uncritically, and at times tacitly, reflect the worldview and dominant values of advanced capitalism. These values, and the often subtle ways they express underlying ethics of patriarchy and hierarchy, are fundamentally at odds with basic criteria for sustainability and equity.[1] As a consequence, such interactions are most effective if they incorporate a transformative element, in which sustainability practitioners shape research and teaching in the light of their own values, methods and ethos. This implies a marked reversal of the power dynamics that conventionally arise when working across university-community boundaries. Para-academics, as liminal agents familiar with and (more or less) comfortable in both environments, play a crucial role in allowing this to happen, but in order to be effective require support from insiders, sympathetic to radical agendas but committed to working within institutions to advance them.

The core context for my own para-academic practice is permaculture: as a research setting, as my own 'home' community of practice, and,

perhaps most importantly, as a set of tools for designing collaborative research projects.

The term 'permaculture' originated as a contraction of 'permanent agriculture', and it is still widely viewed as an elaborate form of ecologically-minded cultivation, but its actual scope is far wider, and better summed up by the newer term 'permanent culture'. It is a design methodology, for the deliberate creation of habitats that reflect its three core ethics of Earth Care, People Share, and Fair Shares. Permaculture lies at the intersection of these three ethics, and derives its methods from careful observation of natural systems and abstraction of principles through which conscious design can emulate these.[2] The tension between these three ethics and the dominant values of twenty-first century capitalism means permaculture is intensely (though not always explicitly) political, and inseparable in the view of many practitioners from more overt forms of social action.[3]

I write, therefore, from three intersecting and mutually interdependent perspectives: as a committed practitioner and student of permaculture, as an advocate seeking to apply my professional knowledge and skills in support of improved permaculture practice, and as a researcher who applies permaculture methods in the design of the projects I am involved in. Concepts, models and methods derived from permaculture have become key tools with which I promote the three ethics in my work.

In this chapter, I illustrate three principal ways I define my self-perception as a mediator between the weakly reconcilable worlds of academia and sustainability activism: the concept of edge, the model of the forest garden, and the method of stacking. Following some further context setting, subsequent sections explore how each of these could apply to a para-academic practice aiming to derive increased environmental and social benefits from university-based research.

CONTEXT

The main context for this ongoing experiment in applying permaculture design to academic research is the development of the *Transition Research Network*, which aspires to provide a framework for more effective collaboration between academics and practitioners in the *Transition* movement of community-led responses to the effects of declining energy supplies on local economies.[4] *Transition* originated in 2005 as an application of permaculture design to community-based responses to peak oil and climate change.[5] A combination of deeper analysis into the roots of these issues, greater experience of the practical challenges, and shifts in context and priorities, in particular since the global economic crisis became conspicuous in 2008, have led to increased focus on the pursuit of wellbeing through sustainable regeneration of local economies.[6] *Transition* has retained close links with permaculture as a core methodology[7] during its growth into a global network that now includes over 1000 active groups in several dozen countries.[8] On the way, it attracted much interest from academic researchers. In principle this is a welcome development: formal research skills could be an invaluable part of an inherently experimental approach like *Transition*.[9] In practice, *Transition* groups who have collaborated with researchers report mixed experiences; in some cases, perceived self-serving, manipulative or exploitative behaviours led to researchers being regarded with suspicion, or even hostility.[10]

My engagement with this issue has led me to the personal conclusion that the basic reason this relationship is so problematic is that it reflects a clash between the core ethics and values of *Transition* and those underlying the economic system it aspires, depending on one's depth of cynicism, to either transform or replace. I take for granted the reader's understanding of the inherent incompatibility between growth-centred capitalism and both environmental protection and social justice, in terms that are structural as well as cultural.[11] In the UK, academia now reflects several decades of uncritical central government commitment to neoliberal orthodoxy. As a consequence, it tends to reinforce rather than

mitigate the corrosive effects of neoliberalism on broader society.[12] This is despite the admirable efforts of many individual academics committed to promoting sustainability, equity and social justice through their work: the relationship between academia and activism remains highly nuanced.[13] There are thus clear tensions between the consequences of universities' domination by the defunct cultural outlook and institutional structures of capitalism and the ethical and political commitments of many academics. I would also take for granted the assumption – although it may not be widely shared either within the academy or beyond – that a fundamental part of the social role of universities is to be at the forefront of finding and enacting solutions to the most pressing issues of our time, not to perpetuate their negative consequences. These tensions create potentially fertile grounds for collaboration with social movements.

Internal and external pressures towards sustainability are, if taken to their logical conclusion, highly subversive of the status quo in universities, as are the possibilities to emphasise grassroots collaborations with marginal and poorly-resourced groups, rather than powerful incumbents, within the emerging requirements for impact.[14] The 'living laboratories' where people are experimenting with the cultural, social, economic and lifestyle innovations necessary to reconcile long-term sustainability with universal provision of acceptable quality of life can provide valuable opportunities for both research and learning on sustainability, and can in turn benefit from the experience, access to resources, mainstream credibility and potential leverage in wider society that universities enjoy.[15] The concepts and methods of permaculture, when applied to academic research, are potentially transformative: both institutionally and methodologically.[16]

EDGE, ECOLOGY AND EMPOWERMENT

Edge—processes of productive interchange among different elements and/or systems—is a central concept in permaculture design. On one level, edge is achieved by choosing elements that support each other's

needs and co-locating them in space and time in ways that maximise their mutually beneficial relationships.[17] A good example is the 'chicken tractor', where chickens are housed adjacent to a vegetable patch, and introduced into a crop rotation system. Rather than clearing a bed after it has been used to grow annual vegetables, it can be fenced and used as a chicken run. The chickens enjoy foraging for insects, worms and other food, and clear the space of vegetation at the same time as manuring it with their dung, leaving it ready for planting. Eggs can be collected at the same time as vegetables are picked, which is especially handy if both are close to a door leading directly from the kitchen, and if the compost heap is nearby it is easy to add kitchen waste (which might also feed the chickens), garden waste and soiled straw from the chicken house, as well as transport the finished compost to the vegetable patch.

This concept of edge is a classic example of how permaculture design observes and adapts natural processes. In ecology, an edge or ecotone is a site where two ecologically distinct zones meet, creating a third that has features of both. An ecotone also has unique properties emergent upon the interaction between the two: coastlands are neither land nor ocean, estuaries are neither river nor sea, glades and woodland borders are neither forest nor open field: each offers features, and supports species and communities, different from those found in each habitat alone. Ecologically, these sites are marked by unusually high levels of diversity and productivity, making them important engines of evolutionary change.

THE FOREST GARDEN

Apprentices on the UK Permaculture Association's Diploma in Applied Permaculture Design are encouraged to include in their portfolio an action learning pathway, that applies permaculture methods to designing the changes in their life circumstances they anticipate bringing about as part of their diploma journey. Reflecting permaculture's roots, and most familiar applications in gardens, and to make more vivid the rather abstract way in which design principles

and methods apply to non-material concepts, many incorporate some sort of gardening metaphor.

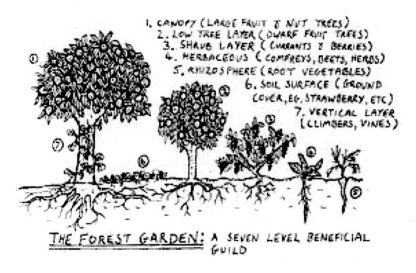

Figure 1. The Forest Garden (by Graham Burnett)

My metaphor for the process of transforming my professional life through permaculture, delivered through and documented in my diploma, is that of the forest garden,[18] a multi-layer agroforestry system. Based on observations of edges in both space—the occurrence of plants of different heights and habits at woodland edges, in glades, and in open patches resulting from treefalls and other disturbances—and time— the succession from herby weeds and grasses through shrubs to high woodland typical of moist temperate climates—the forest garden has become one of the icons of temperate climate permaculture. Structurally, it has up to seven layers of vegetation at different heights, with plants interacting both within and across these (see Figure 1). Trees and other upright plants shelter and protect those in lower layers, creating more humid, less exposed microclimates in which the latter can flourish, and providing support for climbing plants. Ground-hugging plants protect the soil and prevent the establishment of grasses that aggressively compete with young trees. The diversity of plants and their products provides

their human users with a wide range of edible and other useful harvests throughout the year, and their integration in a stable woodland-type agroecosystem keeps ongoing maintenance needs to a minimum. In this way, the forest garden exemplifies a permaculture vision of high-diversity assemblages of species in mutually beneficial relationship.

The diversity of elements and functions that characterises a forest garden, and its contrast with conventional approaches in (especially) commercial cultivation that aim to maximise yields of a single or small number of products, are the heart of my use of it as a metaphor for my para-academic practice. My personal model treats the high canopy layer as equivalent to the prestige elements of academic practice—the high profile publications, grants, international conferences, and appearances in mainstream media that make for an illustrious career. The lower tree layer I consider to represent my more strategic work within specific communities of practice (including contributing to this book): creating frameworks to enable effective collaboration between academics and sustainability practitioners, and the development of new research projects to support this. The shrub layer represents my direct participation in local action, whether on neighbourhood, city or regional scales: involvement in my local Transition group, community garden, energy co-op, and CSA. The herb layer represents my immediate professional and social environment: close colleagues, friends, neighbours; the ground cover my more intimate circles of friends and family, my immediate sources of emotional sustenance and support.

My soil is my internal condition of physical, emotional and psychological health: just as permaculture gardening is based around creating a healthy soil in which plants will naturally flourish rather than trying to look after the plants themselves, the main factor supporting successful para-academic activity, in my experience, is my success in nurturing my own well-being. The root layer includes the subterranean activities of plants in all layers, that both draw upon the soil and enrich it with their roots, in particular the nitrogen fixers that draw nourishment directly from the surrounding air and make it available to the whole forest garden community, and dynamic accumulators whose long roots

draw minerals from the deepest layers of the soil. Building a healthy soil ecology represents the personal, inner transition that often accompanies deep acceptance of the state of the world: not as an excuse for apathy, but as a platform for assuming personal responsibility for contributing to making things better.[19] Climbing plants highlight the linkages and interconnections among all of these.

The forest garden is an exemplary demonstration of edge, in which vertical layers and plants within them interact in myriad ways across space and time. A diverse and structurally complex polyculture of this type can fulfil many different functions simultaneously, each of these in multiple ways. This makes it far more resilient than simpler systems to loss or disruption of any of its constituent elements and processes. Compared to a conventional commercial orchard, canopy trees in a forest garden are more widely spaced (to allow light to reach plants in lower layers) and include a far wider range of species and varieties. The yield from any single species – and probably the total yield from all trees in this layer – is lower, and more widely spread out across the seasons. However, total production may well be higher, and the broader set of yields that take into account factors such as habitat enrichment, amenity value, biodiversity, reduced dependence on material inputs, higher still. In this way, like most polyculture systems favoured by permaculturists, forest gardens prioritise diversity and resilience over efficiency.

STACKING

The major technique used in permaculture to create edge, which the forest garden again exemplifies, is that of stacking: loosely speaking, multifunctionality. Considered placement of elements in mutually supportive interaction in both space and time creates new pathways for the exchange of matter, energy and information, leading to new emergent functions, and builds up a complex network of interrelationships in which the whole is far more than the sum of its parts. This is impossible where a pronounced power imbalance exists: when non-academic

partners in a research project are no more than a source of data, or evidence of 'impact', or when softer, lower layer yields are discounted in favour of numerical metrics of relative performance such as scores in the *Research Excellence Framework* and *National Student Surveys*. Time spent on building relationships with collaborators is only wasted if those relationships are viewed instrumentally in relation to research goals, and in turn to centrally imposed performance targets, not as a means to deeper intellectual and non-intellectual insights and to better understanding of needs and perspectives different to your own that your research might help address, or indeed as worthwhile ends in themselves. If research employs ethnographic methods it is also an integral part of data collection and researcher orientation, which may be directly productive of further non-academic yields.[20]

There are very many different ways, within collaborations that attach equal value to practical, community and personal goals as to academic targets, to find and create benefit in all aspects of the complex interpersonal processes that any engaged research partnerships implies. Para-academics, edge people by their very nature, are particularly well-placed to promote stacking by virtue of their ability to take on simultaneous multiple roles. Fluent in the languages and lifeworlds of both academia and grassroots action, sympathetic to but not constrained by the demands of academic life, both engaged with and able to detach from activist causes, they both face unique demands and challenges, and are uniquely equipped to identify and create common ground and anticipate and deflect possible conflicts.[21] In such collaborations, theirs is the role of the permaculture designer whose systems-level view, alive to potential synergy, creates the enchanted space in which new and unanticipated possibilities, beyond the imagination of any individual participant, freely and spontaneously emerge.

Para-academics can only help create and nurture these edges in partnership with those committed to working as a force for positive change within universities. These collaborations are analogous to that between Martin Crawford's well-known forest garden at the *Agroforestry Research Trust* in Dartington, Devon and a low diversity tree plot at its

immediate western boundary. Gloomy and virtually lifeless below its monotonous canopy of ash and conifers, it contrasts starkly with the vibrancy a few feet away, where over two hundred useful plant species are crammed on two acres in a three dimensional array of bewildering complexity. Although it casts some afternoon shade on directly adjacent parts of the forest garden, and attempts to colonise it with ash and other tree seedlings that must be weeded out, this neighbouring plot provides a vital service as a shelterbelt. Crawford chose to locate his forest garden in this exact spot because it protects the trees he has planted from the wind: he estimates they have grown fifty percent faster than they would have done on an exposed site. Meantime, and knowing its owners might decide to fell it at any point, he has planted his own windbreak of multifunctional Autumn olive and other mid-storey trees.

To me, this is a powerful metaphor for the role of para-academics and their collaborators in more secure academic positions in cultivating diverse, multi-layered forest gardens of community-based action research towards sustainability and social justice. In the face of overwhelming institutional pressures towards 'excellence' and other absurd neoliberalisms, university-led projects and programmes may not be able to emulate their partners fully, but they can provide them with a nurturing environment. In doing so, they make themselves more like commercial forest gardens, which tend to concede a measure of diversity and structural complexity to the demands of market efficiency, but do not treat it as an absolute goal, and so succeed in also retaining their dignity and life-enhancing nature.

FAIR SHARES: PATTERN LANGUAGES, DEMOCRATISING RESEARCH PRACTICE, AND ENERGY DESCENT

Creating a social edge is never straightforward. In addition to the right combination of activist, para-academic and academic partners, reconciling the different interests and perspectives in any university-community collaboration requires suitable collaborative

tools. In the *Transition Research Network's* initial collaborations with Durham University's Centre for Social Justice and Community Action and other university-based partners, we used an approach that I originally encountered through permaculture, that of the Pattern Language, to create such a tool.

Pattern Languages were originally developed by a team of architects led by Christopher Alexander, as a tool with two main purposes.[22] First, to capture the implicit knowledges responsible for the beauty that characterises much vernacular architecture.[23] Second, to encode the expert knowledges of specialists in construction processes (planners, architects, building engineers, builders) in ways that make them accessible to non-specialists, in order that residents and users can themselves determine the course of new building projects.[24] The control of 'experts' over the process is much diminished, and their role reconfigured to that of facilitators of this user-led design process.

In parallel fashion, encapsulating the specialist knowledge of trained researchers in a pattern language allows them to take roles as facilitators of collaborative learning processes in community-led research projects. Our Pattern Language for *Transition* research draws upon published literature in participatory action research and related areas of cooperative inquiry, on permaculture-related sources including pattern languages for forest garden design and Transition, and other pattern languages with community development applications, including Alexander's original.[25] Its aim is to support the collaborative design of research projects in which all participants have equal opportunities to flourish and grow, and yields of all types are recognised, valued and nurtured.

In attempting to apply his Pattern Language method, Alexander reports tensions and confrontations of a type familiar to any practitioner of community-led research within conventional academic establishments.[26] His account of the construction of an educational campus in Japan describes how the interventions of lawyers and others working for the conventional construction industry, exercising a narrowly profit-led agenda, consistently undermined his collaboration with a principal and staff keen to employ his highly participatory approach, recognising its

affinity with their own commitment to radical pedagogy. It also reveals nuances in this interaction, including occasions when aspects of the project benefitted from the organisational efficiency and material power of these corporate giants.

Similar subtleties and contradictions pervade relationships between the academic establishment and transformative approaches to research. Of necessity, these operate on the margins of conventional academic practice – needing both to be free of its institutional limitations and to draw upon the resources it has to offer. Like all efforts towards fulfilling the well-known anarchist pledge to 'build a new world in the shell of the old', they rest upon experiences, skills and insights, individual and collective, developed within the very institutional framework they seek to supersede.

Embracing these tensions and working with them is, I feel, core to realising the transformative potential of para-academic practice. They carry dangers of co-option comparable to much of the work of NGOs which although often dedicated to softening the social impacts of predatory capitalism, effectively contribute to its legitimisation.[27] Similar contradictions have been observed in the introduction of impact among non-academic users as a key criterion in the assessment of funding applications to the UK Research Councils.[28] My personal account of research designed using permaculture principles, and in relation to its ethics, could be read as similar to some of the progressive and superficially benign forms of postmodern capitalism.[29] The difference is in its recognition of the inseparability of the fair shares ethic and processes of energy descent: to respond to current crises by eliminating unnecessary and/or counterproductive consumption of energy and resources, with equity as both an inescapable condition and desirable outcome.

To return to our forest garden analogy, it is as if in the caring postmodern versions of capitalism lower layers are viewed only as means to support the tall canopy trees, rather than of equal and inherent value in and of themselves. In other words, the organisational hierarchy associated with stacking to create a diverse and productive environment is interpreted as a hierarchy of control and prestige. The social and

affective aspects of life are acknowledged, but only to the extent that they contribute to productivity in fiscal terms, other yields having no direct value. The imperative towards financial growth is neither challenged nor balanced with other forms of growth—for example in quality of social life, or emotional well-being. Money is a poor indicator of real wealth or value. This is partly because it excludes from consideration factors that are not easily commodified, or quantified in order to be translated into monetary value. Equally relevant for this analysis, it is also because it does not in any consistent way take account of *emergy*: the way the structure and processes of any phenomenon reflects the energy accumulated over the course of its development.[30]

In contrast, permaculture's quality as a tool for negotiating energy descent depends in crucial measure on its ability to reveal, appreciate, reconcile and create synergies among multiple, overlapping yields of different types. Research comparing intentional and non-intentional communities in North America, for example, shows a greater proportional contribution of social rather than material goods to quality of life in intentional communities.[31] The study concerned did not investigate whether permaculture itself has any role; however it demonstrates that maintenance or even increase of overall standards of wellbeing in the face of declining access to material goods can be achieved through increasing emphasis on activities other than consumption. Applied to people care, permaculture promotes the accumulation of personal and social *emergy* in routines, which allows higher yields in all layers of activity at reduced net throughputs of money, energy and other resources.[32] Its contributions to a post-carbon, post-growth academia are the topic of the final section.

POST-GROWTH ACADEMIC PRACTICE

Money, as Richard Douthwaite has pointed out, is a measure of the surplus energy available to society.[33] Global economic contraction and instability are thus the direct consequence of peak supplies of oil and other primary energy sources.[34] Universities' current experience of relative financial

austerity—minor compared to those of many other, less complicit, sectors of society—simply reflect general declines in overall energy supplies, relative to demand. Without seeking to prescribe any specific measures, this closing section examines how a permaculture-based para-academic practice might contribute to replacing academia's rather undignified scramble to maintain its privileged position with a more constructive response that sees it taking a leading and proactive role in energy descent.

The crucial dimension is the governance and control over research processes and allocation of research resources. Set in a global context, permaculture and *Transition* can be viewed as elements of broader movements to promote and maintain commons, both physical and cultural: tangible and intangible resources that are under the democratic control of their co-users.[35] The creation of new commons, and defence of existing ones, are crucial antidotes to inaction and inappropriate action in response to climate change and other sustainability crises on the part of economic and political elites.[36] A viable post-carbon academia would form an active part of this movement, dedicating itself to the creation and maintenance of knowledge commons to which all are able to contribute and gain access in a radical democratisation of academic practice consistent with the earlier visions of Illich and Friere.[37] A case in point is the UK Permaculture Association's research strategy, in which a single part-time paid member of staff mobilises work by committed long-term volunteers, students on sandwich year placements from Bradford University, projects by trainee permaculture apprentices, documentation of onsite practices by permaculture practitioners and the support of professional academics towards the emergence of capacities for self-documentation and self-analysis on the part of the permaculture movement.

Radical para-academic action, whether along the lines described here or in any of its other myriad forms, has a crucial role to play in bridging relationships between this emerging movement and the academic establishment.[38] Trajectories beyond the age of growth will be varied, with diverse responses likely to co-exist for the foreseeable future. We can expect a small number of elite institutions capable of monopolising increasingly scarce resources to persist with business

as usual, presumably continuing to welcome sponsorship from oil and tobacco companies, the defence industry and dubious political regimes, catering largely for the same vested interests behind current austerity agendas. Others will consolidate as green campuses along the lines of many US universities, and the likes of Plymouth University in the UK, and are likely to cultivate supportive relationships with newly-emerging democratised alternatives to conventional universities. For those who fail to achieve either of these and experience closure, these experiments may act as 'lifeboats', analogous to the role anticipated for ecovillages and other self-reliant communities, perhaps naively, in the event of wider collapse of basic production if current carbon-intensive systems are not replaced in time. If academic responses to austerity continue to be dominated by self-interested outrage at the diminished supply of crumbs off the table rather than constructive action towards alternatives, the gap this would have to fill may be vast.

More optimistically, two concepts prominent in *Transition* suggest a more engaged role, less as alternatives than as agents of transformation. Anne Wilson Schaef's characterisation of society as a whole, and its most powerful institutions, as sufferers of addiction to patriarchal, technocratic, materialist values places responsibility on all of us.[39] As participants in these systems, however reluctant or critical, we are all to some degree culpable and ourselves in recovery from addiction to our personal roles. Individual and collective healing processes can not be separated; there is no us and them, just humanity as a whole seeking, for the first time, to learn how to live in a sane and mutually supportive way on a finite planet. Alastair McIntosh, building on the liberation theology of Walter Wink, sees this as a process of constructive engagement with institutions that, corrupted by their own power, have lost sight of their true purpose, but are nonetheless capable of redemption.[40]

Para-academics have crucial roles in these processes, in many different ways. One is as co-creators of the new institutions against which to compare established powers, supporting them by channelling resources and expertise. Another is by promoting responsible practice within established institutions, or through building and maintaining links

with more radical organisations. Still another is as active supporters for engaged academics within universities, and supporting refugees from academia needing to undertake their own rehabilitation. The vision of resisting the spread of toxic monocultures by cultivating diverse, verdant forest gardens can sustain all of these.

Notes

1 Bookchin, Murray (2005) *The Ecology of Freedom*. Oakland: AK Press.
2 Burnett, Graham (2001) *Permaculture: A Beginner's Guide*. Westcliff-on-Sea: Spiralseed, 14.
3 McKay, George (2011) *Radical Gardening: Politics, Idealism and Rebellion in the Garden*. London: Frances Lincoln, 48-50.
4 See www.transitionnetwork.org and www.transitionresearchnetwork.org.
5 Hopkins, Rob (2010) 'What Can Communities Do?' In Heinberg, Richard & D. Lerch (eds.) *The Post Carbon Reader: Managing the 21st Century's Sustainability Crises*. Healdsburg, CA: Watershed Media.
6 Hopkins, Rob (2013) *The Power of Just Doing Stuff.* Cambridge: UIT/ Green Books.
7 Hopkins, Rob (2011) *The Transition Companion.* Totnes: Green Books, 98-99.
8 Figures from https://www.transitionnetwork.org/initiatives. Last accessed 16 Sept 2013.
9 Henfrey, Tom and Brangwyn, Ben (2013) *The Transition Research Primer v1.0.* Totnes: Transition Research Network. http://www.transitionresearchnetwork.org/transition-research primer.html. Last accessed 16 Sept 2013.
10 Kelly, Ute and Kelly, Rhys (2013) 'Experiences of Transition Research'. http://www.transitionresearchnetwork.org/experiences.html. Last accessed 16 Sept 2013.
11 Jackson, Tim (2009) *Prosperity Without Growth*. London: Earthscan. Filk, Ribert (2009) 'Consuming Ourselves to Death: The Anthropology of Consumer Culture and Climate Change' in Crate, Susan A. and Nuttall,

Mark (eds.) *Anthropology and Climate Change: From Encounters to Actions.* Walnut Creek: Left Coast Press.

12 Chatterton, Paul and Maxey, Larch (2009) 'Introduction: Whatever Happened to Ethics and Responsibility in Geography?' *ACME* 8(3), 429-439. Freedman, Des (2011) 'An Introduction to Education Reform and Resistance' in Bailey, Michael and Freedman, Des (eds.) *The Assault on Universities.* London: Pluto Press.

13 A few among many creditable examples include Fuller, Duncan and Kitchener, Rob (eds.) (2004) *Critical Theory, Radical Praxis.* Vernon and Victoria: Praxis Press. Chatterton, Paul (2008) 'Demand the Possible: Journeys in Changing our World as a Public Activist-Scholar'. *Antipode* 40(3): 421-427. Brown, Gavin & Jenny Pickerill (2009) 'Editorial: Activism and Emotional Sustainability'. *Emotion, Space and Society* 2: 1-3.

14 Maxey, Larch (2009) 'Dancing on a Double-edge Sword: Sustainability within University Corp'. *ACME* 8(3), 440-453.

15 Greenberg, Daniel (2013) 'Academia's Hidden Curriculum and Ecovillages as Campuses for Sustainability Education' in Lockyer, Josh and Veteto, James R. (eds.) *Environmental Anthropology Engaging Ecotopia: Bioregionalism, Permaculture and Ecovillages.* New York and Oxford: Berghahn.

16 Veteto, James R. and Lockyer, James (2008) 'Environmental Anthropology Engaging Permaculture: Moving Theory and Practice Toward Sustainability'. *Culture & Agriculture* 30, 47–58. Transition Research Network 2012. *New Knowledge for Resilient Futures.* Plymouth, UK. http://www.transitionresearchnetwork.org/new-knowledge-for-resilient-futures.html. Last accessed 17 Sept 2013.

17 Whitefield, Patrick (2004) *The Earth Care Manual.* East Meon, Hants: Permanent Publications.

18 Hart, Robert (1991) *Forest Gardening.* Totnes: Green Books. Hart, Robert (1996) *Beyond the Forest Garden.* Totnes: Green Books.

19 Macy, Joanna and Chris Johnstone, 2012. *Active Hope.* Novato: New World Library.

20 e.g. Graeber, David (2009) *Direct Action. An ethnography.* Edinburgh: AK Press.

21 Gillan, Kevin and Pickerill, Jenny (2012) 'The Difficult and Hopeful

Ethics of Research on, and with, Social Movements'. *Social Movement Studies* 11(2), 133-143.

22 Alexander, Christopher et al (1977) *A Pattern Language.* New York: Oxford University Press.

23 Alexander, Christopher (1979) *The Timeless Way of Building.* New York: Oxford University Press.

24 Alexander, Christopher et al (1975) *The Oregon Experiment.* New York: Oxford University Press.

25 www.patterns.transitionresearchnetwork.org

26 Alexander, Christopher (2012) *The Battle for the Life and Beauty of the Earth.* New York: Oxford University Press.

27 Hardt, Michael and Negri, Antonio (2004) *Empire.* London: Harvard University Press, 35-36.

28 Pain, Rachel et al (2011) 'Geographies of Impact: Power, Participation and Potential'. *Area* 43(2), 183-188.

29 Boltanski, Luc and Chiapello, Eve (2005) *The New Spirit of Capitalism.* London: Verso.

30 Odum, Howard T. and Odum, Elisabeth. T. (2001) *A Prosperous Way Down.* Boulder: University of Colorado Press.

31 Muldera, Kenneth et al (2006) 'The Contribution of Built, Human, Social and Natural Capital to Quality of Life in Intentional and Unintentional Communities'. *Ecological Economics* 59, 13-23.

32 MacNamara, Looby (2012) *People and Permaculture.* East Meon: Permanent Publications.

33 Douthwaite, Richard (2011) 'The Supply of Money in an Energy Scarce World' in Douthwaite, Richard and Fallon, Gillian (eds.) *Fleeing Vesuvius: Overcoming the Risks of Economic and Environmental Collapse.* Gabriola Island: New Society Publishers. http://fleeingvesuvius.org/2011/08/04/the-supply-of-money-in-an-energy-scarce-world/.

34 Heinberg, Richard (2011) *The End of Growth.* Forest Row: Clairview. Morgan, Tim (2013) *A Perfect Storm.* London: Tullett Prebon. www.tullettprebon.com/Documents/strategyinsights/TPSI_009_Perfect_Storm_009.pdf. Last accessed 27 June 2014.

35 Henfrey, Tom and Kenrick, Justin (2014) 'Climate, Commons and Hope:

the Transition Movement in Global Perspective' in Buxton, Nick (ed.) *Cashing in on Catastrophe.* Amsterdam: Transnational Institute.

36 Kenrick, Justin (2012) 'The Climate and the Commons'. In Davey, Brian (ed.) *Sharing for Survival.* Cloughjordan: FEASTA. http://www. sharingforsurvival.org/index.php/chapter-2-the climate-and-the-commons/. Last accessed 13 December 2013.

37 Illich, Ivan (1973 [1971]) *Deschooling Society.* London: Penguin. Friere, Paolo (1996 [1970]) *Pedagogy of the Oppressed.* London: Penguin.

38 For examples see http://www.visualculturenow.org/the-militant-research-handbook/. Last accessed 13 December 2013.

39 Wilson Schaef, Anne (1987) *When Society Becomes an Addict.* San Fransisco: Harper Row.

40 McIntosh, Alistair (2001) *Soil and Soul. People Versus Corporate Power.* London: Aurum Press.

Image used with kind permission from **Graham Burnett.** It was originally published in *Permaculture: A Beginner's Guide* by Graham Burnett www.spiralseed.co.uk.

Tom Henfrey is a researcher at the Schumacher Institute for Sustainable Systems in Bristol, UK. He previously did PhD research on indigenous forest management in Guyana, lived in an ecovillage in southern Spain, and worked in the Anthropology Department at Durham University. He helped found and co-coordinates the Transition Research Network, is an active member of the UK Permaculture Association's Research Advisory Board, and is planting a forest garden on his Bristol allotment.

www.transitionresearchnetwork.org
www.permaculture.org.uk/research
www.schumacherinstitute.org.uk

HIGHER DEGREE (UN)CONSCIOUSNESS

Emma Durden, Eliza Govender and Sertanya Reddy

INTRODUCTION

The education system in South Africa, both at secondary and tertiary levels, tends to employ a didactic, top-down transmission of information, from teachers to students, based on the linear Shannon-Weaver sender-receiver model of communication.[1] The flaws of this educational approach becomes evident when tertiary students progress from undergraduate studies to the postgraduate level. Postgraduate study requires students to be active and confident participants who take responsibility and ownership of their own education and research. This level of critical engagement is hindered by the experience of education in schools and at the undergraduate level, which discourages a culture of critical participation.

The Centre for Communication, Media and Society (CCMS), University of KwaZulu-Natal (UKZN), South Africa observed that Honours students were struggling with the transition from undergraduate to postgraduate studies. This paper explores the effects of participatory, engaging, self-reflexive workshops created by CCMS to assist Honours students in addressing some of their challenges and to help them become more self-assured, empowered students. This study is based on our observations of four workshops conducted once a year over a four-year period (2009-2013).

THE HERITAGE OF EDUCATION IN SOUTH AFRICA

The education system in South Africa is criticised for engineering learners for easy entrance into the job market without promoting and developing critical thinking in schools and at the tertiary level. Students are increasingly entering universities unprepared for the challenges of a degree, particularly when they reach the postgraduate level where they are required to conduct extensive research.

There are many questions regarding whether students are part of a system which teaches critical thinking and dialogue for collective action, or whether they are simply 'spoon-fed' knowledge to pass through their years at university, in order to complete a degree and to move into the working world. If education systems in South Africa move students through the system simply to generate quantity labour, where does this leave the development of critical thinkers and scholars to lead the next generation?

PAULO FREIRE, DEVELOPMENT AND PARTICIPATORY EDUCATION

The work of Brazilian pedagogue, Paulo Freire, has strongly influenced notions of participation and the practice of transformative education. For Freire, true development occurs through the use of participatory communication in educational settings. It is through dialogical learning and a fair exchange between people who enjoy equal power relations that the transformation of human beings can be facilitated.[2]

Freire posits that there are two very different approaches to education, namely the 'banking concept' and the 'problem-posing method.'[3] While the former reinforces the social forces and structures that keep people passive, the latter challenges these by encouraging people to be active in word and action.[4] Freire condemns the banking concept of education because it encourages learners to be passive entities who absorb a static knowledge. He proposes a more active, problem-posing approach as an alternative method of education.

While the banking concept encourages the top-down transmission of information, the problem-posing approach challenges hierarchies by advocating the sharing of ideas between the teacher and learners. This approach encourages participation because learning occurs not when students acquire facts, but when they engage in knowledge sharing, by exchanging ideas with each other and with the teacher.[5, 6] The premise of participation is that, through dialogue and the sharing of ideas, knowledge will grow.[7]

Through this process of dialogue, critical consciousness is developed. In Freirean terms, critical consciousness is defined as: 'the awareness of knowing little… and knowing that they know little, people are prepared to know more.'[8] This process of consciousness-building consists of acts of cognition by the learners, and not transference of information by the teachers.[9] An empowering approach to education involves action-reflection praxis where participants are encouraged to take a step back from their circumstances and to examine them objectively in order to develop a critical consciousness of what they see. This reflection offers the participant's perspective to then re-engage in action to change these circumstances, and the cycle continues.

While Freire refers to *conscientisation* as the process of understanding oppressive structures, other scholars use the term *empowerment* to refer to the process of conscientisation in a more general sense.[10, 11] People become more empowered when they gain an awareness of their own identity and talents, when they achieve the self confidence to participate in group processes, and when they gain 'the ability to determine the course of their own lives.[12] This argument was the key motivation behind the participatory workshops created for postgraduate students at CCMS.

The aim of the workshops was to employ a Freirean approach to analysing and solving a range of problems that Honours students were experiencing with postgraduate study. Students were encouraged to participate in discussions, to identify the roots of their study-related problems, and find ways to solve them. Through participation it was expected that the students would build confidence, identify their research interests, find workable solutions, and be able to plan a way forward for their studies.

Discussions with Honours students and the Centre's Director revealed problems with students' ability to participate in classes, and to read and conduct research independently. It appeared that the students' undergraduate education was pre-disposed to banking practices, which is why they reported finding it difficult to make the transition to smaller classes at Honours level, which requires active learning through dialogue and sharing.

The Freirean notion that students should take responsibility for their own learning, for finding the necessary readings, and for weaning themselves from a close dependence on their lecturers came as a shock to many. Students found it initially difficult to cope with this change, even in a supportive structure. They were also overwhelmed by the sheer volume of critical reading to be done at the Honours level, and were reluctant to be assessed on class participation as they lacked confidence in class presentations.

In addressing these problems, CCMS and its partners, Drama in AIDS Education (DramAidE) and the Centre for HIV and AIDS Networking (HIVAN), devised an intensive workshop for new postgraduate students on how to cope with their studies. The workshop is now facilitated by CCMS at the start of each new academic year.

WORKSHOP CONTENT

The workshops consisted of a series of activities deriving from the critical methodologies of Brazilian theatre practitioner, Augusto Boal[13, 14, 15] and the body-mapping processes based on the work of AIDS organisations HIVAN and The ASRU Memory Box project.[16, 17]

INVISIBLE THEATRE

Invisible theatre, devised by Boal,[18] is the use of theatre for consciousness-raising where the audience is not aware that they are part of a theatrical happening. This theatre is performed in unconventional stage spaces, such as on the street, in buses and other areas where ordinary people gather. By its nature, invisible theatre should not be seen to be a theatrical happening, and until the facilitator breaks the action for discussion the audience is unaware that they are part of an artificial, staged situation. For this piece of invisible theatre, DramAidE staged a standard student presentation of a research proposal.[19] A pre-briefed Honours student was asked to present her project proposal to the group. This was facilitated by the course coordinator, who had been briefed about the intervention. Two members of academic staff had also been briefed, and were asked to respond to the proposal, being highly critical of the student. The student audience watched this exchange, rather bewildered.

A number of students exchanged comments amongst themselves, and one student spoke up to challenge the academic staff who was later described as 'attacking' the student. The facilitator then ended the role play and revealed to the shocked group of students that what they had observed was in fact a piece of theatre.

In discussion after the event, students voiced that the presenting student had been harshly critiqued by the staff in an unpleasant manner, and had lost confidence in her work. The group discussed their own experiences, and felt it was a realistic depiction of how they feel about presenting their own work. They cited a number of reasons for this, including not knowing the expectations of them at this level of study and their fear that they had not done enough work. They also pointed to poor communication amongst members of the class, and between staff and students, made worse by imagined power dynamics between staff, senior students, and younger students. Students recognised that they lacked presentation skills and confidence regarding their own ability to enter academic discussions. This activity allowed students to recognise and voice some of their problems, and set the scene for the other participatory elements of the workshop.

PARTICIPATORY GAMES

These games were designed to allow the group to become comfortable with each other and with the facilitators, as well as to develop what Boal calls 'body awareness' (a method of engendering personal consciousness amongst the group).[20] Games created a relaxed atmosphere, and afforded the participants better knowledge of themselves and the relationships that exist within the group. After participating in the games, students were asked to voice their experience of participating in this non-academic and non-threatening environment. The learning drawn from these games was that, as a group, students needed to be aware of what others around them are doing, to listen, and to become more accountable members of the class.

DISCUSSION GENERATION

The facilitator then moved on to a 'speed-dating' activity, based on the concept of the Margolis wheel, dividing the group into two by creating an inner and outer circle in the room. The inner circle members were instructed to listen to the problems of the outer circle student who stood in front of them. The outer circle rotated around the inner circle, with students moving to tell their problem to a new student every 30 seconds. The circles were then switched, with the listeners becoming the talkers in the second half of the activity. This activity allowed every participant to speak at least three times, telling somebody their particular problems, and allowed everybody to listen to at least three other people's problems. Students commented that they enjoyed the time to talk and find common problems through this exercise. The facilitator grouped these problems into four common themes, and arranged the students into four groups to explore one theme each for the next activity.

IMAGE THEATRE

Image theatre, another of Boal's techniques, involves participants creating physical images using their bodies for the purpose of analysing and solving problems.[21] These images can be realistic, symbolic or metaphorical, and are an expression of feeling about a particular issue. The images may have multiple meanings for the participants, and discussion and clarification of these meanings is a way for the rest of the group to understand the problem. The group can then assist in problem solving by changing the image to depict a solution. This solution is discussed by the rest of the group, to assess its practicality, feasibility and application.

The four themes that the groups created images of were based on their common problems identified in the earlier activity. These included: difficulty meeting deadlines; the challenge of balancing studies with other interests; difficulty in finding relevant readings and journals, and finding a way to cope with self-directed learning. Each group created an image of the problem, which was discussed by the other participants. Each group then showed an image of the problem solved, and the whole group explored the feasibility of the solution. This session was particularly helpful in developing some simple workable solutions for the students to implement themselves, as well as some suggestions for CCMS to consider for the future.

BODY-MAPPING

The body-mapping process was first introduced to a group of women in Khayelisha, Cape Town, who used an art-based technique to create life size images of people's bodies, as an advocacy tool for HIV and AIDS awareness, disclosure and diagnosis.[22, 23] The technique uses creative materials for a facilitated process of drawing and mapping the body, where questions are posed to participants to assist them in thinking about their own bodies, experiences, thoughts and feelings. Body-mapping has been used in the context of treatment literacy,[24]

medical anthropology,[25, 26] psychotherapy (which focuses on healing and the integrative power of exploring people's experiences through words and narrative forms of expression,[27] also known as art and narrative therapy), and recently in body theology and pastoral anthropology,[28] where body-mapping was used to narrate people's stories regarding their bodies in relation to their spiritual journeys. These studies indicate that body-mapping, beyond its application in South Africa, has also been applied to diverse issues in various countries.

The initial steps of body-mapping were adapted to be used as a self-reflection tool, assisting students to identify their personal passions and interests and how these can be explored in their research projects. The technique also created an environment for students to engage, communicate and share some of their challenges with postgraduate study. The body-mapping exercises were specifically designed to optimise the participants' internalisation of their 'academic identity', personal motivation and goal setting.

The process involved each participant tracing a life-sized outline of their body and then 'mapping' various internal and external forces on this portrait. Three broad areas were covered, each including a series of specific steps. Firstly, the power of the heart (interests, passions, key emotions); secondly, the power of the mind (personal history, a vision for the future, self motivation, goal setting and a description of individual research areas); thirdly, the power of the hands and feet (practical action planning, relating research activities to goals and aspirations).

The students actively participated in the workshop processes, completing all assigned tasks and working meticulously to complete their maps. Informal discussion indicated that participants were profoundly moved by the realisation that the relationship between personal interest/s and research design would determine levels of motivation and the ability to face and overcome challenges. The mapping exercise involved both text and the drafting of pictorial images. The group expressed enthusiasm for the opportunity to be creative and expressive, a process which they felt enriched and strengthened their personal understanding of the proactive mindset that their postgraduate studies demand.

WORKSHOP EVALUATION

After the workshops, an informal evaluation was conducted with students writing comments on an evaluation poster stuck to the venue wall. They commented on the informative and interesting nature of the workshop, suggesting that it was both fun and helpful. Their comments suggested that the workshop met the initial objectives of encouraging participation, breaking down barriers, and solving some of their study problems.

To further explore the usefulness of these workshops, focus group discussions were conducted with some of the students a few weeks or months after the event. One focus group was conducted in 2009, one in 2010 and one in 2012. A semi-structured interview schedule was created for the discussions, with questions regarding their experiences of attending the workshops and any impact it may have had on them subsequently. The results of this research are detailed below.

RECOGNISING THE NEED FOR AN INTERVENTION

The students all agreed that there was a need for the workshop because they were experiencing genuine problems with the transition from undergraduate to postgraduate study. All the respondents from the 2009 workshop agreed they had been in a crisis, and the workshop was necessary to make them feel more comfortable with postgraduate study. However, on the morning of the workshop itself they felt frustrated about the intervention:

> I think we all came in with a pretty bad attitude, like I know I did. I was like 'Oh my word I can't believe they're making us come in for this stupid workshop.'[29]

We just came in with this attitude that like what is this workshop going to do? What is it going to change? So being in there from moment one right until the end was sort of like a journey that later showed results.[30]

This negative and skeptical attitude changed when the workshop started, as the students realised that the workshop was going to be a participatory and fun process rather than the didactic academic seminar they expected.

I really enjoyed it a lot more than I thought I would because it wasn't the standard type of workshop where you're just kind of sitting in a boring lecture. We were *doing* things.[31]

This notion of 'doing things' is key in the participatory Freirean approach to education, where students are an active part of the process of learning.

THE WORKSHOP PROCESS

The students were asked how they felt about each activity of the workshop. They commented on the structure of the workshop, which began with discussion about the general problems they faced and then focused on an individual exercise exploring each students' specific reasons for choosing postgraduate study. Students found that the structure allowed them to realise the commonality of their problems:

The more people that articulate themselves and the things and ideas and issues they're going through, it kind of resonates with what you're going through.[32]

The group valued the activities that encouraged sharing and finding common ground. They felt the games served as a useful ice-breaker and the fun element helped them feel comfortable with each other.

They suggested the team work required in the games reminded them of the necessity of working together as an Honours group. According to participatory education theory, if the group members are given an opportunity to reflect on the problems that they face, they can start to find solutions to these problems. Knowing that the problems are shared among the group may provide additional impetus to solving them, as the group develops a communal confidence to face these issues together.

UNCOVERING GROUP DYNAMICS

Relationships in the group and between students and staff were raised several times in the focus groups. The invisible theatre highlighted some of these relationships for the group, both in terms of the group's lack of support for each other, and in the imagined hierarchical relationships within the department. Students recognised that they previously felt intimidated by the academic staff. They thought the workshop had given them an opportunity to see the faculty in a different light, by allowing them to engage with their lecturers on a more personal level, as opposed to a 'teacher-to-student level'. This breaking down of the barriers between the 'experts' and the learners is a vital part of Freireian philosophy, as this is necessary for engaging in genuine dialogue. Students also reported that they felt much more at home in the department after the workshop.

The workshop also affected the students' peer relationships. The invisible theatre made them aware that they had taken a passive role in the department as many of them had expected the lecturers to take control of the situation: 'You kind of sit there and think oh well someone else got into trouble, but it's not my problem.'[33]

Recognising this disempowered role allowed students to realise they could play a more active part in their own studies. Students also felt that the workshop reinforced their existing peer network. Several students felt the process helped them get to know each other and encouraged them to be more open with each other.

The body-mapping process, in particular, helped to create or reinforce peer networks. Observations during the 2012 workshop and feedback from the students suggest that body-mapping was very successful in generating a sense of collegiality. One respondent suggested that 'the body-mapping workshop taught us to be open to ourselves and to the other members of the group.'[34] The students were able to develop peer relationships through the body-mapping process, especially with other students who shared similar research interests.

LINKING THE PERSONAL TO THE ACADEMIC

The body-mapping exercise was particularly focused on encouraging students to match their personal interests with their research. Most students found body-mapping very helpful in defining where their research interests lie: 'It made me understand why I'm actually here and for what purpose.'[35]

One of the students changed the entire focus of her degree after body-mapping:

> For me my academics is actually very personal so the body-mapping and the workshop itself actually reminded me that my personality and my persona, well there's a part of it missing and it made me realize that I'm not going to be very happy if that part is missing.[36]

Drawing the link between personal passions and academic research made the students leave the workshop feeling excited about the possibilities for their Honours year. One respondent pointed out that the workshop helped them acquire a better understanding of what they are at CCMS for and what they want to achieve, 'in a sense of what we want to specifically research and where our projects and stuff will actually lead us to.'[37] This suggests the power of body-mapping to deal with internal processes

and to link students' interests to their studies, making their postgraduate study more meaningful. Freire asserts that without meaningful learning that is based on the students' lives, transformation cannot happen.[38] This points to a need for student-centred content, where teacher-selected activities for learning must ensure there is genuine engagement by students with this content.

The fact that the students were able to draw connections between their personal interests and their research aims suggests that a process of introspection was taking place. One student pointed out: '[body-mapping] creates a platform for young people to express themselves, the way they think and the way they feel.'[39] Body-mapping works as a tool of self-reflection, allowing students to reflect on their studies in a structured and creative manner.

Many students in the focus groups commented that the body-mapping process required an introspective approach where they had to ask themselves several questions in order to understand more about themselves. One of the students commented that they had never thought about these questions before: 'I have never asked those questions to myself; and Iactually had to think critically.'[40] This critical thinking was supported by introspection where students had to think about their own academic journey and what they wanted to change in order to advance with their postgraduate studies.

Findings from the body-mapping process indicated that introspection was commonly associated with reflection. This meant the students would take introspection of their own lives and reflect on their experiences, resulting in problem identification and then posing possible solutions. Only after the process of introspection and reflection were students empowered to take action on their decisions. This resulted in more discussions with their lecturers and peer networks being developed.

RESPONDING TO A RANGE OF EXERCISES

The students all responded to different elements of the workshops. For example, some responded to the image theatre, while others felt unsure about participating in this kind of exhibitionist dramatic exercise. The varied responses point to the need to recognise each of the individuals within the group, and to vary methodologies to ensure that a variety of personalities and learning styles are catered for. Every learner must be engaged at some point for the process to have meaning for them as individuals.

In general, however, it appears that creative activities have the power to fully engage students and help them in critically questioning and reflecting on their postgraduate studies. Body-mapping was reported as the activity that the students enjoyed the most, as it provided them with the freedom to express themselves on their body-maps through images or writing. Whilst several models and theories suggest young people need a voice and have to be active participants in projects that affect them,[41, 42, 43] visual art has been widely researched as a means of encouraging expression with young people.[44, 45, 46, 47]

However, one of the 2012 students found the process frustrating, because she was unsure how to express her emotions on the body-map.[48] This demonstrates that not all students may be comfortable with the process of drawing. Another student did not like being unaware of the outcome of the body-mapping process:

> I think it would have helped me personally if I was actually told what is the end-point of this, because for some people they sort of found this whole link between their passion and their research project. But I didn't see that until right at the end.[49]

This indicates that body-mapping can create anxiety amongst participants, who may like to have an idea about where the activities are leading. This suggests participants need to be given an opportunity to discuss in more detail what the body-mapping process will entail, and what the expected outcomes are, before starting the process.

LONG-TERM EFFECTS AND LIMITATIONS OF THE WORKSHOPS

Students in the focus groups felt the workshop had the most impact on their confidence levels. They also noted that it changed the way they related to their classmates. Although the 2009 workshop encouraged links between peers, this did not translate into the development of longer-term study-oriented relationships:

> I think it did help me break the ice with people I didn't know but it didn't really make me interact with them a lot more afterwards.[50]

In contrast to this, several students at the 2010 workshop forged longer-term relationships with other students who became research partners for their class projects. The students also felt the department had become a friendlier place through this process.

In one particular instance, body-mapping became such a powerful moment of reflection for a student that it prompted a change of degree direction:

> After the body-mapping I actually changed my degree as a whole... I realised my passion was drama and so to not do drama meant there was a part of me missing [...] so I found body-mapping very useful.[51]

Body-mapping helped this student to identify her passions and interests and to realise the importance of integrating these with her postgraduate studies.

While most students recognised their increased levels of comfort and confidence within the department after the workshops, some students felt that the workshops had not empowered them to the extent that they had hoped:

> After studying Freire it seemed like the whole communities were changed…and I felt little things had changed, like we felt a little better, a little more comfortable but it wasn't any big thing, it wasn't like Honours was so much easier after that.[52]

This suggests that the students may have been hoping for a quick-fix solution to their problems. This is a rather unrealistic expectation from a one-off workshop, and points to the need for any empowering intervention to be part of a longer-term process. In response to a question about how to incorporate a Freirean approach into the postgraduate programme on a more sustained basis, the students felt that physically rearranging the desks and chairs in the classroom environment for seminars to subvert the 'teacher-in-front' mentality would allow for greater participation, as would allowing a more flowing conversational approach to classes.

A feeling of excitement amongst students about the possibility of more open, participatory classes was inspired by the Freireian workshop. In their first introduction to participatory theory and Freireian methods, the 2010 respondents reported that they 'enjoyed the Freirean approach.' Their understanding from their experience was that Freirean learning takes place in a 'more informal, relaxed' environment where maximum participation is encouraged. They highlighted the differences between the Freirean workshop and the formal department information meeting that had happened the day before. They said that during the meeting they had been 'spoken to', whereas during the workshop there was a 'person-to-person level', and they were 'not just student numbers anymore.' During the workshops, the students were not treated as 'recipients', where the lecturers dictate what students need to do, but were rather seen as 'partners': young people who have an equal voice.[53] This personalisation of the education process may go a long way towards developing more confident and engaged students.

DISCUSSION AND CONCLUSIONS

The workshop evaluation and the data from the focus groups suggest that students considered the workshops a useful exercise. While there was a range of different responses to the variety of methodologies used, it was unanimous that the Freirean participatory approach was one that allowed the students to perceive the department staff, their peers and the role they play in their studies in a different light.

Challenging the banking approach to expert-led education, the workshops encouraged dialogue amongst the group, whose members sought solutions to the problems they were facing in the transition from undergraduate study. Although the Freirean elements of faith, love and humility in education may be approached with some skepticism by the more cynical academics amongst us, these did in fact play out in the workshops. The experience demonstrated that the staff had faith in the students to overcome their problems and to tackle these in a responsible way, the relationships between students became friendlier, and some of the hierarchies within the department were broken down. These elements influenced the academic environment, making it more supportive and less intimidating, and stimulated further dialogue, where students felt more empowered to voice their opinions in class and to participate in research activities.

In addition to developing a sense of community amongst the students, the workshops also focused on making graduate study more meaningful for the individual. The research suggests that the exercises had a profound impact on the lives of some of the students and influenced the direction of their studies. The process of personal reflection that the workshops encouraged led to these realisations, and in this way allowed for the vital component of reflection in Freirean action-reflection praxis. This made for a transformative process for some of the participants.

Over the past four years, CCMS students have felt that the workshops, especially the body-mapping process, have helped to develop their confidence and encouraged their active participation in their studies. When young people are mobilised and feel confident to participate, they

are able to define their own problems, lead the process of investigation, and identify their own solutions. Through this process, they then develop the capacity to participate in decisions that affect their lives.[54] The students' confidence levels increased when they participated in the workshops, as the free space, self-reflection and creative mediums of communication made them more pro-active to explore what they needed to do for their own studies and careers.

While the workshops met the intended outcomes of encouraging participation and developing the students' confidence in their own ability to cope with postgraduate study, the long-term results should not be overestimated. To increase the positive effects brought about by the workshops, it is suggested that CCMS should encourage more dialogue-based teaching and learning processes, as participation needs to be nurtured over a sustained period of time if it is to be truly effective.

In terms of applying a Freirean approach to pedagogy, the following conclusions can be drawn from the students' responses:

1) The workshops actively engaged the participants in a learning process.

2) The workshops allowed students to recognise the passive role they had been playing in their education and to resolve to take a more active part in their studies.

3) Students found that the workshops reminded them how closely academia is linked to their personal lives, and resolved to make their own research choices more meaningful.

4) Dialogue was encouraged through a different range of non-threatening activities that allowed the students to open up.

5) The problem-posing approach allowed students to identify their study-related problems themselves, and to search for their own solutions to these problems.

6) Finding shared problems allowed the students to feel more part of the group and gave them confidence to propose some changes in the way their courses are taught.

7) The workshops served to challenge hierarchies within the department by advocating the sharing of ideas between staff and students.

8) The workshops provided a starting point for a Freirean action-reflection praxis, where students reflected on their problems and then took action.

9) Students recognised the workshops were just one step in an ongoing process of changing the way they think about their own education.

10) This approach has the potential to be a model for genuine transformational education.

These conclusions suggest the workshops provided a useful way for students to become more active in their own learning, and to better prepare them for their final postgraduate research projects. Applying a participatory Freirean approach in a typically hierarchical institution such as a university department can have its challenges, but it allows students to feel more confident and in control of their postgraduate studies, which can only help them succeed in their chosen fields of research.

Notes

1 Shannon, Claude and Weaver, Warren (1949) *The Mathematical Theory of Communication*. Urbana: University of Illinois Press.

2 Prentki, Tim (2008) 'A Mile in My Shoes: Impact Assessment and Evaluation of the ARROW' (Art: A Resource for Reconciliation Over the World) Programme. Unpublished report.

3 Freire, Paulo (2002) *Pedagogy of the Oppressed*. Continuum: New York.

4 Wallerstein, Nina (1987) 'Problem-Posing Education: Freire's Method for Transformation' in Shor, Ira [ed] *Freire for the Classroom: A Sourcebook for Liberatory Teaching*. New Hampshire: Boynton/Cook Publishers, 33-44.

5 Shor, Ira (1987) 'Educating the Educators: A Freirean Approach to the Crisis in Teacher Education' in Shor, Ira [ed] *Freire for the Classroom: A Sourcebook for Liberatory Teaching*. New Hampshire: Boynton/Cook Publishers, 7-32.

6 Wallerstein, Problem-Posing Education.

7 Freire, *Pedagogy of*.

8 Taylor, Paul (1993) *The Texts of Paulo Freire*. Open University Press: Buckingham, 52.

9 Freire, *Pedagogy of*.

10 Nain, Zaharom (2001) 'From Pedagogy to Praxis: Freire, Media Education, and Participatory Communication' in Richards, Michael; Thomas, Pradip and Nain, Zaharom [eds] *Communication and Development: The Freirean Connection*. New Jersey: Hampton Press, 209-224.

11 White, Shirley (2004) 'Introduction—The Concept of Participation: Transforming Rhetoric to Reality' in White, Shirley; Nair, Sadanandan and Ascroft, Joseph [eds] *Participatory Communication: Working for Change and Development*. London: Sage, 15-34.

12 *Ibid*, 23-24.

13 Boal, Augusto (1989) *Theatre of the Oppressed*. London: Routledge.

14 Boal, Augusto (2002a) *Games for Actors and Non-Actors* (2nd edition). London: Routledge.

15 Boal, Augusto (2002b) *The Rainbow of Desire*. London: Routledge.

16 ASRU (2004) *Mapping Workshop Manual: Finding your way through Life, Society and HIV*. Centre for Social Science Research, Cape Town: University of Cape Town.

17 Govender, Eliza (2013) *Processes and Participation in HIV and AIDS Communication: Using Body-mapping to Explore the Experiences of Young People*. Unpublished PhD Thesis, Univeristy of KwaZulu-Natal.

18 Boal, *The Rainbow*.

19 This method was used only in the 2009 workshop, which occurred mid-year. The 2010 and 2012 workshops were initiated at the beginning of the academic year before students had encountered some of these problems and situations, and so both the invisible theatre and the problem-posing methods were excluded.

20 Boal, *Games for Actors*.

21 Boal, *Theatre of*.

22 Narayanasamy, N. (2008) *Participatory Rural Appraisal: Principles, Methods and Application*. London: Sage.

23 Wienand, Annabelle (2006) 'An Evaluation of Body Mapping as a Potential HIV/AIDS Educational Tool'. Working Paper Number: 169. Cape Town: Centre for Social Science Research.

24 ASRU, Mapping Workshop Manual.

25 Cornwall, Andrea (1992) 'Body Mapping in Health RRA/PRA'. *RRA Notes* 16: 69-76.

26 Cornwall, Andrea (2000) *Beneficiary Consumer Citizen: Perspectives on Participation for Poverty Reduction. SIDA Studies*, 2. Stockholm: Swedish International Development Cooperation Agency.

27 Crawford, Allison (2010) 'If "The Body Keeps the Score": Mapping the Dissociated Body in Trauma Narrative, Intervention, and Theory'. *University of Toronto Quarterly*, 79 (2), 702-720.

28 Meiring, Jacob and Müller, Julian.C. (2010) 'Deconstructing the Body: Body Theology, Embodied Pastoral Anthology and Body Mapping'. *Vebum et Ecclesia* 31 (1), 1-7.

29 Respondent 5, 2009.

30 Respondent 4, 2009.

31 Respondent 5, 2009.

32 Respondent 6, 2009.

33 Respondent 5, 2009.

34 Respondent 3, 2012.

35 Respondent 7, 2010.

36 Respondent 6, 2012.

37 Respondent 2, 2012.

38 Freire, *Pedagogy of.*

39 Respondent 5, 2012.

40 Respondent 3, 2012.

41 Shier, Harry (2001) 'Pathways to Participation: Openings. Opportunities and Obligations'. *Young People and Society*, 15,107-117.

42 Arnstein, Sherry R. (1969) 'A Ladder of Citizen Participation', *JAIP*, 35 (4), 216-224.

43 Hart, Roger (1992) *Children's Participation: From Tokenism to Citizenship.* UNICEF.

44 Mitchell, Claudia et al (2005) 'Giving a Face to HIV and AIDS: On the Uses of Photo-voice by Teachers and Community Health Care Workers Working with Youth in Rural South Africa.' *Qualitative Research in Psychology*, 2, 257-270.

45 Wallace-DiGarbo, Anne and Hill, David.C. (2006) 'Art as Agency: Exploring Empowerment of At-Risk Youth.' *Art Therapy: Journal of the American Art Therapy Association*, 23 (3), 119-125. Wallerstein, N. (1987) 'Empowerment Education: Freire's Ideas Applied to Youth.' *Youth Policy*, 9, 11-15.

46 Mitchell, Claudia (2008) 'Getting the Picture and Changing the Picture: Visual Methodologies and Educational Research in South Africa'. *South African Journal of Education*, 28 (3), 365-383.

47 Rao, Deepa et al (2008) 'Stigma, Secrecy, and Discrimination: Ethnic/Racial Differences in the Concerns of People Living with HIV/AIDS'. *AIDS and Behavior*, 12, 265–271.

48 Respondent 3, 2012.

49 Respondent 5, 2012.

50 Respondent 6, 2009.

51 Respondent 6, 2012.

52 Respondent 5, 2009.

53 Klindera, Kent and Menderweld, Jennifer (2001) *Youth Involvement in Prevention Programming. Revised Edition.* Advocates for Youth. Available online: http://www.advocatesforyouth.org/storage/advfy/documents/involvement.pdf. Last accessed 28 June 2014.

54 Amsden, Jackie and Van Wynsberghe, Rob (2005) 'Community Mapping as a Research Tool with Youth.' *Action Research,* 3 (4), 357-381.

Acknowledgements

Thanks to the United States Agency for International Development for funding to undertake this study received through Johns Hopkins Health and Education South Africa (JHHESA) and to the Centre for Communication, Media and Society, University of KwaZulu-Natal, for directing the overall project. Thanks to Keyan Tomaselli, the late Lynn Dalrymple and Abraham Mulwo for their comments at various stages.

Sertanya Reddy is completing her PhD at the University of North Carolina—Chapel Hill. She was previously a research assistant in the Center for Communication, Media and Society at the University of KwaZulu-Natal and the editorial coordinator of *Critical Arts: South-North Cultural and Media Studies*.

Dr Emma Durden is a specialist in the field of theatre for development, with a focus on using theatre and participatory techniques for public health and other social issues. Through her company Act Two Training, Emma consults to a number of local and international organisations, developing materials and training programmes, and evaluating communication projects. She is a partner in the PST Project, an industrial theatre performance company; and manages Twist Theatre Development Projects, an NPO based in KZN. Emma is also a research supervisor and associate at CCMS at UKZN in Durban, South Africa.

Dr Eliza Govender works at the University of KwaZulu-Natal as the health communication programme manager for the Centre for Communication Media and Society. She also lectures and consults for several organisation's in the field of HIV/AIDS, development communication, research and skills development. Her PhD thesis explores the application of participatory approaches as a health communication strategy to address HIV prevention in South Africa. Govender has also developed materials for communities, child-friendly resources and published extensively on communication, health and development in several journals and books.

CROWDFUNDING OF ACADEMIC BOOKS

Oliver Leistert & Theo Röhle

The economies of academic publishing are in profound disorder: the few remaining publishing houses charge libraries astronomic prices for books and journal subscriptions. Often the journals have to be bought in packages, swallowing up library budgets.[1] Also, the publishing houses get the bulk of their work done for free by authors, editors and reviewers, thanks to the rules of the academic reputation system. Generously calculated printing subsidies ensure that academic publishing is turning into a virtually risk-free business. In effect, global publishing houses are being sponsored by tax payers on the one hand and individual scholars in their 'publish or perish' treadmill on the other.[2]

Some academic disciplines have found a way to deal with these contradictions, e.g. the convention in the natural sciences and computer sciences of publishing pre-prints online. In recent years, calls for open access publishing have also become louder. Some publishing houses are starting to experiment with open access,[3] maybe to be prepared for regulations like those planned in the UK and the US.[4] The open access debate provides interesting new concepts not only for distribution, but also for production and financing. One model often referred to in the context of open access publishing is crowdfunding: the idea of collecting financial contributions for a project from a large group of donors via internet platforms.

From a para-academic perspective, crowdfunding offers interesting opportunities. Since many traditional funding paths are hard to travel

without an institutional affiliation, it could be a chance to foster alternative means of funding research outside the confines of the university. Ideally, research proposals could be judged by the presumptive audience on their own merits rather than by the career path or the academic network of the Principle Investigator (PI). In the long term, it could help to move research, writing and publishing away from market forces. But crowdfunding also adheres to its own logics, which are far from unproblematic: campaigns need to be presented in an easily digestible way, their success hinges on their popularity and marketing becomes a key factor.

For crowdfunding in general, academic publishing to date remains a marginal phenomenon. Apart from larger projects in (pop) cultural production, crowdfunding is mainly used by NGOs trying to acquire funds for a large variety of social projects in the Global South.[5] In this sense crowdfunding rests on highly selective networking effects: for those without access to online communication, the only means of participation is through representation by (western) proxies. In this area crowdfunding amplifies a problematic shift of responsibilities, when actors from civil society are taking over more and more obligations formerly managed by institutions. This positions crowdfunding close to ideologies of lean states and private entrepreneurship for the social sphere.

On the other hand, it remains to be seen if crowdfunding actually *will* shift social and cultural sponsoring. In times of austerity politics and a politically fostered harshness towards the most vulnerable members of society, it appears logical to understand crowdfunding as a reaction to these crises. There is, however, one far-reaching functional difference: a crowdfunding project itself is governed by a regime of risk and thus has to anticipate its own failure. This reveals a kinship between the projects and the funding platforms, which are often financed by risk capital themselves.[6] Taking this into consideration, it remains an open question as to whether it is possible to identify different aspects of crowdfunding as a neoliberal or emancipatory project. Additionally, it would be interesting to discuss *what* specific neoliberalism it embodies, since the market as the primary cornerstone of neoliberalism in this case seems somewhat

different to financial markets. A possible criteria of differentiation can be to understand whether a platform itself collects, aggregates and sells data about its users and campaign runners, or if its policies exclude certain projects and for what reasons.

Zooming in on the question of crowdfunding and publishing, the field today presents itself as being in a stage of experimentation. Some publishers already try crowdfunded publication for fiction projects.[7] In the context of academic publishing such platforms are so far only planned,[8] or exist as announcements that have never actually seen the light of day.[9] If crowdfunding were to become a viable alternative for scholarly publishing, a campaign might involve the following stages: first, a research or publication project is presented to the net public via a crowdfunding platform. If the campaign reaches its goal and the project is realised, its outcomes can be published in open access format. In theory, this seems like a promising way to finance academic publications beyond the traditional regimes of funding. For us, this was reason enough to start an experiment aiming at crowdfunding the publication of a book. The following is a report of the campaign – and its failure.

OUR CAMPAIGN 'GENERATION FACEBOOK'

In October 2011, we published the collected volume *Generation Facebook*[10] with a German publisher. The book turned out to be a huge success: it had a considerable impact on the discourse around Facebook in Germany, and shortly after the publication we were asked by several of our contributors to start working on an English version. The mix of German and international authors would have provided an excellent opportunity to promote the particularities of German media studies internationally; however, established funding institutions did not show much interest.

Without success on the traditional paths, the idea arose to ask the 'crowd' directly for financing. The setup of the project seemed promising: the German version was already published, so there was a product to

show; many well-known and established authors, such as Saskia Sassen, Geert Lovink and Mark Andrejevic had contributed, and many more well-connected authors were on board who could, we hoped, spread the word and reach a large interested public.

If you believe the current hype about crowdfunding, you get the impression that it provides a truly new and universal model for financing. But when considering the available platforms, we were facing another reality: poorly coded web pages; missing translations; fragmentary FAQs; complicated registration procedures; mysterious limitations for the projects; restrictions of residency, and rather exotic payment methods. Of course, some of these problems can be seen as teething troubles, but at the same time they pose serious issues for possible donors, most likely with a chilling effect. We finally decided to go with *Indiegogo*[11] because the platform already had a large user base and accepted *PayPal* for payments.

This decision already reveals some systemic problems: established crowdfunding platforms come with a substantial competitive advantage over newer platforms. Smaller platforms—such as the more sympathetic *Goteo*[12]—which exclusively presents open source and open access projects, have a far lower degree of popularity, rendering the success of a campaign a lot less likely. Knowing about this dilemma, the most popular services are also able to dictate the terms of use to a certain extent. Had we succeeded with our campaign, the combined fees by *Indiegogo* and *PayPal* would have amounted to almost ten per cent of the funds raised.[13]

Just as with many other crowdfunding platforms, *Indiegogo* lets you choose between two kinds of campaigns. 'Fixed funding' means that you have to specify a fixed amount which has to be raised until a deadline is reached. The funders only 'promise' their money; the real financial transactions (including fees) only take place if the campaign's goal is reached successfully. This is different from 'flexible funding', where no fixed funding goal is determined and no matter how much money is raised, the funds are transferred (minus the fees, which are much higher in this case). We decided to go for 'fixed funding' and set the goal to 9,000 US$, which would have been the sum needed for translations,

licensing and printing.

During the next stages of the campaign we had to become PR strategists: How do you present the project in a convincing manner on the platform? What mailing list should you use for promotion? Which social networks should you use so that others can relink, retweet etc.? One important element of a crowdfunding campaign is the perks the donor receives when s/he donates a certain amount. Since we felt signed copies of the book, t-shirts or VIP meetings with the authors to be rather awkward,[14] we offered the perk of being mentioned as a donor in the book for donations above 100 US$.[15]

Our campaign was scheduled to terminate after 60 days. The first days looked promising with several 100 US$ contributions and many positive reactions by email. The (long) middle phase went mostly without any events, while the last phase was characterised by rather hectic and desperate attempts to collect enough contributors to reach our goal. On October 17th the financial failure of the campaign became a fact, with only 570 US$ in (promised) donations.

What is to be learned from this failure in the context of a handbook for para-academics? One way of reflection would be to pragmatically list all the mistakes we made and construct a concrete how-to guide for a successful crowdfunding campaign. In that case, we would have to start with the design of the page, which according to experienced crowdfunding campaigners lacked a video explaining our endeavour to the community. Then we would need to talk about transparency, since we had neglected to spell out in detail how the sum of 9,000 US$ was calculated (we did this later, during the course of the campaign). Another blunder was failing to provide convincing arguments why the book, once it was available in open access as PDF, should still be printed. But clearly the biggest mistake was not caring enough about Twitter and Facebook, which we would have had to use frequently to gain momentum during the middle phase of the campaign, to stimulate activity and communicate the liveliness of the project.

REACTIONS BY SOME ADDRESSEES

Rather than compiling such a list of concrete tips and hints, we think it is more interesting to reflect on our experiment from a more abstract perspective. After all, the connection of crowdfunding and open access had raised serious hopes to avoid at least some of the restraints of the contemporary market logic in academia. Considering these hopes, one of the natural questions in the aftermath of the campaign was if there are any problems that can be generalised beyond the individual campaign. One aspect that was especially informative in this respect was a discussion on the *nettime* mailing list,[16] which started after we had sent out our call there. Many of the moderated lists had rejected our call, stating that it did not match the general policy of the list. The *nettime* moderators accepted our mail, but after some days they enquired on the list as to how similar crowdfunding requests should be dealt with in the future. The opinions voiced in the ensuing debate were unequivocal: 'this should continue to be a place of debate and intellectual exchange, not another extension of the market of the so-called social networks,' said one posting;[17] 'gathering cash via "the network" is the same as gathering "friends" and being "liked"...' said another.[18] While this *nettime* typical excitement faded pretty soon, the persuasion prevailed that these kinds of requests should not be posted to the list: 'On this list, solicitations for funding, whether anyone judges them worthy or unworthy, function as noise in the system, or worse.'[19]

Judging from these reactions, it appears that crowdfunding calls are generally interpreted as begging or even considered to be spam – apparently without regard to their actual contents. In this case it is also clear that they are seen as crossing a line or breaching a relation of trust in a communicative environment. From this perspective, crowdfunding does everything but offer a way out of the market logic. Instead, it tends to affect even those areas which so far had been exempted from this logic. Even if this allegation is hard to justify in our case,[20] the argument itself carries some weight. As one of the central hints on the *Indiegogo* site states, it helps to ignore

social conventions and boundaries if you want to run a successful crowdfunding campaign:

> The first 25% of your goal should come from your closest friends, family and fans. Your inner circle includes people who will support your project because they know and believe in you. Use your inner circle to jumpstart your fundraising effort and to spread the word about your campaign.[21]

Apart from the sensitive relationship between self-marketing and (para-)academic peers, there is another aspect worth mentioning that is specific to the combination of academic publishing and crowdfunding. While funding projects for films and other cultural formats have proven to be successful, it was our impression that our campaign failed to reach anyone outside the academic realm. Although the German version of the book had many non-academic readers, donations for the translated version came exclusively from university faculty members. To us, this reflects the relationship between academic work and society at large, where boundaries appear particularly clear-cut at present. Within the crowdfunding community, the relevance of an academic book lags far behind that of a film project. Whether an increase in academic crowdfunding projects will challenge or reinforce such boundaries remains an open question—but a highly relevant one from the perspective of a para-academic seeking to re-negotiate this very relationship. Additionally, this suggests a general public perception of academia being well-funded or having its own monetary acquisition system. Which is true, of course. Nonetheless, to communicate the specific fundamental issues of academic funding to the general public is hardly possible within the scope of a crowdfunding campaign.

HOW MUCH PR IS SUITABLE FOR AN ACADEMIC SUBJECTIVITY?

One of the most important lessons learned from the experiment was that crowdfunding demands constant activity. For a traditional funding application, it might suffice to convincingly present your case and then hope for the best. But not in this case. The so-called viral mechanisms of the net do not emerge out of the blue, but need to be stimulated and fed. One has to be active all around the clock: reviewing and answering comments, hatching up events to justify new postings about the campaign, commenting on all channels about the development of the campaign—in short: one has to subject oneself completely to the speed and beat of social media.[22] Unfortunately for academic projects, the amplifying events during the course of a crowdfunding campaign are distributed rather unevenly. For a film project, it doesn't take much effort to come up with developments that can be announced, such as new commitments by actors. A project that aims at translating a text clearly lacks such possibilities and dynamics—even more so if the authors are not well known outside of academia.

During the course of our campaign we repeatedly felt that we reached a limit in terms of the time spent on it, but also in terms of adapting PR rationales and the degree of self-marketing expected of us. As it turned out, the limits of what we personally considered justifiable were far too low compared to what is expected and needed in order to succeed in this environment. But who knows—one day, maybe crowdfunding will be established as one viable option among others to fund academic and para-academic projects. Then, maybe there are more institutionalised web forums where such calls are not received as aggressive begging or shady advertising.

If crowdfunding develops in this direction and will be regarded just as one among many sources of funding, this could spark several interesting developments. Generally speaking, decentralisation of funding can only be in the interest of the (para-)academic community, since it would improve the agency and independence of scholars. Also, this kind of funding would require a very different set of skills to those needed for traditional

academic funding, offering new perspectives for academics with a knack for PR. For crowdfunding to become a useful tool for para-academics, however, much more active involvement would be needed in order to establish social conventions and best practices that actually meet the needs of this specific community. Maybe a crowdfunding site specialised in such endeavours would help. As the crowdfunding world exists right now, it does display enough openness to make this happen. Maybe it is even possible to use these frameworks to facilitate modes of creative research outside the constraints of increasingly hierarchical, audited and pressurised research environments. But it will not happen by itself.

Notes

1 Not only small universities are affected. This call from the Harvard Faculty Advisory Council stirred some debate: http://isites.harvard. edu/icb/icb.do?keyword=k77982&tabgroupid=icb.tabgroup143448. Last accessed 25 November 2013.

2 It should be noted that 'publish and perish' is quite common, too.

3 E.g. those who are organized in the OAPEN consortium: http://project. oapen.org. Last accessed 25 November 2013.

4 See the Publishing Policy for MIT faculty: http://libraries.mit.edu/ sites/scholarly/mit-open-access/open-access-at-mit. Last accessed 25 November 2013.

5 See Hemer, Joachim (2011) *A Snapshot on Crowdfunding*. Fraunhofer Institute for Systems and Innovation Research ISI, Working Papers Firms and Region, number R2/2011: http://hdl.handle.net/10419/52302. Last accessed 25 November 2013.

6 The 10m US$ seed capital for *Kickstarter*, the best known platform, came in large parts from 'angel investors'.

7 *Unbound* is an example for such a publisher (http://unbound.co.uk); *Thinkcursor* is an integrated platform that can be used by publishers (http://thinkcursor.com).

8 See for example the blog *Open Reflections*: http://openreflections. wordpress.com/2011/08/03/on-crowd-funding-open-access-scholarly-books. Last accessed 25 November 2013.

9 *Open Genius* had been presented as such a project, but the URL (http://opengenius.org) does not show any content anymore, which suggests that the project has been abandoned.

10 Leistert, Oliver and Röhle, Theo (ed.) (2011) *Generation Facebook. Über das Leben im Social Net.* transcript: Bielefeld.

11 http://www.indiegogo.com.

12 http://www.goteo.org.

13 We did not get to the point where the taxation of financial transactions from the US to Germany became an issue. But we got an idea of how complicated things could have become when waiting for weeks to have the EU money laundry limits lifted for our PayPal account, which already become effective at 2,500 EUR.

14 A team of biologists from the US was less conservative in this matter, as an article in the *New York Times* states: http://www. nytimes.com/2011/07/12/science/12crowd.html. Last accessed 25 November 2013.

15 Following the idea of one contributor, we added another perk later on. For US$ 500 we offered advertisement space for media studies institutions in the last pages of the book. None of the institutions we contacted showed interest.

16 http://nettime.org.

17 Broeckmann, Andreas (2012) 'crowd-funding on nettime', 27 August 2012, http://nettime.org/Lists-Archives/nettime-l-1208/msg00025.html Last accessed 25 November 2013.

18 Hopkins, John (2012) 'crowd-funding on nettime', 28.8.2012, http://nettime.org/Lists-Archives/nettime-l-1208/msg00048.html. Last accessed 25 November 2013.

19 Sanborn, Keith (2012) 'crowd-funding on nettime', 28.8.2012, http://nettime.org/Lists-Archives/nettime-l-1208/msg00047.html. Last accessed 25 November 2013.

20 In the later part of the debate the case is made for the benefits of

combining crowdfunding and Open Access – without noticing that this was exactly what we were after.

21 Cf. http://www.indiegogo.com/crowdfunding-tips#buzz. Last accessed 25 November 2013.

22 In retrospect, this begs the question whether we reflected the arguments from our own analysis of Facebook sufficiently. The test on reality was clearly positive.

Oliver Leistert studied Philosophy, Computer Science and Literature. He received his Dr. phil in 2012 for his thesis 'From protest to surveillance –the political rationality of mobile media.' Currently he is a Postdoc at the Graduiertenkolleg 'Automatisms' at University Paderborn. Recent Publications: *From Protest to Surveillance–the Political Rationality of Mobile Media.* Peter Lang 2013; (with Theo Röhle) (Eds.) *Generation Facebook* (transcript 2011).

Theo Röhle is a Postdoc in the project 'Business Games as a Cultural Technique', Braunschweig University of Art. He received his PhD in media culture from the University of Hamburg in 2009 for a thesis on power relations and search engine algorithms. He studied Communication Studies and Cultural Studies at Stockholm University. Pertinent publications: with Irina Kaldrack 'Divide and Share: Taxonomies, Orders and Masses in Facebook's Open Graph' in: *Computational Culture*; 'Power, Reason, Closure. Critical Perspectives on New Media Theory' in: *New Media & Society*, 2005.

PARA-ACADEMIC PUBLISHING AS PUBLIC-MAKING

Paul Boshears

What I'm writing here began as a conversation in preparation for the *Aesthetics in the 21ˢᵗ Century* conference hosted by the University of Basel in Switzerland.[1] There we, the editors of *continent.* and the editors of the journal, *Speculations*,[2] convened a panel discussion entitled the 'Aesthetics of Para-Academic Practices.'[3] Our panel discussion came during the middle of the second day of convening, that potentially grey, bleak zone in a multi-day conference when no one wants to return from lunch and suddenly the crowd has become half the size it was at the commencement. But it was good timing for that panel discussion because it did something interesting to the usual stage directions that choreograph most of the conferences we academics attend: we were discussing the gripes and the grouses that are usually only articulated in the halls, between sessions at the coffee station, or over beers at the end of the day.[4] The backstage talk about how our daily academic practices—that grind that we live, not the polished pearls that we publish or broadcast—was suddenly front and centre in the conference. I'm not claiming that we mobilised our collective frustrations into some tectonic shift; but we cannot deny that some 'real talk' helps shape the contours of how we will behave in the future. At a minimum, when we are in the presence of those with whom we've had that 'real talk' we are likely to behave in a different manner; that is, the promise of collegiality and more broadly of sociality.

These moments might be microscopic in the face of increasing

precarity for the majority of faculty working in U.S. universities (that is, adjunct faculty)[5] and the global cognitariat;[6] I defer to a local leader of the Creek Nation (the indigenous people of the Atlanta area, where I have lived for many years), Tom Bluewolf, who told me: 'No raindrop wants to be responsible for the flood.' And so I offer this pittance, this single tear wept for all my fellow graduate students, and all those adjuncts who make a college or university education possible in the United States (where I am currently based) and across the globe. Your work transforms lives beyond your own. Mine is one of them.

We are witnessing the changing nature of academic practice. My thinking about para-academia and the macro-level forces that are helping forge the para-academic proposition is primarily informed by and concerned with how the para-academic could be practiced in the United States. Although I have also worked in universities in both Switzerland and Japan I am currently based in the U.S. and write from this perspective. This change in practice is being spurred on by the dramatic shift in the technologies through which knowledge work is done. The para-academic proposition is both a response to and a detour away from the conditions that accompany the changes occurring in the Academy. The para-academic is not a fully-formed idea, it is a proposition and it has multiple valences. Bruce Macfarlane emphasises the para-academic as support role, as in 'para-professional.'[7] The PhD holder that acts as counselor to the cohorts, rather than as the traditional mentor, say. Or some other administrative function that frees up the professor to either teach or conduct research. He describes the 'rise of the para-academic' as a result of shifting expectations within international universities toward a more 'Taylorised' model of operating so as to achieve the optimal efficiency in delivering educated people. In order to achieve these efficiencies, the role of the scholar has become what he terms 'unbundled.'[8] If the university can find its greatest return on investment through the kinds of knowledge generation that happen in research labs, then the university should be hiring those professors that are best able to acquire research dollars and manage that funding stream. Meanwhile the historical vision of the professor as one who professes to their students

and society-at-large has been relegated to an army of adjunct labourers. To be fair, there is no shortage of reporting about the current academic crisis. But to whom are these notices directed? The disconnect between those working in universities and colleges and seemingly everyone else in the U.S. is perhaps best exemplified by Vice President Joe Biden's statement last year in January: that the rising costs of higher education in this country is due to rising professor salaries. Typically the significant loss of funding from individual states is not emphasised.[9]

Currently the trend in higher education is to celebrate openness.[10] For example, Open Access is bandied about as an antidote to the sky-rocketing expenses of subscriptions to academic journals. But, as I have discussed elsewhere, what is meant by Open Access is not clear.[11] Open software initiatives like those being developed at the Public Knowledge Project (their *OJS* platform is the WordPress of academic publishing) continues to be adopted and developed by younger academics as they go about their work. We initiated *continent.* with aims that include developing the *OJS* platform to integrate the variety of media that are now available for the contemporary academic to mediate their labour (e.g. static and moving images, code-based practices, audio, etc). Like our friends at punctum books, we are Open Access publishers utilising Creative Commons licenses, the so-called 'Diamond Open Access' model of publishing.[12] We do so in an effort to emphasise the fun of creating both a material object called a publication but also to emphasise that the process of publication is the process of public-making. Yes, many of us involved in these projects share precarious positions relative to the universities we draw incomes or other resources from; we may also share a certain gallows humour about the sad state of funding for our beloved Academy. But when Harvard University, with one of the richest endowments in the world at its disposal, announces they can't afford journals,[13] the tectonic change that comes with widespread adoption of Open Access policies isn't about a disruptive technology that finally breaks a monopoly. Open Access and MOOC's are not disruptive technologies, they're labour models.[14] Under the so-called Gold Open Access model, academics already do a large amount of work for these publishers, and pay for that

opportunity (or access to this work is paid for by the tax payers).

Today, the value of lecturers approaches zero. Their talent at communicating their knowledge is given away freely through vehicles like edX, Coursera, Udacity, or Academia.edu. Today the academic must demonstrate that their work has impact. As the CEO of Academia.edu, Richard Price, stated, 'a core problem for researchers is how to build their brand [....] To make yourself established in a field, the core way you do that is to share your work.'[15] This isn't liberating academics, this is neoliberalising academia. We are the brand, the dotcom update to Marx's comment about the proletariat, doubly free, 'as a free individual he can dispose of his labour-power as his own commodity, and that [we are] free of all the objects needed for the realisation of [our] labour-power.'[16] The premium paid has instead been placed on the bureaucracy necessary to achieve and maintain accreditation. Similar to the dynamic established by overseas campuses (such as Australia's Monash Indonesian campus or the National University of Singapore and Yale), what we are seeing is the triumph of university branding. Students around the world want to attend Ivy League schools because those schools have the veneer of excellence, not because the programs themselves are the best—in fact, these Ivy League schools are frequently outperformed by public/state schools in many areas. Yes, anyone will be able to take classes from Harvard, but that won't matter unless they also purchase the accreditation. When it is impossible for any one person to distinguish signal from noise, reliable signal markers are necessary and this is, arguably, what accreditation does.

The university will continue to become McDonaldised. Just like the chair on the airplane looks like the chair in the rental car looks like the chair in the faculty lounge, looks like the chair your department head holds, so will one's education become a packaged 'experience.' The student-consumer will expect certain events and interactions while away at their university.[17] For those paying for accreditation, this education experience will be delivered on a spectrum: the flavour of timeshares for the poorer community college students, and more like Semester at Sea—or some other expensive study abroad program— for the affluent.[18]

Perhaps there will even develop a Hooters-style experience, student-consumers can enjoy their education as its delivered by Abercrombie & Fitch model-like adjuncts, the university finally capitalising on the chilli-pepper grade system used by ratemyprofessor. com. Regardless of their appearances, the academic workers at those universities will be expected to deliver the education experience efficiently, reliably, and in the most uniform manner possible.[19] If you think that I am too wildly speculating, consider this sombre report: the top two growing sources of escorts (primarily young women to service men) are universities.[20] Faced with student loan debt that has grown by orders of magnitude, the future demands that those seeking an education be creative.

But what does para-academic afford us? Why this term that so clearly adheres to 'academia,' a conservative, discipline-insistent, change-averse social institution? It was from Nicola Masciandaro that I first learned the term 'para-academic.'[21] For Eileen Joy and Masciandaro the phrase:

> captures the multivalent sense of something that fulfills and/or frustrates the academic from a position of intimate exteriority [...] The para-academic embodies an unofficial excess or extension of the academic that helps, threatens, supports, mocks (par-ody), perfects and/or calls it into question simply by existing next to it.[22]

To their description I would like to add the concept *parabole*. A term within rhetoric, *parabole* operates in a manner not dissimilar from analogy: a transaction that enables two incommensurable items to become somehow representative of a truth. Like a promise, what is offered is perhaps never able to be delivered, and yet there are ample examples in our daily lives that we can turn toward and identify moments where the incommensurable promises are somehow not reduced to simply payback or tit-for-tat, but something excessive, generative. The consummate performance of communal living, what I believe the para-academic proposition aspires toward, is a generative activity in the creation of further exchanges. These further exchanges are the creation of further

public goods. Let us maintain an openness toward the para-academic as a parabolic figure, concerned with the generation of knowledge. The para-academic, regardless of the relationship to the university at any particular point, will be characterised by their practices for novelty generation as a mode of educational working.

In English we arrived at the term 'education' by conflating two Latin words: *educare* and *educere*.[23] With *educare* there is a concern with training, like a vine; a process of installing an incremental amount of knowledge into the student with the ends already presupposed. At the end of the *educare* process there will be the skills-trained student, an ideal consumer, empowered with the knowledge to do what is known in advance. *Educere*, on the other hand as Roger Ames and David Hall state, 'suggests that one "extends" one's inner tendencies through a mode of self-cultivation that is, in fact, self-creation.'[24] *Educere* is a drawing-out,[25] an aesthetic re-understanding, it is knowledge that has appreciated through experience and thereby enables one to generate novelty. This is the difference between the academic as a parergon (a supplemental worker or ad hoc by-product) and being a paragon (an exemplary person of what it means to cultivate and generate in the face of what we don't yet know). We vacillate between these polar modes of being and in these hesitations between moments of decision-making knowledge is generated.

CIRCULATING THE PRACTICE OF KNOWLEDGE-MAKING

The practice of knowledge-making that marks our knowledge economies circulates so much text, and from the advent of publishing the para-academic has haunted public life. I've previously argued that publication is the process of public-making,[26] but I am arguing that para-academia meets Michael Warner's characterization of counterpublics, 'spaces of circulation in which it is hoped that the poesis of scene making will be transformative, not merely replicative.'[27] The generation of counterpublics occurs when the dominant modes of public address

make it such that the individual can pay attention to the fact that there is this public address, but that public addressing doesn't allow the individual to participate. This isn't to say that para-academics are limited in their relations to academics through antagonisms, a loser's club that generates its own cool by being defined only by the membership's inability to be brought into the academic public. Although it can be that: a crowd of disaffected, bright, committed, well-read folks that heard the promise of education as a panacea against the social ills of our times. And of the times before us, to go not too far back we could thank Marie Curie for her sacrifice, or we could go way, way back and ask Plato if his pharmacological betrayal of Socrates was a promise or a curse to future generations.[28]

Indeed, the question still hangs in the air: how do we collectively make sure that promises are kept? During the early modern era this was achieved through conversation as commerce. 'Conversation' was Richard Eden's word for commerce in his *Decades of the Newe Worlde* (1555),[29] and referred to equal exchange among strangers— the *sine qua non* of public life. Abbé Du Bos in 1719 defined 'public' as those that have gained enlightenment either through reading or through life in society [*le commerce du monde*].[30] These are calls to *isegoria*, the promise of equal access to the agora as both point of social assembly (or *þing*)[31] and the place for exchanging material goods. Indeed, the very concept of democracy as a social relationship is impossible without the Ancient Greeks' simultaneous churning over of what *isonomia* could possibly mean during their years of colonial expansion.[32] In short, the development of economic crises has fueled the development of our thinking about what qualities an educated person ought to have to make living in society bearable. Isn't this at the heart of Hesiod's *Works and Days*? 'Hey, brother, don't be a jerk. Learn how to plough. Here's how you ought to be comporting yourself going forward,' is among the earliest messages to be transmitted to us from the Big Bang of literary practice.[33] A public is the result of the circulation texts, a text being understood in the broadest way possible to encompass reading as a technique for consuming manifold

media. But this circulation of texts is not only the mechanism by which subjects are interpellated, it is also the mechanism by which the common good is established.

TOSSING LOVE LETTERS INTO THE SEA

Please allow me a moment of autobiography as I try to make sense of both how I came to be involved in the para-academic conversation as well as something I said at my first 'official' para-academic event. I had accepted an invitation from Eileen Joy to join a panel discussion at the Public School New York that included people from *Cabinet*, from Sequence Press, Eileen, and several others in 2012. I'd never heard the phrase 'para-academic' before then. During the panel discussion—for which I had not prepared notes, a situation that had me very nervous since I've been taught that a speaker should always value the audience's time and thus prepare notes—I heard myself say at one point that *continent.* in many ways operates as a love letter stuffed into a bottle and tossed into the sea. It was a bit heavy-handed and smarmy, but it is true. When we began we didn't know to whom these texts were being sent and certainly can't say what value ought be attached to our publishing what we publish. I can't say that I know any better who our readership is, what they want, or why we agree to read each other, but the experience of publishing *continent.* has consistently demonstrated to me a lesson I first heard when Jacques Derrida eulogised Emmanuel Levinas: that every gesture is always toward an Other that is entrusted to me.[34] And that language is, in its essence, friendship.

In the Anglo-Saxon legal tradition a subjective promise becomes an objective legal obligation when there is the circulation of a text, called a material consideration, between two parties.[35] This transformation from essentially private words between two people into a communal concern is at the heart of what it means to live in a society. Communal living, regardless of the scale, appreciates in value when people are able to deliver on what they say they will. The virtue of these acts radiates across societies

and creates a flourishing that is distinct from the 'safety' of order that policing demands. The consummation of one's promise, delivering on what one has promised, is an expression of mutual determination that affirms the communal in being in a communicating community. Being a para-academic publisher is a practice that enables me to demonstrate publication as a process of public-making.

Notes

1 I am grateful to the comments and conversations that came from sharing early versions of this presentation at the Neil Postman Graduate Conference at NYU as well as at the New York Public School in February, 2013.

2 Both *continent.* (www.continentcontinent.cc) and *Speculations* (www.speculations-journal.org) are Open Access online journals established by graduate students in the late oughts of the twenty-first century. *Speculations* is a member of a broader Open Access publishing initiative, punctum books (www.punctumbooks.com). We learned at the Basel conference that none of the editors of *Speculations* had ever physically met one another prior to convening in Switzerland that weekend. Such is the nature of academic collaboration in the early twenty-first century.

3 We at *continent.* also published preliminary remarks about the matter in 'Discussions Before an Encounter', *continent.* 2.2 (2012): 136–147.

4 Video documentation of our conversation can be viewed at http://vimeo.com/continentcontinent/para-academic-practice. Last accessed 3 August, 2013.

5 See the New Faculty Majority Foundation's national summit from 2012, 'Reclaiming Academic Democracy: Facing the Consequences of Contingent Employment in Higher Education' reportage with summaries and links to presenters available from John A. Casey, Jr. 'Reflections on the New Faculty Majority Summit 2012'. http://johnacaseyjr.com/2012/01/29/reflections-on-the-new-faculty-majority-summit-2012/. Last accessed

3 August 2013.

6 On the cognitariat, see Matt Fuller's (2001) interview with Franco Berardi (Bifo). Berardi discusses the cognitariat as a virtual class, a class whose effect is only known by the aggregatation of knowledge workers' micro-actions (http://amsterdam.nettime.org/Lists-Archives/nettime-l-0106/msg00033.html). Last accessed 3 August 2013. See also Berardi, Franco (2010) 'Cognitarian Subjectivation', *e-flux journal* 20 November (http://www.e-flux.com/journal/cognitarian-subjectivation/). Also see Bruno, Isabelle and Christopher Newfield's (2010) 'Can the Cognitariat Speak?', *e-flux journal* March (http://www.e-flux.com/journal/can-the-cognitariat-speak/) and Newfield, Christopher (2010) The Structure and Silence of Cognitariat', *Edufactory* 0, 10–26.

7 Macfarlane, Bruce (2011) 'The Morphing of Academic Practice: Unbundling and the Rise of the Para-academic', *Higher Education Quarterly* 65.1, 59–73.

8 *Ibid.*

9 Williams June, Audrey (2012) 'Professors Seek to Reframe Salary Debate', *The Chronicle of Higher Education* April 8, 2012. (https://chronicle.com/article/faculty-salaries-barely-budge-2012/). Last accessed 3 August 2013.

10 See, for example, Carlson, Scott and Blumenstyk, Goldie (2012) 'For Whom Is College Being Reinvented?', *The Chronicle of Higher Education* December 17, 2012. (https://chronicle.com/article/The-False-Promise-of-the/136305/). Last accessed 3 August 2013.

11 Boshears, Paul (2013) 'Open Access Publishing as a Para-Academic Proposition: Besides OA as Labor Relation', *tripleC—Communication, Capitalism & Critique* 11 (2), 589–596.

12 Fuchs, Christian and Sandoval, Marisol (2013) 'The Diamond Model of Open Access Publishing: Why Policy Makers, Scholars, Universities, Libraries, Labour Unions and the Publishing World Need to Take Non-Commercial, Non-Profit Open Access Serious', *tripleC–Communication, Capitalism & Critique* 11 (2), 428–443.

13 Harvard's Faculty Advisory Council Memorandum on Journal Pricing. The Harvard Library April 17, 2012. (http://isites.harvard.edu/icb/icb. do?keyword=k77982&tabgroupid=icb.tabgroup143448). Last accessed 3 August, 2013.

14 Ian Bogost shares my point in his contribution to a round table discussion, 'MOOCs and the Future of the Humanities: A Roundtable' between Al Filreis, Cathy N. Davidson, and Ray Schroeder in *Los Angeles Review of Books* 14 June 2013 (http://lareviewofbooks.org/essay/moocs-and-the-future-of-the-humanities-a-roundtable-part-1). Last accessed 3 August 2013.

15 Cutler, Kim-Mai (2013) 'Academia.edu, The Social Networking Platform For Researchers, Raises $11.1 Million', *TechCrunch* September 26, 2013. (http://techcrunch.com/2013/09/26/academia-edu-2/). Last accessed 23 November 2013.

16 Marx, Karl (1990) *Capital* Volume 1, Ben Fowkes [trans] New York: Penguin Classics, 272–273.

17 For a profile of what the very rich seem to expect from a college 'experience' for their children see Carol Matlack's report on the development of High Point University, 'part corporate campus, part theme park' in 'Bubble U: High Point University', *Bloomberg Businessweek* April 19, 2012. (http://www.businessweek.com/articles/2012-04-19/bubble-u-dot-high-point-university#p1). Last accessed 3 August 2013.

18 Some of this we see playing out, for better or worse, in the trends for students graduating with student loan debt in excess of US$100,000, see Mark Kantrowitz 'Who Graduates College with Six-Figure Student Loan Debt?', (http://www.finaid.org/educators/20120801sixfiguredebt.pdf). Last accessed 3 August 2013.

19 As Deborah Withers pointed out during the process of editing this writing, there are significant managerial problems with actually delivering this, however, due to the nature of last-minute course assignments from department chairs and so on. I am grateful to her for this point.

20 Downey, Maureen (2013) 'Faced with tuition bills, more GSU and UGA students turning to "Sugar Daddies"', *Atlanta Journal Constitution* January 14, 2013. (http://blogs.ajc.com/get-schooled-blog/2013/01/14/

faced-with-tuition-bills-more-gsu-and-uga-students-turning-to-sugar-daddies/). Last accessed 3 August 2013.

21 Masciandaro, Nicola (2010) *Hideous Gnosis: Black Metal Theory Symposium 1* Brooklyn: Glossator/punctum books, 267.

22 From the organising notes for a panel discussion on para-academic publishing at the Observatory for the New York Public School held 17 April 2012 (http://thepublicschool.org/node/28961). Last accessed 3 August 2013.

23 I am primarily relying upon the Ames and Hall discussion here and as such I am opened to the criticism that I am forcing the point a bit. Certainly one can make the claim that *educare* is just as much a concern with cultivation, perhaps more so than *educere*.

24 Ames, Roger T. and Hall, David L. (2001) *Focusing the Familiar: A Philosophical Interpretation of the* Zhongyong (中庸) Honolulu: University of Hawai`i Press, 51.

25 See Lewis & Short *educo*, II., A., 1., b. Available online (http://www.perseus.tufts.edu/hopper/morph?l=educere&la=la#Perseus:text:1999.04.0060:entry=educo1-contents). Last accessed 23 November 2013.

26 Allen, *et al* (2012) 'Discussions Before an Encounter', *continent.* 2.2: 147.

27 Warner, Michael (2002) 'Publics and Counterpublics', *Public Culture* 14.1, 88.

28 See Derrida, Jacques (1981) 'Plato's Pharmacy', in Johnson, Barbara [trans] *Dissmerinations.* Chicago: University of Chicago Press.

29 Quoted in Pietz, William (2002) 'Material Considerations: On the Historical Forensics of Contract', *Theory, Culture & Society* 19.5/6, 41.

30 Quoted in Warner, Michael, 'Publics and Counterpublics', 67.

31 See Pálsson, Gísli (2005) 'Of Althings!', in Latour, Bruno and Weibel [eds] *Making Things Public* Cambridge, MA: MIT Press, 250–259.

32 'The relevant good to be shared out was not monetary profit, as with a joint-stock company, but land, possibly pasture but more likely the limited fertile plain on which corn and vines and olives could be grown. It would make sense to ask how the available land was going to be shared out before embarking on a hazardous enterprise with strangers,

and in the absence of already established custom, an equal distribution would not only seem natural, but would be the only basis on which outsiders would be willing to join.' Lucas, J.R. 'Isonomia', draft available at http://users.ox.ac.uk/~jrlucas/libeqsor/isonomia.pdf. Last accessed 3 August 2013.

33 '[L]et us settle our wrangling with straight *dikai*, which are from Zeus best. For we had already distributed the holding (*kleros*), but you snatched and carried off many other things...' *Works and Days* 27 from Tandy, David W. and Walter C. Neale (1996) [trans] *Hesiod's Works and Days: A Translation and Commentary for the Social Sciences*. Berkley, CA: University of California Press. Thus the opening of the epic poem is a question of how these brothers, Perses and Hesiod, will split the family's lot (*kleros*) in the wake of their father's death. It should be noted that *kleros* (lot) carries the same metaphor as in English: fate/land holding. In Hesiod's day one's home, *oikos*, (from which we get the prefix eco-) was on a family *kleros*, apportioned (*nomos*, from which we get the suffix—nomy). Hesiod's epic is concerned with *oikonomia*, the management of one's lot in life. From the inception of the written word we have struggled with our economic relations.

34 Derrida, Jacques (1999) 'Adieu', in Pascale-Anne Brault and Michael Naas [trans] *Adieu to Emmanuel Levinas*. Stanford, CA: Stanford University Press.

35 Pietz, 36.

Paul Boshears is co-founder and editor of the media-agnostic, Open Access journal *continent.* (ISSN: 2159-9920) and is completing a PhD at the European Graduate School, under the advisement of Avital Ronell. Living in Atlanta, Paul is the Circulation Manager for Art Papers magazine and responsible for their social media as well as distribution and subscription operations. He has served on the Editorial Boards for *Itineration: Cross-Disciplinary Studies in Rhetoric, Media, and Culture* and *BurnAway*, where he regularly writes reviews of performance and

visual arts events. As an Americorps*VISTA he served the metro-Atlanta community with the nonprofit microlender Acción USA where he was central in partnership development and their financial literacy programming. He has conducted research and studies in West Africa, East Asia, North America, and Europe. Paul is married to Karen Rommelfanger, founder and Program Director of Emory University's Neuroethics Program at their Center for Ethics.

AN ACTIVIST-ACADEMIC'S REFLECTIONS

Louise Livesey

I am an activist, by which I mean a person who engages in activities designed to create social change; in the mode of Walden Bello's[1] words that 'I am engaged because I think one should do something worthwhile with one's life. There's nothing heroic about it. It's just that you have to do it, to be human.' I have also spent the last fifteen years employed in academic roles, evenly split between 'full' academic and para-academic roles in the Social Sciences and Women's Studies. These roles have been variously full-time and part-time on permanent and casual contracts at higher education, further education and dual FE/HE institutions and in the voluntary sector in various locations in the UK. I have taught students on courses ranging from pre-undergraduate to Master's level across a range of interdisciplinary and disciplinary topics. Most of the casual contracts have been roles which MacFarlane[2] categorises as 'contingent faculty' created by the casualisation of the traditional academic role, the development of widening participation roles and consultancy for organisations based on my research work. I am, thirdly, an activist-academic, in that I bring my activism into the classroom and the staffroom and use it as the basis of pedagogic and ethical considerations. Many activists in academia choose to separate these two aspects of their lives, other academics eschew activism entirely and some academics limit their activism to become what Mitchell[3] has called 'desk bound radicals.' I make no judgement about these choices. My personal ethic involves

what Doreen Massey[4] has called ensuring we bring 'our lived practice more into line with our theorizing about that practice' or rather, for me, seeing the relationship as one of praxis.

But this relationship between activism and academia is not a simple one and frequently involves conflict. What I want to do in this piece is explore how we can understand the position of para-academic roles and the sorts of conflicts they can create through reflecting on some of the questions raised by my para-academic practice. Ultimately, I want to make an argument that working in para-academic positions may be one way to continue the 'long march through the institutions'[5] and engender social and institutional change, but that there are personal, professional and contextual risks involved in this which demand that we remain critical about this claim.

A BRIEF CAVEAT

I am aware that my fields are relatively resource un-intensive compared to, for example, an analogous position within the natural sciences. What I do does not require lab equipment, chemicals or complex facilities; a well-stocked library or good online journals access is usually enough to keep me busy in terms of my non-teaching work. However, the resource factor is important in making arguments about para-academia because the ability to further our practice is limited by the restrictions of access to such materials. This is particularly clear when it comes to research or consultancy work which needs specialist, technical or complex materials and equipment. Certainly the arguments I will make here would be markedly different if I did need such materials and this caveat should be borne in mind in reading what follows.

PARA-ACADEMICS: BESIDE, MARGINAL OR LIMINAL

Conceptualising the para-academic position is complex. For MacFarlane[6] the prefix of 'para-' denotes a position 'beside' the subject, in this case the traditional academic job. But the specific sort of para-academic roles with which I am most familiar are those which deliver 'unbundled' parts of the traditional academic's job through part-time and temporary roles created to fill gaps in teaching, research capacity and administration. These roles have become increasingly core to the delivery of programmes to students over the last decade (see MacFarlane for more on this) and are now often necessary for the delivery of research. This idea of 'beside' therefore seems more and more inadequate and in need of further interrogation.

The term para-academia can be seen as a form of liminal academe:

> Liminality, in Turner's work, refers to what he calls 'an interstructural situation' that is experienced by people undergoing a rite of passage. [...] For those within the rite of passage, Turner argued, their identity is neither that of the old nor that of the new. [...] the initiands were not enacting institutionalised roles, yet nevertheless were performing the values of the common good.[7]

Thus para-academic roles could be seen as a liminal threshold between statuses, in effect a form of 'time serving' awaiting a 'full' academic role. This idea of liminal academe, though, is based on a presumption that academia is inevitably the desired outcome (just as for initiands passing over the threshold becoming part of the wider society is the goal) and therefore people in para-academic roles must necessarily be seeking to cross the 'threshold' into 'full' academia. Indeed some advice to those in para-academic positions represent these roles as an endurance test in which one must 'keep the faith'[8] in order to survive. The advice for how to survive these roles is to work smarter (inevitable in time-pressured days where the key phrase we hear—and use—over and over is 'time-management'), but also to treat that work as something to be endured and resisted, potentially sacrificing quality of work for

'getting through.' For example, Beals[9] recommends to 'make your lectures formulaic' because 'in reality, you may end up teaching modules for which you have little specialist knowledge. In these cases, you may feel the need to read dozens of monographs [this] will completely devour your time, leaving none for continuing your research.'

There are a number of assumptions I wish to draw out of Beal's argument. First, it works to re-assert the *difference* and in particular the lesser status of the para-academic role by advising teaching styles which run contrary to the accepted current emphasis on student-centred learning (see for example Attard et al. 2010 and Grove 2012[10]) or, beyond that, nurturing students' sense of belonging, which Goodenow[11] describes as feelings of 'being accepted, valued, included, and encouraged by others (teacher and peers) in the academic classroom setting and of feeling oneself to be an important part of the life and activity of the class.' Formulaic lectures suit a tutor-centred pedagogy far more than student-centred, nurturing learning. Second, embedded in this advice is this very notion that the real para-academic desire is for research and that para-academic roles are just a way of supporting a research habit and their demands should, therefore, be minimised.[12] This position, underpinned by an assumed homogeneity about the ways para-academics approach their work, is predicated on the notion that a 'full' academic job at a research-intensive institution is the goal of all para-academics. Whilst some in para-academic roles may hold this ambition, there are those, including those of us considering themselves activist-academics, who will have different sorts of ambitions. As such, the concept of liminality (i.e. as a threshold) is restrictive and is part of a discursive moulding of future academics.

But as Joy says:

> The '*para*' is the domain of: shadow, paradigm, daemon, parasite, supplement, amateur, elite. The para-academic embodies an unofficial excess or extension of the academic that helps, threatens, supports, mocks (parody), perfects and/or calls it into question simply by existing next to it.[13]

Adopting such re-definition, I would argue that the position of most activists in para-academic roles is constituted more by marginality than liminality: 'marginals, like liminars, are also betwixt and between, but unlike ritual liminars they have no cultural assurance of a final stable resolution of their ambiguity.'[14] As marginals, activist-academics find ways of using that marginality to both support activism and to engender change in academia itself. Marginality allows the activist-academic to move through a multiplicity of environments with limited or improvised permission and in ways which can allow the creation of spaces for change within those environments. My experience is that, when based within these marginal roles, activism or change-making has been consistently seen as less contentious than when I participated in or developed similar activities after employment in a non-para-academic role. This is irrespective of what that activism consists of, whether it is attending events, demonstrations or creative work.

To take an example, over a decade ago I was involved in an eighteen-month creative project which culminated in the writing of a play. People I had met through activism, some of whom were also students at the higher education institution where I was then employed on a casual basis, acted as readers during the writing process and also contributed ideas around staging, scripting and character generation. Conducting this work, sometimes within university buildings, although outside of my contracted hours, received praise from academic colleagues for helping 'round out' students' education, showing them that academic learning wasn't always about academic writing, and for inclusive working which linked community and institution. It was seen as positive that students involved themselves in the experience and that I had enhanced the institution's credentials through this project despite my marginal status (or rather the positive view of the work was enhanced by the fact that I was not a 'full' staff member at the institution). More recently, I was similarly involved in a creative project which staged a play each year for three years for which (a changing cast of) people came together through an activist organisation, some of whom were also students on higher education courses at the institution where I taught on a permanent

contract. Here, the involvement of other activists who were also students became a site of contention, discussion and rumour among colleagues, despite the fact that I was not the only colleague involved in projects also engaging students. However, my activism and the presence of activists/students swiftly became targeted as somehow sinister. It was linked to assumptions about my sexuality and my motivations were questioned in a deeply uncomfortable and quite disturbing way. Among some colleagues these rumours were then represented as 'concerns' about my professionalism and accusations against me spilled over into the way the activists/students were also spoken about and treated. As an activist-academic, I was both deeply concerned and astounded. The project continued (and delivered) but not without a personal and professional toll.

But the differing responses were (now out of the maelstrom) fascinating and reflective of both the change in my employment status and changes within the academic context itself. In the most recent experience, my location within a traditional employment model of 'academia' re-cast the previously positive experience as an example of transgression of the 'proper' boundaries of academia. It was assumed that staff and students, out of college hours, should either maintain a complete separation or at least adhere to a hierarchical relationship. It was suggested to me that the situation might be seen as less problematic if I acted as a 'consultant' to the creative project rather than being involved in it as an equal participant, working collaboratively with other activists. In the former experience, when in a position of marginality, I had been allowed to transgress assumed boundaries in a way which was considered uncontentious, presumable because my marginality meant those boundaries were already more permeable. In the latter experience, those boundaries were seen as being absolute and my perceived transgression of them became directly linked to other presumptions about transgression of social norms.

Of course engagement with activist worlds is not limited to those in para-academic positions, but inhabiting activist spaces in which current students are also active has, as the above example illustrates, become a site of contestation in recent years. This is because the 'professionalisation' of

Higher Education becomes synonymous with developing a rigid stratified understanding of the academic role, which is to deliver teaching and assess students' abilities but—crucially—not to engage with them at an individual level (despite the rhetoric of 'individualisation'). Exactly what an activist-academic is supposed to do when current and future students join their activist groups is unclear, except perhaps the presumption is that once one becomes an academic, one stops being an activist.

Thus, the marginal and outsider spaces of para-academia offered chances and choices in how I was active which I now find more circumscribed. La Shure[15] argues that 'viewed in a positive light, liminality [or marginality] provides freedom of movement, but the flip side of that coin is a lack of stability. Being betwixt and between means that you don't belong anywhere'. Whilst not-belonging is often inscribed as a negative, it also offers opportunities; not-belonging can also mean less control executed by institutions. Whereas institutions can assume a degree of control over activities for their full-time, permanent employees, staff employed on temporary and part-time contracts retain relative control over the other hours of their lives. As Askins posits, 'there is a point to make here regarding how institutional context is significant in terms of how we may be active beyond the university.'[16] Although marginal staff may have other demands on them, the day-to-day demands of physical presence, ongoing contact and constant interruptions is decreased by the (literally) outsider position.

MARGINALITY AND THE UNWRITTEN RULES OF ACADEMIA

It should now be clear that I believe marginality (as either a para-academic or as an academic-activist) means not being an 'insider' of any environment. Indeed activist-academics often find the other part of their lives (either academic or activist) renders acceptance more difficult in the opposite spaces. As Turner[17] has conceptualised, 'outsiderhood refers to actions and relationships which do not flow from a recognised social status but originate outside it.' For activist-para-academics, outsiderhood

is inevitable both within and outside the academy; we are constituted as outsiders by the academy (including at times by academic colleagues) and seen with suspicion by fellow activists because of our engagements with academia. As Chatterton[18] recounts, 'we have come under fire from many activists and campaigners who see us professionalising something that should be organic and on the streets.' Outsiderhood is therefore constantly reinforced.

How then can the activist-academic make use of this? Marginality can also allow for opportunities to do academia differently. If we accept the presumption that academics work alongside the students to guide learning, being both part but also not part of the institution can allow that guidance to be done differently. By accepting that insiderhood is generally not conferred on part-time, temporary or marginal para-academic positions, the foothold of the activist-academic is precisely to create the sorts of spaces needed to question the ways in which the neoliberal university operates. The flexibility of working patterns and teaching smaller groups allows para-academics to relate differently to students, including helping develop activist awareness amongst those students who show interest in their subject beyond the classroom. Seminar discussion can raise critical questions, classroom examples can relate to activism and ethical discussions can draw on real-life (and directly experienced) problems. Not only does this invigorate classroom practice but it also allows students spaces for discussion of problems otherwise excluded by a curriculum which is often shaped by its neoliberal institutionalisation. As Chatterton[19] has said: 'engaging with the activist world, while it raises the eyebrows of many senior colleagues, excites and inspires my students.'

Doing things differently also means working with Pickerill's suggestion that:

> Until we challenge our collective obsession with publishing in obscure, albeit highly regarded academic journals, graduate students and early-career academics will have little choice but to do the same. However, for those of us in a position of relative comfort (and this is much earlier than many seem to think) we

have a responsibility to reprioritise how we write. It is not for others to decipher our work. We could so easily write more in the style through which we teach. This is not simplifying our analysis or undermining our academic seriousness, just enabling more people to understand it.[20]

Certainly being in para-academic roles, and now in an institution which does not and never has submitted to the Research Excellence Framework or its predecessors,[21] has allowed me to use my research and my teaching skills in ways that would not be counted in other sorts of institutions. I have consulted with a number of organisations on issues directly connected to my research specialism (violence against women and girls and particularly disclosure), and with other organisations on issues connected with research more generally. This has involved scholarly engagement more broadly than simply publishing in academic journals and writing for academic publishers. I see my research being used in a very practical sense, helping to improve the lives of others. For example with one, small voluntary sector organisation I delivered staff training on including research and evaluation methods that would enable them to represent their work to funders and policy makers. But the mode of doing this is also important. Although I hold expertise in some aspects of this work, I approach it with a sense of skill-sharing rather than being 'an expert' and have learned much from the experience of working with organisations which has enhanced both my academic practices and my commitment to activism.

JUST WAITING TO BECOME ACADEMICS?

Margin employment within contemporary Higher Education clearly has practical limitations. Much has been written about the metamorphosis of the Higher Education sector under neoliberalism.[22] As identified by Ross:

higher education institutions have followed much the same trail as subcontracting in industry—first, the outsourcing of all non-academic campus personnel, then the casualisation of routine instruction, followed by the creation of a permatemps class on short-term contracts, and the preservation of an ever-smaller core of tenure-track full-timers, crucial to the brand prestige of the collegiate name. Downward salary pressure and eroded job security are the inevitable upshot.[23]

That insecurity is true, although to different extents, for both non-para-academic staff and para-academic staff and it is worth noting MacFarlane's[24] warning that 'the binary distinction between "academic" and "non-academic" roles and activities is no longer clear-cut.' The significant difference is that making a living through para-academic roles is much more precarious and contingent on being able to develop and manage networks, multiple employers and income streams; complex, overlapping calls on time, and negotiating flexibility between different office-based tasks. Compared to genuine self-employment, precarious para-academic positions are less free. However, they remain freer than most structured jobs and non-para-academic roles.

Traditionally academia is seen as a vocation[25] to which one is drawn and the achievement of which involves overcoming some sort of existential challenge, a Pilgrim's Progress. In this model, 'academic citizenship is based on the idea of the University as an intellectual collective sustained by individuals with a commitment to service.'[26] However, like many in my academic area, I never set out to become an academic. Growing up as a working class girl in Lancashire, *going* to university was aspirational in itself. The idea that the likes of me would or could *teach* at universities was not part of my experience, even after I progressed to university. I was, however, lucky enough to grow up in a milieu of socially and politically engaged individuals and groups, so it seemed natural that I would be active in social and political causes. This myth of academia is, then, an alien one to me, and whilst I had initially assumed it was my failure as a working-class woman that meant I did not

(and do not) subscribe to such a myth, as someone already feeling the weight of Imposter Syndrome among my largely middle-class colleagues whose familiarity with academia came with their childhoods, this lack of belief in the prevailing mythos just exacerbated the detachment I felt. But realising its status as mythos, I now realise that this myth is used pragmatically to explain away the negative realities of the academic role,[27] to stigmatise those who do not succeed or pursue a traditional academic career and to excuse socio-inequalities in Higher Education.

This myth also propels the way in which para-academia is thought about. The idea of a vocational calling ignores the ways in which universities have operated as societally exclusive rather than inclusive institutions.[28] Wakeling's findings show persistent class inequalities at higher degree level, which have increased since the expansion of undergraduate education and yet:

> Universities [which] themselves express commitment to the cause of widening participation [...] should also be concerned with the social composition of their academic staff: today's PhD students are tomorrow's professors. Just as it is important, for instance, that the House of Commons reflects the diversity of the broader population, so it is of benefit to intellectual life that university teaching and research is carried out by people from a variety of backgrounds with different life experiences. Without such diversity, the production of knowledge is likely to reflect only the concerns and outlooks of a narrow and already privileged group.[29]

There is a known gender and ethnicity bias in Higher Education staffing in the UK, which the Higher Education Statistics Agency (*HESA*) returns demonstrate. *HESA* (2013, reporting on 2011-12) shows that only 12.6% of permanent Higher Education academic staff are from minority ethnic groups, whereas 15% of what HESA designates as 'atypical' (defined as 'members of staff whose contracts are those with working arrangements that are not permanent, involve complex employment relationships and/

or involve work away from the supervision of the normal work provider'
i.e. para-academic roles) employees are from minority ethnic groups.
Similarly in terms of gender, women constitute 44.5% of permanent
academic staff (full and part-time) but 46.9% of atypical employees.
Does this mean that we should assume that this 'vocational calling'
is heard selectively by class, gender and ethnicity? Or that the notion
of the vocational calling is itself socially constructed within (white,
middle-class male) groups? Moreover, intersectional pressures exist in
the ways in which decisions about academic progression are made by
tomorrow's professors, as Wakeling[30] says: 'women are less likely than
men to proceed immediately to postgraduate study once other factors
are controlled. This seems to be in addition to social class differences,
which remain within both genders.' Thus the very notion of the vocational
calling should be treated with scepticism. But alongside this, any ideas
around the desirability of para-academia should also be treated sceptically
where para-academic status is being used to perpetuate existing socially
stratified exclusions. Using *HESA's* 2011-12 statistics,[31] it's clear that
the gendered and ethnicised differences are exaggerated in the para-
academic divisions—for example, for every male academic across all
categories there were 0.8 female academics; for every man in a tenured
academic role there were 0.7 women. For every 'unbundled' (i.e. teaching
or research only) male post there were 1.2 similar female posts. As such
the outsiderness of the para-academic position, while perhaps part of the
'long march through institutions' may well also be replicating existing
socio-inequalities within academia.

HOW BEST TO MAKE CHANGE?

But I now find myself in the position of questioning, as an
activist-academic, where I am best placed to make most difference.
In some ways, para-academia afforded opportunities to engage with
academic activities and structures in unorthodox ways but it also clearly
has not substantially changed the make-up of academic institutions,

even if it does offer institutions ways to mask such inequalities to their students through the use of para-academics as student-facing staff. This is not a new phenomenon and we should be careful not to present it as such. There has been a growing use of para-academic staff over the last decade, but such marginal positions have a long history in the UK higher education sector—in 2003 (the first time such data is available from *HESA*), 45% of academic employment in higher education institutions were fixed-term contracts.[32]

I do not aim to offer any solutions to these questions but to offer some pertinent questions in the contemporary higher education setting. I think para-academia can work, as Joy says above, as a challenge or threat or an interruptive position to the traditional models of academia and this can only be a positive thing. But for para-academia to do so, those in such positions must be self-aware and critical of the ways in which para-academia operates as both inclusion and exclusion. They must also be mindful of the sorts of discursive mythologies being subscribed to in creating the contingent negotiations which characterise para-academic existence. I appreciate I am writing from the position of now being permanently, full-time employed but what I am not doing here is a nostalgic and hypocritical call to arms for others. It is more an assessment of the lessons I've learnt from both sides of the fence and in this I am guided by Massey[33] where she says: 'the various products of intellectual labour are here conceptualised as engagements in the world of which they are inextricably a part. We write of this a lot. The question I want to ask is whether, in our actual lives as academics, we really manage to live it.'

Notes

1 Bello, Walden (2008) 'Why Am I Engaged?' *Antipode*. 40: 3, 436-441, 440.

2 Macfarlane, Bruce (2010) 'The unbundled academic: How academic life is being hollowed out' in Devlin, M, Nagy, J, and Lichtenberg, A *Research and Development in Higher* Education: *Reshaping Higher Education*. 33, 463–470.

3 Mitchell, Don (2008) 'Confessions of a Desk-Bound Radical' in *Antipode*. 40: 3, 448-454.

4 Massey, Doreen (2000) 'Editorial: Practising Political Relevance' in *Transactions of the Institute of British Geographers*, 25: 2, 131-133, 133.

5 Watts 2001 in Mitchell, Don (2008) 'Confessions of a Desk-Bound Radical' in *Antipode*. 40: 3, 448-454, 449.

6 MacFarlane, 2010.

7 Field, John and Morgan-Klein, Natalie (2010) 'Studenthood and identification: higher education as a liminal transitional space' Conference Paper presented at the 40th Annual SCUTREA Conference, 6-8 July 2010, University of Warwick, Coventry available at http://www. leeds.ac.uk/educol/documents/191546.pdf. Last accessed 29 June 2014.

8 Beals, M. H. (2013) 'Keeping the Faith: Researching as a Part-time Teacher or Teaching Fellow' in Institute of Historical Research HistoryLab blog posted 7 August 2013. Available at http://historylabplus.wordpress. com/2013/08/07/keeping-the-faith-researching-as-a-part-time-teacher-or-teaching-fellow/. Last accessed 11 August 2013.

9 *Ibid.*

10 Attard, Angela et al (2010) *Student-centred learning—Toolkit for students, staff and higher education institutions* Brussels: European Students' Union & Education International; Grove, Jack (2012) 'Teaching should be student-centred: discuss' in *THES* available at http://www.timeshighereducation. co.uk/news/teaching-should-be-student-centred-discuss/419033.article. Last accessed 29 June 2014.

11 Goodenow, Carol (1993) 'Classroom belonging among early adolescent students: Relationships to motivation and achievement'. *Journal of Early Adolescence,* 13, 21-43, 25.

12 Beals is not alone in this presumption, see also Muller, Nadine (2013) *Research Survivors: Tips by Senior Academics and Professionals* available at http://www.nadinemuller.org.uk/category/research-survivors-tips/ Last accessed 13 August 2013.

13 Joy, Eileen (2012) 'Disturbing the Wednesday-ish Business-as-Usual of the University Studium: A Wayzgoose Manifest' in *Continent* 2.4, 260-268. http://www.continentcontinent.com/index.php/continent/article/view/119. Last accessed 29 June 2014.

14 Turner 1974 in La Shure, Charles (2005) 'What is Liminality?' Available at http://www.liminality.org/about/whatisliminality/ Last accessed 5 August 2013.

15 La Shure, Charles (2005) *What is Liminality?* Available at http://www.liminality.org/about/whatisliminality/ Last accessed 5 August 2013.

16 Askins, Kye (2009) '"That's just what I do": Placing emotion in academic activism.' *Emotion, Space and Society.* 2, 4–13.

17 La Shure (2005).

18 Chatterton, Paul (2008) 'Demand the Possible: Journeys in Changing our World as a Public Activist-Scholar.' *Antipode.* 40: 3, 424.

19 *Ibid*, 421.

20 Pickerill, Jenny (2008) 'The Surprising Sense of Hope'. *Antipode.* 40: 3, 483-487, 485.

21 Making the institution marginal amongst assessment frameworks for UK higher education institutions.

22 See for example Amsler, Sarah and Canaan, Joyce (2008) 'Whither critical pedagogy in the neo-liberal university today? Two UK practitioners' reflections on constraints and possibilities' in *ELiSS*, 1: 2; Canaan, Joyce and Shumar, Wesley (2008) *Structure and Agency in the Neoliberal University*, London: Routledge; Hall, Stuart (2007) 'Universities, Intellectuals and Multitudes: An Interview with Stuart Hall (by Greig de Peuter)' in Coté, Mark, Day, Richard. J and de Peuter, Greig *Utopian Pedagogy: Radical Experiments against Neoliberal Globalization*, Toronto: University of Toronto Press, 108-28; WASS Collective (2007) 'Gender Transformations in Higher Education' in *Sociological Research Online* 12 (1). Available online at http://www.socresonline.org.uk/12/1/lambert.

html. Last accessed 5 August 2013); Levidow, Les (2002) 'Marketising higher education: neoliberal strategies and counter-strategies in Robins, Kevin & Webster, Frank (eds.) *The Virtual University? Knowledge, Markets and Management.* Oxford: Oxford University Press, 227–248; Slaughter, Sheila & Rhoades, Gary (2000) 'The Neo-Liberal University', *New Labor Forum.* 6, 73-79; Bourdieu, Pierre (1998) 'The Essence of Neoliberalism'. Available online at http://www.analitica.com/bitblioteca/bourdieu/neoliberalism.asp. Last accessed 5 August 2013.

23 Ross, Andrew (2009) *Nice Work If You Can Get It: Life and Labor In Precarious Times.* London: New York University Press,176

24 Macfarlane, Bruce (2012) 'The rise of the para-academics.' Conference Presentation for *Changing Conditions and Changing Approaches of Academic Work,* Berlin 4-6 June, 2012

25 See for example Evans, David (2010) "What's your vocation?" at *The Chronicle of Higher Education Blog* posted November 5. Available at http://chronicle.com/blogs/onhiring/whats-your-vocation/27668 Last accessed 9 January 2014 or Barcan, Ruth (2014) 'Why do some academics feel like frauds?' in *Times Higher Educational Supplement* 9 January 2014. Available at http://www.timeshighereducation.co.uk/features/feature-why-do-some-academics-feel-like-frauds/1/2010238.article Last accessed 9 January 2014.

26 Macfarlane, 2010, 464.

27 See for example Gill, Rosalind (2009) 'Breaking the silence: The hidden injuries of neo-liberal academia' in Ryan-Flood, Róisín and Gill,Rosalind *Secrecy and Silence in the Research Process: Feminist Reflections.* London: Routledge.

28 See for example Ahmed, Sara (2012) *On Being Included: Racism and Diversity in Institutional Life.* Durham: Duke University Press.

29 Wakeling, Paul (2009) *Social Class and Access to Postgraduate Education in the UK: A Sociological Analysis* Unpublished PhD Thesis University of Manchester. Available at http://ebookbrowsee.net/paul-wakeling-phd-thesis-2009-social-class-and-access-to-postgraduate-education-in-the-uk-pdf-d69065144, 295

30 Wakeling, 2009, 286.

31 HESA (2013) *Staff Introduction 2011/12* available at http://www.hesa.ac.uk/ index.php?option=com_content&task=view&id=2729&Itemid=278 Last accessed 13 August 2013.

32 HESA (n.d.) *Staff Data Tables* available at http://www.hesa.ac.uk/ index.php/component/option,com_datatables/Itemid,121/task,show_category/catdex,2/ (accessed 26th November 2013)

33 Massey, 133.

Louise Livesey teaches Sociology and Women's Studies at Ruskin College, Oxford. She is also an activist. Her particular interests are violence against women, the relationship between feminist activism and academia and praxis. She is currently particularly interested in forms of institutional and organisational control as well as how individuals negotiate potentially conflicting identities.

NO MORE STITCH-UPS!

Dr Charlotte Cooper

I have been a fat activist for about 25 years and I have noticed is that it is very difficult for fat activists to get a fair hearing when they agree to appear in the media.[1] This is a problem because it means that alternative perspectives on fat never get a proper airing, even though they can illuminate the issues profoundly.

To address this, I produced some research about media misrepresentation and possible strategies for change. I called the research *No More Stitch-Ups! Developing Media Literacy Through Fat Activist Community Research*. This chapter is an edited version of that essay, based on the survey's main questions. I also outline my methodology and, towards the end of the chapter, discuss some of the implications of the project.

It was important to me that the work not be limited to a series of complaints about malpractice, but to draw on community expertise and use it to help empower people to demand something better. Although this work was specific to fat activism, it also reflects how minorities and activists are treated by the media more generally. This piece of work is aimed primarily at supporting fat activists as people in the public eye but it is also aimed at people who work in media industries, activists more generally, and anyone interested in the dynamics of media production, representation of minority views, and mass communication. I hope that researchers will take note of my methodology and consider the

political ramifications of their work, and I encourage activists to consider developing their own research agendas. As a newly-qualified PhD facing the realities of the university career system, I am interested in how I might develop research beyond the academy. *No More Stitch-Ups!* has shown me that I can create research of worth from the margins of academia and that I do not need institutional patronage in order to act. In this way, this chapter is also aimed at advocates of Research Justice and those interested in knowledge production beyond the traditional boundaries of academia.

Like all research, this work is a product of the researcher's interests rather than 'truth'. It is not a universal blueprint for managing media invitations. Each encounter is different, and fat activists' experiences will vary according to factors such as gender, ethnicity, disability, class and so on. Further work is needed that addresses the effects of these intersections on fat activists' media engagement.

METHODOLOGY[2]

At the end of May 2013 I invited fat activists within my social networks to participate in a survey about how they are treated when they engage with media makers. By media I meant a broad range of public platforms. I introduced the idea of the survey with a blog post about my friends' experience on TV, and my own history of being misrepresented as a fat activist.[3]

I worked with few resources: alone, on a low income and without university or institutional support. I made use of my flexible working conditions, my computer and its software. I used an online survey generator to collect data. SurveyMonkey's free service limits the number of questions users can ask, but it is sophisticated. I publicised the survey through my online social networks and closed it to new entries when I had reached the limit of the amount of data I could handle. I explained the purpose of the survey clearly, outlined my process, the benefits and risks of taking part, offered people the option of dropping out at any point,

and ensured participants' confidentiality. I used pseudonyms throughout.

I wanted to invite people to talk about their experiences in their own words, to provide a rich picture of what it is like to be a fat activist engaging with media. This is a basic premise of qualitative research. So, after gathering some demographic data and asking some closed questions about the types of experiences people had with media, I asked open-ended questions where participants could describe what happened in their own way. I stripped out identifying details from this data and analysed it with software called hyperRESEARCH to draw out themes and common experiences.

Twenty-eight people responded to the survey. I did not know everyone who participated, but they are connected to me through fat activist networks. Inevitably, this limits the demographic spread of the data, and 28 is a small sample, but it represents a peer group's experiences of engaging with media as a fat activist. I encourage others to build on this work by gathering or generating more data from different demographics about fat activism and media work.

The sample are currently residents of the following countries: USA 13 (46.5%), Australia 6 (21.5%), UK 5 (18%), Canada 1 (3.5%), Denmark 1 (3.5%). One respondent reported bi-national status in the UK and USA (3.5%) and one offered no response (3.5%). The dominance of the USA reflects the readership of my blog and possibly indicates the higher public profile of fat activism in that country. Participants from Australia and the UK led the rest of the sample and one other European contributed, perhaps reflecting the English language bias of the survey. Overall, the participants represented the heavy North American and Western slant of fat activism as it is popularly understood, which I have critiqued elsewhere.[4]

I did not gather information about the sample's identities because free surveys using SurveyMonkey allow for only a limited number of questions and I could not afford a paid account. There are good arguments to be made about the differing experiences of engaging with media workers as fat activists in terms of gender, ethnicity, sexuality, disability, class and so on, and I encourage other researchers to take up this work.

Meanwhile, readers should not assume that the sample consisted of straight, white, middle-class men.

Twenty-seven of the respondents thought of themselves as fat, one did not. This is significant because fat people, and fat activists, rarely get to tell their own stories. Our voices are more often mediated in research by normatively-sized academics, for example, or through medical discourse.

The sample was largely polarised between relative newcomers and people who have a lot of experience of media engagement: 35% had had 1-5 experiences, and 32% had lost count of the number of times they had spoken to media. Engaging with media invariably meant being interviewed by someone. I listed a wide range of media types: academic journal; advertisement; film; magazine; newspaper; photographs; radio; social media; television; website; wire service; zine. Newspapers were the most predominant outlets, with 75% of the 28 respondents saying they have appeared in them, and television came in second place, with 62%. This suggests that fat activists are being courted by Big Media, and that fat activism is being recognised as part of a bigger discussion about fat.

In thinking of their appearances in media, most respondents felt stitched-up some of the time (39%) with 20% most or every time. A minority, 10%, said that they had never felt stitched-up. These answers underscore the ambivalence that participants express in later answers, they have mixed feelings about their media appearances. People self-selected to participate, one of the drawbacks of using online surveys, so it could be that they are not typical of all encounters between fat activists and media. Nevertheless, the purpose of the survey was not to record how often people feel stitched-up, but to examine what happens when they are.

HOW DID THEY [MEDIA] STITCH YOU UP?

Initial contacts from media workers, often researchers, were characterised by assurances given to inspire trust and confidence, though not everyone is drawn in by this, as Selena says: 'I've had reality shows try to get me

to help them recruit fat activists, but their assertions about interest in our 'message' was unconvincing'. Nevertheless, media makers often lay on the charm at this stage. Sara said that the programme makers for a TV show in which she appeared promised:

> [...] they wanted to do something different—that they wanted to represent a different perspective, that we'd be 'taken care of.'

But these early promises are often empty or unsustainable. Fat activists turn up for a live debate, for example, to find that the subject they had agreed to discuss has been changed at the last minute. This may be typical of the fast pace of modern media but it is nevertheless disconcerting and undermining to experience and gives the impression that one fat-related subject is the same as any other.

> It was a current affairs television show. I was told that the story would be about childhood obesity and stigma. In reality, the story mainly featured a bariatric surgeon who wanted to operate on teenagers. (Kate)

Swapping subjects at the last minute also implies that fat activists do not have areas of special expertise and are similarly interchangeable.

By far the biggest problem that fat activists face when speaking to media is selective editing that reinforces a fatphobic, sensationalist or ignorant agenda. Such editing happens via the use of quotes, or altering footage, or simply inventing ridiculous things, for example:

> There was a promo for the programme in which a bouncy castle collapsed on a few of the other contestants. This was due to the fan coming out of the castle and not because there was too much weight in there. The programme suggested that they broke the castle. (Naomi)

The use of simplistic anti-fat messages, or visual clichés such as headless fatties,[5] are an important part of this selective editing, as is the framing of fat activists through other editorial choices, for example:

> Lots of joking, punning headlines and visual fat jokes in illustrations of otherwise decent articles. (Selena)

Much of the sample had undergone a character assassination at some stage of their engagement with media, where their integrity and personhood as fat people was publicly attacked:

> [The *New York Times* reporter] insisted on trying to get me say that I believed the [quack weight loss gadget] would work. I explained to him how absurd that was, given my long history as a fat advocate. I thought I had cleared it all up and then I see he printed the article with my 'quote' in it anyway. (Aileen)

Fat activists do not consent to this treatment when they agree to participate in media production, yet there are few perceived rights of reply or remedy once the article or piece has been published or broadcast. As Aphra experienced, 'I demanded a retraction, and they only corrected my title.'

As well as the more dramatic instances of being stitched-up, the sample reported a pervasive lack of care for them, lack of understanding for the subject, and a feeling that they were not being listened to:

> Some academics using my experiences/photos in their work have treated me as a curiosity or a resource rather than human. (Natasha)

This creates an atmosphere of dehumanisation, where contributors who offer their insights in good faith are treated as fodder. Where fat activists have good experiences when they engage with media, it is regarded more as a matter of luck than design.

A key presentation method that undermines fat activist voices is the use of the expert to represent the dominant view of obesity and act as a supposedly objective voice of reason and authoritative confidence. This positions the fat activist as someone without expertise, unreasonable, lacking in professional identity or power. The expert invariably brandishes high medical status within obesity discourse, or benefits professionally from the exploitation of fat people in other ways, perhaps as a member of an anti-obesity Non Governmental Organisation, or a representative from weight loss industries (they are not mutually exclusive). The experts are never fat themselves—fat people are objects of their organisations and institutions, not leaders or managers. The experts' normative embodiment reproduces the idea that expertise around fat is not to be found from fat people, and that the problem of fatness is both proposed and solved by thin people. In this context, fat people are reduced to their bodies instead of being seen as full human beings with intelligence and agency. As Steve states: 'Most commonly they made the interview about me and my body instead of my expert opinion.'

Fat activists who participate in media are often positioned as part of a debate against such experts, but this format is contentious. Media makers use debate to instigate a conflict between what they perceive to be polarised positions. Because of this polarisation, productive dialogue and consensus is rare; the debate produces winners and losers rather than dialogue. Debate implies a balanced discussion, but this is not an evenly balanced encounter. Debate itself is embedded within classed, gendered and colonial constructions of civilised discourse within which the uncivilised (the angry activist) are put on the defence and destabilised. Whilst activists have the advantage of first-hand experience in these debates, they are otherwise disadvantaged against the institutional and social power of the expert, their usual contender, a power relationship in which they are already marginalised. It is not always clear in advance who the fat activist will be debating; media production can be a last-minute affair, but it could also indicate that the media makers want to unsettle the debaters in order to get more exciting results. Although they create this situation, media makers refuse

accountability for it, positioning themselves as neutral facilitators, but this is disingenuous.

WHAT EFFECT DID [YOUR TREATMENT BY THE MEDIA] HAVE?

Personal reactions to being dehumanised, humiliated, lied to, used, misrepresented and ridiculed in front of an audience ranged from irritation, frustration and relief 'that it wasn't worse' (Tina) to feelings of anger, betrayal, powerlessness and shame. Other participants stated that they felt violated and depressed, afraid of going out, and that being stitched-up reawakened old feelings of being bullied and of social anxiety:

> This particular example traumatised me. It's been a week and I'm not recovered—I'm forcing myself to leave the house and talk to people. I am burnt by it, distressed, angry, furious, teary, flat. (Sara)

It should be stated that these emotional responses do not exist in a vacuum; they re-traumatise and re-victimise fat people, who already experience elevated levels of discrimination and harassment when compared to the general population.[6]

For some, a media appearance was the gift that went on giving. Online reader comments are notoriously caustic and Sara 'had to hide from the backlash of emails.' For Brenda, harassment segued into serious threats:

> But worst of all, drew trolls and abuse to me—I have been subjected to hate campaigns online after appearing in the media where the piece has been unfavourable towards fat people. I have even received death threats.

One participant described how she continued to be harassed by other media makers:

> The second effect was the stream of invitations that followed for months afterwards from TV and radio producers and researchers

who wanted me to appear in documentaries about 'why fat people lie so much' (yes, seriously...), or to 'advise' on TV shows that would 'teach' fat people where they were going wrong. (Catherine)

The same participant reported that their experience with Big Media led to them losing professional credibility with the group of people who had supported their research.

The immediate and most upsetting effect was that the participants in my research recognised my relatively unusual family name and thought that I had stitched them up. I was the subject, quite understandably, of aggressive verbal attack on the discussion forums through which I had recruited them, and they felt very betrayed. It was made worse by the fact that I was moving house on the day the story broke, and without an internet connection, which made it hard to intervene. I eventually contacted the forum moderator to explain and he posted a message on my behalf. Peace was restored and they were very understanding about what had happened, but I felt terrible for them to have been so insulted, and for that insult to be attached to me. (Catherine)

These unpleasant experiences led participants to reassess their availability to do media appearances, and engendered feelings of cynicism and fear in the community. Some participants decided to withdraw completely from media work, either temporarily or longer-term. Others became more vigilant in how their image is used. Few participants responded to this question with examples of the possible social effects of their experiences. Tina remarked about how fat activists might be reluctant to put themselves forward as public speakers in a context where they are likely to be attacked.

As such, positive media portrayal of fat rights views (and related topics, like anti-healthism views) is vitally necessary for us as fat people. And yet attempting to do that is terribly damaging

for the individuals who bravely put themselves forward to be quoted/photographed/discussed. It's very difficult to see how best to tackle this. I have the sneaking suspicion that it can't be done without painful costs for those who do it (see previous examples of other civil rights movements). *deep sigh* Seeing what happens to other fat people who do put themselves in the media, is something that very effectively prevents me from taking part in the media much at all. Ah yes, the ol' silencing technique. (Tina)

The reluctance of fat activists to engage with media is to the detriment of the movement more generally, and prevents the issues from being raised in wider society. This is not to say that fat activists should take abuse by media makers on the chin, the argument here is that unfair and unethical media practice has profound negative consequences and contributes to a spiral of marginalisation for groups of people, including those who are fat, who are already pushed to the edges. But, where fewer experienced fat activists are prepared to speak because they are afraid of the consequences, it means that fat activism remains a fringe activity and is treated as though it has little social relevance. In addition, it means that media makers are more likely to approach inexperienced fat activists whose contributions to a public discourse of fat can lack sophistication and insight.

IN TERMS OF REPRESENTING FAT PEOPLE AND ISSUES RELATING TO FAT ACTIVISM, OR CRITICAL APPROACHES TO 'OBESITY', WHAT ADVICE DO YOU [FAT ACTIVISTS] HAVE FOR MEDIA MAKERS?

The responses to this question were peppered with the most expletives, exclamation marks, capitalisation and general sense of frustration and urgency compared to the rest of the project. The sample felt passionate that media workers can improve their representation of fat activism, and they offered a series of suggestions.

Media makers should stop certain practises that are already widespread, for example they should resist using fatphobic stereotypes, avoid the

gladiatorial debate format, and be respectful of fat activists, particularly in terms of language used:

> Respect the terms of self-description that the interview subjects use; if I call myself fat, just say fat, jeezus. (Chelsea)

They should have a basic understanding of the issues involved in fat activism, especially research:

> On health studies: Don't report studies that talk about weight loss unless there is at least two years of follow-up data, and report results in terms of the entire group who started the intervention (dropouts and all). Ask and report on whether the researchers studied a special group like people seeking help and don't allow generalisation to the larger group. Ask and report on whether researchers controlled for SES [Socio-Economic Status], weight cycling, social support/stigma and physical activity as potential alternate hypotheses for what may be affecting health. (Grace)

They should listen. Inherent to the listening is respect for the validity of the topic, space to speak, power-sharing and a belief that critical work on fat is already a hot story that needs little embellishment.

> I would ask them to listen rather than hear what they want to hear. Fat activism / critical obesity studies is a great story, if only they'd stop to hear it. (Catherine)

Of other aspects of media production that could be altered, Chelsea suggests that 'the person who does the interview should be involved in all the peripheral text (pull quotes, headlines, captions)' so that the continuity of the media encounter can be traced for accountability. This is not so far-fetched given that industry practices are changing and where, for example, the work of writing, editing, uploading material as well as producing accompanying video segments becomes the

responsibility of one journalist rather than many. Grace has two further suggestions; the first acknowledges the influence that advertising has on editorial content, and the second recognises the necessity for developing diverse fat activist voices in public in order to challenge all forms of oppression:

> Don't accept advertising from the weight cycling industry so you can afford to be critical of it in your editorial content.

> Give more of the media exposure to people of colour, who are being targeted as too fat, too unhealthy, and 'needing education' by racist governments and industry, and whose voices are rarely heard as authorities on their own experience.

Participants recognised that a fair representation of fat activism involves a shift in journalistic values. This is rooted in ethics and actions that have a harm-minimisation philosophy at the heart of their public service, as outlined below:

> Mostly, I feel the same eroding journalistic ethics should apply: document and credit your sources, fact check, obtain consent and permissions, be clear about your conditions if they do not allow for editorial review, don't misrepresent your intentions (exploitative), don't hatchet someone's words to misrepresent their meaning and undermine their voice (unethical); and don't dehumanise us by stripping us of our ideas, identities, faces, rights, and, when applicable, dignity. (Aphra)

It also entails the development of a more reflexive practice. This means journalists understanding the motivations in representing fat activism, considering the relationship to fatness and potential critical understanding of fat hatred, and addressing prejudices. Selena sums this up succinctly:

Think of a fat person you know and love when you are writing your story. And think of how much pressure there is for you to stay thin and how much you resent it.

WHAT ADVICE DO YOU [FAT ACTIVISTS] HAVE FOR OTHER PEOPLE THINKING OF TALKING ABOUT FAT IN THE MEDIA?

Most of the sample felt that they had been stitched-up at various times, to greater and lesser degrees. None of the participants said that fat activists should not try and work with the media; however they offered many caveats and snippets of advice for those thinking of going public.

Activists were urged to have low expectations of what working with media makers might entail and prepare 'to be personally insulted,' (Steve), for 'bullshit' (Chelsea), 'for the worst' (Sofia). Sara offered the following recommendation: 'If you think you're being cautious, be more cautious. Trust no one, even if they seem to be leftie, kind, charming, and a good listener.' Grace suggested that people be realistic about what can be achieved:

> Manage your expectations of yourself—even when it goes really well, it is almost always a tiny slice of what you really want to say. Be in it for the long haul. (Grace)

Activists may be geographically and socially isolated from fat activist communities, or other forms of supportive community. They may be new to the movement and feel a great responsibility to speak out, even at the expense of their own safety. They rationalise that engagement with Big Media must happen, because of the potential audience reach, and that the negative side-effects are merely unfortunate. This comes from a mind-set that all publicity is desirable regardless of the cost, but it is unsustainable and is a crucial factor in activist burn-out. Survey participants reiterated the importance of respecting one's instincts about taking part in a media event. Referring on (passing on media makers' contacts to others, not

releasing people's private details to researchers, etc.) and walking away are legitimate methods of handling an enquiry.

> Have other people you can refer the request to if it seems OK but you are not able or inclined to do it so you don't feel like the only person doing the work—and it gives different people a chance to be heard. (Grace)

Aileen, an activist with many years of experience, provides an important reminder: 'Not doing one interview won't make or break the movement.'

Where fat activists do decide to participate, survey respondents advised doing some background work such as building a relationship with the media maker; working with trustworthy people; researching them and their previous work; asking critical questions of them; considering the reasons for media work and maintaining one's ethics and values.

> Take a deep breath and think about the media involved. Is it controlled by a community that you know, trust, are part of, want to address? Have you watched it, seen it, listened? Is the tone in general consistent with the conversation you'd like to have? Is there a specific reason that you want to do this interview? Have you told the journalist the reason? What was their response? Does it seem likely that the conditions involved will meet your goals? Are you at a moment in your work at which public scrutiny would be likely helpful or harmful? I developed rules: I don't talk about my family. I don't meet media at my home. I try to keep the focus on the thing itself, in my case, usually a book. I try to check in with my own core values when I'm asked to do something that I'm not sure about doing. (Selena)

Fat activists should weigh up the issue of payment when deciding about working with media. Whether or not it is possible to negotiate payment for participating in an interview or acting as a consultant will

vary according to the kind of media with which they are working. In some forms of media, especially academic publishing, the assumption is that participants have institutional support and no payment is offered, even though academic publishers are often profit-driven. Fat activists should ask if payment can be made, and negotiate, but be prepared to hear that there is no budget or that expenses only are covered, which may or may not be true. Payment does not necessarily mean immediate financial compensation; it could refer to future sales that publicity may bring, for example, or non-financial benefits such as increased visibility or general promotion. The issue of whether or not to work for free raises questions about who benefits from a media engagement, community responsibility and self-promotion, fat activist celebrity culture and neoliberal individualism in relation to media more broadly, all of which are beyond the scope of this chapter.

One participant mentioned a work-related resource of which she was able to make use, and how this affected her decision to do media:

> In work that I have done since with the media (on other, less contentious topics), I have worked with specific journalists carefully chosen by a discriminating and sensible press officer (I work in a university, so this is an option available to me). This limited the craziness, but I still feel very vulnerable. So be careful. (Catherine)

Not everyone will have access to an institution's press officer, but there may be other resources available that can help ameliorate the difficulties of developing a public life for your work.

Activists in the sample proposed other strategies once a media engagement has been accepted:

> Get the questions ahead of time, plan your answers, reserve the right to review before publishing and don't be afraid to pull your approval. (Moxie)

It should be noted that media makers do not always want to release their questions ahead of time. They may argue that this is to enhance a feeling of spontaneity, but they may really want to maintain an upper hand. It may be that they do not yet know their questions, or that things are likely to change at the last minute. Whether or not questions will be available beforehand, and will be used during the encounter, cannot be ensured, and will vary, but it is acceptable to ask for them.

Activists may not be able to prevent being stitched-up, but they should ensure they have a back-up recording or transcript of the interview, 'ie your unedited/uncompromised words' (Naomi), so that editing and stitching-up is easier to identify and bring to people's attention if the worst happens. I post my own unedited version of interviews on my blog alongside the published version where I can. This has led to apologies and compensation where I have been misrepresented.

During the interview, the idea that one should 'stay cool' was valued by the participants in terms of doing media work successfully. Having a professional identity to draw on can help engender respect from the interviewer and enable fat activists to appear more credible. But staying cool presents some contradictions; for example, Steve says that fat activists should not get defensive, whereas Davina says that they should defend themselves:

Stay on message and don't get defensive. (Steve)

Be prepared to defend yourself, but always stay calm. Be confident. (Davina)

It is up to the person themselves how they handle defending or not defending. Given that media makers may be seeking to rile fat activists with personal remarks or devil's advocate questioning, defending is a strategy intended to undermine the participant and to produce sensationalist media, so some activists refuse these kinds of events:

> Don't participate in media that is about 'defending' your side or trying to convince someone that you have a right to exist, they don't actually want to listen they just want to exploit your desire to connect, I try to approach any interview as an opportunity to educate from my own personal knowledge. I don't do debates if at all avoidable. (Moxie)

Grace has her own tactic for avoiding defensiveness, and this is simply to listen carefully to the questions and deal with them directly, even if they appear facile, irrelevant and insulting. The drawback here is that it is difficult to disrupt the agenda set by the questioner, or to use the interview to develop a more radical discourse.

> I really try to address exactly what they are asking, contrary to a lot of media training, because I think what they are asking is what a lot of people are thinking, and I want to get them from there to here. (Grace)

Nevertheless, what helps fat activists to feel secure and 'stay cool' is the knowledge that they have valuable things to say and that they are already embedded within communities who seek social change concerning fat people:

> Remember: you're not the underdog, you're the expert who is pointing out serious flaws in science and/or society. (Aileen)

These valuable offerings are not mono-dimensional, they are intersectional and enable activists to bring many different themes to the table, enriching the media encounter:

> For many people being fat is inseparable from other identities like race and class. I like to use media as a way to discuss and highlight all the parts of myself so if they want to interview me because I'm fat ok, but we're also talking about racism and food justice and being poor. (Moxie)

Two participants urged fat activists to resist the lure of being cast as 'the exceptional fatty' or of being groomed for celebrity or spokesperson status.

> While promoting your work, credit the work of your/related communities, as your work doesn't live in a vacuum and people are likely unaware that such a community exists. (Aphra)

Demonstrating how one is embedded within different communities and themes humanises fat activists and illustrates the collective and interdependent nature of social change.

Antoinette's proposal that one's appearance is important strikes me as more complex than it first appears:

> Pay attention to your grooming. You need to look like a million bucks if you want to be taken seriously. (Antoinette)

'Looking like a million bucks' is a strategy that this participant finds helpful, but it means different things to different people, is loaded with cultural assumptions, and may backfire. In a media discourse saturated with fatphobia, fat people will never be able to convince audiences that they 'look like a million bucks' and, indeed, many fat activists would want to dismantle the idea that appearance is everything 'if you want to be taken seriously'. Perhaps what Antoinette is getting at with this statement is that what a person wears can affect their confidence and portrayal, and appearance is another thing that is being judged when a fat activist does media work.

I want to critique the idea that fat activists should stay cool, even though the survey participants find this idea valuable. Staying cool is linked to a value of respectability in fat activism, that is, of appearing rational as a means of seeking access to power, or of appearing as though one already belongs amongst the powerful. It might be connected to the avoidance of more painful public humiliation, something that fat people experience regularly, personally and collectively. If there is rapport and the relationship with the media maker is sound, and they are trustworthy,

coolness, being 'well-dressed' and being charming can certainly go a long way in ensuring a positive outcome. But in instances where journalists and media producers are intent on annihilating fat activists, these tactics will not protect anyone from being misrepresented. Such strategies are simultaneously located within a bourgeois, liberal sense of politeness and respect for authoritarianism that keeps fat people in their place.

Not staying cool or being charming could be a different possible strategy. Jackie Wykes, whose experience on an Australian talk show helped instigate this project, produced *Fifteen Seconds of Bitchface*, a video constructed of clips from that appearance.[7] Wykes had been invited to the show as a main guest, but her comments were edited out and she was rendered by the programme makers as an angry, glowering, unreasonable fat activist. In collating these clips, Wykes not only demonstrated her disgust at being reductively represented, but also the emotional effects of such stereotyping. *Fifteen Seconds of Bitchface* is both hilarious and a result of Wykes's pain. In producing the video, Wykes did not remain calm and respectful; she reclaimed her power, expressed her feelings clearly, and created a picture of herself that is sophisticated and expansive. She revealed and refused to be complicit with the Machiavellian workings of the TV show's producers, including their fatphobia. The value of staying cool is understandable, but in offering these comments I would like fat activists to appreciate that not staying cool has radical potential, and that those who lose their cool should not be shamed for doing so.

What happens after the interview can help solidify a good media experience. Preparing aftercare with or without other people and creating space to reflect, rage, delight or commiserate is regarded by the survey participants as part of the work of engaging with media.

> Have a group of people who are cheering for you no matter what happens, in case things go badly, because you can't control everything. (Grace)

REPRESENTING FAT ACTIVISM IN A WIDER LANDSCAPE OF JOURNALISTIC ETHICS AND POWER

This chapter is not about fat people's media portrayal in its broadest sense; there is a growing body of interpretive literature about that within Fat Studies.[8] Instead it is about a particular kind of representation: when fat activists criticise obesity discourse in public, often in news media. This type of media representation is significant because fat activists can have a direct effect on this representation. It also matters because fat activists' critical voices are dangerous: they threaten weight loss corporations, they threaten valuable advertising contracts and they are also threatening to media that relies on that advertising. No wonder Big Media (established, dominant, corporate, mainstream media outlets that have a large audience reach) consistently reproduces the belief that there is only one way of understanding fatness, that anti-obesity rhetoric is unavoidable and that fat activism is an absurd endeavour. In denigrating fat activism Big Media is protecting its interests.

The continuing impossibility of getting fair and accurate media portrayals of fat activism is embedded in a bigger context in which there is a crisis of media ethics that affects anyone, regardless of their status as fat activist. This ethical crisis relates to how media is owned and structured, and the working conditions that media makers negotiate, particularly within Big Media. Speaking at the Leveson Enquiry, which is concerned with media ethics in the UK, Michelle Stanistreet, General Secretary of the National Union of Journalists (NUJ), gave evidence about cultures of bullying in the newsroom that inhibit journalists from taking risky ethical stances with their material.[9] Even though there may be a will to produce more challenging work on fat in the media, the broader editorial and business culture may not allow it.

In addition to this, the issue of who journalists are and the values they represent is central to why fat activists find themselves marginalised by media. John Johnstone et al's iconic sociological study of 1300 journalists in North America found that news-based journalists tended to be young, male, white and middle or upper-middle class.[10] It is nearly 40 years

since that study's publication and this demographic still predominates; media is not a diverse profession.[11] Contrast this with fat people's low socio-economic status and the unequal power relations that underpin fat activists' media encounters become more apparent.[12] Indeed, foundational texts in media studies, and many subsequent publications, explore these power relationships far beyond the scope of this chapter.[13] The likelihood of media makers being able to hear and understand fat activists, or other minority groups and activists, remains under question.

CREATING CHANGE

There are possibilities for working with unions to help develop ethical codes for journalists. Indeed, the NUJ Code of Conduct is explicit in setting out journalists' responsibilities around hate speech.[14] Unfortunately not all journalists are NUJ members, and survey participants in the UK reported that at least half of the Code of Conduct's 12 clauses have been broken by journalists who have approached them. Post-Leveson, Stanistreet explains that journalists' unions, in particular the NUJ in the UK, can serve an important role in 'guarding the guardians' but that they are systematically undermined by press barons threatened by their power, and wider anti-union sentiment.[15]

There may be a role for a fat activist media watchdog organisation along the lines of GLAAD in the US, or Trans Media Watch in the UK. These Non Governmental Organisations take an active role in monitoring media output in relation to their populations of interest, and seek to transform policy for fairer representation. However, there are questions about who monitoring organisations serve, how power is addressed within them and what constitutes positive images.[16]

Research and sharing information within and beyond fat activist community is critical in enabling activists to make informed decisions about whether or not to participate in public life. Research should not be restricted to elitist and exclusive academic spaces, or disseminated in journals behind expensive pay walls. Research Justice, and what is

sometimes called the Para Academy, are movements that seek to make knowledge production available and relevant to all.[17] Research Justice in particular is an ethos of organising and developing community voices in ways that benefit those communities directly. This chapter is a product of those values.

It is vital that fat activists share their experiences of public life, and support each other through community learning projects.

> I appreciated a workshop Lynn McAffee and Miriam Berg held on media strategy, which was not focused on defensive measures, but strategic and scrappy offenses such as how to get a quick sound-bite in to mainstream media. It's a different approach I usually do my best to avoid at all costs, and I appreciated these veterans sharing their experience and strategies. (Aphra)

More experienced fat activists should reach out to those with less experience, especially since neophyte fat activists can find themselves fielding invitations from Big Media at points in their life when they are vulnerable, isolated and have little prior experience of public political life. This chapter is one attempt to generate more dialogue and share community findings about media engagement. I hope that it spurs fat activists to have conversations, produce workshops, training, skill-swapping sessions, and materials to engender greater media literacy within the movement.

Finally, perhaps the most immediate shift that might happen is that fat activists learn to recognise the value of their voices and experience to media makers, and use that more systematically to leverage change, including more editorial control. Perhaps what is ultimately required is that more fat activists become media workers and cultural producers in their own right, take advantage of new technologies and media fragmentation and bypass exploitative, unethical, poorly-informed mediators altogether.

Notes

1 Freespirit, Judy (1983) 'A Day In My Life' in Schoenfielder, Lisa et al
 eds., *Shadow On A Tightrope: Writings By Women on Fat Oppression*,
 San Francisco: Aunt Lute, 118-120; Freespirit, Judy (1986) 'doing
 donahue', *Common Lives/Lesbian Lives*, 20, 5-14; sizeoftheocean (2013)
 'A Complete Lack of Insight', *Fatuosity* [online], available: http://www.
 fatuosity.net/2013/06/02/a-complete-lack-of-insight/. Last accessed
 25 October 2013.

2 By methodology I mean the philosophical assumptions behind my use
 of particular methods.

3 Cooper, Charlotte (2013) 'No more stitch-ups: media literacy for fat
 activists', *Obesity Timebomb* [online], available: http://obesitytimebomb.
 blogspot.co.uk/2013/05/no-more-stitch-ups-media-literacy-for.html
 Last accessed 25 October 2013.

4 Cooper, Charlotte (2009) 'Maybe it should be called Fat American
 Studies?' in Rothblum, Esther and Solovay, Sondra, eds., *The Fat Studies
 Reader*, New York: New York University Press, 327-333.

5 Cooper, Charlotte (2007) 'Headless Fatties', [online], available: http://
 www.charlottecooper.net/docs/fat/headless_fatties.htm Last accessed
 26 August 2008.

6 Campos, Paul (2004) *The Obesity Myth: Why America's Obsession
 With Weight Is Hazardous To Your Health*, New York: Gotham Books;
 Herndon, April Michelle (2005) 'Collateral Damage from Friendly Fire?
 Race, Nation, Class and the "War Against Obesity"', *Social Semiotics*,
 15(2), 127-141; O'Hara, Lily and Gregg, Jane (2006) 'The war on obesity:
 a social determinant of health', *Health Promotion Journal of Australia*,
 17(3), 262-264.

7 sizeoftheocean (2013) 'A complete lack of Insight', *Fatuosity* [online],
 available: http://www.fatuosity.net/2013/06/02/a-complete-lack-of-
 insight/ Last accessed 25 October 2013.

8 See, for example, Brown, Sonya (2005) 'An Obscure Middle Ground:
 Size acceptance narratives and photographs of "real women,"' *Feminist*

Media Studies, 5(2), 237-260; Sarbin, Deborah, n.d., 'The short happy life of plus-size women's fashion magazines', *Commentary and Criticism.* Clarion University, 241-243; Saguy, Abigail and Almeling, Rene (2008) 'Fat in the Fire? Science, the News Media, and the 'Obesity Epidemic'', *Sociological Forum,* 23(1), 53-83; Rich, Emma (2011) '"I see her being obesed!": Public pedagogy, reality media and the obesity crisis', *Health (London),* 15(1), 3-21; Graves, Jennifer and Kwan, Samantha (2012) 'Is There Really "More to Love"?: Gender, Body, and Relationship Scripts in Romance-Based Reality Television', *Fat Studies: An Interdisciplinary Journal of Body Weight and Society,* 1(1), 47-60; Ganz, Johanna (2012) '"The Bigger, the Better": Challenges in Portraying a Positive Fat Character in Weeds', *Fat Studies: An Interdisciplinary Journal of Body Weight and Society,* 1 (2), 208-221; Contois, Emily J. H. (2013) 'Food and Fashion: Exploring Fat Female Identity in Drop Dead Diva', *Fat Studies: An Interdisciplinary Journal of Body Weight and Society,* 2(2) 183-196.

9 Leveson Enquiry (2012) 'Leveson Enquiry: Culture, Practice and Ethics of the Press', [online], available: http://www.levesoninquiry.org.uk/ Last accessed 25 October 2013. Stanistreet, Michelle (2012) 'Closing Statement on behalf of the National Union of Journalists: Leveson: press, union & ethics', *The Journalist,* available http://www.nuj.org.uk/documents/leveson-inquiry-nuj-special-edition/. Last accessed 1 July 2014.

10 Johnstone, John W. C. et al (1976) *The News People: A Sociological Portrait of American Journalists and Their Work,* Champaign, IL: University of Illinois Press.

11 Baracaia, Alexa (2013) 'Do diversity schemes work?', [online], available: http://www.theguardian.com/media-diversity/do-diversity-schemes-work. Last accessed 2 January 2014.

12 National Obesity Observatory (2013) 'Adult Obesity and Socioeconomic Status,' [online], available: http://www.noo.org.uk/uploads/doc/vid_16966_AdultSocioeconSep2012.pdf. Last accessed 2 January 2014.

13 Root, Jane (1986) *Open The Box.* London: Comedia Publishing Group; Herman, Edward S. and Chomsky, Noam (1988) *Manufacturing Consent: The Political Economy of the Mass Media,* New York: Pantheon Books.

14 NUJ (2013) 'NUJ Code of Conduct', [online], available: http://www.nuj.
 org.uk/about/nuj-code/. Last accessed 21 December 2013.

15 Stanistreet, 'Closing Statement', 4.

16 Kirchick, James (2013) 'How GLAAD Won the Culture War and Lost
 Its Reason to Exist', [online], available: http://www.theatlantic.com/
 politics/archive/2013/05/how-glaad-won-the-culture-war-and-lost-
 its-reason-to-exist/275533/. Last accessed 2 January 2014.

17 DataCenter (2009) 'Research Justice', *DataCenter* [online],
 available: http://www.datacenter.org/research-justice/ Last
 accessed 24 July 2012. Assil, R., Kim, M. and Waheed, S.
 (2013) 'An Introduction to Research Justice', [online], available:
 https://www.z2systems.com/np/clients/datacenter/product.
 jsp;jsessionid=2F1EEE41401FBEAD18A848DED1D302E7?product=5
 Last accessed 2 January 2014.

Dr Charlotte Cooper offers counselling, consultancy, and research concerning fat identity, politics and culture. Her publications include *Fat and Proud: The Politics of Size* (1998) and an award-winning novel, *Cherry* (2002). She performs in the queercore band Homosexual Death Drive and blogs about fat at Obesity Timebomb [obesitytimebomb. blogspot.com]. More information at www.charlottecooper.net

Participatory projects:

http://obesitytimebomb.blogspot.co.uk/p/queer-and-trans-fat-activist timeline.html

http://badartcollective.blogspot.co.uk/

http://www.bigbumjumble.blogspot.co.uk/

http://www.chubstergang.com/

http://www.dur.ac.uk/geography/research/researchprojects/ fat_studies_and_health_at_every_size/

http://queerchub.blogspot.co.uk/

http://fattylympics.blogspot.co.uk/

My blogs:

http://obesitytimebomb.blogspot.co.uk/
http://deathtothefascistinsect.tumblr.com/

SIMULTANEOUS LIFE AND DEATH

Georgina Huntley

My art-making is often a reaction to what is happening in my life, this can include personal emotions, political ideologies and responses to real life events. Working in palliative care with older adults lead me to address issues of loss, separation, life and death.

By making the art-work I was shifting what was in my head via the art-making which seemed to have a therapeutic benefit. In Jeanette Winterson's novel *Why Be Happy When You Could Be Normal?* the author explains how creativity was for many years her outlet to express her unorthodox childhood and helped prevent her own mental deterioration: 'Creativity is on the side of health—it isn't the thing that drives us mad, it is the capacity in us that tries to save us from madness.'[1]

Within my paid employment I work on a busy nursing ward as a health care assistant. It is crucial to listen, understand and empathise with the patients' emotions. This nursing home provides end of life care and due to this circumstance many of the clients experience fear, loss of control, anger and resentment as well as physical pain. There are limitations within the role of the support worker/care assistant, however, I try to offer practical solutions, engaging in empathy and reassurance or offer distraction, through the care I provide. I have identified a link between my ability to listen, engage and offer sympathy to clients when working as a support worker and my own art-making. If I create the time and space

to generate art-work I feel that I provide a better standard of care to the clients when working as a support worker. The art-making equips me with the ability to have more empathy and understanding. I am able to empty my thoughts in my art-making and make mental space to engage with clients and 'care' to my full potential. This piece of art making was conceived after caring for and observing a woman who passed away. The experience made me want to address this issue by making art.

For me, making art-work outside the confines of the institution has its highs and lows, ups and downs and pros and cons. Having limited access to technical expertise, resources, space and definitive feedback from fellow tutors and students can cause frustration and angst when grappling with the challenges of how to muster my creations. However finding resolutions to these issues is an interesting part of the art-making challenge. The internet is proving to be a useful tool in teaching techniques and skills. There is also a sense of freedom in being able to 'do what you want' without having to fit into a house-style, please, or be categorised, which I enjoy immensely.

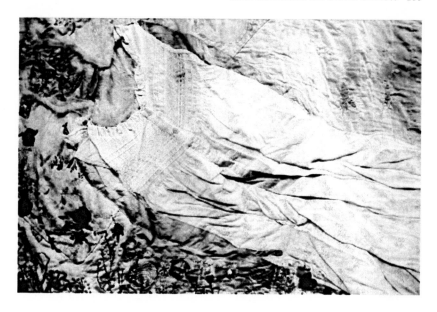

Now that I am back within an educational institution, studying for an MA in Art Psychotherapy, I have found gratitude for the library, the tutors' support and interaction with students. With confidence I am trying to maintain my artistic freedom and personality and not succumb to the pressures of 'fitting-in'. This notion and appreciation would have not been applicable if I had not had ten years of working independently as an artist whilst supporting my living by working within contrasting social care settings.

Notes

1 Winterson, Jeanette (2012) *Why Be Happy When You Could Be Normal?* London: Vintage, 171.

Georgina Huntley graduated in 2002 from the Winchester School of Art with a BA (Hons) in Fine Art Sculpture, specialising in performance and video. She works with a range of media but textiles are often used to express conceptual ideas and interests. Inspired by the artists Jenny Holzer, Mona Hautom and Tracey Emin, her work addresses themes of power, status and dominance. Since 2011 she has worked as a Community Artist assisting older adults with Dementia; young people and children; adults with depression, anxiety, drug and alcohol issues. She is currently studying for an MA in Art Psychotherapy at the University of South Wales.

ON THE ACADEMY'S POINT OF EXTERIORITY

Fintan Neylan

Incommensurability is a term not much liked by the academy. Its possibility attests to there being no common measure between two areas of study and this is nothing short of abhorrent for administrators. For something to be incommensurate is to stand against a species they have intensively bred and which currently thrives in the contemporary university, that of the interdisciplinary course. Not to be confused with the practice of being open to the ideas of other fields, the grand administrative push for interdisciplinarity reveals far more about how those smitten by the word 'innovation' understand intellectual work rather than those who perform it. On the shining surface of such programme advertisements, we read how the best of two or three courses were ratcheted together, forming the components and tools of a new specialised discipline.

But why might this be an anathema to thought? The point is simple: the innovation they promise rests on the assumption that originality comes from combining elements of things which we already know. Only nominally faithful to the ideal of radicality, what is found in practice is a wilful inertia to keep to the same subject matter, to study only that which is expected to be found. Further to the contemporary university's zeal for them lies the implication that every area of study, every mode of inquiry can have their boundaries disintegrated and their definitions dissolved, all eventually coming under the rubric of corporate utility.

This problem of interdisciplinarity is however symptomatic of a wider

237

issue: it is merely one aspect of a process of total disavowal of the outside, a non-acceptance of its existence on the order of trauma. Within the educational practice of the academy, students are now only permitted to engage in taxonomy: you must do a PhD in this or that specialised topic, but only a highly obscure facet of it which your supervisor didn't have time to explore. The operation of this logic is in effect a process of insulation, buffering thought from its own exteriority. As a product of this, there is a growing host of individuals who, perhaps mistaking the contemporary university's intentions for something to do with inquiry, now find themselves at odds with what it calls its goals and directives.

The task of reclaiming this exteriority finds its point of convergence with philosophy in the concept of the outside. While this problem was not foreign to the final score of years of the previous century, it is emerging as a most urgent of tasks in the 21st, if its first decade tells us anything. Specifically, with the 2006 publication of Quentin Meillassoux's *After Finitude,* the concept of the outside and the project of elaborating thought's capacity to grasp it has been galvanized.

While the opening chapters diagnose what is now called correlationism—the thesis that the relationship between subject and object delineate the scope of thought and knowledge, and that either component conceived in isolation is meaningless—the latter pages of the book outline the possibility grasping the outside. Meillassoux's aim is not to offer a guide of how to proceed from insularity outwards, but instead to argue for a conceptual shift; his point turns on recognising that through the thought of contingency (of ourselves) we in fact have—and always have had—a sole point of exteriority.

This thesis of *After Finitude* has triggered an avalanche of texts since its publication. United only in antipathy towards correlationist theses, numerous threads have emerged with some emphasising the primacy of the subject and its capacity for thought (especially Meillassoux and Brassier) and others the primacy of the object (broadly speaking, the Object-Orientated philosophies).

While these variegated positions all lay claim to the ever more nebulous term of speculation, there is in fact one point at which there seems to be

agreement. In line with Meillassoux's point that we are all in possession of a modicum of exteriority, it may be said then that to speculate means to attempt to engage with this incommensurate outside, to be amidst it; that is to go precisely to what is *after* our finitude. The possibilities opened up in approaching this incommensurability bring about nothing short of a radical reconceiving of our present situation—indeed what may be seems now to be on the order of rebooting the future.

It is precisely here that DUST seeks to intervene.

DUST's mission is to investigate the outside, both in regard to its philosophical import and to tackle the academic insularity which has become endemic to institutionalised thought.

Our position is not so much one where we are outside the academy, or have even infiltrated it at some point of weakness; rather it is that we are interested in the ones who *go outside*, who can venture forth into the exterior and smuggle back in all manner of seditious ideas and concepts. It is the one who moves in plain sight, who can still transverse the logic of the academy without being detected or lodged in its basin of attraction, that can realise this illicit commerce. To borrow Reza Negarestani's term, DUST is engaged in investigating the concept of the 'insider', the one of the outside who has found themselves on the interior.

On a practical level we aim to bring the theoretical rigor in which all of us were trained to the elements of the outside. Our choice of event locations (galleries, art schools, etc.) is deliberate in that we feel that discussion must move beyond the sterile and sometimes torturous framing of traditional academic events; indeed, this act is not so much against academies, but rather rooted in the belief that theoretical work faces an existential threat if it not removed from its currently decaying environment.

We thus aim to be a rallying point for such insiders, a mobilisation point where materials of the university can be disturbed and perverted to our aims: attacking from the outside in will have little effect, as the defences built against the exterior are vast; in the face of this we must follow Nick Land's point, that our weapons must be built entirely from the enemy's resources.[1]

Thus we conceive the para-academic as not forming an Other to the academy, but rather a potential insider. Never, where possible, should she disavow her academic credentials; never should she claim to be against the institution; the very strength of her position lies in that she still has currency with the university, and through such commerce para-academics can hold the breach open for all manner of pathogens to swarm in and catalyse a mutation.

For in her capacity to approach the incommensurate and draw its elements back with her, she may initiate transformations unbeknownst to the administrators, she may force an identity change in that institution, recoding it away from the procedures and protocols of corporatism in order to make it a space of engagement once again.

Thinking the outside is about seeing the same content in a different light; not the spectrum which is visible to philosophy, but from elsewhere.

In short, through her smuggling she is opening the institution up to ex nihilo logics.

<div align="center">X</div>

DUST manifesto

EVERY POSSIBLE BARRIER HAS ALREADY BEEN INFILTRATED

The situation of contemporary theoretical work is one where it is at risk of atrophying within the bounds of institutional walls. Output, inter-disciplinarity, and internationalisation have become the watchwords of the contemporary university, contributing to an ever accumulating body of work—one which actively defangs itself—and a faux-openness, comprehending only to that which it expects to find.

But boundaries are porous, for decay is present within their genesis; as intense its efforts may be, along the academy's walls there is always illicit transit with the outside. The academy denies these itinerant lines of transit which run through it, those which it recognises as not its own. It is along such axes we move, encrypted within the institution's own

generation. Our infiltration is not an entry from some exterior point, and neither have we been transformed by some seditious force: we have always been of the outside, but have found ourselves on the inside.

Travelling along such lines, amidst every barrier, there is movement of material, carrying an infection of that which we know not into the sterile zones of academic discourse. This is the movement of DUST. It does not just bring in that which institutions sought to prohibit, but also exhibits that which the contemporary university has failed to maintain: DUST seeks to bring theory back to the outside. Beyond the supposed theoretical divisions concocted by administrators, we investigate not through one discipline, nor even through inter-disciplinarity or multi-disciplinarity, but by way of non-disciplinarity: on the outside there are no such distinctions—there is only theory.

DUST creeps inside by its own secret machination: it is swept into the living's lungs by the desire to breathe; it is the decay which life must concede to in order to survive.

We infiltrate, but also are aware that we ourselves may have already been infiltrated by others, that we may be playing host to something else entirely. Awareness of such forces comes only when it is too late. One cannot predict such infiltration, so to think it, one must speculate: to think the world beyond experience—to the absolute and the extinct.

Not hemmed within confines, to speculate means to realise that we are already on the outside, amidst the incommensurate.

Notes

1 Land, Nick (2011) 'Machinic Desire' in *Fanged Noumena: Collected Writings 1987-2007*. Falmouth: Urbanomic, 338.

Fintan Neylan is an independent researcher currently living in Dublin. He studied philosophy at University College Dublin and is a co-founder of the Dublin Unit for Speculative Thought.

The Dublin Unit for Speculative Thought (DUST) is a Dublin-based cultural organisation founded in 2012 whose mission is to rouse engagement with artistic and theoretical issues through use of specific sites and localities which are outside institutional spaces; it works by facilitating the collaboration of artists and theorists, while allowing them to address their work to the wider public.

facebook.com/speculation
www.dust.ie

THE PROS AND CONS OF PARA-ACADEMIA

Tony Keen

In the summer of 2013, I read a review on the *History News Network*, of my friend Marc Morris's *The Norman Conquest*.[1] Marc was described as a 'non-academic' (with some implied surprise that a non-academic could produce what was described as a '*tour de force* of scholarship'). But 'non-academic' sells Marc short by a long way. True, he does not hold a position at an academic institution, and earns his living entirely through his books, other writing, public appearances and radio and television spots. But he took his Ph.D. at the University of Oxford, and has taught both there and in London. He is certainly academically trained. Marc, like me, is a para-academic.

In a recent online article,[2] subsequently reproduced on the website of *The Guardian*,[3] Alex Hope, a relatively young lecturer at Northumbria University, enthusiastically argued that the traditional academic career is dead, and that a diverse portfolio of academic activities, usually on short-term contracts, is the way of the future. If so (and the comments on *The Guardian* piece are worth reading for some of the objections they raised to Hope's vision), then we need to understand what it is that we are getting into, and I hope that my contribution to *The Para-Academic Handbook* may help.

'Para-academic' is a term I was unaware of until May 2013, but people who fit the description of the para-academic have been around the entirety of my (para) academic career, which began in 1988 with

the commencement of my PhD study. A couple who are good friends of mine have spent more than twenty years rewriting the archaeology of Roman Scotland with little more academic affiliation than a couple of Honorary Research Fellowships; they drew their funding from small grants from archaeological societies. I remember an article from *The Guardian*'s Education pages back in the 1990s written by someone who taught a number of *ad hoc* courses, discussing the problems involved in such a lifestyle (no chance of finding that now, I'm afraid, as I can't remember enough about it to locate it in the digital archives – and it may have been in *The Times Higher Education Supplement* anyway). I myself have been a para-academic since I finally realised in 1999 that I would never be offered a full-time academic post, after three years of not being shortlisted for anything. At that point I went to work in industry, but taught a course for the Open University to keep my hand in. However, it was still the OU work to which I devoted more time and attention, and after a decade I went back to earning my living solely through teaching and other academic-related activities.

I think few of us who have gone the para-academic route would have chosen it as our first preference. I certainly harboured hopes of a 'proper' academic career, teaching in an established university. But, though I got close at times, there are simply not enough posts available for those who want them, and it is something of a lottery who makes it and who doesn't. I eventually chose the para-academic route because I felt (and still feel) that I had something to offer my subject (Classics/Classical Studies), and did not want to fully disengage from the academy. And let's be honest, I love teaching and I love being part of an academic community, however tenuously.

There are definitely downsides to being a para-academic. Unless you are very lucky (which generally means taking a route into para-academia that involves broadcasting, and even then you need a lot of luck and to land quite a few contracts for presenting television series, rather than just appearing as a talking head from time to time), I don't believe that there is any serious money in it. Sessional pay rates are often low, and it's hard to argue that para-academics are not exploited by academic institutions.

I've seen Ph.D. studentships advertised with a stipend that is comparable to my annual earnings, and I am some distance behind a junior full-time academic (and a long way behind what I would be earning now had I managed to secure a post in the 1990s); if I restricted myself to only teaching three courses (once considered by one institution I've worked for as the equivalent of a full-time post) I'd be earning even less. I worry that institutions may want to push their staff towards para-academia simply because it will cost them less.

There are people I know who are attempting to monetise para-academic activity, through getting people to pay for online courses, etc. I'm not sure how successful that will be. With the MOOC bubble already starting to burst, I have yet to be convinced that there is serious money for academics in writing course materials, much though I would like it to be true.

I can only really contemplate this lifestyle because my wife earns enough for us both to live on if we had to. A supportive partner and/or home environment have been vital for me in a number of ways, and I suspect this is true for many para-academics. It's not just the financial support I've been given; it's also the moral support to encourage me to embark on such a risky approach. It's my partner who must put up with the long nights when there are deadlines to meet, and my partner is often the one to remind me that I must take days off from time to time. It is all too easy to work constantly, which in the end has a detrimental effect. The para-academic must be disciplined, both in getting on with their work, and in taking breaks. The temptation is to work all the time, even when ill. It's hard to resist that temptation when if you don't work you don't get paid, but making yourself more ill will only mean that you work less and get paid less.

It can take a bit to get established, and you might have to get by on one or two courses to start with. Once you start getting more work, keeping track of everything can be a bit daunting. One academic year I had eight separate contracts with the Open University, for teaching and academic-related activities. By the end of this calendar year I shall have worked for four separate universities, and because none of the individual pieces of work I do pay well, I end up taking on a lot of work in order

to make up a living wage (my tax returns are quite complicated). This can cause time-management issues. The life of the para-academic is a constantly insecure one, and, just as with those on zero-hour contracts, you're always tempted to take any piece of work that comes your way, in case you're never asked again. But I've learnt the hard way that the one way to really ensure that one is never asked again is to take on a piece of work and then fail to complete it on time. A para-academic must develop the ability to say no to some invitations, however tempting they may appear. As Neil Gaiman says, one of the secrets of surviving as a freelancer is to deliver the work on time, and this applies to academics as much as it applies to writers.

The bitty nature of the para-academic's work has an impact upon their research. It's possible to find enough free time to write the occasional article or chapter. But you get no paid research time or sabbaticals – again, if you don't teach you don't get paid. This can make it very difficult to conduct any large-scale sustained piece of work. I have managed to be a co-editor of an edited collection and chair of a conference over the past couple of years, but a planned book is showing no good sign of progress at the moment.

There are, nevertheless, positives to being a para-academic. For a start, for the academically-minded, it's better than not being an academic, and realistically, that is the choice confronting many people contemplating the para-academic route, not a choice between academia and para-academia.

Secondly, one of the things that academics have been complaining about for the past twenty years is the increasing burden of administration that is placed upon them, in particular administrative work that seems to be unconnected with their primary roles of teaching and research. The para-academic is largely protected from that – it is unlikely that you will be asked to take senior roles in people management or quality assurance.

The benefit I always focus upon most is that I have much more freedom than most established academics to write what I want to write, or sometimes not to write at all. In the UK, at least, research output is distorted by what is currently called the Research Excellence Framework, which is supposed to rate the excellence of people's research, and on which

considerable funding allocations rest. There are certain forms of output that the REF recognises, and certain forms that it does not. Monographs and articles in certain recognised journals are good. But student textbooks, or more popular works such as Marc Morris's with which I opened this piece, get no credit. Credit is given for chapters written for edited collections, but apparently none for editing those collections. Academics hoping to gain promotion, or, increasingly, avoid redundancy, are pushed by their university research committees into REF-friendly work; this, as the editors of this volume point out to me, instrumentalises knowledge, funnelling it in certain directions. It ultimately leads to distorted approaches where people only start on research projects if they have a fair idea of what the results are going to be. The para-academic is under no such pressure, and one of the great benefits of my status (as I often say) is that I can write – within reason – pretty much what I like about what I think is interesting, without having to answer to research committees who are trying to second-guess other research committees. Someone is going to have to write the student textbooks and popular works, because these volumes are important and academia needs them. It may be that this becomes increasingly the province of the para-academic.

Moreover, the opportunities to cross disciplinary borders abound. My research is on the reception of Greece and Rome in modern science fiction and fantasy. This became my research field at a time when I was employed in industry. I had two hobbies on the go, being both a para-academic and a science fiction fan. The only way that I could survive was by collapsing those two hobbies into one. But I have found this immensely rewarding. It was a largely empty research field, in which I've been able to make a name for myself, far more than had I continued being an ancient historian, which was my original pathway. One thing about having such an interdisciplinary research field is that one has to publish in the journals of both fields. This is another thing discouraged by the REF. Publishing in respected journals within the field of one's home department is given credit – publishing in another field's journals, however respected such journals may be within that field, gets less credit, and universities, not unreasonably, want to game these research exercises

to their best advantage. Again, the para-academic has no such concerns, and can therefore do interdisciplinary work properly.

The variety of students you get to teach, across a range of subjects, is invigorating. I've taught adult learners, UK undergraduates, and US students on overseas placements. I've taught Classical studies, film and television history, and science fiction and fantasy literature. I can't imagine any permanent post in a UK university would ever have allowed me that degree of variety. (And through the Open University, which is largely the province of the para-academic, I've taught, among others, a concert violinist, a BBC radio producer, and a Formula 1 racing driver.)

In the end, the life of a para-academic is not a bad one, and I am content. Perhaps it is second-best to full-time academia, but I'm not so sure these days, and in any case, for me, it's a *good* second-best. However, my approach to para-academia, and para-academia overall, is not for everyone. If para-academia does become the norm, I do worry that exploitative practices may multiply. I can cope with that, for para-academia allows me to pursue the sort of activities that brought me into academia in the first place.

Notes

1 George Mason University/Jim Cullen, 19 July 2013, *History News Network*, 'Review of Marc Morris's *The Norman Conquest: The Battle of Hastings and the Fall of Anglo-Saxon England* (Pegasus, 2013)', http://hnn.us/article/152670, Last accessed 2 October 2013.

2 Hope, Alex (2013) 'The Academic "Career" is Dead. Long Live the Academic Career!', 11 November 2013, *Dr Sustainable*, http://www.drsustainable.com/the_academic_career_is_dead. Last accessed 30 November 2013.

3 Hope, Alex (2013) 'The role and place of the academic is changing – and it's a good thing', *The Guardian*, 13 November 2013, Higher Education Network, http://www.theguardian.com/higher-education-network/blog/2013/nov/13/academic-job-changing-flexibility-university, Last accessed 30 November 2013.

Tony Keen is currently an Associate Lecturer and Research Affiliate at the Open University, and an Adjunct Assistant Professor at the University of Notre Dame's London Undergraduate Programme, though the latter contract will have ended by the time you read this.

REFLECTIONS OF AN INCIDENTAL MAVERICK

Paul Hurley

This essay begins on the small kitchen table of the narrowboat on which I live, currently moored in Clarence Dock, Leeds. I say currently, as the nature of boat life means that one can move one's home without much ado, for a simple summer weekend away, for a longer-term relocation, or to live peripatetically, as what's known in boating terms as a 'continuous cruiser'. This seems important to mention not only because I have another relocation on the horizon, but because it seems to chime with some of my approaches to being a para-academic, to a practice of being resourceful, nomadic and to existing on the edges.

I've worked as a professional artist for just over 10 years, making a lot of experimental performance art (usually in art galleries, covering myself in buckets of paint, morris dancing naked in stilettos, that sort of thing…) and more recently running art projects with different community groups (getting people involved in processes of performance art making, creating spaces that facilitate dialogue between different people, exploring familiar places in different ways). My gateway to becoming an artist was study —a BA (hons) in Drama and Theatre Studies, then an MA Fine Art, and then after I had been working as an artist for a few years, a PhD, in a Drama Department but in collaboration with a large contemporary art centre. My relationship with academia has therefore been a positive, if not an exclusive one—something in me likes to move, and thrives on being around the borders and margins of things. A while ago the

phrase 'incidental maverick' came to me—the term 'maverick' originally referring to an unbranded calf, separated from its herd and belonging to nobody, and 'incidental' suggesting an element of chance but also that nonconformity has been a by-product rather than an intention in my work.

What follows is a series of sketches, memories and moments from some of the work I've done the last 18-months or so, all of which has been in different ways with Knowle West Media Centre, Bristol. I hope these will illustrate some of the things that have happened, some of the exchanges that have taken place, and some of the ways in which my approaches reflect or resist those of academia.

SKETCH #1

I am stood at a long kitchen table in a empty shop-turned-art-space in central Bristol. There are six, seven or eight other people around the table and we are baking bread, or at least I am trying to teach them how, having only learnt a couple of weeks earlier myself. There is flour all over the place, and myself and Michael are dashing around frantically. We are making sure everyone has the ingredients and equipment they need, that basins are washed, scales are shared, that the instructions make sense and that everyone is kneading properly. The kneading is the most important part! Michael is an academic researcher in architecture and planning, and is the lead investigator on *Foodscapes*, a project exploring issues around food poverty, resilience, sustainability and art, of which this event is part. The other people around the table are clients from The Matthew Tree Project, a charity that helps people in food crisis, by providing them with free food and support and signposting to help them get over whatever circumstances have brought them to this situation. Some of the women around the table are speaking in Jamaican *patois*, talking about making dumplings at home, or about cooking with or for their children. Other people talk about the practice of cooking alone, about using fuel for the oven at home, about storing leftover dough in the fridge. We stir

and we work, we talk and we eat. We get our fingers sticky with dough, our muscles tired with kneading, and we share stories about our pasts, about our aspirations, about our day-to-day lives. The shop becomes a gallery becomes a workshop becomes a kitchen becomes a café becomes a home. I suspect that most of the workshop participants don't really understand that / how what we are doing is art—in the previous weeks I have moved between the roles of food store volunteer, photography facilitator, researcher from the university, and now cookery tutor—but no one seem confused. What we are doing now, talking, laughing, opening up, working and enjoy ourselves together, somehow this goes beyond any of that. As artist Robert Filliou said, 'Art is what makes life more interesting than art.'

SKETCH #2

I am chalking the outline of my footprints on wet cobblestones, at the quayside of Bristol's floating harbour. I am one of five artists working here today (with Phil Owen, Soozy Roberts, Clare Thornton and Caroline Wilkins), making a four-hour-long durational performance over a cold, wet and windy May bank holiday afternoon. We have come together for CONNECTION / TIME, a project exploring what happens when solo artists from different disciplines (classical music, theatre, installation, sculpture, performance art) come together to play, and how we can present these experiments to different audiences (in public spaces and via an online documentation tool, also called CONNECTION / TIME). We have all brought a selection of materials with which to work, which make a wonderful and bizarre list of ingredients: a large gramophone horn; a sailor's hat; balls of multi-coloured wool; white chalk; blue sou'westers; kitchen towels; loaves of bread; gold stilettos; a snorkelling mask; matches; a plastic bucket; rope; tinned hot dogs; a metal teapot; kitchen foil. Over the course of four hours we make a series of improvised interactions with our bodies, with the architecture of the space, with each other and with the weather. They are strange,

fantastical, and often amusing. Passersby stop and talk to us or to the documenters who are with us—we have a small team of volunteers who are helping us to document the performance, via sketches and writing, and via tweets and photographs uploaded via their smartphones onto a dedicated webpage. Other people watch from across the harbour, also tweeting their observations about whatever it is they're watching; others watch and contribute to the live web feed remotely, from the warmth of their own homes. The impetus behind the project is to research ways of working and making performance in public space, and an element of it includes me reading about and visiting other artists' groups. But the majority of it involves learning through doing and reflecting—as a group of artists with different backgrounds we all bring different things to the table, all challenge each other (and ourselves) in different ways, and do so with deep generosity and respect. This, we hope, nourishes our own practice but also opens it up to audiences, who or wherever they may be.

SKETCH #3

I am stood wearing a grey boiler suit and drinking a mug of strong tea, in the large hall-like studio at Knowle West Media Centre in South Bristol. A group of people are also gathering in the room, some of them looking at the chipboard panels on which are exhibited an array of borrowed manual tools, while others are looking at large light-drawing photographs of myself and artist Clare Thornton, performing movements in the dark whilst holding neon lights. Clare is also here, and we are chatting to visitors and preparing for our performance, *A Lexicon of Labour Movements*. The performance, part of an exhibition of the same name, comes out of a period of research and engagement with manual labours and trades in Bristol. Clare and I spent a period of time visiting small businesses around Knowle West (a traditionally white working- class housing estate) and the recently re-named Enterprise Zone (a series of industrial estates and works behind the city's main train station). Politically, we were interested in reframing the work of Bristol from the

more visible, professional, middle-class and dematerialised labour of the modern city centre, to also include the hidden industries of production, skill, graft and materiality at its margins. Personally, we were interested to meet and talk to people, to find out about their business of scrap metal recycling, or horse rescue, or bricklaying, or tool repair. Our objective was to 'collect' tools and the movements associated with using them— Clare and I both have practices that shift between performance, visual art and movement—but the process necessarily involved learning about their histories, their skills, their learning, and the meaning of work to them. We were humbled and inspired by the people that we met, by their generosity with time and tools, and by their enthusiasm to come along to the exhibition, performances and public talks that formed the project's programme at Knowle West Media Centre and at The Parlour Showrooms, Bristol. Those exchanges, between different individuals and audiences, were almost as exciting to watch as some of our conversations were to have. I have since taken up carpentry at home and started a part-time course in screenprinting, and felt a groundedness (both social and material) in my practice that has sometimes been absent. This I consider incredibly useful.

COLLABORATORS

The way in which I work is characterised not only by the kind of professional nomadism that I have already mentioned, but by an impulse to connect and collaborate with other individuals and organisations. The projects I mention above have all been made in partnership with others, whom I must of course credit properly: *Foodscapes* was an AHRC-funded Connecting Communities Project. It was led by Dr Michael Buser at the University of West of England, with Dr Emma Roe at the University of Southampton and Dr Liz Dinnie at the James Hutton Institute. Community partners were Knowle West Media Centre, The Matthew Tree Project and the Edible Landscape Movement. *CONNECTION / TIME* was an Arts Council England funded project led

by me, in partnership with Knowle West Media Centre (especially Dane Watkins, who co-developed the CONNECTION / TIME interface) and Arnolfini, Bristol. Supporting partners included STATION art space, Bristol, Performance Exchange / SITE festival, Stroud and] Performance Space [, London. *A Lexicon of Labour Movements* was a collaborative project with Clare Thornton, with photography from Kim Fielding, co-produced by Knowle West Media Centre and The Showroom Projects, and is indebted to the contributions of the businesses and tradespeople who took part in it.

Paul Hurley is an artist currently based in Yorkshire, but working across the UK and further afield. He is perhaps best known as a performance artist (usually doing odd and messy things in galleries), but his practice extends to participatory and socially-engaged projects, critical writing and occasionally teaching university students and other artists.

www.foodscapesbristol.wordpress.com
http://connectiontime.wordpress.com/
http://www.parlourshowrooms.co.uk/blog-post-working-in-the-city-a-lexicon-of-labour-movements-by-paul-hurley-and-clare-thornton/
www.paulhurley.org

OTHERWISE ENGAGED

B.J. Epstein

Engagement.

Engagement is a big word that covers many concepts. Betrothal. Warfare. Appointment. Employment. No matter the exact context, the meaning of the word always seems to come back to commitment. Being engaged is committing yourself to a person, a job, a situation, an idea, a community.

And being engaged is an essential part of being an academic. As academics or para-academics, we commit ourselves to thinking, teaching, researching, developing. And, as I see it, we are also committing ourselves to doing those things outside of the academy, and not only for and with those who are privileged enough to find themselves at an institution for higher learning.

This is what is termed public engagement. The National Co-ordinating Centre for Public Engagement, which is based in Bristol, defines it this way on their website: 'Public engagement describes the myriad of ways in which the activity and benefits of higher education and research can be shared with the public. Engagement is by definition a two-way process, involving interaction and listening, with the goal of generating mutual benefit.' Obviously, what form engagement work takes differs according to the subject matter, but what is important to understand here is that it means bringing concepts that may be complicated and/or traditionally

exclusive out of the academy and making them accessible to everyone, while also learning from those who are not part of the university system and bringing their input back into the discipline.

For academics and para-academics, engagement work is an alternative mode of working alongside—or outside—the traditional university system, and it is an excellent way of doing activities that might otherwise be sneered at or not considered appropriate. While I have a full-time job at a university, I also consider myself a para-academic to a certain extent, because a lot of the work I do is with people outside of academia. Such work is not always understood or respected by my colleagues, and sometimes it is not even understood by the people I attempt to connect with through it.

Colleagues at the university sometimes ask: 'How does engagement work add to my CV?' 'Will this help me in the REF?' 'What could I possibly learn from non-academics?' 'Is this considered an output?' 'How can I make my subject comprehensible to those without specialist training?'

And people outside the university say: 'What is it my taxes are paying for?' 'The university isn't for people like me.' 'I'm intimidated by campus and I won't step foot on it.' 'Will I be able to understand someone with a PhD?' 'How is what you do at the university relevant to my life?

So the overarching goal for engagement activities is to show the connections between research and 'real life' and, along the way, to help people—including ourselves—learn and grow. And while this is important in and of itself, it is also worth noting that many, though not all, engagement activities come with a small fee or salary, so those without a permanent position can generate income, and of course these events can lead to contacts and additional paid work in the future.

You may at this stage be feeling engaged by the idea, but unsure about what types of events there are or how to go about making them happen. The examples I will give here are all from my own field, literature, but they can be adapted as appropriate to other fields.

Workshops are an ideal way of making your subject available to those outside your niche area. Over the years, I have taught writing, reading, and translating workshops, and I know others who have offered editing,

acting, or various art classes. In such a course, which can last one day or a longer period of time, you can easily weave theory and practical activities together. Workshops can take place on campus or elsewhere, such as at libraries, museums, or community centres.

Similarly, reading and/or discussion groups are often fantastic arenas for fruitful conversations about big topics. I have started groups dedicated to gender and sexuality, international literature, and children's literature. As of this writing, I still run the latter two, but I encouraged community members to take over the first one and to shape it so that it best fit their needs; eventually I may do that with the others as well, because a danger with such groups is that members begin to look to the person with more academic qualifications to lead a seminar rather than to facilitate a discussion. I am regularly told that these groups have enabled people to learn about subjects that they found too complicated or inaccessible. If one person decides to pick up a translated text when they would previously never have done so or if someone now feels able to consider their sexuality, then for me, these groups have succeeded. I usually hold the groups at the public library rather than on campus so that no one needs to feel frightened by the prospect of entering the so-called ivory tower, though there is also an argument in favour of trying to get more people to step onto the campus.

Academics spend a lot of time writing: writing up our research, writing grant applications, writing lectures, writing notes, and much more. But we tend to forget a form of writing that I find to be among the most enjoyable sorts: writing for popular publications, including online newspapers and even blogs. There are many publications that are open to research-related articles, as long as they are written in non-specialist language, free from jargon. Also, of course, we can review books that are connected to our field; book reviewing often does not pay, but you do get free books, which I personally never turn down. Sometimes this is also linked to judging prizes, such as literary awards. Then there are other forms of creative writing, such as personal essays about our experiences, short stories, poems, or translations. You can also turn such publications into appearances in other media: radio or TV interviews or podcasts.

I have received much more feedback from my popular publications than I have from my academic pieces; this says something about the number of readers the respective types have, and therefore the number of people we can touch.

Other common forms of engagement include giving a lecture or reading or participating in a panel or debate. Such activities can be connected to specific anniversaries (the centenary of a particular book, movement, or person, for example) or events (I have participated in Holocaust Memorial Day, Pride, Banned Books Week, among others), or they can be organised just to raise awareness of a topic. The audience can range from a few very animated people to hundreds.

A growing movement is that of café conversations, which are usually hour-long discussions on a certain topic, sometimes with an activity included. For two years running, I have organised a series of café conversations on culture-related topics (literature, language, history, philosophy, etc.), and the conversations take place once a week throughout the academic year in – as the name suggests – a café, and they are free and open to everyone. There are regulars who attend every session, sometimes referring to the series as 'further education' or 'free university seminars,' while others come only for the topics that most interest them. The cafés who have hosted us appreciate that we turn them into something of a salon, and that they make money from attendees buying cake, sandwiches, and drinks.

A final engagement activity to mention is school outreach. While some consider outreach to be quite different from engagement, I see them as intrinsically connected, because with both, we are attempting to introduce subjects to an audience who might not otherwise be able to access them, while also getting their ideas about the subjects and potentially encouraging them to learn more. Many teachers at primary and secondary schools welcome visits from academics and para-academics, although they do sometimes require that speakers have criminal background checks. It is amazing to stand in front of a class of cynical, bored-looking teenagers and to be able to enthuse them and get them talking.

This is not an exhaustive list, obviously, and there will be some ideas

that suit your subject matter, while others are inapt.

The rules of engagement are fairly straightforward. After you have narrowed down your possibilities in regard to what sort of activity or activities you want to do, you can begin to contact publications along with institutions and organisations (libraries; museums; writing centres, heritage groups; community centres; charities; schools; festivals, etc.). These are the typical outlets for engagement work, although there are others. If you teach, you might also want to think about ways of getting your students (both undergraduate and postgraduate) involved. This enables them to get valuable experience, such as in marketing/publicity, preparing presentations, leading events, working in a team, and so forth, and they might very well be able to help you figure out the best way to shape the event.

While developing plans for your engagement activities, you must remember to state upfront whether you are looking for payment or to get your travel costs covered or for nothing at all. Some organisations assume that those with PhDs have institutional backing and will not need payment for petrol, not to mention a fee, so this must be discussed. Other organisations, of course, take it for granted that they need to pay you for your time (even if the payment comes in the form of books, chocolate, gift certificates, or other items rather than hard cash). You also need to clearly discuss and agree on expectations and hoped-for outcomes.

Once you begin to work on the structure and content of your event/article/whatever, you must consider the language you use, the approach you take, and the general attitude. Many people in the community-at-large feel 'done to' when academics swoop in to engage, and they feel talked down to or treated like idiots who should be grateful that a doctor or professor would be willing to spend time with them. Explain difficult concepts but do not assume that people who may or may not possess advanced degrees have no knowledge or education. Likewise, do not assume that they have nothing to contribute or teach you. As the National Co-ordinating Centre for Public Engagement makes clear, engagement works both ways; both academics/para-academics and the participants in engagement activities that we run have ideas and

understanding, and we need to listen to one another. We are equals in this process; there is no hierarchy.

Personally, I have found that engagement work can be incredibly stimulating, fun, and beneficial for my research and teaching, and it feels meaningful, as though in some small way I am giving back to the larger community. People choose to attend engagement activities in a way that they do not always choose to attend university; what I mean is that some young people feel forced by their parents to embark on an undergraduate degree and thus do not always make the most of it, while many people come to workshops or reading groups or pick up articles because they genuinely want to, and they often are passionate about learning. This can be truly inspiring and encouraging to experience.

I also think that engagement work offers additional proof that the work that university-trained people do is relevant to those of all ages and backgrounds, and that the academy is not as snobbish, elitist, or closed-off as is sometimes assumed. Yes, one could argue that engagement work is important for your CV and for the research excellence framework, and this is a tack that I take with my more reluctant colleagues, but I think it is much, much bigger than that, as I hope I have shown here.

As someone committed to an intellectual life, it is essential to me to share my knowledge and the findings of my research, but it is also essential to me to continue learning from others. Engagement work enables me to do both those things.

Now if you will excuse me, I have an engagement elsewhere.

B.J. Epstein is the author of over 160 articles, book reviews, personal essays, and short stories. Her new book, *Are the Kids All Right? Representations of LGBTQ Characters in Children's and Young Adult Literature*, was published in October 2013 by HammerOn. She previously published *Translating Expressive Language in Children's Literature* and *Ready, Set, Teach! Ready-Made Creative Classes for the English Classroom* and also was the editor of *Northern Lights: Translation in the Nordic Countries*. She

is senior lecturer in literature and public engagement at the University of East Anglia in England, and she is also a translator from the Scandinavian languages to English. More information about her can be found at www.awaywithwords.se.

MARGINAL INQUIRIES

Margaret Mayhew

This chapter explores a range of images of para-academia, which haunt the self-conception of those who are employed on short term contracts in either teaching or research in universities, who I also refer to as 'the precariat'. In particular I examine the concept of the parergon and how it may allow us to develop narratives of critical resistance and agency within the often marginalised experience of para-academia.

When initially considering the topic of para-academia, a number of connotations sprung to mind, particularly concerning my own experiences of fledgeling academia. Para-professional seemed the most obvious – para-academics being akin to paraprofessionals in the health sector; undertaking the vast bulk of 'hands on' health service delivery, without the authority of medical doctors to diagnose and prescribe (or their concomitant social status). This led to the image of parallel lines, considering what it is to travel on one of two paths that never meet; or even worse, that appear to diverge. I continue to observe the diverging career paths of my former postgraduate colleagues; those few who manage to secure lectureships (interstate or overseas), others obtaining post-doctoral research grants, others nestled in the relative security of regular contract teaching or research work at our home institution, as well as those like myself who scrape by with less security and familiarity in research and teaching work at other universities, or for government organisations or other research institutes. I am haunted by an image

of how the parallel lines of our PhD completion trajectory bifurcate; between tenure track optimism of sticking it out until something comes along, or being worn away by the exhaustion of teaching and poverty, the inability to publish enough to pass as a credible researcher, until a point where we admit defeat and accept our fate as casual academics, or start exploring alternative career options. I'll return to the types of images that haunt the academic precariat a little later, noting that in this chapter, I switch between para-academia as a figment and a hauntology and para-academics as marginalised actants (generally those on casual contract employment) within the variety of spectres of academia as an increasingly difficult area in which to sustain employment.

MY PARA-ACADEMIC CAREER

The story of my own para-academic career is not unique. During my PhD I undertook the 'apprentice' labour of undergraduate tutoring and occasional guest lecturing in art history, architecture, cultural studies and gender studies, in order to supplement my scholarship. In the three years since the conferral of my PhD in Gender and Cultural Studies I have continued to eek out a living from a range of short-term contracts in research (Art History, Public Health, Australian Studies) as well as tutoring and contract lecturing (in Gender, Sexuality and Diversity Studies) meanwhile trying to develop relevant publications from an increasingly remote area of specialist doctoral research.

Like most of my cohort from my home institution (a prestigious sandstone university in a major Australian city), I now find myself grimly hanging on to a series of sixteen-week teaching contracts and even smaller morsels of research assistant work, sustained by the generosity of 'benefactors'; tenured lecturers able to offer tutoring and research assistance work, or departments who are able or willing to offer short term contracts convening (lecturing and marking) an entire subject.[1] At an institution in another Australian city (which could be described by that bizarre epithet of 'second tier') I was recently provided with

$14,000 worth of piecemeal wages to convene a subject of 100 students after the previous lecturer (renumerated at around $60,000 pa) took voluntary redundancy.[2] My luck in securing this position was enabled by my considerable affective labour in securing the trust and confidence of departmental colleagues who would recommend me for the position, convincing departmental management that hiring an existing casual tutor would be more cost effective than conducting external recruitment. Obtaining payment for five hours of face-to-face teaching consisted of a fortnightly ordeal of completing and submitting paper timesheets, cross signing from a range of 'supervisors' and laborious placating of recalcitrant (and overworked) administrative staff to process my pay. I have worked casually in seven universities in Australia. In all of them I have waited at least four weeks to receive my first pay and only one institution used electronic timesheets.

Recent estimates in Australia now state that less than 36% of university employees are employed on a secure basis, with around ten thousand academics with PhDs earning less than $25,000 per annum.[3] There is a wealth of local reports and articles joining similar comments from the USA, Canada and the UK that decry this state of affairs as parlous; that the impact on quality of teaching is of concern, as are the effects of having an expanding cohort of highly educated, highly exploited, precariously employed individuals who are unable to conduct the sustained innovative contribution to the knowledge economy for which we have been trained, frequently at considerable expense.[4]

The intention of this chapter is not to add to the existing narratives of woe. Whilst I continue to experience intense personal frustration at the spirit-crushing fatuousity of managerialist culture in the university sector, I am more interested in how the conditions of working and existing as a member of the precariat impacts on the practices of knowledge formation and research that I and my colleagues are engaged. The cruel optimism with which we negotiate our career trajectories, professional networks and symbolic capital within academic circles, as well as the movements and connections formed outside of 'the sector' has the potential to reframe how academia constitutes itself, or how we as actants constitute our performativity as para-academics, or what I will propose as a form of para-ergo-academic praxis.

PARALLEL LINES: CAREER PATHS AND STRATIFICATION

I am particularly concerned with the affective work undertaken by casual academics, the endless round of networking, placating, pleading and playing in order to sustain an illusion of our symbolic capital and in order to sustain relationships with potential and actual employers. The sites of this affective work—disciplinary conferences, social media, campus corridors and departmental seminars—recreate institutional space as far less of an ivory tower than as a loose collection of circuits, of personal networking, professional collaboration and speculative ambition. I am also fascinated with the mental images that we carry with us, the schemata of academia and our precarious position within it and how the sense of precarity and anxiety seems to permeate even those academics with relative security or tenure. I wonder about the power of these images to haunt us, to cajole us into accepting exploited conditions, as well as to blind us to the opportunities for encounter, expansion and creation that can exist through the work that we do.

Returning to the earlier image of where parallel career paths diverge, it is worth nothing that the decision to turn away from an academic career rarely occurs at a crossroads, or at a particular asymptotic turning point. This image functions as a figment, that haunts all early career academics, as we apply for grants, apply for lectureships, sign another casual contract, submit articles for publication, submit abstracts for conferences and grimace reading the names of our former fellow students in journal contents pages. It is an image that continues to haunt academics even into the relative security of post-doctoral fellowships and lectureships. This may contribute to the narratives of self-pity and anxiety even among tenured academics. Anxiety levels are linked to the seemingly endless departmental restructures and to the extensive levels of performance evaluation to which non-casual employees are subjected to in Australian universities, whereby academics are constantly compelled to account for themselves according to institutionally branded evaluation frameworks concocted in the language of undergraduate commerce textbooks. I am amazed by the passivity and compliance of academics with what

many admit are often ludicrous (not ludic), laborious and intellectually insulting exercises in tedious dissimulation to a subject formation that lies somewhere between falsehood and humiliation.

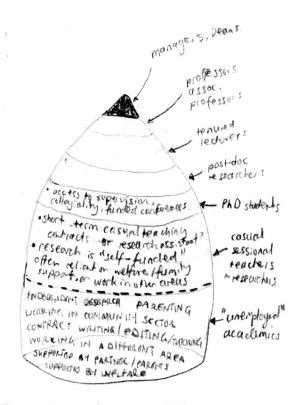

Figure 1: Para-academia as parallel layers in a stratified institutional hierarchy.

Narratives of compliance and dissimulation are evocative of a second para-academic imaginary; the figment of the academy as a singular institution in which we are embedded, as a one layer of a stratified workforce (see Figure 1). According to the stratified imaginary of Figure 1, para-academics imagine ourselves at the 'bottom of the heap', literally squashed into the lower layers of academic life. Casual academics imagine ourselves as somehow better-off than non-university-employed academics, who may work in other industries or be supported by other means. Female academics (if they manage to

secure a tenured position) imagine themselves trapped within the strata of entry-level lecturing, unable to enter the professoriate. The shape of this model is stratified by the dialogues of *ressentiment* among tenured and fledgeling academics, among academics and postgraduate students, and among postgraduate students. We all devote considerable amounts of mental energy imagining, resenting or aspiring to those in a higher tier than ourselves, or dreading falling into a lower tier than ourselves. This culture of anxiety and resentment has a pernicious effect on academic research cultures. Most readers would be familiar with the lugubrious quality of departmental research seminars consisting of tired recitations of published papers or research reports by senior academics, or nervous recitals of conference papers or thesis abstracts by junior academics and postgraduates. Questions are regarded as interrogations and cross-disciplinary seminars are rare or confined to addresses by prominent experts, rather than opportunities for collaboration and exchange. Such spaces serve to reinforce the figment of stratification shown in Figure 1 (above).

The limitation of this model are that it assumes that para-academics only have a relationship to a single institution; whereas in reality, the relationships casuals have with universities bears closer relation to the model in Figure 2, below.

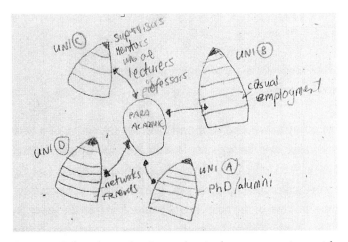

Figure 2: Polypara-academia: academics have connections with multiple institutions.

Recent data in Australia suggest that only 29% of casual academics hold a single appointment; 25% hold two appointments and 17% hold three.[5] In addition to working at multiple campuses, para-academics have affiliations and connections with former supervisors, current mentors, colleagues, collaborators and former alumni at a range of institutions. The strata where para-academics have an experience of connection may frequently vary between institutions and complicate our sense of entitlement to or identification with a particular strata of academia. However, the assumption of para-academics as peripheral members of a single institution persists and is perpetrated by the requirement of journals to ask authors to declare our institutional affiliation and in Australia by our employees union, which requires members to elect a single branch of which they are members. The union branches of both campuses where I work are two hours from where I live and so my participation in on-campus union meetings is limited. It also assumes that academic institutions are only comprised of academic employees. In Australia this is far from the truth, with most growth in university employment consisting of administration and management positions. These areas are also reliant on extra-mural engagement, through casual employment and use of contractors, consultants and collaborative research funding. Thus the model of universities as a whole can be described as paraphilial; whereby the integral function of all of the sectors (which are arguably highly stratified as academic work) is based on the engagement and employment of paraacademics and paraprofessionals (see Figure 3 below).

PARAPHILIA, PARASITES: THE FEELING OF MARGINALISED WORK

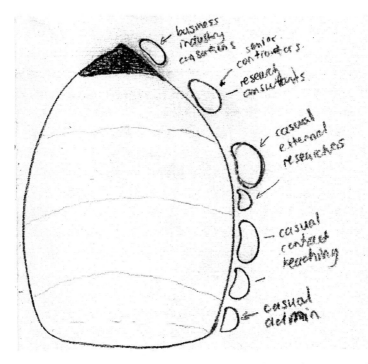

Figure 3: Para-academia as paraphilia; the prevalence of contract and casual labour throughout academic institutions.

The model in Figure 3 above still retains the imaginary of academia as comprising singular and separated institution, which casual employees cluster around. As I have argued above, this does not accurately reflect the multiple affinities that many casual academics have with a range of institutions, however it may reflect how we see ourselves in relation to academia as a singular behemoth; the *alma mater* that we remember or aspire to join. Actually I seriously doubt if any academics cling to such outmoded romantic notions. It is, like most professions, comprised of continuous movement and shifting allegiances of career mobility. Possibly it is more useful to consider the micro-relations of para-academia; and the types of flows that occur within and around the singular precariously employed academic.

I suspect that there is something embedded in the character of academic work; in promoting and managing the intellectual compliance of students, in performing a level of compliant self-discipline in our own assiduous application to study and research. Rather than react outwardly or verbally, academics internalise our disgust and outrage. We abject ourselves, as 'chicken shit', small fry, singular powerless entities, easily crushed by the immensity of institutional juggernauts (see Figure 4).

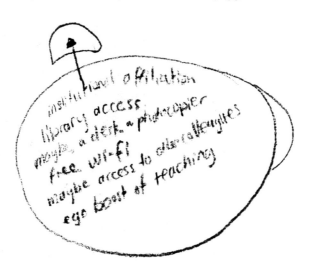

Figure 4: Para-academic as parasite

This feeling of smallness; the internalised sense of abjection, contributes to another para-academic imaginary, particularly among casual academics. We imagine ourselves as parasites, as a clinging abject self that clings to any contacts, dribbling job opportunities, promises of contracts, hanging on the telephone (or email), feeling parasitic, feeding off whatever opportunities, charm or connections we can find. Observing the efforts of precarious colleagues 'touting themselves' as prospective casual labour among academics at annual conferences is a painful and pitiful reinforcement of this idea of the casual academic as parasite, leaping from host to host in the hope of sustaining themselves for another year of short-term contracts. This sense of attachment,

of feeding off an institution that we are external to, embeds itself in the network of arbitrary rewards and privations that are part of casual academic life: having access to a research library, but not having a security swipe card; having a pigeon hole, but not an office; having access to a communal lunch room, but never being invited to lunch or departmental meetings; having a university email address, receiving daily communiqués from the institutional Media and Communications departments, but being excluded from departmental e-lists. Precarious academia involves the constant negotiation of our sense of privation and privilege and is constantly played out in the micropolitics of how and where we do our work. I feel like a mosquito, constantly buzzing in the ears of my colleagues, asking for basic information, listening in on corridor chat, smiling and hoping I can be included. Luckily I do have an office and mostly pleasant and inclusive colleagues and yet I am not quite and not ever one of them. This feeling of being parasitical is because our work is not legitimated by research awards, or tenure, but is always something conducted outside of the pragmatics of our casual teaching or casual research assistant work, that we do for others. It is also a condition exacerbated by the social inequalities of class differences, of gendered behaviours of caretaking and self-sacrifice and the endless labour of border-crossing and cultural mobility undertaken by academics of colour.

PRECARIOUS THOUGHT

The topic of intellectual precarity often reminds me of Pierre Bourdieu's notes on Immanuel Kant in the appendix to *Distinction: A Study On Taste*.[6] In a postscript titled 'Towards a Vulgar Critique of "Pure" Critique', the invisible beholder of Kant's sublime aesthetic encounter is situated as a highly anxious, socially precarious and fraught individual desperate to ensure his social authority through the development of an epistemology where his own precarious positionality is erased.[7] In Kant's writings the sublime encounter occurs through an imaginative

act where the writer sees themself and their inquiry as entirely separate from the practices and spaces where the inquiry is conceived and wrought into words. This imaginative leap is utterly transcendent of the material and embodied conditions where the imagination occurs. It effaces the banalities of peering through smudged spectacles, or the daily views of the desk, pen, paper, door or the dim room where intellectual labour takes place and transcends the precarious and anxious subjectivity of the intellectual beholder, who like Kant (as Bourdieu reminds us), was heavily invested in the legitimation of his particular class and disciplinary identity in order to negotiate financial and institutional support from his benefactors.

Bourdieu's insistence on the social and class context of any knowledge production and the situatedness of epistemology in class contestation provides a lucid framework in which to contextualise some of the wrangling around identity and agency of para-academics and possibly reconfigure our conditions of precarity within embattled and competitive research arenas into a critical epistemology of genuine reflexive inquiry. It is a reminder of the difficult material conditions under which most intellectual activity has been conducted for most of modern history. Rather than imagining financial demands and socialised identities (class, gender, ethnicity) as extraneous factors to be managed and contained within a performance of the idealised mobile unmarked subject of neoliberal knowledge economies, I wonder what would happen if we chose to regard our 'external' factors as integral components of how we conduct our work of research and teaching. By reimagining ourselves in a contingent relationship to academia, rather than as a parasite, we may perhaps be able to envisage our position in more productive terms.

PARERGONS AND PARA-ACADEMIA

In the image in Figure 5, the para-academic becomes a node of non-academic and academic relations. Our relation to other (para) academics constitutes the border of the academic institution, but this is

rarely articulated. Our own condition is somewhat schizoid, as precarity of our academic employment means that we are more embedded in our non-academic activities for emotional and financial sustenance. A casual academic employed for less than ten hours per week teaching, or for less than thirty weeks in a year, constitutes their identity, if not their financial security, through other activities and relationships. Even the volunteer work of writing for publication is undertaken entirely separately from the institutions that employ us to casually teach or undertake research assistant labour. Thus our very precarity means that we are constituted as a nexus of a field of relationships and exchanges that are both academic and non-academic. The way in which I consider this liminal positionality is as a parergon.

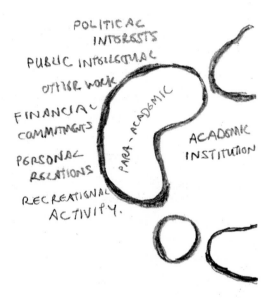

Figure 5: The paraphilia around the para-academic

I have derived my understanding of parergons from Jacques Derrida's reflections, in *The Truth In Painting*, on the aesthetic philosophy of Immanuel Kant in *A Critique of Judgement*. Bourdieu includes a sharp dismissal of Derrida's work in the same postcript mentioned earlier.

Despite Bourdieu's critique of Derrida's play as excessively detached from social relations, I find the latter's reflection on Kant's ideas is useful for how margins and relationships can be spatialised. According to Derrida, a parergon may appear as a supplement to a particular object, such as the frame around a painting; however, it is more than an ornamental addition and in fact is integral to how the object is itself constituted or separated from its milieu:

> A parergon comes against, beside, and in addition to the *ergon*, the work done [*fait*], the fact [*le fait*], the work, but it does not fall to one side, it touches and cooperates within the operation from a certain outside. Neither simply outside nor simply inside. Like an accessory that one is obliged to welcome on the border, [*au bord*] on board [*a bord*. It is first of all the on (the) bo[a]rd[er] [*Il est d/abord, là-bord*].[8]

In the quotation above, I have used Derrida's play on parerga as a fact, as what is done and what is above board, onboard and on the border to emphasise a link to action and also to borders and the ideas of borders and border crossings. The link to border crossings is deliberate, as I will later draw some threads of critical praxis between precarious academics and other more precarious lives of asylum seekers and refugees. The facts of what we do (or can do), of the movements made across the borders of legitimate and illegitimate knowledge creation and the connections made with legitimate and illegitimate citizens, are a potent reminder of the continuing possibilities and challenges of critical intellectual praxis. Para-ergo-academics appear as a supplement, a marginal addendum to the institution; however, our function is more constitutive than an ornament or addition; the border-work we undertake in moving between institutions and between institutional and non-institutional praxis facilitates possibilities for a critical praxis of knowledge creation as essential to and excessive of the exigencies of the neoliberal university.

PARA-ACADEMIA AND PARADOX: THE LIMITS OF INSTITUTIONALISM

Critical discourses of academia frequently rely on a phantasm of infinite knowledge and 'free' education idealised as the essence of the university as a repository of knowledge and incubator of ideas. This essence is always embedded within a temporal rupture; either to a past of full government funding of universities, or to a future of radical social upheaval. However, universities have historically imbricated with the restriction of knowledge, either within rigid disciplinary parameters or through the direct or indirect forms of social exclusion: of women, of the working class, of indigenous peoples and racially marginalised identities. In Australia, higher education debates are always polarised between the decrying of reduced government funding and increased corporatisation of universities and the massive increase in tertiary education levels across the population. Rather than embedding the possibilities of free education within a mythologised past of fiscal support, or a redemptive future of social equality, it may be more productive to regard universities as profoundly conflicted sites; where knowledge is both created and destroyed and participants are both liberated and crushed. The conflicting tendencies within universities may thus be considered as a continuous oscillation, which participants negotiate rather than contest.

A similar structural account of universities as fundamentally divided was articulated in Fred Moten and Stefano Harney's 2004 article 'Seven Theses On The Undercommons'.[9] Moten and Harney's description of the limitations of scholarly endeavour within American universities is increasingly pertinent to universities in Australia and the UK. They depict the 'free' activity of knowledge creation, or 'the commons' of open-source knowledge movements, as increasingly subordinated to the neoliberal imperatives of information packaging and production within the corporatised academy. They cite how in critical discourses of contemporary academia, the university ideal of 'free' education and 'pure' research is contrasted with the increasingly pragmatic model of 'professional training'; however, they argue that the latter has always been a core function of universities. They cite the contested histories of

universities as state institutions, embedded in the writings of philosophers such as Hegel and Kant, as intimately concerned with the direction of surplus or invisible labour as intellectual activity, legitimated through the creation of particular classes of professionals, within the academy. The increasingly utilitarian articulation of this professional formation in contemporary universities is merely the continuation of the nation-state imperative to contain and manage intellectual activity. In the neoliberal academy, they argue, this is bifurcated between quasi-fordist articulation of educational and research outputs and the anxious dissimulation of critique undertaken by the 'posturing critical academic'. Moten and Harney argue that such 'critical celebrity' academics are as professionalised as the besuited managerial caste of university administrators and are merely performing a dissimulated extension of the practice (and discourse) of research and inquiry as a colonising and recuperative enterprise.[10]

Despite the enticing nihilism of such studious cynicism, the apparent conflict between types of university employees, and particularly within 'academic' professionals, does have some potential to contest reductive imperatives of cognitive capitalism and to reshape how knowledge is generated and sustained even within the imperatives of professional formations. In particular, the casualisation of academic workers and the increasing reliance on exploited and precariously employed intellectual labourers for the 'service delivery' of education and research labour contains the possibility of such precarious intellectual life to embody a form of genuinely critical and even undisciplining praxis.

PRECARIOUS PRAXIS: PARA-ERGO-ACADEMIA

Moten and Harney's proposal for 'critical praxis of the undercommons' is entirely suited to the precarious position of para-academics. To envisage it as para-ergo-academic praxis requires a recognition of our position as double agents, contaminants and specifically porous elements of the framing margins of institutional identity. It involves a commitment to

open-source learning and information management and the transcription of closed-source circuits within the knowledge economy into broader arenas. While this is becoming increasingly difficult in institutional environments that rely on internal blackboard programs for recording of lectures (that can be replayed but not downloaded) as well as online discussions between students, there are still spaces where these closed-source activities can be complemented by more open-source approaches. It also involves a conscious eschewal of the ludicrous activity of contributing vast amounts of unpaid labour (as writers, peer reviewers etc) to closed-sourced academic journals. It also relies on a reflexive use of the work of our non-academic peers within academic environments. This may involve hiring guest lecturers, or using the reports, blogs and articles from community activists as reference material and opening our spaces of learning and exchange to include the voices even more marginalised than our own and to encourage students and peers to encounter non-academic materials in a scholarly engaged fashion. Para-academic praxis is based on a recognition and deployment of the privilege we do have, even as precarious, exploited and marginalised knowledge workers. While universities continue to embody a promise of knowledge creation as open-ended possibilities it is our intellectual responsibility to facilitate that knowledge creation in as many ways as possible.

These suggestions described above are discrete movements, often undertaken individually and even clandestinely. They are context specific; assuming that the para-academic may be working in a socially progressive field of the humanities or social sciences and that the para-academic may have a philosophical investment or personal networks with political activists, advocates or volunteers in the community sectors or environment movements. It would be hard to know how to advise my friends working precariously in fields such as pure mathematics or computational modelling (although even in these areas, para-academics undertake creative commons in establishing their own open-source online journals and under commons work in collaborating with electronic activists).[11] The cloak and dagger approach of undercommons knowledge contestation doesn't contest narratives of redemption (things will get better)

and embeds a level of ethical and temporal displacement in the way we engage with the institution, that could be psychologised as adolescent.

However, an articulation of our para-academic position as contingent and in a dynamic relationship between academic and non-academic sites may facilitate a more grounded articulation of our critical approaches to the knowledge economy. Para-ergo-academics do not split ourselves between the demands of paid academic work, the unpaid hopes of publishing our own research and our private worlds of sociality and recreation. We recognise our embededness across a range of fields and attempt to deploy this in our processes of knowledge making, as in Figure 5.

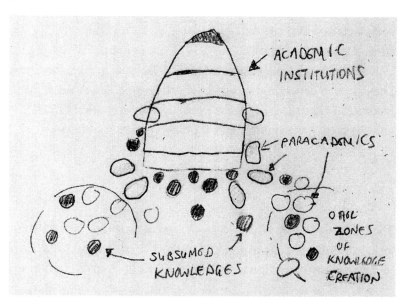

Figure 6: Para-ergo-academia and subjugated knowledges

For para-academics, the flows of information and knowledge bear less resemblance to a colonising model of knowledge recuperation as described by Moten and Stefano and more of a relationship of flux and cross cultural negotiation, as evoked in Homi Bhabha's account of vernacular cosmopolitanism among diasporic populations from former colonies. This shift is dependent on para-academics no longer regarding

the academic institution as 'home' or colonial centre to which they can return. It is based on our recognition that our relationships to institutions are contingent, temporary and mobile and that our identities and labour are based on a liminal relation to a range of zones, in effect, a form of border-work.

Beyond this form of individual activity there are a number of examples of collaborative forms of para-ergonomic praxis that promote agency and resilience of marginalised academics and the publics with which we engage. These counteract the scarcity economy of knowledge commodification within the institutions, where ideas and information are seen as rare commodities to be exchanged for cash and instead focus on creating spaces for open exchange to occur. The work of both has been initiated and sustained by casual academics and PhD students from a number of institutions and is dependent on the time made available through underemployment and lack of family commitments. They are also dependent on a level of voluntary disinvestment from the institution (encouraged by the limited prospects offered by it) and a broader commitment to a form of public intellectual activity.

A FREE UNIVERSITY

The Melbourne Free University emerged in 2010 on the initiative of a group of PhD students grumbling in their shared offices, who decided to act on their frustration with the lack of intellectual discussion within universities as well as the absence of public forums where ideas could be exchanged. From tutoring they noted that students were frequently constrained by pressures of assignment deadlines, or from a simple lack of engagement, whereas academics were often under too much pressure (from administrative loads, research performance deadlines or excessive teaching loads) to engage in open, public discussions or share their knowledge outside of formal academic spaces. However, they did not want to copy the model of existing university 'extra mural' seminars; where knowledge is streamlined and contained, either through

highly expensive 'continuing education' courses or through public lectures offered by host universities. As founding member Jasmine Kim-Westendorf explains, 'Public lectures are often on a campus and held during the day, so people who work can't get to them. They only allow fifteen minutes for discussion, so audience members only get to respond for one or two minutes and it has to be a question, or they get ignored or ridiculed, so this means that there is little space for genuine discussion or engagement with ideas.'[12]

In contrast to the contained model of public presentations, Melbourne Free University developed seminars consisting of a short presentation of forty-five minutes followed by audience-led discussion for the same amount (or longer, depending on audience interest). Sessions are held two nights per week in the upstairs gallery area of a bar and the back room of a café, in inner-suburban Melbourne. Participation is entirely free and speakers, facilitators, coordinators, publicists and venues are all unpaid. In its fourth year, the Melbourne Free University courses are still popular (and occasionally jam-packed) and as Westendorf says, 'Invited academics are usually very excited about this alternative type of learning environment.' Seminar topics are arranged in six-week blocks of courses on specific subjects, decided and coordinated by a collective and advisory committee of academics and students. In addition, the Free University host regular special event panel discussions on topical areas. Topics range broadly across the humanities and social sciences, extending to environmental studies, economics and design and talks are archived on the Melbourne Free University website.[13]

The website of the Melbourne Free University has continued to sustain itself as a quality open source repository of ideas and discussion between academic and non-academic audiences. The website also includes a downloadable manual on 'How To Start Your Own Free University'. This includes a series of essays and comments by participants articulating their grounded critique of the limitations of the current outcome oriented format of higher education, as well as a set of guiding principals for ensuring that education retains the radical character of 'free' learning as articulated in Paolo Friere's writing and practice four decades earlier.

The listed principles of the Melbourne Free University (on the website) are as follows:

- The Free University combines the academic rigour of a traditional university with the open discussions of a philosophical salon.
- The Free University stands for radical equality: the *a priori* belief in universal equality and possibilities of emancipation.
- The Free University is free and accessible. It remains politically and economically autonomous from political parties and organisations, government, private bodies, universities and NGOs.
- The Free University is based on the belief that people have the responsibility to seek and engage with knowledge. Learning is an act of will and empowerment.
- The Free University is an alternative to the exclusive and outcome orientated education sector, enabling the pursuit of knowledge for its own sake and thereby freedom.

The Free University resembles similar initiatives undertaken during the global 'Occupy' movements in late 2011. In Australia, as in the USA and Europe, students and academics brought in spare copies of books and journals to form ad hoc libraries and occupying activities would invite academics to give guest lectures to the assembled crowds. Judith Butler's address to the Occupy Wall Street movement remains one of the most publicised forms of these.[14] The Melbourne Free University briefly collaborated with the 'Occupy Melbourne' collective, offering courses in the city square site during and even after the occupation. However, the forms and implications of 'freedom' for both groups came into some conflict, with the Melbourne Free University insisting on the principle of political independence, even from the well-intentioned social-justice imperatives of the activist organisers of the occupation movement. This political independence has allowed the Melbourne Free University to continue as a community initiative, where discussion and exchange is serious, rigorous and critical, but not beholden to assessable outputs of profit-based education, nor to the activist imperatives of partisan political

groups.

Arguably it is this liminality, the porous capacity of the collective to be linked to academics, but not be tied to institutions, to create links with activists, but not be constrained within a particular political identity and to explore a range of subjects, without being confined within a disciplinary methodology that is its greatest strength. And arguably this conscious and critical liminality represents the most effective form of Para-ergo-academic praxis.

CREATING REFUGE; LEARNING AND PRAXIS WITH REFUGEES

In Sydney an open-source learning project emerged in entirely different context, initiated by casual academics and artists working together. They started informally visiting a high-security refugee detention centre located in the outer suburbs of Sydney, initially as a form of volunteer visiting of Afghani, Iraqi and Iranian prisoners inside. In late 2010 the loose coalition of artist and academic visitors decided to take a more collaborative and conscious approach to starting art classes with detainees.[15] Since then, they have continued to have regular visits and art classes, as well as hold a series of local and interstate exhibitions of refugee art, as well as publish journals, zines and articles comprising collaborations between detainees, released refugees, artists and academics. One of the academics, Safdar Ahmed, casually working at Sydney University, previously trained as an artist and is an accomplished illustrator and printmaker. He initially coordinated art classes among the detainees, then worked with other volunteers to curate a series of exhibitions and, three years later, continues to collaborate with detainees in illustrating their stories, preparing cartoon strips and graphic novels. In Melbourne a similar project started in 2013. Melbourne Artists for Asylum is a collaboration between academics, artists, writers, students and asylum seekers. They hold weekly art classes in refugee detention centres and in the community. The latter are particularly important for refugees living in isolated areas, on low incomes or with severe visa

restrictions on work and study.[16]

The work of the refugee art project academics involves translation, transcription and dissemination of the poetry, writing and verbal narratives of refugees, as well as supplying them with art materials, exhibiting and reproducing their art work, even fundraising for legal advocacy for asylum seekers. Safdar has used his academic work to give talks and publish papers on the refugee art project and the treatment of asylum seekers, in addition to his own academic publishing in Islamic Studies.

The refugee art projects represent a form of collaborative engagement where the informalised labour of casual academics meets the unrecognised non-citizens of refugee detention centres. In Australia, even refugees housed in community detention or on bridging visas are prohibited from working and so any 'work' they undertake is either voluntary or illegitimate. The collaborations between academics, artists and asylum seekers in extra mural activities of knowledge exchange facilitate new forms of knowledge creation; where the effacement of the identity, culture and knowledge of refugees forced into black-market manual labour or the dehumanising conditions of detention and surveillance can be contested. This extends the informal economies of emergent communities into an informal knowledge economy, where the marginalised 'refuse' of institutional academia, or the intellectual precariat, may use our abilities and resources to create new circuits of ideas and exchange.

The scenario above may seem hopelessly idealistic, particularly as it is dependent on the financial means of casual academics being sufficient to allow us the luxury of undertaking unpaid work. I am proposing a reorientation of the unpaid work that para-academics already perform, towards a more proactive and constructive relationship to emergent knowledge economies, rather than continued exploitation and marginalisation within the increasingly neoliberal environment of universities. This involves the continuous and conscious negotiation of our relationship to professional institutions, as well as a reorientation of our disciplinary practices and relationship to our critical epistemologies.

CRITICAL UNDISCIPLINE: CONTESTING FROM THE MARGINS

Jack Halberstam's introduction to *The Queer Art Of Failure* argues for the necessity and possibility for the undisciplining of critical inquiry.[17] In insisting on the need for research to facilitate practices of epistemic contestation, Halberstam argues for the necessity for disciplinary contestation; allowing for a dialogue not only between disciplines, but with practices, knowledges and practitioners that are undisciplined. The introduction includes a discussion of Michel Foucault's writings on subjugated knowledges, the role of academic institutions in suppressing localized forms of social knowledge creation and the necessity for critical thinkers to turn to the naïve knowledges subjugated by disciplinary power of academic institutions.[18] The praxis of *Society Must Be Defended* is based on a search for undisciplined knowledges and non-disciplinary knowledge formation, which Halberstam articulates as a refusal of mastery, even to the extent of pursuing failure as a deliberate strategy of critical survival.[19]

As its title suggests, Halberstam's book is concerned with critical aesthetics of visual culture from 'dude' cinema, Pixar animation and fine-art photography. The exhortation to fail well and fail often evokes the condition of knowledge production as profoundly excessive, a space of plenitude and play, where activity is ceaseless and unhampered by expectations of results or outputs. The emphasis on process and play resonates with the experience of labour undertaken by creative artists. My own creative arts study and practice is a frequent reference point as I wonder why academic work seems so laborious and creative work (often intensely laborious) always seems more productive. I believe somehow it is the relationality of creative work, whereby open-ended processes are oriented towards engendering and furthering connections between people that contributes to the sense of agency and fulfilment derived from creative activity. It is not impossible to approach knowledge creation—research, writing and teaching—with a similar process-driven,

open-ended approach. Para-ergo-academic praxis is profoundly creative, exploratory and relational; it works in and generates contingent spaces where relationships and ideas can connect and move in unexpected ways. However, it does imply forgoing any attachment to mastery or individual success and possibly to sovereignty as well.

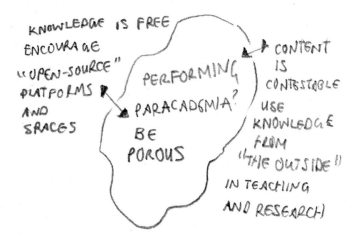

Figure 7: The para-academic as porous para-ergon

While Foucault evokes a critical undisciplinary praxis as a challenge to the principle of sovereignty, the term itself is open to reconfiguration.[20] Much of Foucault's work carries echoes of his surrealist predecessor George Bataille. However whereas Foucault evokes sovereignty as part of the illusory subject of biopower, Bataille evokes sovereignty as that which exceeds socialised forms of desiring and knowing.[21] While it is beyond the scope of this chapter to articulate the elusive boundaries of desire, subjectivity, sovereignty and dissolution in twentieth-century French theory, the ideas of sociality and agency in both authors are pertinent. Bataille's ideas on economies of surplus versus economies of scarcity were a starting point for my own shift from resentment on the edge of the academy to activity across the borders of academic and

non-academic work. Bataille's exploration of the economies of excess, where the designation of particular desires and behaviours marked as taboo and the consideration of certain thoughts and emotions as superfluous, pointless and excessive, indicate where a range of social and psychic economies encounter one another, contesting the boundaries of each.[22] The emphasis on borderwork as both constitutive and restrictive of sovereignty, resonates with my own para-ergonomic praxis of creative activity and knowledge dissemination among communities of displaced people, who, outside and across the borders of state sovereignty, manage to create new forms of sociality and knowledge.

This chapter has not offered a clear manifesto for action nor a specific methodology for successfully negotiating the challenges of precarious living under what is increasingly described as 'cognitive capitalism'.[23] This is an invitation to pause and to critically reflect on positionality and agency of para-academics as critical agents, capable of creating knowledges, epistemologies and forms of encounter and exchange that promote constructive and dynamic intellectual engagement. Rather than regarding the increasing marginalization and exploitation of academics as a threat to the conduct of legitimate research, I prefer to see it as a critical imperative, which demands that para-academics consciously position our practices and discourses in relationship to fields of knowledge production that are fundamentally contested and contesting. I'm interested in how the conditions of conflict and relationships of contestation affect us and the practice of scholarship and disciplinary inquiry. I'm interested in what types of disciplining practices are embedded in our scholarship and if and how extra-disciplinary practice can be critically articulated. This chapter hopes to encourage a mental shift away from haunting images of being fixed, or trapped or bound into a precarious and marginalised relationship to academia, into a reimagining of our position as being porous elements of institutions; as leaky portals between academia and other sectors; as positive contaminants of universities and creators of new forms of knowledge and society. Whether conducted within, beneath, across or outside of academic disciplines, genuine inquiry embodies a symbolic contract to have the potential to actually contest the institutional

exigencies and insist on challenging the parameters of what critical inquiry and knowledge creation and action can become.

Acknowledgements

The ideas, praxis and conversations with the following have been invaluable in preparing this article: Safdar Ahmed, Carol D'Cruz, Anne Deslandes, Jasmine-Kim Westendorf, Rizwana Kousar and Shannon Woodcock.

Notes

1 For a more evocative description of precarious living of emerging academics please see Deslandes, Anne (2013) 'Students ill served by tutors facing uncertain futures', *Sydney Morning Herald,* 20 August http://www.smh.com.au/comment/students-ill-served-by-tutors-facing-uncertain-futures-20130819-2s7ai.html. Last accessed 20 August 2013.

2 Figures are quoted in Australian dollars. At the time of writing one Australian dollar equated 50 UK pence. To contextualise the amount of earnings, the Australian poverty line for March 2013 for a single adult was $489.00 per week, or around $25,000 per annum. (Source: Melbourne Insitute of Applied Economics).

3 National Tertiary Education Union (2012) *Submission to the Independent Inquiry into Insecure Work in Australia,* 5. http://www.unicasual.org.au/publications/submissions. Last accessed 13 August 2013.

4 Broadbent, Glenda *et al* (2011), 'The Casual Approach to University Teaching: Time for a Rethink?' in Krauss, Kerri-Lee *et al* (eds) *Research And Development In Higher Education: Reshaping Higher Education,* 34, 188-197. Available online: http://www.herdsa.org.au/wp-content/uploads/conference/2011/papers/HERDSA_2011_May.PDF. Last accessed 2 July 2014.

5 National Tertiary Education Union (NTEU) 2012, *Casual Teaching*

& Research Staff Survey Summary of Results, http://www.nteu.org.au/library/view/id/2651. Last accessed 13 August 2013, 3.

6 Bourdieu, Pierre (1979) 'Postscript: Towards a Vulgar Critique of 'Pure' Critiques', *Distinction: A Social Critique Of The Judgement Of Taste*, Nice, Richard (trans) Cambridge Massachusetts: Harvard University Press, 492-493.

7 *Ibid*. See note 21.

8 Derrida, Jacques (1987) *The Truth In Painting*, Bennington, George & McLeod, Ian (trans) Chicago: The University of Chicago Press, 54.

9 Moten, Fred and Harney, Stefano (2004) 'The University and the Undercommons: Seven Theses', *Social Text*, 79 22 /2, 101-5. http://www.elkilombo.org/the-university-and-the-undercommons/. Last accessed 5 August 2013.

10 *Ibid*.

11 The *Fibreculture* journal emerged in the 1990s from a loose network of academics and 'geek' activists who were involved in community access technology projects, Indymedia and Electronic Frontiers Australia. See: http://www.fibreculture.org/

12 Westendorf, JK. Personal communication. August 2013

13 See http://melbournefreeuniversity.org/

14 Judith Butler addresses Occupy Wall Street, 23 October 2011, Youtube video, http://www.youtube.com/watch?v=JVpoOdz1AKQ. Last accessed 2 July 2014.

15 See 'About the RAP' *Refugee Art Project* website, http://therefugeeartproject.com/home/faqs/. Last accessed 5 August 2013.

16 See http://melbournefreeuniversity.org/?page_id=3873.

17 Halberstam, Judith (2011) *The Queer Art of Failure*, Durham: Duke University Press.

18 *Ibid*, 11.

19 *Ibid*, 23.

20 Foucault, Michel (2003) *Society Must Be Defended: Lectures at the College de France, 1975-1976*, David Macey (trans.) New York: Picador Press.

21 Bataille, George (1991) *The Accursed Share, Volume 3: Sovereignty*, Robert Hurley (trans) New York: Zone Books, 209.

22 *Ibid*, 225-6.

23 I acknowledge that the term has had a revived currency since the publication of Yann Moulier-Boutangs book of the same title in 2012.

Margaret Mayhew is an artist, performer and academic who holds degrees in Science, Fine Arts and Art History as well as a PhD in Gender and Cultural Studies. She is a former artist's model who has published on practice-based research, life modelling and visual ethnography. She teaches in the gender, sexuality and diversity studies program at La Trobe University and provides volunteer art classes inside refugee detention centres in Melbourne.

Margaret Mayhew's blog:
http://www.margaretmayhew.com

Archive of open-source teaching in gender studies.
(Includes links to open source teaching and to student blogs)
http://studyingsex.wordpress.com/

Melbourne Artists for Asylum:
http://mafamelbourne.wix.com/mafa

Melbourne Free University Asylum Seekers Project:
http://melbournefreeuniversity.org/?page_id=3873
Refugee Art Project: http:the refugee art project.com/home

EPICUREAN RAIN

Eileen A. Joy

for Michael O'Rourke

Thinking about habit and habituation, especially in relation to where we live when we do our work, and reminding ourselves that the university (if we live, or *have*, lived there) is *one* important form of social life—it is not just a place where we study, think, and develop knowledge apart from our 'real' lives, but rather *is* a form of life, a *habitus*—this is how Isabelle Stengers describes what *she* does as a university researcher:

> One way of articulating what I do is that my work is not addressed to my colleagues. This is not about contempt, but about learning to situate oneself in relation to a future—a future in which I am uncertain as to what will have become of universities. ... Defending them against external attacks (rankings, objective evaluation in all domains, the economy of knowledge) is not particularly compelling because of the passivity with which academics give in. This shows that it's over. Obviously, the interesting question is: who is going to take over? At the end of the era of the medieval university, it was not clear who would take over.[1]

It was not clear. Things are not clear, or they are very clear. It ain't over 'till it's over, or it's already over. We've entered an era of loving our catastrophes, of tuning them for scholarly fugues about the end of everything, where it's no longer about preparing for the end or even surviving that end, but about living on the rising waves and pandemic fumes of its temporal drag, where we cultivate and adorn shipwrecks instead of gardens.[2] The anthropocene is nearing its end, and this isn't just another milleniarist fantasy. And this isn't about taking notes from Lee Edelman's *No Future: Queer Theory and the Death Drive*,[3] because we still care about political action with some sort of forward motion. But posterity isn't the point anymore; we've given up on this thing called posterity.

Speaking of drag, history's a real drag. It makes thinking hard, because you can't get out of it. It's always giving you headaches, especially if you work or were trained in a university of a certain Western-white-Anglo-German variety, which is almost all of them. There's no remedy for this, no over-the-library-counter medication. There's a lot of alternative histories but we call those 'minor', they're at the 'bottom', and there's never an alternative no-history. No blank pages. No Lucretian laminar void. The only thing to do in a laminar void is fall and bump into things, and that makes it the perfect setting for novelty and new relationalities—in fact, for history. History without laminar voids is not history; it's propaganda. Cruising is historical, or vice versa; I'm speaking also of Bersani's 'non-masochistic *jouissance* (one that owes nothing to the death drive)'.[4] It means we get to have our *jouissance* without demands, without insisting that someone else pay a price for it. And maybe also without always over-thinking it. Because history is a drag.

That's the tragedy of Meryl Streep as Susan Orlean in Charlie Kaufman's film *Adaptation*, standing up to her waist in the Everglades swamp after her lover, the orchid thief John LaRoche, is eaten by a crocodile:

> Oh my God. Everything's over. I did everything wrong. I want my life back. I want it back before it got all fucked up. Let me be a baby again. I want to be new. I want to be new.

That's our tragedy, too.

Becoming-new (as opposed to, say, Deleuze and Guattari's becoming-intense, becoming-animal, becoming-imperceptible, etc.)[5] feels practically impossible. We'll admit that we can't escape history, exactly, and that Epicurus's laminar void—through which atomic particles once 'rained', and then, through various small 'swerves' (Luctretius's *clinamen*),[6] created our world—is no longer possible (at least, not from the standpoint of the universe being empty). At the same time, we need not only to be able to account for novelty (isn't that partly what critical studies of art, for example, are about? and also historical studies?), but to also be able to create it, and this can't be accomplished without somehow charting returns to (or reboots of) that laminar void, in order to cultivate its radical contingency, its powers for engendering material encounters that can't be predicted in advance, and out of which alternative life- and art-practices become possible.

Why does novelty matter? Because without it, everything is always set to repeat, even with overtly subversive variations—Judith Butler's thinking on drag as performative repetition 'with a difference', for example, where creative innovation is of course possible, but also always depends on iterations of the same and thus never entirely breaks free of its object of critique.[7] As Aaron Bady has argued recently, with regard to the institutional unrest within the University of California, critique 'is often not very good at breaking away from its object; critique is dependent on its objects, and its objects will define the meaning and possibilities of critique'. Further, to critique 'can be to obey: by applying only where obedience is not required, this kind of free speech is just the flip side of power, a kind of supplementary and enabling excess'.[8] But this is just a caution, for we will always need critique (Bady himself never stops critiquing)[9] and it has not, contra Latour, 'run out of steam'. As long as there exist asymmetrical power relations and the capitalist-neoliberal uptake-reification of everything, we will need critique, especially if, by 'critique', we mean speaking truth to power, from within its relations, in order to insist that power account for itself, that it be held accountable (which is also a way of putting particular checks on power, from a

position of 'equal standing' and in full view of some sort of 'commons'—at least, that's the optimistic view).[10] But we have to be able to envision a possibility of change, for the university, that might mean a new university that would betray its own history, one that might even arrive from what Althusser termed 'the assignable nothingness of all swerve', situated in a no-place of aleatory encounter that Althusser imagined as being (if somewhat paradoxically) before history:

> In this 'world' without being or history (like Rousseau's forest), what happens?...What happens there is what happens in Epicurus's universal rain, prior to any world, any being and any reason as well as any cause. What happens is that there are encounters...it is enough to know that it comes about 'we know not where, we do not know when,' and that it is the 'smallest deviation possible,' that is, the assignable nothingness of all swerve.[11]

Towards the end of his life, in the early 1980s, recently discharged from a psychiatric hospital in Paris, where he was hospitalised for three years after murdering his wife in 1980, and living in a neighborhood apart from the École normale supérieure that had formerly provided a more socially sheltered existence (and thus, working more in the Outside), Althusser threw himself into a work never to be completed on the 'materialism of the encounter', which began simply, 'It is raining. Let this book therefore be, before all else, a book about ordinary rain' (167). In this work, Althusser hoped to show that the most radical (and importantly, for him, anti-logocentric, anti-Meaning) philosophy of all would be one that takes account of the aleatory and the contingent as opposed to 'necessity and teleology, that is to say, a . . . disguised form of idealism' (168).[12] Philosophy, for Althusser, would then become a practice of observation and description of 'crystallised' encounters, out of which the world would 'open up' to us, as a sort of 'gift', 'in the facticity of its contingency' (170). Philosophy would also dispense with the 'problem' approach (i.e., 'why is there something rather than nothing?') by 'refusing to assign itself any "object" whatsoever . . . in order to set out from nothing, and from

the infinitesimal, aleatory variation of nothing constituted by the swerve of the fall' (174–175).

This is not to say that one avoids history—after all, the world is filled with millions of *some*things, as opposed to black voids, and history 'gels at certain felicitous moments' (194)—for example, Althusser's murder of his wife, which can never be undone[13]—but rather, in order for anything different to happen (and that is an ethical project, I would argue), one has to figure out strategies for creating special starting conditions that void (or at least temporarily stay) presupposed parameters of thought and movement and allow one to attend to the shock and materialism of the encounter. There would never be any final conclusions or certainties, just a Rousseauvian forest in which 'the radical absence of society . . . constitutes the essence of any possible society' (184). Ultimately, for Althusser, the materialism of the encounter 'is the materialism, not of a subject (be it God or the proletariat), but of a process, a process that has no subject, yet imposes on the subjects (individuals or others) which it dominates the order of its development, with no assignable end' (190). All possible arrangements and complementarities possess a certain readiness for possibility, in such a world of collision (190, 192), and Meaning (with a capital 'M') is no longer about origins or ends, but inheres instead in the felicity of encounter.

Let us work, then, to build a Rousseauvian forest, or Kaufmanesque swamp, in which we can practice our tiniest deviations. We need, of course, our arts of living, which have a history (that we need not neglect) and which the traditional humanities has been so adept at cultivating, but this also means that the humanities is a reservoir of the sorts of creative delusions (and fuzzy thinking) that are necessary for not just surviving, but thriving.[14] As the poet Lisa Robertson has written, 'I need to be able to delude myself, for as long as it takes, as long as it takes to translate an emotion, a grievance, a politics, an intoxication, to a site, an outside'.[15] We need our delusional spaces. The University, and the humanities especially, is an important space, for the artfulness of living, for enriched environments, and real-time experimental ecologies—which is to say, for alternate delusions, and this means we also need an alternate

delusion for the University.[16] I've never liked the phrase, 'what's Plan B?' But honestly, what *is* Plan B?

Who will take over? You know what's missing in Isabelle Stengers's comment—'At the end of the era of the medieval university, it was not clear who would take over'? The *what*. Who's going to take over *what*? The 'diplomatic institution' (Stengers's description) called a university, which is already dead, or maybe just a little ruined? A little ruination never hurt anyone. This world looks beautiful in the light of a ruined moon, in the dusk of the carbon dust of a ruined world. But it might look better in the hail of an Epicurean rain. And you know what that means? We need to go outside, where it's raining.

Who's going to take over what? How about if, when they get here, there's nothing to take over? Because we dispersed, and went rogue-medieval-itinerant? We went out in the rain. We might decide, with Michael O'Rourke, to seek out 'a recalibrated futurity for the humanities which recognizes that its future will always have been its end, which, more affirmatively put, is to say that its future will have been always to begin its ending again. . . . [and] we can find a certain dignity in what we are doing if we maintain absolute fidelity to the incalculable and unreckonable event of the university to-come, the university without condition'.[17] This will also mean embracing what Geoffrey Bennington has written, by way of Derrida, about the institutionality of the university:

> The University . . . [has] a responsibility to foster events of thought that cannot fail to unsettle the University in its Idea of itself. . . On this account, the University is in principle the institution that 'lives' the precarious chance and ruin of the institution as its very institutionality.[18]

So let's affirm some ruinous possibility now—that means knowing your history, but also when to let go of it, and to be willing to remain perpetually unsettled, both in terms of knowledge disciplines, but also in terms of place, or as Simone Weil once put it, 'we must take the feeling of being at home into exile. We must be rooted in the absence of place'.[19]

The university isn't a place, it's a state of mind. Wherever we are, wherever we gather, wherever we profess—that is the university, and there will never be a take-over of that situation.

But we have to get out in the rain and also learn how to make it rain. We have to go outside and join hands with the ever-growing academic labour precariat and start forming new initiatives for para-academic outstitutions.[20] It's a question of the atmosphere, and how we need to be more drenched in it. And as Derrida wrote, 'take your time, but be quick about it, because you do not know what awaits you'.[21]

Notes

1 Stengers, Isabelle (2011) 'The Care of the Possible: Isabelle Stengers interviewed by Erik Bordeleau', Ladd, Kelly [trans] *Scapegoat* 1: 12. 12–27.

2 Mentz, Steve (2009) *At the Bottom of Shakespeare's Ocean.* London: Continuum, 98.

3 Edelman, Lee (2004) *No Future: Queer Theory and the Death Drive* Durham: Duke University Press.

4 Bersani, Leo (2010) 'Sociability and Cruising' in Bersani, *Is the Rectum a Grave? And Other Essays.* Chicago: University of Chicago Press, 45–62, 61.

5 See Deleuze, Gilles and Guattari, Félix (1987) '1730: Becoming-Intense, Becoming-Animal, Becoming-Imperceptible . . .', in Deleuze and Guattari, *A Thousand Plateaus: Capitalism and Schizophrenia*, Massumi, Brian [trans] Minnesota: University of Minnesota Press.

6 See Furley, David J. (1967) *Two Studies in the Greek Atomists.* New Jersey: Princeton University Press and *Lucretius* (1947) De Rerum Natura, Bailey, Cyril [ed], 3 vols. Oxford: Oxford University Press.

7 See Butler, Judith (1993) 'Gender Is Burning: Questions of Appropriation and Subversion', in Butler, *Bodies That Matter: On the Discursive Limits of 'Sex'.* New York: Routledge, 121–140.

8 Bady, Aaron (2013) 'Bartleby in the University of California: The Social Life of Disobedience', *The New Inquiry: Zunguzungu* [weblog]: http://thenewinquiry.com/blogs/zunguzungu/bartleby-in-the-university-of-california-the-social-life-of-disobedience/ Last accessed 8 May 2013.

9 Witnessed, for example, by Bady's own stream of critical postings on his blog zunguzungu at *The New Inquiry*: http://thenewinquiry.com/blogs/zunguzungu/.

10 On this point, see Foucault, Michel (2001) 'on parrhesia' in *Fearless Speech*, Pearson, Joseph [ed] CA: Semiotext(e).

11 Althusser, Louis (2006) 'The Underground Current of the Materialism of the Encounter', in Althusser, *Philosophy of the Encounter: Later Writings, 1978-1987*, Corpet, Oliver and Matheron, François [eds], Goshgarian, G.M. [trans] London: Verso, 163–207, 191. All subsequent quotations of this work cited parenthetically, by page number.

12 But it should also be noted here that a logocentric critique isn't—or in my view, shouldn't be—scorn for creaturely attachment to meaning-making as creative activity and meanings as creative productions. These are life-saving activities, after all, and key to thriving in this world. I learned this lesson from Fradenburg, L.O. Aranye (2013) *Staying Alive: A Survival Manual for the Liberal Arts*. New York: punctum books.

13 In a prologue to his unfinished book on 'the materialism of the encounter', Althusser wrote, 'in November 1980, in the course of a severe, unforeseeable crisis that had left me in a state of mental confusion, I strangled my wife, the woman who was everything in the world to me and who loved me so much that, since living had become impossible for her, she wanted only to die. In my confusion, not knowing what I was doing, I no doubt rendered her this "service": she did not defend herself against it, but died of it' (164). This strange and quasi-emotionally distant 'confession' (if it can be called such) is somehow more honest than the official confession Althusser wrote later in 1985, where he claimed he was only giving his wife a neck massage that somehow went awry and which induced in him a sort of hysterical amnesia: see Althusser, Louis (1995) *The Future Lasts Forever: A Memoir*. New York: New Press. I mention these biographical details because, in reading Althusser's late writing on

a 'materialism of the encounter,' one can't help but feel that his search for a philosophy of the radically empty, of the contingent encounter from which anything was possible, was also somehow a search for his own void from which to begin, again.

14 On this point, again, Fradenburg (2013) is indispensable.

15 Robertson, Lisa (2001) 'The Weather: A Report on Sincerity', *DC Poetry*: http://www.dcpoetry.com/anthology/242. Last accessed May 8, 2013.

16 On the subject of the ways in which the university, and especially the humanities, have been undermined and how they might reclaim new space(s) among the 'ruins', as it were, see (among other works), Fradenburg (2013) and Readings, Bill (1997) *The University in Ruins* MA: Harvard University Press. On how the university has reached its current state of troubling affairs, see Newfield, Christopher (2008) *Unmaking the Public University: The Forty-Year Assault on the Middle Class*. MA: Harvard University Press: MA and Ginsberg, Benjamin (2011) *The Fall of the Faculty: The Rise of the All-Administrative University and Why It Matters*. Oxford: Oxford University Press.

17 O'Rourke, Michael (2010) 'After', In The Middle [weblog]: http://www. inthemedievalmiddle.com/ 2010/11/guest-post-michael-orourke-after. html. Last accessed May 8, 2013. This post is a transcript of O'Rourke's keynote address at the 1st biennial meeting of the BABEL Working Group held in Austin, Texas in November 2010.

18 Bennington, Geoffrey (2007) 'Foundations', *Textual Practice* 21.2: 231–249.

19 Weil, Simone (1952) *Gravity and Grace*, Thibon, Gustave [ed] London: Routledge, 86.

20 Here I am making a nod toward new educational (and occasionally anti-institutional) and alt-cult initiatives and start-ups, such as the Brooklyn Institute for Social Research (http://thebrooklyninstitute. com/), The Public School New York (http://thepublicschool.org/nyc), continent. journal (http://www.continentcontinent. com/index.php/ continent), punctum books (http://punctumbooks.com), and The Bruce High Quality Foundation (http://www.thebrucehighqualityfoundation. com/), just to name a few.

21 Derrida, Jacques (2001) 'The Future of the Profession or the University Without Condition (thanks to the "Humanities," what could take place tomorrow)', in Cohen, Tom [ed] *Jacques Derrida and the Humanities: A Critical Reader*. Cambridge: Cambridge University Press, 24–57.

Eileen Joy is a specialist in Old English literary studies and cultural studies, as well as a para-academic rogue drone-strike machine, with interests in poetry and poetics, historiography, ethics, affects, embodiments, queer studies, the politics of friendship, speculative realism, object oriented ontology, the ecological, and the post/human. She is the Lead Ingenitor of the BABEL Working Group, the Editor of *postmedieval: a journal of medieval cultural studies*, Director of punctum books: spontaneous acts of scholarly combustion, and Assoc. Director of Punctum Records. She blogs at *In The Middle* (http://www.inthemedievalmiddle.com).

RESOURCES

We thought that it might be helpful to include a resource list to help guide you on your para-academic adventures.

It is by no means exhaustive and it will express a certain geographical and disciplinary bias. Find out what works for you, for your research and teaching needs, desires, and hopes.

FIRST PORTS OF CALL:

Whenever setting out on Big Adventures it is always best to go with company. And when negotiating the troubled waters and icy winds of the para-academic world talking to, and working with, as many different people as possible will sustain you, challenge you, and make your work more rigorous, more playful, more meaningful.

Talk to friends, neighbours, and family—see what work you could develop together. Investigate what arts, education, or activist networks exist in your local area, get in contact. If there aren't any—*make* networks of practitioners, thinkers, and hopeful educators. Remember that networks can be real as well as virtual—so play with whatever resources feel most comfortable for you and your work.

Once you have yourself a para-academic posse you might need some space to work in. Contact community centres or village halls for low-cost room-hire and facilities. Let libraries become your friend—working closely with library staff can help you develop sustained programmes of activities which are specifically tailored to your local area. They are, of course, also

invaluable repositories of free or low-cost knowledge. *Use them.*

Collaborating with existing community groups, projects, art galleries and museums can be really good for developing your ideas and making connections with other researchers and practitioners.

Don't be afraid to talk to institutions—most education institutions have passionate and committed practitioners who want to explore higher education in different ways. If you live near an HEI, get in contact with their public engagement or WP teams, as well as the academic faculty. Working with schools, youth groups, refugee rights groups, or elder care support can offer really exciting opportunities for developing new education practices as well as provide all too necessary support. However, remember to adhere to safeguarding protocols and legal requirements.

In short, make connections and think hard about what you want to do. If you want to work with communities, research what is needed in your area and what your skills can provide. Listen to others, and listen to yourself.

And remember, whatever you do, practice self-care.

Here is a list of websites which might be of use to some of you. They are roughly grouped into categories to help with accessing support—though we understand that these categories melt and work across each other. We are also aware that not everyone has access to web resources.

ACTIVISM:

Listen to this: '**A Slam on Feminism in Academia' by Shaunga Tagore**-http://rabble.ca/podcasts/shows/redeye/2011/04/slam-feminism-academia

http://www.arcusfoundation.org – The Arcus Foundation was founded in 2000 and is a leading global presence in the advancement of critical social justice and conservation issues. The Arcus Foundation works globally and has offices in Kalamazoo, Mich., New York City and Cambridge, UK. The provide funding and produce research.

http://absentfromacademy.co.uk – An archive, web resource, and video documentary series with seeks to expose, explore, and challenge the institutional racism of the UK's HE sector. This is UK-focused but explores issues vital to anyone committed to a more just education system.

http://www.blackgirldangerous.org – BGD is a forum which aims to 'amplify the voices, experiences and expressions of queer and trans* people of color. It is a crucial location for exploring and expressing big, bold, crazy, weird, and wild selves – in a world that violently or tacitly demands those selves be silent.'

http://www.blackfeminists.org – A group for Black Feminists who 'express strength and solidarity in our shared experience of inequality and power imbalance based on our race and gender.' In addition to their fantastic website they have an established network of campaigners and practitioners across the UK – and they seek new collaborators and workshop ideas.

http://blackfeministmind.wordpress.com – A fabulous site exploring Black Feminism, education, political, and personal activism, including workshops and 'Sunday Schools'.

http://conditionallyaccepted.com – Conditionally Accepted hopes to provide a space for academics at the margins of academia. They provide news, information, personal stories, and resources for scholars who are, at best, conditionally accepted in the academy. This community of the 'Conditionally Accepted' is committed to a more academically, personally, and socially just academy.

http://dream.syr.edu – DREAM is an in-process organisation based at Syracuse University in the US, which aims 'to promote a national (US) disabilities agenda for post-secondary students and their allies and serving as an educational resource and source of support for both individuals and local campus-based groups.' They have links to

educational resources and links to other useful sites and organisations.

http://feministkilljoys.com – Goldsmith's Sara Ahmed's research blog – regularly updated, always provocative and interesting. This is a useful resource for anyone working at the intersections of feminism, race, and contemporary thought.

http://www.furiousandbrave.com – Still Furious and Brave is a collective of three black Mississippians committed to bridging the gaps between academic and activist spaces. They unapologetically, furiously, and bravely seek to subvert 'the pace and exclusivity of academia by drawing on and providing access' to a whole host of personal and collective resources.

https://www.facebook.com/presumedincompetent – *Presumed Incompetent* was a pathbreaking collection (2012) exploring the intersectional roles of race, gender, and class for the working lives of women faculty of colour. Their Facebook site is an ongoing resource and network supporting women of colour working in the academy and beyond.

http://universitywithoutconditions.ac.nz – This is a university free of conditions. They are a self-organising collective, without ties to Government or corporations. Courses are open to all, and anyone can run a course.

ARTS/CREATIVE:

http://www.a-n.co.uk – A web resource for those engaged in the visual arts. Their in-depth features and content are designed to represent the multiple voices and wide range of activities and industry insights within contemporary visual arts.

http://www.artisticactivism.org – A space to 'explore, analyze, and strengthen connections between social activism and artistic practice.' They have publications, links, and video clips exploring the intersection

of art and activism.

http://www.arts-emergency.org – A UK-based national network of volunteers 'coming together to create privilege for people without privilege and counter the myth that university, and in particular arts degrees, are the domain of the privileged.'

http://platformlondon.org – Platform combines art, activism, education and research in one organisation to create unique projects driven by the need for social and ecological justice. They offer educational courses, workshops, and activities, produce publications, and hold events. Based in London, UK.

EDUCATION:

http://www.academia.edu – A free academic networking platform. This is useful for accessing papers and presentations and making transnational connections. However, it is accessible only to those who sign up.

https://archive.org - Huge internet archive of many different things! Lectures, audio books, websites, software, texts and much more.

http://www.babelworkinggroup.org – Established in 2004, the BABEL Working Group, is 'a non-hierarchical scholarly collective and para-institutional desiring-assemblage with no leaders or followers, no top and no bottom, and only a middle.' Their websites provide links to research, spaces for discussion, and, critically, works as a 'site of global alliance' for those asking pertinent questions about the place of the humanities and the university more broadly.

http://backdoorbroadcasting.net - Backdoor Broadcasting records and archives conferences, symposia, workshops, public lectures and seminars held at universities.

http://www.ceres.education.ed.ac.uk – The Centre for Education for Racial Equality in Scotland aims to embed issues of social justice and anti-discriminatory practice across all levels of society and its institutions. They hold seminars, workshops, and events and produce reports and briefings.

http://www.chronicle.com – Based in Washington D.C., The Chronicle of Higher Education is a key source of news, information, and jobs for college and university faculty members and administrators.

http://www.communityeducationnetwork.org – a US-based independent non-profit organisation by a group of committed professionals who aim to provide technical assistance and resource support for community organisations engaged in the delivery of health education and community outreach at the grassroots level.

http://www.criticalclassroom.com – The team behind the Critical Classroom is committed to encouraging 'big thinking' in educators and the education system at a local, national, and international level. It provides Indigenous resources and curriculum support to Australia's learning communities. It is a fundamentally important resource place for any educator looking to engage critically with their practice.

http://www.ecu.ac.uk – The Equality Challenge Unit furthers and support equality and diversity for staff and students the UK's HE sector. They have a practitioner network, publish research, and hold a number of events and conferences.

The European Graduate School's YouTube channel has video clips of many of their seminars for free viewing – **https://www.youtube.com/user/egsvideo**

http://evekosofskysedgwick.net – an amazing archive of the life and work of the fantastic Eve Kosofsky Sedgwick. In addition to links to teaching and research, the website includes the art works produced by the godmother of queer theory.

http://www.friendscentre.org – The Friends Centre is an independent adult education organisation based in Brighton in the UK. It is a space where people can develop their knowledge, skills, understanding and creativity in a supportive environment. They offer tailored information and guidance, student support, and low-cost room hire.

http://www.globaladvancedstudies.org – Based in the US but with a global outlook, GAS is creating a transformative institution of higher education that is inclusive, democratic, and committed to justice for the oppressed.

http://www.heacademy.ac.uk – The HEA provides services to the UK HE sector – for individual learning and teaching professional, for senior managers in institutions, and for subject and discipline groups – they hold training and development sessions across the UK.

http://www.historyofphilosophy.net - History of Philosophy Without Any Gaps is a series of 20 minute podcasts which examines the ideas, lives and historical context of the major philosophers, as well as the lesser-known figures in the Classical, Later Antiquity and Islamic traditions. Also includes suggestions for further reading.

http://www.insidehighered.com – Inside Higher Ed is an online source for HE news, opinion and jobs – its main focus in the US HE sector but it is international in scope and their 'University of Venus' blog has featured a piece on para-academia.

LSE Public Events and Archives - http://www.lse.ac.uk/ newsAndMedia/videoAndAudio/channels/publicLecturesAndEvents/ Home.aspx - An audio and video archive of public lectures held at the LSE that goes back to 2006.

http://www.nen.gov.uk – The Education Network is a learning and teaching resource providing UK schools with a secure network designed and maintained by experts within the educational community. This might be a good resource for those working with schools.

http://www.niace.org.uk – The UK's National Institute of Adult Continuing Education aims to encourage all adults to engage in learning of all kinds. This is a crucial website for anyone working in the UK interested in Adult Continuing Learning.

http://www.openculture.com/ - A collection of free cultural and educational media on the web including online courses and downloading audio, audio-visual and written resources.

http://www.publicengagement.ac.uk – The National Coordinating Centre for Public Engagement is a hub for strategic public engagement activities – UK-based.

http://thepublicschool.org – The Public School is not accredited, it does not give degrees, and has no affiliation with the public school system. It provides a framework which supports autodidactic activities, and it operates 'under the assumption that everything is in everything.' It is a fantastic resource for making transnational education connections and learning new things.

http://www.publicseminar.org – The New School's Public Seminar site offers short posts, long essays, links, discussions, video and audio clips exploring issues of critical public debate.

http://publicuniversity.org.uk – The Campaign for the Public University is a UK-based campaign which works across party ties and political affiliation. It was started by a group of university teachers and graduate students committed to defending and promoting the idea of the university as a public good. They have a mailing list, hold events, and link up the often disparate strands of contemporary HE activism.

http://researchjustice.com - 'Knowledge by and for the 99%.' Socially engaged activist-academics using research to mobilise for radical change.

http://www.runnymedetrust.org – Runnymede is the UK's leading independent race equality think tank. They produce publications and hold events and web-seminars which rigorously engage and challenge race inequality.

http://www.timeshighereducation.co.uk – A print and online source for higher education jobs, news and educational resources for college professionals and teachers worldwide. You have to register to view online (you get 10 free articles a month), pay a subscription for their print copies or read them for free at most UK libraries.

https://www.vitae.ac.uk – Vitae provides online information, advice and resources for higher education institutions and researchers on professional development and careers – UK-focused but international in outlook.

http://gender-archives.leeds.ac.uk - Using Archives to Teach Gender is a resource database with images and descriptions of over 150 artefacts and documents that relate to gender and feminism that belong to the collections of the Feminist Archive North and the Marks & Spencer Company Archive.

http://www.wea.org.uk – Founded in 1903, the Workers' Educational

Association is the UK's largest voluntary sector provider of adult education. You can apply to be a WEA tutor in your local area.

http://www.wonkhe.com – A website for those who work in HE and anyone else interested in HE policy, culture and politics – UK focused.

PUBLISHING:

http://www.continentcontinent.cc – *continent.* is an online platform for thinking through media, text, image, video, sound and new forms of publishing. Their work reflects on and challenges 'contemporary conditions in politics, media studies, art, film and philosophical thought.'

http://www.ephemerajournal.org - open access journal which explores theoretical and conceptual understandings of organisational issues, organisational processes and organisational life.

http://feralfeminisms.com - is an independent, inter-media, peer reviewed, open access online journal. It is a space for students and scholars, artists and activists, to engage with the many sites and problematics of feminist studies—as understood broadly and across disciplines, genres, methods, politics, times, and contexts.

http://www.hammeronpress.net – HammerOn is a grassroots publishing label who release books that break down boundaries between academia, art and popular culture.

http://www.openhumanitiespress.org – Open Humanities Press is open access publishing collective that is scholar-led and international in outlook – they have a 'mission...to make leading works of contemporary critical thought available worldwide.'

http://punctumbooks.com – punctum books is an open-access and print-on-demand independent publisher dedicated to radically creative modes of intellectual inquiry and writing across a whimsical para-humanities assemblage. They specialise in neo-traditional and non-conventional scholarly work that productively twists and/or ignores academic norms, with an emphasis on books that fall length-wise between the article and the monograph. punctum books seeks to pierce and disturb the wednesdayish, business-as-usual protocols of both the generic university studium and its individual cells or holding tanks. They solicit and pimp quixotic, sagely mad engagements with textual thought-bodies.

Lightning Source UK Ltd.
Milton Keynes UK
UKOW02f2239300814

237776UK00004B/63/P